WINGED VICTORY

REFLECTIONS OF TWO ROYAL AIR FORCE LEADERS

Air Vice-Marshal J. E. (Johnnie) Johnson

CB CBE DSO DFC

AND

Wing Commander P. B. (Laddie) Lucas

CBE DSO DFC

Stanley Paul

LONDON

PHOTOGRAPH ACKNOWLEDGEMENTS

The authors and publishers are grateful to the following for permission to reproduce photographs:

Associated Press, page 78
Dr Frederick R. Buckler, page 193
Harold G. Coldbeck, page 107
Victoria Giradet, page 227
House of Lords Record Office, page 222
Hulton-Deutsch Collection, pages 16, 31, 119 right, 144 centre left, 154, 155 and 174
Robert Hunt Library, pages 42, 90 below left, 92 and 128
Illustrated London News Picture Library, page 232
Imperial War Museum, pages 14, 25, 30, 32, 33, 35, 41, 43, 49, 51, 53 above and below, 60 above and below, 72, 80, 84, 90 above and below right, 93, 99, 101, 104, 114, 121, 123, 126, 127, 131, 132, 134, 135, 138, 142 below, 143 below, 144 above and below left, 158, 162 right, 163 above and below, 166, 168, 172, 173, 175, 177 above, centre and below, 190, 196/197, 206, 209, 211, 218 above, 231, 234 and 235
Charles Patterson, page 240
Lionel Persyn, page 73
Popperfoto, pages x, 7, 26/27 and 34
Range/Bettman, pages 137, 142 above, 143 above, 144 centre right, 145, 192 and 233
Royal Airforce Museum, pages 40 above, centre and below, 63 and 218 below
Teresa Ryde, page 226
Vic Seymour's Photographic Services, Folkestone and E.J. Howard of Hythe, page 110

All other photographs are from the personal collections of the authors

First published 1995

1 3 5 7 9 10 8 6 4 2

Copyright © J.E. Johnson & P.B. Lucas 1995

J.E. Johnson & P.B. Lucas have asserted their rights under the
Copyright, Designs and Patents Act 1988 to be identified
as the authors of this work

First published in the United Kingdom in 1995
by Stanley Paul & Co. Ltd
Random House, 20 Vauxhall Bridge Road
London SW1V 2SA

Random House Australia (Pty) Limited
20 Alfred Street, Milsons Point, Sydney
New South Wales 2061, Australia

Random House New Zealand Limited
19 Poland Road, Glenfield
Auckland 10, New Zealand

Random House South Africa (Pty) Limited
PO Box 337, Bergvlei, South Africa

Random House UK Limited Reg. No. 954009

A CIP catalogue record for this book is available
from the British Library

ISBN 0 09 178697 5

Design & make-up Roger Walker/Graham Harmer

Printed and bound in Great Britain by
Butler & Tanner Ltd, Frome and London

CONTENTS

THE AUTHORS

Air Vice-Marshal J.E. (Johnnie) Johnson
CB CBE DSO DFC

Johnnie Johnson, the Royal Air Force's outstanding Wing Leader in the Second World War, became the Allies' top-scoring ace on the Western Front with a total of 38 enemy aircraft destroyed. Apart from his individual successes which brought him three DSOs and two DFCs and several foreign decorations, Johnson's aggressive command of the brilliant Canadian formations, allied with his acute tactical mind, placed him in the forefront of fighter leaders of two World Wars.

Later, Johnson, who had flown in Douglas Bader's Wing in the Battle of Britain and then at Tangmere, flew jet fighters with the United States Air Force during the Korean War. No allied leader had a longer run of operational success.

It is not surprising that after so extensive a Service career this officer has already published five widely read books on military aviation. In *Winged Victory*, his sixth work, Johnson recaptures the highlights of his exceptional operational experience and tells, often with characteristic humour, many of the stories which colour the record of one of the Royal Air Force's most popular characters.

Born at Barrow-on-Soar, in Leicestershire, and a thoroughgoing countryman who was a civil engineer pre-war, he is a fine game shot, an attribute which aided his marksmanship in the air.

Wing Commander P.B. (Laddie) Lucas
CBE DSO DFC

Laddie Lucas rose in two years from Aircraftman 2nd Class, the lowest rank in the Royal Air Force, to command No. 249, the top-scoring fighter Squadron in the Battle of Malta, in 1942. He was then 26.

In three tours of operational flying, interspersed with two spells as a Command HQ staff officer, Lucas led two Spitfire Squadrons and, in 1943, a Wing on the Western Front. He then switched, in 1944, to Mosquitoes in 2 Group of the 2nd Tactical Air Force, commanding No. 613 (City of Manchester) Squadron in France during the Allied drive through north-west Europe until the capitulation. He was awarded the DSO and Bar, DFC and French Croix de Guerre.

A Tory MP for ten years in the 1950s, Lucas was obliged, by his business commitments, to refuse ministerial office when it was offered by Harold Macmillan in the former Prime Minister's first administration. He was earlier one of the country's best-known amateur golfers, captaining Cambridge, England and then, in the Walker Cup, Great Britain and Ireland against the United States.

He retired in 1976 from the chairmanship of a public company to turn again to writing. *Winged Victory* is Lucas's eleventh published work in a successful run as an author, his early experience pre-war as a journalist with Lord Beaverbrook's *Express Newspapers* in Fleet Street, standing him in good stead.

OTHER BOOKS BY THE SAME AUTHORS

J.E. (Johnnie) Johnson

Wing Leader; Full Circle; The Story of Air Fighting; Glorious Summer: The Story of the Battle of Britain (with Laddie Lucas); *Courage in the Skies: Great Air Battles from the Somme to Desert Storm* (with Laddie Lucas)

P.B. (Laddie) Lucas

Five Up: A Chronicle of Five Lives; The Sport of Prince's: The Reflections of a Golfer; Flying Colours: The Epic Story of Douglas Bader; Wings of War: Airmen of All Nations Tell Their Stories, 1939–45; Out of the Blue: The Role of Luck in Air Warfare, 1917–60; John Jacobs' Impact on Golf: The Man and His Methods; Thanks for the Memory: Unforgettable Characters in Air Warfare, 1939–45; Glorious Summer: The Story of the Battle of Britain (with Johnnie Johnson); *Malta: The Thorn in Rommel's Side: Six Months That Turned the War; Courage in the Skies: Great Air Battles from the Somme to Desert Storm* (with Johnnie Johnson)

ACKNOWLEDGEMENTS

The authors express their thanks to those who have helped with the preparation of this story.

To Group Captain Ian Madelin, head of the Air Historical Branch at the Ministry of Defence, our thanks are due for enabling the detail of the operations by the Coltishall Wing of Fighter Command in 1943 to be checked and secured. Likewise, we thank Katie Conrad, widow of Wing Commander Walter Conrad, the Canadian leader, for the use of her late husband's personal account of the help he received from the French Resistance in his escape through France and into Spain in the late summer and autumn of 1943.

We offer our thanks, too, to Wolfgang Falck, the celebrated Kommodore of the Luftwaffe's Nachtjagdgeschwader 1 in Holland, for describing the circumstances of Squadron Leader Peter Tomlinson's forced landing in his reconnaissance Spitfire near Deelen in September 1941. We also thank Peter Tomlinson himself, resident in Cape Town since the war, for corroborating the detail of this rare incident.

Further, we acknowledge specially the help given by Teresa Ryde and her husband, Peter, former journalist of The Times, in providing details, from family papers, of Michael Robinson's extraordinary encounter with a Luftwaffe fighter pilot in a Kentish field during the Battle of Britain of 1940. Michael, Teresa's brother, who was later lost leading the Biggin Hill Wing, had, with two other friends, dined with the Me109 pilot and his comrades in the Richthofen Geschwader's Mess at Augsburg only 18 months before while on a skiing holiday in Garmisch!

We also gladly recognise, in the context of the Malta battle of 1942, the value of the authoritative opinion expressed by Eduard Neumann, the Kommodore of the Luftwaffe's Jagdeschwader 27, supporting Erwin Rommel's Afrika Korps. Seeing the picture, as he did, at first hand, he leaves no doubt about the strategic importance of the Island's retention to the allies' victorious North African campaign.

Finally, to our friends and comrades, with whom we served in wartime and who now figure in the story which follows, we offer our salute. It is our privilege to have known them.

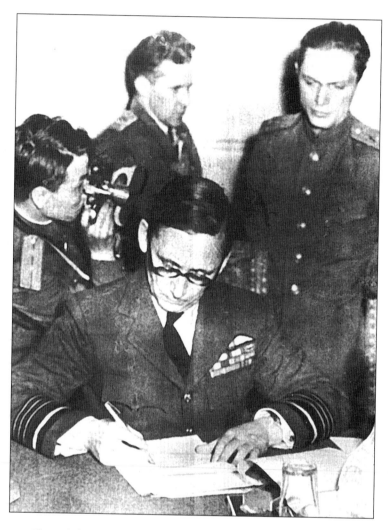

The early hours of 9 May 1945: Air Chief Marshal Sir Arthur Tedder, Deputy Supreme Commander, signs on behalf of General Eisenhower, and under Russian auspices, the German High Command's formal ratification of unconditional surrender

VICTORY!
8 MAY 1945

'The instrument of total, unconditional surrender was signed by Lieut-General Bedell Smith and General Jodl, with French and Russian officers as witnesses, at 0241 hrs on 7 May. Thereby all hostilities ceased at midnight on 8 May. The formal ratification by the German High Command took place in Berlin, under Russian arrangements, in the early hours of 9 May. Air Chief Marshal Tedder signed on behalf of Eisenhower, Marshal Zhukov for the Russians, and Field Marshal Keitel for Germany.'

WINSTON S. CHURCHILL,
THE SECOND WORLD WAR: VOL. VI, TRIUMPH AND TRAGEDY
(CASSELL, LONDON, 1954)

Thus wrote Winston Churchill on the final surrender of the German armies, which, after five years and eight months of strife, brought the Second World War in Europe to its close ...

Where were the two authors, and what were their thoughts, on this historic day as they pondered the impact of the signals which reached their commands from Group Headquarters in the 2nd Tactical Air Force?

First, Johnnie Johnson, now a Group Captain in command of No. 125 Wing of Spitfire XIVs in 83 Group. With its three Squadrons, the Wing was based at Celle, the most easterly of the Allies' airfields in Germany:

The day after it was all over I drove slowly round the perimeter track and tried to get accustomed to the rare sight of 50-odd Spitfires squatting idle on the grass on such a fine day. During the next few months I had to make sure that upwards of 1000 airmen left the Service speedily and with pleasant memories. My own future was assured since, happily, I had been awarded a permanent commission and in all probability would soldier on for the next 25 years.

Five years ago, I reflected, I was a sergeant-pilot in the Royal Air Force Volunteer Reserve. I was commissioned at Sealand and a few weeks later, with 616 Squadron, my operational career almost came to an inglorious con-

clusion. My right shoulder was giving me some trouble. An old rugby injury had been improperly set and a bad crash at Sealand had given it a nasty wrench. The old break at the collarbone was tender and sore, and sometimes after dog-fighting a Spitfire at high stick pressures the fingers of my right hand were cold and lifeless. I went to see the doctors, was promptly grounded and had to see the Station Commander, Wing Commander Stephen Hardy, who thought I was yellow and wanted to get off operations. He looked very uncomfortable when he offered me the choice of flying light Tiger Moths or taking a chance with an operation, and, of course, I chose the latter.

Nearly three years later, I was leading the Kenley Wing when the weather clamped and we landed at Middle Wallop, where the Station Commander was none other than the big, likeable Stephen Hardy. He seemed pleased to see me and over a drink he said, 'You know, I always like to think I had something to do with your career, Johnnie. When you got that bad shoulder, I could have thrown you out of the Squadron, couldn't I? And put you into Training Command. But I gave you a chance.'

'I shall always be grateful,' I replied.

'Well, you made the grade. So we were both right, weren't we?'

I suppose I had made the grade helped by good men like Hardy and tutored by a great leader, Douglas Bader. Fighter Command of those days was all about leadership and morale, when young men made of the right stuff climbed the ladder of promotion while accepting and responding to their responsibilities, so that, still in their twenties, they led fighter wings across the Western Desert and into Sicily and Italy, or from Normandy to the Baltic. We had learned about the privilege of command and something of the qualities of leadership which, in a good Squadron, extended from the commander to the hangar floor.

My reverie was interrupted as a captured Fieseler Storch bearing our own markings swung into view and glided in to land. This could only be our Group Commander, Air Vice-Marshal Harry Broadhurst, and I was alongside the Storch as he clambered out. After the usual formalities he uttered some rare words of praise about our performance during the past few weeks, when we had destroyed more than one hundred German aeroplanes. He went on to say that we had been asked to send a token British force to Copenhagen, and because we had done well, I was to get the Wing there as soon as possible.

I thanked Broadhurst, and after he left I rounded up my Wing Leader, George Keefer, and two administrative officers, jumped into an Anson and set course to Kastrup airfield, on the southern flank of Copenhagen. We were warmly greeted by the Danes and a brief inspection of the airfield showed that it was more than adequate for our modest needs. We returned to Celle, and the next day I led the three Squadrons over the Danish capital in tight formation. A crowd of milling Danes were on the tarmac to greet us and we began a happy and relaxing holiday.

Soon after our arrival I was taken to see the gutted remains of Shell House, until recently the headquarters of the dreaded Gestapo. The Danish

underground had asked for it to be bombed, hoping that some prisoners, under sentence of death, might escape. Bob Bateson had led eighteen Mosquitoes, including one flown by Air Vice-Marshal Basil Embry, at tree-top level and taken out Shell House.

Unfortunately, the Danes told me, one of the Mosquitoes struck a flagpole and crashed into a convent school; the building caught fire and other Mosquitoes bombed it instead of Shell House. Many children were killed and some were maimed for life. I made a mental note to tell Embry about this misfortune, for I knew he would fly to Copenhagen to console the relatives and nuns, which he did soon afterwards.

Several Danes asked me whether we could hold an open day on the airfield so that they could have a close look at our Spitfires. Why not? And why not put a few aeroplanes into the air: a vic of Spitfires for formation aerobatics, a Meteor to show the speed of a jet, Typhoons to strafe and sink German seaplanes moored on the Baltic, which lapped our eastern boundary, Bob Bateson's Mosquitoes and the WAAF Band. And why not charge a small entrance fee of two kroner and put the proceeds into an endowment fund for the children?

The Danes were flat out for the Air Show. They would look after all the publicity and collect the brass. Aeroplanes were promised from afar, for all our young bloods wanted a weekend in Copenhagen. Broadhurst, however, was rather cool and said it would have to be cleared with the Commander-in-Chief, 'Mary' Coningham.

With less than twenty-four hours to go things became complicated when a lady-in-waiting phoned and said the Queen had heard of the Air Show. I said it was a very small show, just a few aeroplanes and hardly suitable for the Queen. She thanked me and said she would call back; when she did she said the Queen, accompanied by the Crown Prince, would arrive at Kastrup a few minutes before the show began.

I phoned Broadhurst and told him about the Royal visit. He listened in silence and then said he had told me not to let things get out of hand. Obviously they had. He would speak with the Commander-in-Chief and call me back. The whole thing might have to be cancelled. I played my last card and said we had already sold more than 100,000 tickets, and the socially inclined Coningham might like to present a sizeable cheque to the Queen on his forthcoming triumphal visit to Denmark. Broadhurst agreed about the cheque and soon called back to say we could go ahead. Game, set and match!

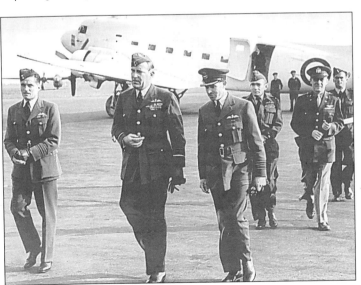

After the surrender: Johnnie Johnson (left) escorts 'Mary' Coningham, Commander of the 2nd Tactical Air Force, on arrival at Copenhagen, May 1945

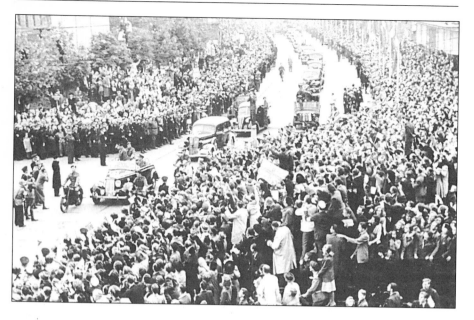

Montgomery acknowledges the cheers as his victorious cavalcade passes through the Danish capital

The Air Show was a great success, and soon after the Commander-in-Chief arrived in his VIP Dakota. He inspected the Guard of Honour and, as we walked to his car, he said, 'You escorted me today with three Spitfire Squadrons?'

'Correct, sir,' I replied.

'What did you give the Field Marshal* when he came here last week?'

'I gave him a Squadron, sir.'

'Quite right,' chuckled Coningham, and drove off to present our cheque and collect his Danish gong.

• • •

We had a long affair, you the most slim and most beautiful fighter ever built and me the happy proud pilot. We grew up together in combat over England, the Channel, France, Belgium, Holland and Germany. The jet age is here and it is time to say farewell.

We fly home together for the last time and I remember how you saved me twice, once over Dieppe and again over the Seine. We cross the Channel ...

Which serves it in the office of a wall,
Or as a moat defensive to a house.†

The Queen of Denmark inspects the Guard of Honour

*Field Marshal Sir Bernard Montgomery, later Viscount Montgomery of Alamein

†William Shakespeare, *King Richard II*, Act II, Scene I

as we had done a thousand and more times before with never a break in the song of your Merlin. Over the south coast the high sky is blue and clear – just as it was in that long, hot summer of 1940. The contrails that marked the great air battles have long been swept away, but, as long as men fly, you, my beautiful Spitfire, will be remembered.

Second, Laddie Lucas, now a Wing Commander commanding the City of Manchester's No. 613 (Mosquito) Squadron in 2 Group of the 2nd Tactical Air Force:

The morning of 8 May 1945 had an unreal, end-of-term feel about it. The exams were over, the tests completed. The signal made by Headquarters, 2 Group to 138 Wing at Cambrai/Epinoy in northern France, and thence relayed to the Squadron, confirmed the rumours which had been circulating for days. Hostilities were over. Operations must cease forthwith.

Steve, the adjutant, passed me the signal. Almost disbelieving, I read it half a dozen times to absorb its meaning. Did it mean what it said? Could it honestly be true?

It certainly did not have the effect I might have expected. It did not provoke jubilation and an instant desire to call the Squadron together and impart the official news. Rather did it numb my senses like a pain-killer working through the system to quell the agony of an aching tooth.

Three exacting tours of operational flying since the summer of 1941, at home and overseas, tasting triumph and reverse, elation and despair, excitement and utter boredom, had inured me against the extremes of human emotion. The mental training which had taught us to meet and shut out losses when they came, and get on with the job, had also served as an antidote to over-reaction at unlikely rumours.

Those of us who had been through the fire, and survived, had long since developed a protective armour against disturbance at the first suggestion of exceptional and deranging tidings. We had a ready-made retort for the most blatant rumours: 'Bollocks – unless proved otherwise.' And usually it was bollocks.

Something of this mechanism was operating now. There was, of course, the relief that the fighting was over, that the tensions and the pressures were apparently behind. But there was another side to it. I had, if I was truthful, enjoyed my time in the Service hugely. The comradeship, the humour, the sharing in a great crusade, the closeness of personal relations, the dependence of one upon another for survival, the exhilaration of operations, the overwhelming feeling of everyone-being-in-it-together – all this had represented a priceless by-product of war.

Certainly, there had been moments – days – which I would never have wished to see repeated, but these periods were quickly swamped by the strength of the morale which enveloped the good operational Squadrons of the Royal Air Force.

To say that I had 'enjoyed the war' would at once encourage the charge of being a warmonger or being indifferent to the feelings of those for whom the whole concept of war had been an abhorrent nightmare. And yet it was undeniable that the conflict which had now ended had promoted sensations and relationships which could never be repeated in peace.

But all this was now over ... Finished ... Ended ...

I got up from my desk and went next door to see the Adjutant.

'Steve,' I said, 'ask the two Flight Commanders to come and see me now, and then call the aircrews together in thirty minutes' time, with the ground-crews and the rest of the Squadron forming up a quarter of an hour later. I'll speak to each lot separately.'

Six-one-three was the third and last Squadron I had commanded, with my leadership of the Coltishall Wing, in Fighter Command, being sandwiched in between. All this experience had taught me the wavelength to select for such short talks and briefings. Emotions were always exposed and easily roused. Morale was normally so high you couldn't miss ...

But this time, I recognized, the circumstances were different. This was Victory, the reward for years of toil and courage, sacrifice and devotion to a cause, and to a Service in which we now possessed an almost obsessive pride. The future would take care of itself. It was the present – this very moment – that mattered. The fruits were here to be tasted. Tonight, parties, organized by the two Flight Commanders, would be held in Arras and Douai for all ranks in the Squadron ...

There was, of course, much elation at the news, with the Canadians, who made up almost 30 per cent of our aircrew strength, quickly taking up the running. I did, however, notice an unmistakable reticence on the part of some of the crews immediately to turn their back on the ordeal through which the Squadron had so recently passed. The experience of those awful winter nights supporting, in atrocious weather, the US First Army and the US VIIIth Corps, slugging it out with Field Marshal Gerd von Rundstedt's Fifth and Sixth Panzer Armies, and the Seventh Army, high up in the snows of the Ardennes, in eastern France, was still too fresh to be banished from the mind.

Then, we had had the inevitable losses as our AOC,* the unforgettable Basil Embry,† for whom the crews would have done anything, gone anywhere, called for 'one more heave in support of the gallant United States' stand up in the mountains'.

For me, commanding this City of Manchester Mosquito Squadron in the final months of the war, with its low-level attacks against precision targets in daylight and its interdiction missions by night in support of the advancing Allied armies, had been a totally different remit from the single-engine, day fighter role I had come to know so well – and like – in my first two operational tours.

It had been an unnatural and, at times, testing transition. I was thankful it was now over; but my thankfulness can have been as nothing compared with that of my two first-class navigators, Johnny Vick, one of Cadbury's managers

*Air Officer Commanding

†Air Vice-Marshal, later Air Chief Marshal Sir Basil Embry with, *inter alia*, four DSOs and a DFC to his name ...

in Bristol in peacetime, and Patrick Jefferies ('Jeff', inevitably, to the Squadron), an emergent exponent of the Civil Service, who, in succession, had carried, for me, a major responsibility.

• • •

As the meaning of this special day struck home, I became acutely aware of my remarkable wartime fortune. I had survived without a scratch: not a scar had the enemy left upon me. In contrast, I began to think about those among my many comrades who had not been so fortunate and, in particular, of the loss of two of my closest friends whose final sacrifice I felt more deeply than all the rest.

Michael Strutt, a Squadron Leader, Harrow-educated and a Wall Street dealer when war broke out, had been lost with the Duke of Kent in an air accident in the late summer of 1942. He and I had been golfers together pre-war. The golfing visits we had paid to his family – to his stepfather and mother, Lord and Lady Rosebery, at Mentmore, in Buckinghamshire, and to Dalmeny, on the southern shore of the Firth of Forth, and, again, to his father and stepmother, Lord and Lady Belper, at Kingston, near Nottingham – were treasured memories.

I had seen Michael, by chance, three years before in the old Berkeley Buttery, just off Piccadilly, after returning from my spell in Malta at the end of the summer of 1942. We had each taken a girl there to lunch. An air gunner (having failed, predictably, his pilot's course), he had just finished a tour with Bomber Command, sitting in the tail of a Wellington. For his rest period, he had been posted as an instructor to a gunnery school, a task for which he was, in almost every way, unsuited. What, he asked me, was my rest job to be?

Tragedy on a Scottish hillside, 25 August 1942: the crashed Sunderland flying boat in which HRH the Duke of Kent and others were killed *en route* to Iceland

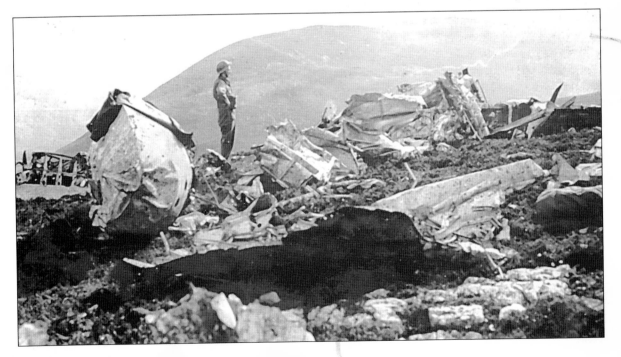

'Subject to interview,' I said, 'the people at the Air Ministry tell me I am to be PA* to the Duke of Kent.'

'My dear old boy,' countered Michael, 'it's an excellent job. Do you know the Duke? He's such a nice man.'

It soon became clear to each of us that it was plainly Michael, and not I, who was the obvious choice for this assignment. He knew the Duke and his circle of friends, and I didn't.

With my prodding, he moved fast. That same afternoon, his stepfather, an old friend of the Prime Minister, spoke to Churchill at 10 Downing Street. Within a day or so, Michael's appointment with the Duke was confirmed, while I was dispatched to the staff of the C-in-C, Fighter Command – Sholto Douglas – at Stanmore, in Middlesex. I felt it was a happy switch.

Less than a month later, the aircraft taking his Royal Highness and his party to Iceland crashed into a hillside in the north of Scotland. Michael Strutt and the Duke were among the dead ...

Squadron Leader the Hon Michael Strutt, His Royal Highness's PA, with a tour in Bomber Command behind him, was among the dead

I thought, too, of my other great wartime loss.

Raoul Daddo-Langlois, son of an able Group Captain in the Royal Air Force, and I had done all our training together in Canada under the great Empire Air Training Plan early in the war. From there, via the same Operational Training Unit (OTU) in England, we had been posted to the same Spitfire Squadron in Fighter Command and, later, to the same unit in Malta as the Mediterranean battle rose to a climax. There, Raoul had fought with special distinction, becoming a Flight Commander in 249 Squadron, which I was then commanding.

Back in England after my rest, I had taken over 616, the South Yorkshire Auxiliary Squadron, and soon had a vacancy for a Flight Commander. Raoul was my first choice. He was then just finishing his stint, instructing at an OTU. 'How about it?' I asked him. 'How would you feel about coming to us in 616? It must only be a matter of time before you get a Squadron.'

'No,' he said, 'I've made up my mind. I'm going to do my next tour on PRU.† I'm off to Benson in ten days' time to do the conversion course.'

I couldn't believe it. After all his experience on day fighters and possessing, as he manifestly did, undoubted squadron and wing leadership potential,

*Personal Assistant

†Photographic Reconnaissance Unit

I thought it was an appalling waste, and said so. Beside, I knew that such a lonely role, flying an unarmed Spitfire high up, deep into enemy territory, would never fit his restless and impatient temperament. But nothing I said would dissuade him.

A few weeks later he flew a PRU Spitfire down to Gibraltar from the UK and, after an intrepid forced landing in the Algerian desert, had made his way, somewhat chastened, to Castel Benito.

There, under Adrian Warburton, an acknowledged master of the reconnaissance art, he quickly realized that PRU was not for him. He transferred back on to fighters, joined 93 Squadron in Malta as a supernumerary flight lieutenant, and was killed a few days later covering the landings on the opening day of the Sicilian campaign.

Almost at that moment, I was looking for a new CO for 611 Squadron, one of three units in the Coltishall Wing of which I had then just become the Wing Leader. Raoul would have fitted the job to a T ...

On this historic spring morning at Cambrai/Epinoy, set amid the old battlefields of the First World War, it seemed a cruel price to pay for Victory ...

PART I

BEFORE THE BATTLE

The late Sir Dermot Boyle, the first Cranwell cadet ultimately to become Chief of the Air Staff, and one of the Royal Air Force's most skilful pilots, was adamant about the importance of a trainee's first flying instructor.

'It is one of my best-established theories,' he once wrote, 'that a pupil will normally worship his first instructor. This carries an enormous moral responsibility for the instructor because everything he does and says in the air and on the ground will automatically be what the pupil will afterwards emulate ... '*

For Johnson and Lucas, the prelude to war, the effects of their flying training on their subsequent selection as fighter pilots, and their eventual progress to an operational state, all combined to produce different and somewhat contrasting results ... A little removed, perhaps, from what the distinguished Marshal might have envisaged!

*Laddie Lucas (ed.), *Wings of War* (Hutchinson, London, 1983)

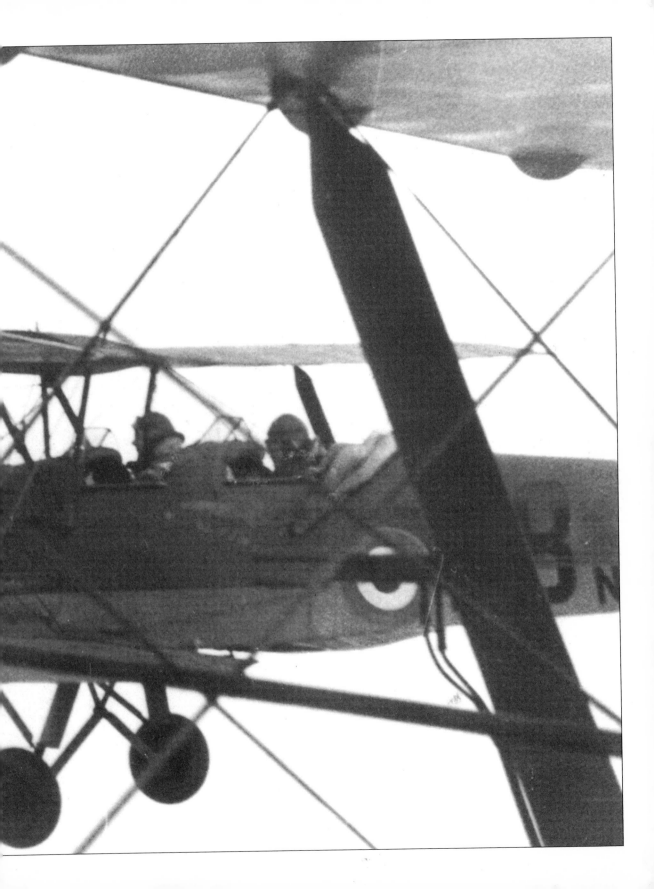

CHAPTER 1

DRIFTING TO WAR

The path which took Johnnie Johnson into the Royal Air Force and eventually to a squadron in the Duxford sector of Fighter Command, as the Battle of Britain surged to its height, was characteristically unconventional:

The young men, and young women, of my generation were very much aware in that autumn of 1938 that sooner or later war against Germany was inevitable; and because we wanted to have some control over our destinies we all belonged to one or another of the various Territorial organizations. I tried to join the somewhat exclusive Auxiliary Air Force, but I was turned down because I lived at Melton Mowbray and did not hunt. I lowered my sights and applied to join the Royal Air Force Volunteer Reserve, but they were full and could not accept any further applications for pilot training.

Any hopes I had of ever joining one or the other of the part-time flying organizations of the Royal Air Force were now firmly put aside, and, as we drifted to war, I decided that I must join some other Territorial organization, as my civilian appointment was a reserved occupation and I could not build up any enthusiasm for building air-raid shelters or supervising decontamination squads. Despite my lack of interest in the hunting field I had learned to ride at an early age, and on my next visit to Melton Mowbray I applied to join the Leicestershire Yeomanry. I was interviewed by the local troop commander and was pleased to find that he did not think it necessary to know how to fly to ride a horse.

Service with the Yeomanry was a very happy, light-hearted affair and at our annual camp at Burleigh we spent many enjoyable days charging over the countryside on our various manoeuvres. Our troop of six or seven troopers, led by a second lieutenant, carried various parts of a machine gun, and when the time came to 'engage' the enemy, the troopers dismounted, assembled the machine gun and disappeared on foot – except for one trooper known as the 'horse handler' who remained on his charger with three other horses on either side. Hours later, or so it seemed at the time, one trooper returned, grabbed his mount and said I was to bring the others some miles across the country to the lieutenant and his men.

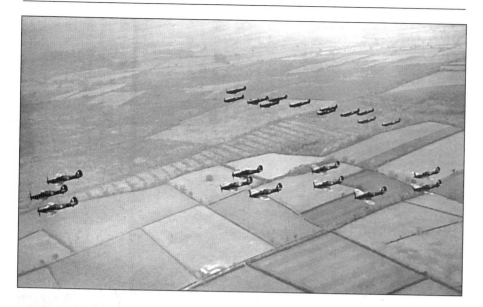

The 'Phoney War': dawn readiness at RAF Wittering, early 1940. Hurricanes on patrol with Spitfires behind

The next day it was the same procedure, but this time I dismounted with the others. The lieutenant asked why I had got off my horse. I said that since I was the horse handler yesterday it was perhaps someone else's turn. The lieutenant said that since I was a very good horse handler he had decided to make it a permanent arrangement!

At the end of our annual camp in the spring of 1939 Colonel 'Cocky' Spencer called us together and said that on our last day at Burleigh we would all hack down the Great North Road to Royal Air Force Wittering to see the new fighters; and that afternoon we sat on our horses, 600 strong in line abreast, and watched the Spitfires and Hurricanes split-arsing about the sky. The Germans, I mused, were already on the march, and I turned to the trooper next to me, Dick Black, farmer and noted steeplechaser, and said, 'Dick, if I've got to fight Hitler, I'd rather fight in one of those than on the back of this bloody horse.'

Fortunately, it was decided to expand the Volunteer Reserve and I was duly sworn-in as a sergeant-pilot under training. In late August, the Reserve was mobilized and several hundred of us were sent to Cambridge – there to be housed in various colleges until we could be slotted into the flying training schools.

One day we were all interviewed by a few elderly officers about what we wanted to become – bomber, fighter, reconnaissance or training pilots. I shall never forget the scene as we queued in the great hall with the sun slanting through the high windows and we gradually approached the dais. The old officers had obviously lunched well and were noticeably bored by the whole proceedings because we all wanted to be fighter pilots – except for me.

The old boy snarled, 'Another Billy Bishop, of course?'

'No, sir,' I replied. 'I would like to be a reconnaissance pilot.'

'And what makes you think you could be a reconnaissance pilot?'

The start of it all: Johnnie Johnson's class of cadets No.2 ITW, St John's College, Cambridge, September 1939

'Well, sir, I am a civil engineer and know about surveying, topography, mapping and – '

The Wing Commander interrupted. 'Excellent. Put this lad down as a reconnaissance pilot.'

And that is how I came to be a fighter pilot.

It took me until August of the following year before I could get my hands on a Spitfire, and when my instructor showed me the various controls I had a total of 176 hours on Tiger Moths and Miles Masters. I climbed into the cockpit while he stood on the wing root and spoke about the various instruments, and the emergency procedure for getting the undercarriage down. I was oppressed by the narrow cockpit and said that it seemed far more confined than the Master, especially when the hood was closed.

'You'll soon get used to it,' he replied. 'You'll find there is plenty of room to keep moving your head when the Me109s are about. And get a stiff neck from looking behind. Otherwise you won't last long!'

And with this boost to my morale we pressed on with the lesson.

He told me to start her up. I carried out the correct drill and the Merlin surged into life with its booming song of power, a sound no Spitfire pilot will easily forget.

The instructor bellowed into my ear, 'You're trimmed for take-off. Don't forget your fine pitch or you'll never get off the ground! Good luck.' And he sauntered away with a nonchalant air, but I knew he would watch my take-off and landing with critical eyes.

I trundled awkwardly over the grass, swinging the Spitfire from side to side with the brakes and bursts of throttle. This was very necessary, for the long high nose made forward vision impossible, and more than one pupil had recently collided with other aeroplanes or vehicles. I reached the boundary of Hawarden airfield and made the final cockpit check. I swung her nose gently into the wind. Throttle firmly open to about four pounds of boost. She accelerated very quickly. Much faster than the Master. Stick forward to lift the tail and get a good airflow over the elevators. Correct a tendency to swing with coarse rudder. Airborne, and already climbing into the sky. Wheels up. Pitch control back and throttle set to give a climbing speed of 200 mph. After a struggle, during which the nose rose and fell like the flight of a jay, I closed the perspex canopy and the cockpit seemed more restricted than before. I thought about flying with the hood open, but one could not fly or fight in this fashion.

Preparing for war: a Spitfire I in flight, July 1938

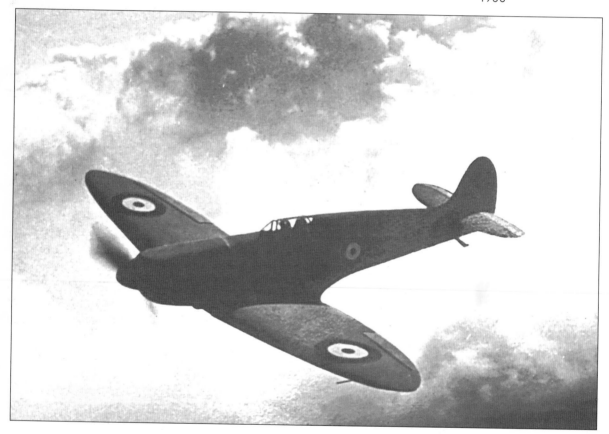

I made an easy turn and tried to pick up my bearings. Not more than four or five minutes since take-off, but already I was more than 20 miles from the airfield. A few barrel rolls. A Master loomed ahead. I overtook him and, oozing confidence, attempted an upward roll. I forgot to allow for the heavy nose of the Spitfire with sufficient forward movement of the stick, and slipped out of the attempted manoeuvre losing an undignified amount of height.

Over Hawarden again. Throttle back, and join the circuit at 1000 feet. Hood open. All clear ahead. Wheels down and curve her across wind. Flaps, and a final turn into the wind. One hundred and twenty mph on the approach, and too high. Throttle back, and she drops like a stone. More power to clear the boundary at 100 mph. Too fast. Stick back, and head over the side to judge the landing. Too high. Eventually I drop out of the sky and hit the unyielding ground with a hefty smack. The instructor, nonchalance gone, was waiting:

'I saw the Spit get you into the air! And given a fair chance she would have made a better landing than yours! If you make a mess of your approach, open up and go round again. You've been told that since you began flying. Get into the front seat of that Master and I'll show you a Spitfire circuit!'

Tales filtered back to Hawarden of how previous pupils were faring in the south. We gleaned from our instructors' small talk that someone 'had bought it' on his first trip, that 'the Yank had got a couple before they got him', and 'Jones was last seen going down in flames!' This news was not encouraging and we tried, whenever there was an opportunity to get our instructors – some of whom had fought in France – to answer our humble questions. They were, however, a dour, silent lot and all our attempts to discover how best to get on the tail of a Messerschmitt were met with: 'You'll soon find out when you get south!'

Then, one evening in the Monks Retreat, a cellar bar in Chester, I found my opportunity. My usually morose and silent instructor was perched on a stool at the bar actually talking and smiling. I alerted my companion, 'Butch' Lyons, and we sidled alongside the splendid fellow, who was downing whiskies at a fair rate of knots. Would he, I enquired, take a dram with his grateful pupils. He would, he beamed, be delighted, and he took a large dram from me and soon another from Butch. I figured that time was not on my side and I'd better ask my questions fairly soon. Alas, my timing was wrong, and the gallant chap spun off his stool and crashed to the ground in what is described in King's Regulations as Conduct Unbecoming an Officer and a Gentleman. Not conducive, they told us, to the maintenance of good order and discipline. So we picked him off the floor, got him outside, into a taxi and back to Hawarden where we put the drunk to bed.

The following day I bounced my Spitfire once or twice before she finally settled on the grass, and I hoped that no one had noticed my poor landing. When I clambered out of the cockpit my instructor strode across the grass to, I assumed, thank me for our help on the previous evening. I was wrong. All I got was an obscene bollocking on how not to land a Spitfire. What a bastard! We should have left him on the floor of the Monks Retreat!

In late August I left Hawarden with 205 hours in my log-book, including 23 on Spitfires. It had taken almost a year to complete my training. A year of destiny which had seen the Germans change the face of Europe. We British, as Churchill put it, stood alone, and we green fighter pilots went south to take our places in the line ...

CHAPTER 2

CANADIAN CAPER

Every member of aircrew in the Royal Air Force was a volunteer: none was conscripted. For Laddie Lucas, beginning nine months or so later than Johnnie Johnson, the choice of the Service, and the extended route which was followed to an operational squadron, necessarily broke new ground:

My decision to offer my services for the Royal Air Force Volunteer Reserve was reached by a somewhat unusual process of elimination which could just have been unique.

The sequence began, surprisingly, as long ago as the very early 1930s with a Field Day in the OTC* at school. It was a hot midsummer's day with the temperature nudging the eighties. My thick and prickly khaki uniform, with collar buttoned right up to the throat and puttees wrapped tightly round the calves, topping off a pair of heavy and unyielding leather boots, was more suited to a Siberian winter.

My school, Stowe, were defending a particularly high and steep hill in the Chilterns against two other similar institutions, one of which, if memory serves, was Eton.

As a lowly member of the Machine Gun Section, I was one of two of our number detailed to pull the cart, laden with firearms, up the sharp gradient. My colleague on the other guy rope was a strong, 1st XV colour, later Captain of Boxing at Oxford, who was, later still, killed in the war. By the time we had toiled to the summit, through the gorse and brush, I had concluded that whatever life might hold for me after school and university it would certainly not be in the service of the British Army.

There was an unexpected outcome to this military exercise. As the opposing hordes pressed on up the hill in the face of our repeated and spirited volleys of blanks, it was clearly only a matter of time before the defence crumbled and surrender followed.

This was altogether too much for the impetuous temperament of my fellow 'mule' on the other guy rope of the machine gun cart. I never discovered where or how he had got it, but, unseen by others save those close to, he slipped a live .303 round in the breech of his rifle and let fly – safely – but quite low enough above the heads of the enemy to cause mayhem.

*Officers' Training Corps

The menacing 'ping' of a live round whistling through the air, in contrast with an innocuous barrage of blanks, set the umpires springing to life, frantically waving red flags, blowing whistles and shouting 'CEASE FIRE! CEASE FIRE! ALL SECTIONS CEASE FIRE!' The officer commanding the defenders, a splendid old Colonel, and also a school housemaster, was seen to be moving stealthily through our ranks muttering, 'Jolly poor show, you fellers, jolly poor show,' but, secretly, thoroughly enjoying it.

The opposition had been stopped in its tracks. The defence had prevailed.

The elimination of the Royal Naval Volunteer Reserve as an alternative for service followed a rather more improbable course.

As an up-and-coming young undergraduate golfer, I had been selected in my second year at the university to represent Great Britain and Ireland against the United States in the Walker Cup match at Pine Valley, in the state of New Jersey, 70 miles or so from Philadelphia, one of the loveliest and narrowest inland golf courses in all the world.

The Royal and Ancient Golf Club of St Andrews, the governing body financing the visit, in those days (unlike today) had few funds. The British team was therefore dispatched from Greenock, on the Clyde, in the good ship *Transylvania*, an Anchor Line vessel, which, converted to an armed merchant cruiser, was sent to the bottom by enemy action a few years later.

It took twelve days to reach Boston after what the captain described as the 'worst August Atlantic crossing within living memory'. I spent most of the voyage prostrate in my cabin. When we reached Pine Valley, the fairways, greens and tees were still pitching and tossing in unison with the gyrations of the *Transylvania*. I couldn't play at all…

So when Neville Chamberlain went to the microphone on that grim Sunday morning of 3 September 1939, the Royal Navy's Volunteer Reserve clearly hadn't got my vote. The following day I threw in my lot with the Air Force, and in no time they had me on their books as 'AC2 Lucas, PB, 911532'.

Fresh and eager volunteers, I and a few thousand others then hit an unexpected snag. There weren't, they told us, any aeroplanes to fly, so we were to return immediately to our civilian occupations, pending a summons.

A journalist and a member of the editorial staff of Lord Beaverbrook's *Express Newspapers*, I thus spent the next six months not contributing to Britain's war effort, but reporting it for a few million of our readers. Sidelong glances from a few of my friends as they returned to London after the ordeal of Dunkirk indicated to me that the sooner the Royal Air Force could take advantage of my incomparable services the better.

It was not, in fact, until nine months after first volunteering that I walked out of *Express Newspapers*' black glass building in Fleet Street for the last time to go away to war. By then, Churchill, as Prime Minister, First Lord of the Treasury, Minister of Defence and Leader of the House of Commons, had already stamped the authority of his great office on the British people with a series of speeches which gripped the country and the whole free world: 'What General Weygand called the Battle of France is over. The Battle of Britain is

about to begin. Upon this battle depends the survival of Christian civilization.'

Cast down at having to quit a job which I was thoroughly enjoying, I nevertheless, with head held high and mind alert, was ready for the worst that Adolf Hitler and his Nazis might unleash against us…

A year later, by mid-summer's day, 1941, I still hadn't reached an operational fighter squadron in the Royal Air Force…

• • •

The Initial Training Wing at Cambridge – No. 2 ITW in 54 Group of Training Command – where, for many of us, the so-called pre-flying ground training began, provided unexpected contact with a few of the valued characters who had become a feature of my undergraduate days.

Fifty of us, as diverse and as spirited a bunch as might be found – among it a pair of lawyers, an accountant, a surveyor, a brace of stockbrokers, a bookmaker, an academic, a steeplechase rider, an actor, a Tourist Trophy motor bike winner in the Isle of Man, an embryo cleric, a printer, a publican, a renegade Australian, a representative of the British aristocracy and several others straight from school or university – reached the old university town by train from Uxbridge (which we were thankful to leave).

Formed up in 'column of threes' outside the station, we were then marched off at '140 paces to the minute, arms swinging smartly right up to the shoulders', down Trumpington Street until we reached the gates of Pembroke, my old college. Here, the NCO in charge of us halted the party to inquire whether this was indeed be our billet. I could hardly credit that, barely four years before, I had passed through that gate to go out into the rough world to earn a living and never given the possibility of war a thought.

As we stood at ease, Tom, Pembroke's famous head porter, who had been brought out of retirement 'for the duration', came to the gate and started searching the ranks for a familiar face. Spotting me in the middle of the rear rank, he instantly slipped back into the lodge to bring out Cronk, the underporter, to confirm his discovery.

Their utter disbelief was manifested as old Tom, drawing himself up to his full, imposing height, lifted his top hat high above his head in incredulous salute.

I had one undoubted advantage during our sojourn at the ITW at Cambridge. The AOC of 54 Group was a friend from our peacetime golfing days together. He was also as good an example as could be found – perhaps even the best – of the type of successful businessman which the Royal Air Force had been able to attract into its more senior ranks when war broke out.

Air Commodore Alfred Cecil Critchley, a Canadian by birth and upbringing in Calgary, had been the youngest brigadier-general in the Canadian Army in the First World War. 'Critch', as all his friends called him, had an acknowledged genius for organization. Cast in much the same mould as his friend and

compatriot Lord Beaverbrook, Critch had enjoyed an unstoppable rise in the inter-war years, becoming one of Britain's highly publicized and widely known entrepreneurs.

When he formed 54 Group in Training Command, at the Air Ministry's behest in 1939, he staffed his Group and Wing headquarters with many of the executives and managers (mostly retired serving officers) whom he had employed in his company in peacetime. These he now dragooned into the Air Force.

Torquay, Bexhill, Hastings, Scarborough... Training Wings were sets up, one after another, at leading coastal resorts. If, in these watering places, there was a good four- or five-star hotel, Critch commandeered it. So, too, were parts of selected Cambridge colleges taken on board.

The process was driven ahead at a breathtaking speed which left staff officers at Command HQ and Air Ministry gasping.

But Critch, who for a few years had been the Member of Parliament for Twickenham, had friends at court, notably Harold Balfour,* the highly personable and influential Under-Secretary of State for Air, who had commanded a flight in the famous 43 Squadron on the Western Front in the First World War and won two Military Crosses in the process. The AOC thus knew the way around...

When, towards the end of the war, he resigned from the Royal Air Force to become Director-General of British Overseas Airways (now British Airways), it was Brendan Bracken,† then Minister of Information in Churchill's wartime Coalition, who recommended him to the Prime Minister.

'I know, Prime Minister,' said Bracken, 'that Critchley rather goes at things like a bull in a china shop, but ...'

'Two bulls in a china shop,' muttered Churchill.

• • •

The AOC came to inspect the Wing one late summer's afternoon as the Battle of Britain was reaching its critical stage. Cadets of A Squadron were being put through a session of vigorous physical jerks by the PT instructor for the Air Commodore's benefit. Suddenly, the instructor's voice rang out during a short break. 'Will Cadet Lucas fall out and report at once to the AOC?'

I sprang out at the double and came smartly to attention before the Air Commodore to hear him say, 'How would you like to go to Canada to learn to fly under the Empire Plan which is about to start up over there?'

'Sir,' I said, 'I'd go tomorrow.'

• • •

Forty of us, 'graduates' from the Cambridge ITW, forgathered in Liverpool towards the end of September 1940 in readiness to embark on the Canadian Pacific liner *Duchess of Richmond*, bound for Halifax, Nova Scotia.

With an apprehensive Atlantic crossing ahead, I was determined that our close-knit party of five stalwarts – John Harwood, Ion Constant, James Shaw,

*Later the Rt Hon Lord Balfour of Inchyre

†Later the Rt Hon Viscount Bracken of Christchurch

Raoul Daddo-Langlois and myself – would mark our departure in style with a final dinner at the Adelphi, one of the best hotels in the north-west.

I telephoned the restaurant manager, a golfing nut, who, in other days, had always looked after us with attentive care on our visits for matches at Hoylake, the Royal Liverpool Golf Club's historic links overlooking the Dee estuary.

'Could you,' I asked him, 'possibly let us have a table for five this evening? I fear we're all aircraftmen, not a commissioned officer among us.'

The response was given without a pause.

'Sir, I'm fully booked, but your party will have the best table in the restaurant.'

He was true to his word, giving us what he called 'the bridal table'. There we settled, the only 'other ranks' in the room, looking out upon an ocean of red epaulets and heavy gold braid. Deprecating eyes were at once glued on us as a pair of waiters gave our needs priority. It would have made a nice setting for an H.M. Bateman cartoon.

My valedictory diary entry recorded the outcome.

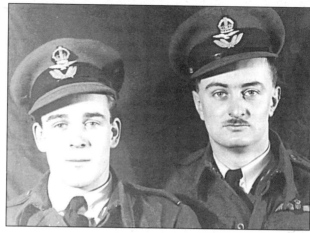

Two 'starred' graduates, Ian Constant (*left*) with E. 'Kosh' Cotton

'27 September. A fine farewell dinner – good wine, liqueurs, brandy, cigars. We leave England with our spirits high. Note: while drinking cocktails before dinner, Liverpool's barrage goes into action. The Adelphi shakes in protest. Our bill for five comes to £5 9s 6d – say, £6 5s 0d (£6.25) with tip… on 2s (10p) a day!'

• • •

With the establishment of the Commonwealth Air Training Plan in the Dominion, the Canadian Government and the Royal Canadian Air Force produced a war winner. There, literally thousands of aircrew – for the most part wartime amateurs, those who were just in for the duration – were trained far removed from the trappings of war in conditions of peace and calm which came close to being ideal.

Apart from the period in November, when snow fell heavily in Quebec and Ontario, the autumn, winter and early spring days of 1940 and '41 were clear, sunny and crisp. Temperatures in mid-winter fell to 40 and 50° C below zero, and, if there was moisture about, icicles formed on the cylinders of the radial engines of our Fleet Finch* biplanes – Canada's answer to the de Havilland Tiger Moth. But visibility, under the blue skies and frost, was usually unlimited.

And if you ever got lost in an aeroplane in eastern Canada, there was always a remedy ready to hand – fly south till you hit the St Lawrence river and the transcontinental railroad running close by; then read the name of the station, pinpoint it on the map and set a compass course back to base. Life

*Fleet Finch II Kinner B5-R

went on in a pretty even-handed and relatively leisurely way. One could absorb all the instruction without interruption or a thought for the enemy.

Off duty – and there was plenty of it – there were the skiing weekends up in the Laurentians, easily reached by the packed ski trains from Montreal. In Ottawa, with so much of the young and eligible manhood already serving overseas, and so many of the daughters of the well-placed and wonderfully hospitable families looking for fun, the social scene never lacked promise.

Leave in the Laurentians: Laddie Lucas was the guest of Montreal's Russell Cowanses at Up North, St Marguerite, PQ

As for our elementary and Service flying, I struck lucky right from the start.

At No. 11 EFTS* at Cap de la Madeleine, near Trois Rivières, a civilian establishment managed by Quebec Airways, I was allotted an instructor of rare worth. In retrospect, I have little doubt that my survival in three tours of operational flying owed much to my first mentor.

George Clarke, a wealthy and well-educated Canadian, was the nephew of the president of the Clarke Steamship Line on the St Lawrence river, but he never joined the family business. Instead, he had set up on his own as a middleman in the newsprint market, buying shrewdly from mills in Canada and selling the product profitably to newspapers along the eastern seaboard of the United States. For this purpose, he had his own private aircraft and a bagful of hours in his flying log book. Newspapers made a bond between us. He was strict and punctilious.

The preliminary exchanges as we waited at the downwind end of the grass airfield for our first take-off together are still embedded in my memory. The cockpit drill had been briskly disposed of.

'Now,' he said – and the voice was sharp, metallic and clipped – 'listen to me carefully. Have you ever ridden a motor bicycle?

'You have? Swell. Then you shouldn't have any trouble smoothing and co-ordinating the movements in flight.

'And do you understand me when I say that I want you to climb this airplane at 72 mph and not 71 or 73, and that, in flying airplanes well, precision – real precision – is everything?

'You do? Right.

'Now, are your straps fixed properly?

'They are? OK. Let's go.'

George Clarke's judgement of instructor–pupil relationships – when to bawl out after a mistake and when to be tolerant – was acute.

*Elementary Flying Training School

The petrol gauge in the Fleet Finch looked like a transparent test tube suspended from the top mainplane. A cursory and less-than-particular glance at it did not always register the difference between full and largely empty.

One morning, when I had done rather less than 20 hours solo, I took an aircraft off, unwittingly, with no more than a gallon or so of fuel in it. After a short time, when I was at 3000 feet and some 12 miles east of the airfield, the motor cut dead. I felt a gimlet pierce my heart.

Picking a small field, I went through Clarke's forced landing drill and, with luck playing its part, did an immaculate, dead-stick landing on three points. The aircraft was undamaged.

I rang up the airfield from a nearby tobacco firm and said I had had an engine failure. Half an hour later, the manager of Quebec Airways, the immortal Monsieur de Blicquy, one of Canada's legendary bush pilots, landed his aircraft beside mine. He had another instructor with him.

As he walked over to me, I noticed he was carrying a five-gallon can of petrol. 'I guessed,' he said with a twinkle, 'that a little gasolene might help you out!'

George Clarke was waiting for me as I landed back at the airfield with Monsieur de Blicquy at the controls. The two of them exchanged a few sentences, then George came over to me.

'You did a swell job. I'm sure pleased with you the way you put that airplane down under pressure.'

There was a pause. Then, pointing to about half a dozen aeroplanes parked in a line beside the control tower, he added a brief postscript. 'I've told the CFI* that you'll be pushing all those airplanes into the hangar tonight.'

• • •

After Cap de la Madeleine, the Service flying course on North American Yales and Harvards at No. 2 SFTS† at Uplands, Ottawa, followed a well-ordered, competent and deliberate pattern.

I had, however, one periodical and clandestine task to perform by which I set governing store.

While I was still on my embarkation leave before setting sail for Canada, a message had reached me at home from AOC, 54 Group. In return for being drafted on this Canadian venture with a number of my friends from A Squadron at the ITW at Cambridge, I was to send the AOC, in confidence, to

*Chief Flying Instructor
†Service Flying Training School

DINNER

Graduating Members of Class

FIRST GRADUATING CLASS

AT

QUEBEC AIRWAYS (TRAINING) LIMITED

MONDAY, DECEMBER 9, 1940

1001427—Alves, G. J.
1250555—Bickerdike, H. F.
926725—Brown, D. E. W.
R-62212—Brown, D. H.
929001—Bruce, G. R.
R-64203—Carter, E. M.
911886—Constant, L. B.
1000950—Cotton, E.
1164369—Duddo-Langlois, W. R.
1152502—Duder, M. S.
R-64760—Gould, W. L.
R-64753—Hall, J. H.
926681—Harwood, J. W. H.
R-68167—Lamb, J. W.
985585—MacGillivray, J.
911532—Lucas, P. B.
R-60905—Martin, J. S.
R-59334—McConechy, A. F.
9238897—Pearson, L. B.
R-60893—Pliahka, L.
R-64770—Porter, R. E.
R-58229—Quick, J. A.
R-60258—Roseland, A. W.
R-65192—Smith, J. B.
R-62334—Togseth, M. C.
1152750—Thorley, T. H.
1000309—Walker, S.
987214—Wardill, J. C.

No. 11 ELEMENTARY FLYING TRAINING SCHOOL
British Commonwealth Air Training Plan

CHAPTER 3

COLLAPSE IN THE WEST

The prelude to hostilities and the unreal months of relative inactivity
which followed the outbreak of war did little to prepare the Royal Air
Force's young volunteers for the impact, when it came, of the enemy's
spring offensive of 1940. The events of this period were to become
embedded forever in Johnnie Johnson's agile mind.

The unsavoury Munich agreement of 1938 gave Fighter Command the
necessary breathing space to get the new Spitfires and Hurricanes
into squadron service and to expand the Royal Air Force and its
reserves. Some of the finest young men from the old Empire were attracted
by the short-service (five-year) commission – not only to learn to fly but
because they realized that, sooner or later, Hitler and his Nazis had to be
stopped. Many became outstanding fighter pilots and fighter leaders, includ-
ing 'Jamie' Jameson, 'Hawkeye' Wells, Colin Gray and Al Deere from New
Zealand, Stan Turner from Canada and 'Sailor' Malan and 'Dutch' Hugo
from South Africa.

One day, during Hugo's flying training, a retired general telephoned and
said he had known his grandfather in South Africa and would he like to
spend a few days in the country. The South African gladly accepted, and
when he arrived at a small country station a tall, elderly, well-dressed man in
tweeds and wearing the Brigade of Guards tie grasped him by the hand and
exclaimed: 'Hugo, I would have known you anywhere. You see, you are the
spitting image of that old grandfather of yours when we fought in the Boer
War. On opposite sides, of course. But I knew and respected him. Welcome.'

Having completed his flying training, the young South African was clas-
sified as an exceptional pilot and excellent marksman and suitable for posting
to a fighter squadron, which, in December 1939, was 615 (County of Surrey)
Squadron, Auxiliary Air Force, whose Honorary Air Commodore was Win-
ston Churchill.

The Squadron was sent to France and Dutch flew Gladiators from Vitry-
en-Artois. It was the time of the 'Phoney War', when the Germans were quiet,
biding their time for their spring offensive, and the Luftwaffe was rarely seen
– which was just as well for Dutch and his fellow pilots in their ancient Glad-
iators would have been shot from the skies by the modern Me 109s. Hugo

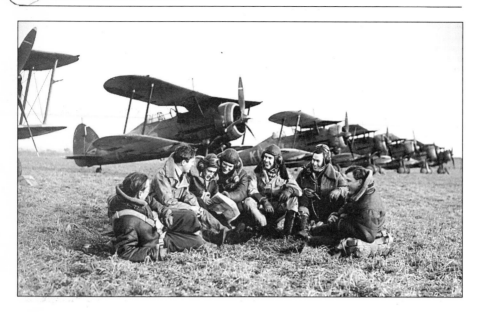

Early spring in the Pas de Calais, 1940: pilots of obsolete Gladiators prepare to meet Willie Messerschmitt's hordes

was well aware of their vulnerability but was told by his CO that, since their Gladiator biplanes could turn well inside the 109s, there was little to worry about!

The South African became friendly with another 'Colonial', Hedley Flower, a strapping young man from Australia. They lived well in a comfortable farmhouse where the food was good and plentiful with excellent wines. Often they entertained visiting VIPs, including their Honorary Air Commodore, who was then First Lord of the Admiralty, and soon, in the dark days ahead, to be Prime Minister.

While on detachment at another airfield, St Inglevert, the two young officers 'found' a derelict Morane 138E Parasol Monoplane and decided to rebuild this vintage machine from the First World War. 'After a bit of trouble,' Dutch told me, 'we managed to do so and had a lot of fun flying it, mostly while giving shapely easy-on-the-eye French girls joy rides.'

615 Squadron was re-equipping with Hurricanes when the Phoney War ended and Germany invaded Denmark and Norway. Later, on 10 May 1940, ten Panzer divisions, supported by masses of fighters and fighter-bombers, and with medium bombers blasting targets further afield, drove westward, thus beginning the most brilliant campaign in military history, which, within three weeks, drove the British Army into the sea at Dunkirk.

• • •

Dutch had his first combat when he was flying with his CO, Joe Kayll, and Tony Eyre, but the latter passed out through lack of oxygen and dropped away from the formation – a wretched vic of three. Kayll found a box of Heinkel bombers and led Hugo into them. Kayll soon accounted for a Heinkel. Dutch 'rather inexpertly' hose-piped at another and got far too close to his target, when he noticed 'something red spiralling back from the bomber towards my

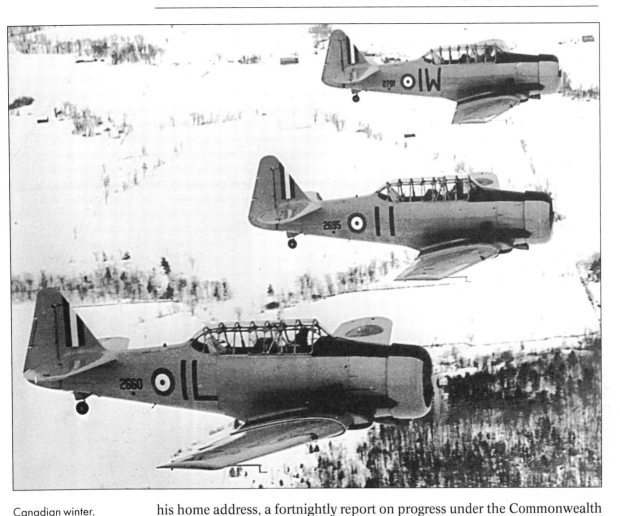

Canadian winter,
1940/41: RCAF Harvards
from No. 2 SFTS, Uplands,
Ottawa, over Ontario's
snows

his home address, a fortnightly report on progress under the Commonwealth
Air Training Plan. I followed the instruction to the letter, knocking off on a
typewriter the 1000 words required for each message.

It was not until after the war that I discovered from Critch that these
reports were transmitted, in similar confidence, to Harold Balfour, to whom
much of the credit for the conception and introduction of the Common-
wealth Plan was due. Anxious for background information, he guessed he
could rely on a former Beaverbrook Newspapers' reporter to provide a regu-
lar, unexpurgated, no holds barred account of progress under the Plan as
seen, at first hand, through the critical eyes of a trainee.

The Air Staff* never did discover how it was that the Under-Secretary of
State always seemed to be so well informed of the detail of the early stages of
this Canadian triumph...!

*Executive staff, working
under the Chief of the Air
Staff, at Air Ministry

PART II

CLIMBING THE LADDER

The opening months of a potential Squadron or Wing Leader's first operational tour had a special significance in the forward march.

Put him in a good, well-led Squadron in a busy theatre against strong opposition and the experience – if he survived – could have a direct influence upon his own, later performance. Just as a budding games player, playing in a quality, well-captained XI or XV against stern competition will quickly lift his sights to match those of his team-mates, so the embryo fighter pilot would profit massively from early membership of a Squadron which was operating successfully in the premier division of the wartime league.

The future style and method of the accomplished leader began to be shaped unconsciously – but certainly – early on in the right environment. Good leading and fighting in aerial combat were infectious. Put a pilot of real promise in the right company alongside, or behind, a class Squadron Commander or Wing Leader in the opening stages of an operational career, and the rub-off was unmistakable, the advantage undoubted.

Those who survived the fighting in France, then over Dunkirk and, later, in the skies over south-east England in 1940 learnt the hard way – if they came through unscathed. This experience became the base upon which much of Fighter Command's subsequent offensive work was shaped. There were the obvious adjustments which had to be made to suit the changed circumstances of offence after defence, but the datum – the bottom line – was there on which to build.

Johnnie Johnson, as an alert and impressionable Pilot Officer, saw the transition at first hand. He was a witness to Douglas Bader's leading of the Duxford Wing in the later stages of the Battle of Britain in 1940. The following year, he took his place in the 'legless ace's' Tangmere Wing of all the talents in 11 Group as Fighter Command, in Sholto Douglas's (its C-in-C) graphic phrase, started 'leaning out over France' and taking the fight to the enemy. It provided the grounding for what was to follow.

For Laddie Lucas, who did not take his place in the line with Athol Forbes's 66 Squadron until mid-summer in the second full year of the war, the start was very different. The fare offered by the Command's 10 and 12 Groups' offensive operations laid a fundamental but diverse base upon which to thrive.

But, before this, with the German break-through in the west, the subsequent fall of France and the Luftwaffe's inevitable onslaught against the homeland, the Royal Air Force had to counter and overcome the threat to Britain's survival.

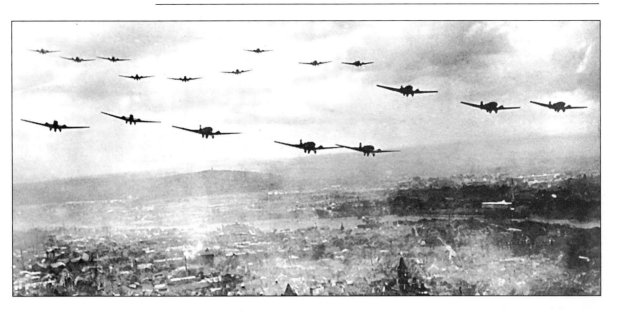

Hurricane, and decided that they had a secret weapon – coils of wire they threw out to snag your airscrew! Was my face red when I landed and heard Squadron Leader Kayll describe how tracer from the rear gunner's machine gun spiralled past him!'

To try and stop the rot more Hurricanes flew from England, did whatever they could and returned home at dusk. One day a reinforcing squadron was refuelling at a French airfield while the Royal Air Force pilots watched a dazzling aerobatic display by a Frenchman in a Morane fighter. Suddenly a lone Dornier 17 – possibly on a reconnaissance mission – flew across the airfield at about the same height as the Frenchman, who, concentrating on his performance, failed to see the German aeroplane. One of the Air Force pilots, Pete Brothers, rushed to the control tower and shouted, 'Tell him about the Dornier and he can shoot it down.'

'It is not possible, *mon Capitaine*.'

'Not possible?' shouted Peter. 'There's the —— Dornier.'

'Not possible, *mon Capitaine*. You see today he is only authorized for aerobatics!'

To try and live in the air our bombers sometimes attacked at tree-top height, where they hoped to avoid the concentrated flak, but they were so slow that the German gunners had time to traverse and aim their weapons. Of 32 Battles sent out on 10 May 13 were lost and the rest damaged.

On 12 May the invaders were well over the Albert Canal and 12 Squadron – the 'Dirty Dozen' – were ordered to attack two important bridges. Five lumbering Battles took off. Flying Officer Thomas and his crew were shot down and captured. Pilot Officer Davey, his bomber riddled by flak, struggled back to base and crash-landed. Pilot Officer McIntosh and Sergeant Marland, and their crews, were brought down and taken prisoner. Flying Officer Garland and his observer, Sergeant Gray, were both posthumously

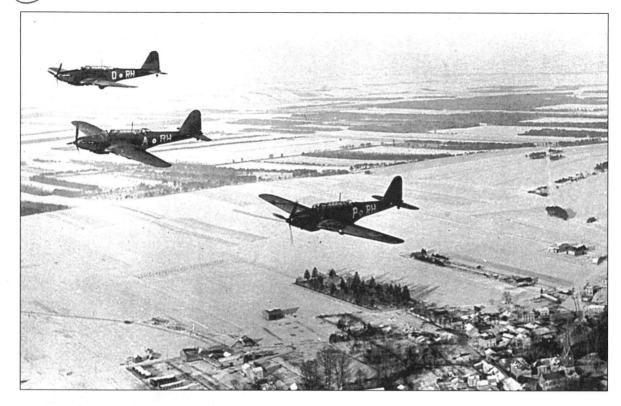

awarded the Victoria Cross, but for some inscrutable reason their gunner, Leading Aircraftman Reynolds, received no award.

Five days of daylight bombing had lost about half the RAF's strength in France, and some squadrons had to be taken out of the line. Some of the RAF's forward airfields had been captured or badly bombed, and so light bombers, flying from England, tried to provide daylight support for the battlefield; but mobile targets reported by the Army were seldom there when, hours later, the bombers turned up, and when they did they suffered heavy losses.

At this dramatic time, Wing Commander Harry Broadhurst was commanding a new fighter airfield at Coltishall in Norfolk. Broady, as he was universally known, had made his mark as a peacetime fighter pilot, and he said that the best time of his long flying career was in the 1930s when we had the Siskin followed by the Bulldog, the Gauntlet and the Gladiator, the last of the old-fashioned biplanes. The golden age of flying!

At Coltishall, he had time to spare because the fighter squadrons detailed for the new airfield had not arrived. He was well aware of the crisis in France, and when he saw a signal asking for experienced Hurricane Squadron Commanders in France, he volunteered to go. His AOC, the friendly but somewhat pompous Leigh-Mallory, telephoned and expressed his displeasure at losing an experienced Wing Commander and at his dropping a rank to go to France, which would soon be finished anyway; but Broadhurst held his ground and was posted to command 85 Squadron at Vitry.

Winter 1939/40, the quiet before the storm: Fairey Battles over northern France. Grievous casualties would follow

Broady found Vitry 'an absolute shambles'. The sustained bombing had wrecked communications, isolated headquarters and left the Wing ignorant of the battle situation in the forward zones and the whereabouts of the nearest German armour. He was told that the retreating units of the French Army were demoralized; the *poilu* were getting rid of their arms and deserting. To make matters worse the local people, terrified by the Stukas, wanted peace at any price and often tried to block their grass airfields with carts and tree trunks.

Perhaps, thought Broady, he should have stayed at Coltishall after all! He went to report to Wing Commander Jack Boret, who, however, was out of action with a nervous breakdown, and Harry Broadhurst was ordered to assume command of what remained of 60 Wing.

He was astonished at the seemingly unbridgeable gulf that existed between the Army and Air Force. An ex-Army man himself, he had been

Before the Nazi breakthrough – but whoever would have parked them like that! Hurricanes and pilots of 87 Squadron at Lille Séclin

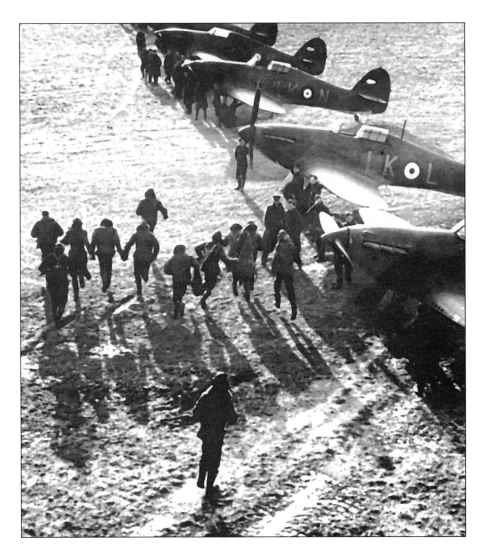

taught at the Staff College that the soldiers wanted air support at the right
time and the right place, and that the whole thing depended on understand-
ing and confidence between airman and soldier. But here, as the grey legions
blasted their way through France, there was no common language, no joint
procedures and a complete lack of confidence between the two Services. All
the antiquated Lysanders from our Army Co-operation Squadrons had been
shot out of the sky

Lacking positive information about the ground battle, the Hurricanes
patrolled where Broady and his Squadron Commanders thought best. When-
ever they encountered German bomber formations escorted by fighters, they
were always outnumbered, and many Hurricanes were shot down. Full-
strength Hurricane Wings and Squadrons should have opposed strong enemy
formations, but their losses meant that each Squadron could only put four or
five fighters into the air. Every pilot was flying four or five missions a day and
they were becoming very tired. Leading a few Hurricanes on 21 May, Harry
Broadhurst was patrolling the Lille – Arras area when they tangled with some
Me 110 fighters and he shot one down. Later that day he was ordered to with-
draw 60 Wing to Merville, and to an airfield near Lille soon after.

' "Doggy" Oliver, one of my Squadron Commanders went sick. I didn't
blame him, and I replaced him with Michael Peacock, a well-known Auxil-
iary and an excellent lawyer, who had his ear shot off in a dog-fight. He came
to see me with a bloody great bandage round his head, and I told him to get
on the next aeroplane to the UK. But he did not want to lose his Squadron
and begged me to let him stay. I agreed because I realized that very soon we
should be leaving France. But, contrary to my orders, he was soon in the air
again and was shot down and killed.'

• • •

As Dutch Hugo and his brother pilots fell back from airfield to airfield they
were told about a 'planned strategic withdrawal'; but they realized there was

Primitive days: the Nazis
occupy France, summer
1940

little strategy about the masses of
refugees who jammed all the roads
leading to the south and safety with
every kind of transport, including
horse-drawn vehicles, bicycles and
even perambulators. On the choked
roads these helpless people were
continually bombed and strafed by
the cold-blooded Stuka pilots. One
who was shot down and captured
told Dutch that they were merely
carrying out their orders, and that
their superiors wanted to screw up
the French roads so they could not
be used by Allied reinforcements.

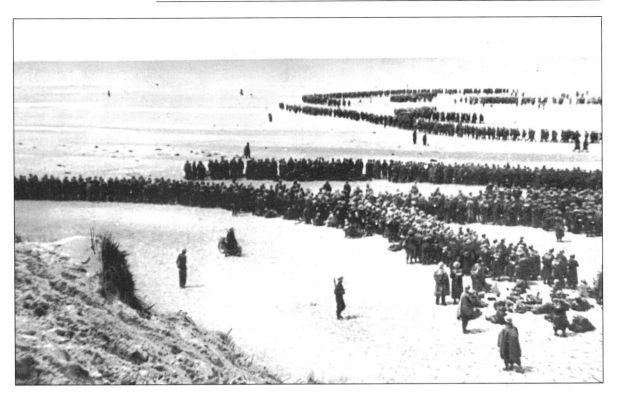

Dunkirk… 'We must be very careful not to assign to this deliverance the attributes of a victory. Wars are not won by evacuations…' Churchill in the House of Commons, 4 June 1940

On 22 May the British Expeditionary Force faced the prospect of being driven into the sea by Hitler's Panzers, for they and some twenty French divisions were cornered at Dunkirk. To the south, a French counter-attack had failed. The Dutch Army had laid down its arms and the Belgium Army was finished. At Lille, where 60 Wing had been joined by the remnants of another Hurricane Wing led by Wing Commander Finch, Broady received orders to destroy all ground equipment and fly his Hurricanes to Northolt. Finch was to get the airmen to Boulogne and thence, hopefully, by boat to England.

'I arranged for groundcrews, two for each Hurricane, to see us off, and they would then be taken home by transport aeroplanes of 24 Squadron.

'I set about assembling dumps of valuable equipment – radios, guns and tool kits – that I knew to be in short supply in the UK from wrecked and unserviceable Hurricanes. A distraught and overworked warrant officer violently disagreed with the order, thinking that they should try and make some of the Hurricanes airworthy, and for the first and last time during the war I pulled my gun and ordered him to get on with it.

'Together with my senior admin. officer, who had served in the First World War, we went to the Naafi where we found lots of goodies and cases of whisky and brandy. We emptied the stores and I gave the cigarettes and chocolate to the troops – I dared not give them whisky – and sent them on their way. I stuffed my Hurricane with whisky and brandy bottles, and filled the boot of my staff car with a well-packed suitcase and some cases of Highland Cream.

'The transports landed (I think they were old Harrows) and the Wing took off and circled over the airfield to escort them back home. I arranged for one of the Harrows to take my suitcase and some whisky.

'When I took off, the Harrows and the escorting Hurricanes were mere specks in the sky, so I chased after them, completely forgetting about German aeroplanes. Very soon four Me 110s (I was fortunate they were not 109s) jumped me and I was hit in the wing and in the oil tank in the root of the port wing. I was turning steeply with oil squirting all over the place and bottles bouncing all round the bloody cockpit, but I managed to get back to Northolt.'

Dutch Hugo, however, had a bigger problem than a mere case or two of whisky. Somehow, he had got his Parasol to the French coast, and he debated whether or not to attempt the Channel crossing in the ancient machine. Fortunately common sense prevailed and he and a few 615 pilots flew to Kenley to prepare for the next round.

Pilot Officer Denis Crowley-Milling, one of the few Volunteer Reserve pilots to fight in France, fell back with 242 Squadron to an airfield at Nantes, south of Brest, where they refuelled before flying to Tangmere. However, recent events proved too much for their weak CO, who repaired to the French Officers' Mess to sample the local vino whilst his pilots, including Crowley-Milling, a former Rolls-Royce apprentice, worked on their Hurricanes. This took some time and later the pilots, too, walked to the Mess where they found their CO drunk and fast asleep in an armchair. Someone scribbled a note and placed it on his tunic: 'We have taken off for Tangmere. When you sober up you had better join us, because the Germans are heading this way.'

New Zealander Alan Deere, having had the misfortune to be clobbered by a Dornier 17's single rear gun, made his way to Dunkirk where enemy bombers were attacking thousands of men on the beaches and the mass of small boats riding the swell near the shore. He thought about wading to a boat but was advised by a Royal Navy lieutenant to wait for the next destroyer. Amidst the noise and confusion from bombs, shot and shell, and the chattering of machine guns, he made his way to the east mole where soldiers were sheltering from air attack on either side of the causeway. Al walked along the causeway to board the destroyer, but he had an angry exchange with an Army major who tried to stop him. The New Zealander explained that he was a fighter pilot trying to get back to fight again, whereupon the major snarled: 'For all the good you chaps seem to be doing over here you might as well stay on the ground.'

On 22 July 1940 France surrendered. The Germans had proved their new concept of war – *Blitzkrieg* (Lightning War) – by storming and conquering Europe in a little over two months. We in Britain were bereft of allies. The British Army was virtually disarmed. The Royal Air Force was severely weakened. We faced invasion by the strongest military power in the world.

CHAPTER 4

THE UNBROKEN SHIELD

The story of the Battle of Britain, as it unfolded throughout July, August and September 1940, has been told from many different angles. As the fighting reached its peak, Johnnie Johnson, coming straight from an Operational Training Unit to the Duxford sector of 12 Group, saw it through the eyes of a newly-joined squadron pilot:

When Broadhurst got back from France there was a message for him to go and see Air Chief Marshal Sir Hugh Dowding. He was ushered into the beautiful room at Bentley Priory overlooking the rose garden, where his austere Commander-in-Chief pondered behind his desk, and he had plenty to ponder about, for the air fighting over France had sapped Fighter Command. Soon his force of thirty-six Squadrons of Hurricanes and Spitfires would face the whole might of the triumphant Luftwaffe. Broady gave him a blow by blow account of his hectic five days in France, which, although he did not realize it at the time, would influence his thinking for the rest of his brilliant Service career. 'Stuffy' – for that's how the C-in-C was known throughout Fighter Command – wanted to know about the various performances of the enemy aeroplanes, especially the Me 109, which, Broady told him, was superior to the Hurricane, and the ability of their fighter pilots. He knew all about the Lysander tragedy and was worried about his two-seater Defiants, which were faring badly after a brief and short-lived success.

Dowding said that all Air Vice-Marshal Keith Park's Squadrons were gaining valuable experience over France, but the Squadrons in the other groups were not so fortunate, and would Wing Commander Broadhurst please immediately visit all the Squadrons in 12 and 13 Groups and talk to the pilots about the fighting over France. There was not much time left, and perhaps the Wing Commander could talk to all these units during the next two or three days, and, concluded Dowding, on 28 May he was to take over the command of the well-established fighter station at Wittering.

Wittering, hard by Stamford on the Great North Road, is a pleasant pre-war fighter station set in quiet and gentle countryside with the flat fens stretching away to the east and the North Sea. There were some good hostelries, including the famous Ram Jam Inn, whose renowned barmaid attracted the pilots for many an evening pint. Here, Harry Broadhurst thought about

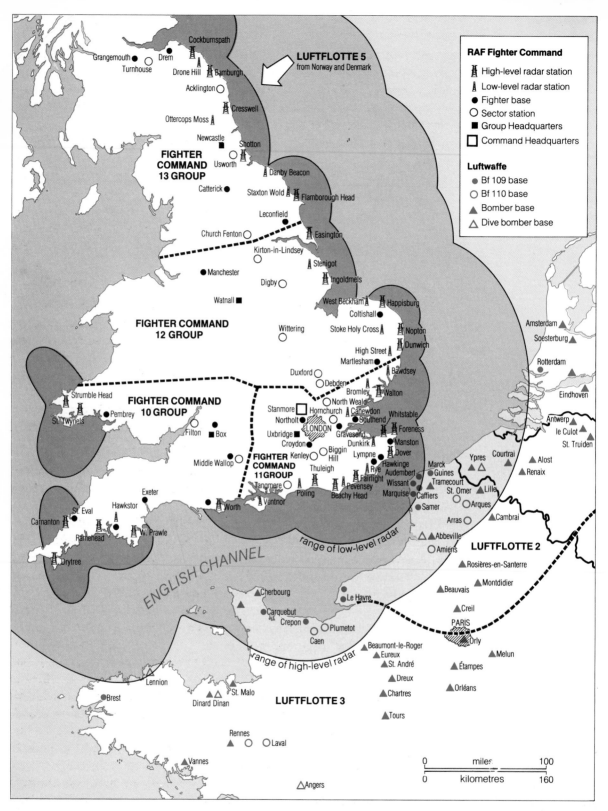

Battle of Britain, September 1940

the recent disasters in France, our lack of fighter tactics, the big enemy formations escorted by many fighters and the yawning chasm between the Army and the Royal Air Force. For the moment, however, there were more pressing affairs, as the war depended on a few hundred fighter pilots based at a dozen sector stations like Wittering.

It was at Wittering that I first met Broady, who, at thirty-five, was an experienced fighter leader and developing into a brilliant tactician. Of average height and weight, he had a somewhat impassive face, and his brown eyes had a penetrating quality that could be quite disconcerting, especially when you were being closely examined. Yet he always knew how to relax and loved a good party. Group Captain Duncan Smith, who flew with Broady throughout 1941, and later occasionally in the Desert and Italy, said he was the best fighter leader he ever knew.

Broady's character was aptly described by 'Laddie' Lucas, who wrote:[*]

> He was a rugged, competent buccaneer who knew exactly what he was about and where, the Lord willing, he intended to go. He and Douglas (Bader) had several similarities. Neither was an easy man and each was strongly assertive. Both were controversial figures and always prepared to swim against the current to sustain a personal conviction. As a pair of officers they were outstanding by any test. With 'Sailor' Malan, the South African commander of 74 Squadron, and later the highly distinguished leader of the Biggin Hill Wing, they possessed the three most resourceful brains among the senior pilots in Fighter Command.[*]

Which was just as well, because 'L-M', and most of his contemporaries, seldom took to the air and therefore had to rely for tactical advice on their Wing Commanders.

A few days after our last troops left Dunkirk, Dowding lunched at Wittering with Broadhurst and Air Vice-Marshal Trafford Leigh-Mallory. The authors, in another work,[†] have already recorded this momentous meeting when Broadhurst strongly advised Dowding not to send any more fighters to France; and soon after the C-in-C tendered the same advice to the War Cabinet, saying that 'if the present rate of wastage continues for another fortnight we shall not have a single Hurricane left in France or this country.'[‡]

The great air battles now being fought in the south never reached Wittering, and when an engineer officer phoned to say that Broadhurst's shot-up Hurricane had been completely refurbished, the Wing Commander flew to Northolt in a two-seater 'Maggie' to collect it. He was delighted with his trusty fighter, but it did not have any squadron markings, and Broady told his rigger to paint 'HB' on either side of the fuselage. This was the first time that a Wing Commander had had his initials painted on his own fighter – soon to be a common practice throughout Fighter Command.

He often flew at night in his Hurricane against the German bombers attacking our aircraft factories and cities. On 27 June he attacked and damaged a Heinkel III which tried to escape to the east, but over Coltishall our

[*]Laddie Lucas, *Flying Colours* (Hutchinson, London, 1981)

[†]Johnnie Johnson and Laddie Lucas, *Glorious Summer* (Stanley Paul, London, 1990)

[‡]Robert Wright, *Dowding and the Battle of Britain* (Macdonald, London, 1969)

Paragons of their trade: three of Fighter Command's first (and best) Wing Leaders – Sailor Malan of Biggin Hill (*left*), Harry Broadhurst of Hornchurch (*below*) and Douglas Bader of Tangmere, 1941 (*bottom left*)

gunners, trying to hit the Heinkel, succeeded in getting Broady's Hurricane. He called the Coltishall controller and said he would have to land on their spacious grass airfield. A few cars were hurriedly assembled and their head-lamps illuminated his touch-down point. He landed safely and was taken into the Mess, where he met Douglas Bader for the first time. Douglas was very interested in Broady's initials on his fighter, and did not wait to become a Wing Commander before having 'DB' painted on his Hurricane!

• • •

Meanwhile, the pilots of 615 Squadron continued to fight over France, refu-elling at various French airfields, until she surrendered in mid-June. They fell back to Kenley, and realized that they were in for a hard time with the crack fighter squadrons of the Luftwaffe now deployed but thirty miles from Dover, in the Pas de Calais, and with most enemy operational units based on airfields between Hamburg and Bordeaux. This was now especially true as Fighter Command had lost the equivalent of fifteen Hurricane Squadrons in the recent fighting.

On landing at Kenley after a mission over France on 27 June, they found King George VI waiting to decorate their CO, Squadron Leader Joe Kayll, with both the DSO and the DFC, and Flight Lieutenant Sanders with the DFC. They moved south to Hawkinge, near Dover, and there their Honorary Air Commodore snatched a few hours from his heavy responsibilities to visit them in an old Flamingo, escorted by a lone Hurricane flown by none other than the Air Officer Commanding (AOC) 11 Group, Air Vice-Marshal Keith Park, whose brilliant handling of his Squadrons in the weeks ahead would save us from defeat. To dine with the pilots, Winston Churchill stayed the night, but Park, who did not drink, returned to his headquarters.

Flying from Hawkinge, the Squadron did not have time to get sufficient height to tackle the 109s and Dutch Hugo remembered being always out-numbered and lower than the 109s.

Tough and accomplished, Joe Kayll (*right*), seen here with Peter Dixon, was a pre-war Auxiliary who later won a rare DSO and DFC in France in 1940 leading 615 Squadron. After fighting through the Battle of Britain he was promoted to lead the Hornchurch Wing. A fortnight later, flying No. 2 to the Station Commander, Harry Broadhurst, he was shot down over France and made a POW with 11 1/2 kills to his credit

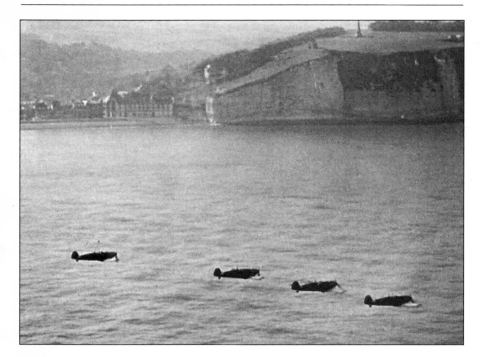

Armed reconnaissance in the Straits: a *schwarme* of Messerschmitts, flying the Luftwaffe's customary line abreast, passes St Margaret's Bay

'On 14 July we were scrambled to patrol Hawkinge, and then vectored on to a raid approaching Dover. Over Dover we engaged dive-bombing Ju 87s. I fired at one but was going too fast and finished up nearly ramming it. However, on breaking away I could see that the rear gunner was not firing any more. I then attacked another Stuka that had already been shot at by Flying Officer Collard, and when he returned to the attack, I transferred my attention back to my original target, which was diving very steeply. I kept firing in short bursts and observed strikes all over the enemy aircraft, which eventually levelled out over the sea. By now, I was overshooting badly, and with the throttle hard back and the undercarriage warning horn blaring, I closed in to only about fifteen yards. My aircraft was being thrown about badly in the slipstream of the Stuka, but I could see pieces of perspex glittering in the sun as my fire knocked the cockpit to pieces. The rear gun was pointing upwards at an angle, and the rear cockpit hood had almost entirely gone. Of the rear gunner there was no sign; he must have been slumped down in the rear cockpit. The Stuka was now very low over the sea, and a small fire started in the starboard wing at the crank where the starboard undercarriage was attached. The enemy aircraft then landed in the sea, slewed round and turned on its back with the starboard undercarriage broken off. Almost immediately the aircraft sank; there were no survivors. My aircraft was Hurricane IP 2963 and I fired all my ammunition. Collard also destroyed a Ju 87 and Pilot Officer Mudie was shot down in flames, baled out and died the next morning.'*

Two days later, Pilot Officer Hugo damaged a Dornier 17 off Folkestone, which, oddly enough, made a forced landing at the Squadron's old base in

*The Johnson papers

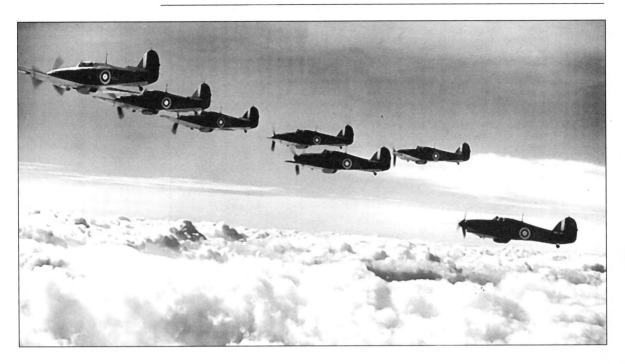

Above the overcast:
Hurricanes of 85
Squadron on patrol

France, St Inglevert. After two days escorting shipping convoys in the Channel, Elmer Gaunce, a Canadian, Tony Eyre and Dutch destroyed three Me 109s over convoy 'Bosom' near Dover and damaged others, which, however, got back to France. On 27 July, following direct orders from the Prime Minister that Luftwaffe air-sea rescue seaplanes carrying the Red Cross emblem, but thought to be spotting for German long-range guns, be attacked, a formation of 615 pilots shot a Heinkel 59 to pieces before landing at Hawkinge for supper and sleep.

The fine, cloudless days of that summer continued into August, with 615 and other Squadrons in the front line giving as good as they got. However Fighter Command was approaching its climax, because experienced pilots shot down were being replaced by raw novices, who, with but a few hours on Spitfires, were mere passengers and often a liability. Dowding found it necessary to reduce the already dangerously low hours at our fighter operational conversion units, and hastily to train volunteers from Bomber Command, Coastal Command and Army Co-operation squadrons. Our fighter pilot wastage was averaging about 120 a week, and since the output was some 65 inexperienced pilots, Fighter Command was wasting away.

On 11 August, Gaunce, Hugo and Collard were each awarded the DFC, which called for much celebration, but three days later Collard and Pilot Officer Montgomery were killed over Dover by a mixed pack of Me 109s and 110s. On 16 August, the Squadron, Hugo recalls, 'got stuck into some Heinkels over Newhaven, and I was just beginning to make an impression on one when I was shot up by an Me 110 and wounded in both legs. I landed normally at Kenley with minor wounds.'*

*The Johnson papers

Two days later, on 17 August, Hugo was flying Hurricane R 4333 from Kenley with bandaged legs. 'We had a scrap with 109s over London and I was shot down and crashed south-east of the capital in Sudbury Park. I was wounded in the left leg, right jaw and left eyebrow. The wounds were not serious, but I spent the rest of the Battle in Orpington Hospital.'*

• • •

It was at this time that I and two other inexperienced pilots joined 19 Squadron at Fowlmere, near Duxford. I had twenty-three hours on Spitfires and would not be the slightest use to the Squadron until I had at least fifty. Our problem was how to get those vital flying hours in this front-line Squadron, which was heavily engaged in the air fighting and had little time to train newcomers.

The Spitfires of 19 Squadron looked different from those at Hawarden, and a close inspection showed that the usual eight machine guns had been replaced by two 20 mm cannon. However, I soon learned that the new cannon seldom worked correctly and often jammed after a few rounds. A harassed-looking NCO told me that on every mission at least half the Spitfires had cannon stoppages, and that the pilots would far sooner have their eight-gun Spitfires.

The faulty cannon had been reported to their Station Commander, Wing Commander A.B. 'Woody' Woodhall, to their Group Commander, Trafford Leigh-Mallory, and to the C-in-C himself, Sir Hugh Dowding. And so it was that shortly after my arrival a small aeroplane landed on our grass airfield and the sparse, unsmiling Dowding got out to see things for himself and to decide whether or not to take 19 Squadron out of the line.

Dowding and his pilots knew that the old .303 inch machine gun was a First War weapon, and that it took a lot of little bullets to knock down a German bomber. On the other hand, when the guns worked, the 20 mm Hispano cannon shells tore the guts out of bombers and set their engines on fire. They simply had to be put right. However, it would take some time to get the cannons firing properly, and that evening our original Spitfires, with their old machine guns, were returned to Fowlmere.

• • •

Those lovely early autumn days at Fowlmere dragged on. Some experienced pilots were usually on dawn readiness and flew until dusk, averaging two or three sorties a day. We three, with little to do, usually had breakfast at Duxford and then drove to Fowlmere, where we hung about all day listening to the pilots after their fights, talking to the groundcrews and anyone else who would listen. We did odd errands for the genial Adjutant, like driving the Squadron van into Cambridge to get him a few razor blades, or helping him sort out the possessions of dead pilots. On paper, we were members of 19 Squadron, but we were far from being admitted to their select and exclusive ranks, and with each day the gulf seemed to get wider.

*The Johnson papers

One cloudless morning in early September, the Squadron Adjutant sent for us. 'You chaps are to report to 616 Squadron at Coltishall at once. They've just been pulled out of the front line and will have time to train their new pilots. It's probably the best thing. You can see what the form is here. We must have experienced pilots who can take their place in the Squadron.'

The phone rang and the Adjutant listened for a few moments before he slowly replaced the receiver. 'They've found the CO. Probably dead when he crashed.' For a moment he brooded: 'Well, good luck with 616.'

•　　•　　•

High summer, 1941: Bader always led the Tangmere Wing with 616, the South Yorkshire Auxiliary Squadron. Billy Burton (*left*) was the unit's CO

I have told, in *Wing Leader*,* of my arrival at the demoralized 616 Squadron, who, badly led, had, in eight days, lost five pilots killed or missing and five others wounded and in hospital. The Squadron had been ignominiously taken out of the front line at Kenley and sent to Coltishall in tranquil Norfolk to re-form; and I have written about how that fine officer Billy Burton, aided and abetted by his immediate superior Douglas Bader, licked them back into shape.

Much has been written about Douglas Bader's Big Wing, of the antagonism between Park, in the hot seat, and Leigh-Mallory, whose role was confined to reinforcing the south. 'L-M', as we called him, was the advocate of the Big Wing. 'Meet strength with strength,' he would say, whereas Park held that he did not have enough time to get his Squadrons into Wings. I have discussed this subject hundreds of times with people who were there, and we have concluded that Park could have used the outlying Big Wings, from 10 and 12 Groups, to far better advantage.

Later on, the Germans gained a lot of experience with the size of their fighter formations when they opposed the massive daylight bombing raids of the 'Mighty Eighth', and at a fighter symposium, long after the war, I asked Adolf 'Dolfo' Galland and 'Macky' Steinhoff how many fighters they could lead and control.

'Five Squadrons, each of about 12 fighters ... Not more than 60,' replied Galland, the General of Fighters, and the most experienced fighter leader in the world. 'I could not control more than 60. I often organized many Wings – hundreds of fighters – to oppose the Americans, but it was the ground controllers' job to get them into action at the right time!'

*Chatto & Windus, London, 1956; Reprint Society, London, 1958; and various paperback editions

General Steinhoff, a thinker, added: 'We could lead 60 fighters on the first co-ordinated attack, and then we tried to regroup for another attack. But the air fighting was spread and it took time to get together for a second attack. And if we made a third attack it was only with a dozen or so fighters. Then we harassed the bombers in fours, pairs or singly. Once I tried to lead two Wings, 120 fighters, on a broad front against the B-17s, but it was impossible because we could not manoeuvre and stay together.'

● ● ●

In early September, 616 moved to Kirton Lindsey on the Lincolnshire plain, where we newcomers trained hard with an occasional foray to the south; but there were no tactical discussions and I still did not know how to get on the tail of a Me 109. Indeed, when I put the important question to an experienced pilot, I was mildly rebuked by Burton for 'talking shop in the Officers' Mess'!

We knew that on 7 September Hermann Göring switched his bombers from our battered guardian airfields to London, but we did not know that this change of strategy was our salvation. It was the turning point of the Battle of Britain for it gave Dowding the opportunity to repair his damaged airfields and restore his communications. On 15 September the air fighting cost the Luftwaffe 56 aeroplanes for 26 of our fighter pilots. Two days later Hitler's invasion fleet left the Channel ports – never to return.

CHAPTER 5

LEANING OUT

A new vision had now gripped the Squadrons. The Battle of Britain had been won and was put behind. Fighter Command, regrouped and largely re-equipped, was, with the Royal Air Force's other operational Commands, intent on taking the fight to the enemy. Fresh horizons beckoned.

NO. 11 GROUP: IN AT THE DEEP END

With 11 Group's Tangmere Wing now in the forefront of the fighting with the Messerschmitts of Adolf Galland's Jagdgeschwader 26, Johnson was soon playing a pilot officer's part in the cut and thrust of the sweeps over northern France:

As 1940 closed, Dowding, the architect of one of the world's most decisive battles, was sent on some obscure mission to America and his first lieutenant and master tactician, Park, was posted to a flying training group. They were replaced by the ambitious Sholto Douglas and the genial Trafford Leigh-Mallory, and soon there was a flurry of promotions and postings within Fighter Command. These included Harry Broadhurst, who was promoted to Group Captain and moved south to command Hornchurch, an important sector station in South Essex and, at the beginning of 1941, the home of 41, 64 and 611 (Spitfire) Squadrons.

In early 1941, when the Luftwaffe did not resume daylight attacks, it was natural that Fighter Command should seek the enemy across the Channel. We began to hear about 'leaning towards France', and soon we were 'leaning out' over the Channel. At first, the enemy ignored our high-flying fighter sweeps, and rightly so, for we presented little threat when we patrolled the Pas de Calais at a high altitude. So Douglas introduced 'Circus' operations, whereby we escorted a few Blenheim bombers to short-range targets in France, hoping that the Luftwaffe would oppose this daylight effrontery. On 7 January 1941, Group Captain Harry Broadhurst, DFC, AFC, led the Hornchurch Wing on one of the first Circus missions as close escort to a few Blenheims attacking a target in the Fôret des Guines.

The 'leaning out' doctrine included low-level flights over France known as 'Rhubarbs'. The idea was to take full advantage of low cloud and poor vis-

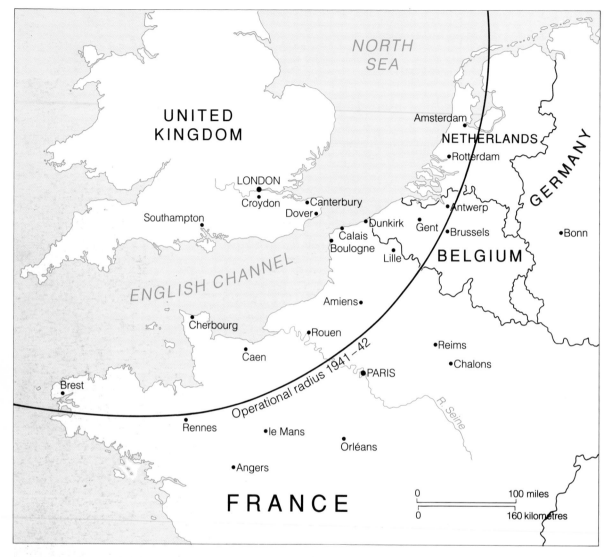

ibility to slip sections of Spitfires across the coast, then let-down below the cloud to search for opportunity targets, rolling stock, locomotives, aircraft on the ground, staff cars, enemy troops and the like. They were usually arranged on a voluntary basis and a few pilots seemed to prefer this type of individual, low-level work to the clean, exhilarating teamwork of the dog-fight. But the great majority of fighter pilots thought privately that the dividends yielded by the numerous Rhubarb operations fell far short of the cost in valuable aircraft and trained pilots.

I loathed those Rhubarbs with a deep, dark hatred. Apart from the flak, the hazards of making a let-down over unknown territory and with no accurate knowledge of the cloud base seemed far too great a risk for the damage we inflicted. During the following three summers, hundreds of pilots were lost on either small or mass Rhubarb operations, and when I later held an

'Leaning out': Circus operations 1941–2. Spitfires' short duration limited the penetration

Shipping strike, 1941: a 2 Group Blenheim of Bomber Command hits a tanker off the French coast

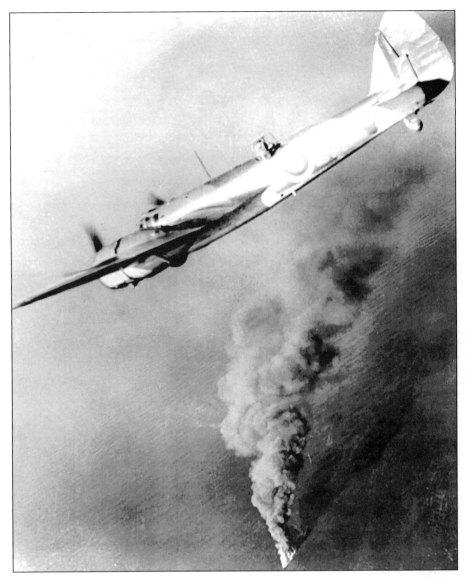

appointment of some authority at 11 Group, my strong views on this subject were given a sympathetic hearing and Rhubarbs were discontinued over France, except on very special occasions.

• • •

Wings were here to stay and the next logical step was to appoint Wing Commanders to train and lead their Wings of three Squadrons; this appointment was officially termed 'Wing Leader', and we pilots regarded it as the best job in Fighter Command. Douglas Bader went to Tangmere, the indomitable 'Sailor' Malan to Biggin Hill (soon to be succeeded by Bob Tuck), and the experienced Joe Kayll, DSO, DFC, to Hornchurch. A few days after his arrival, the Wing Leader had harsh words with his Station Commander about who would lead

the Wing on a Circus operation over France. As usual, rank prevailed and Broadhurst led with Kayll flying as his number two. Well inside France, bandits were reported behind and well above. Broadhurst, at a tactical disadvantage, turned and climbed towards the 109s and in the ensuing melee Kayll had to bale out from his damaged Spitfire and was taken prisoner.

Another Broadhurst nominee, Eric Stapleton, took over the Wing. It was Stapleton's primary duty to train and lead his Wing and be free of all administrative chores. On the other hand, the Station Commander was expected to get on with administering a fairly complex sector station and its satellite airfields, and so far in this contest there had been no pressure on Station Commanders to remain 'operational'. Indeed, most Station Commanders in Fighter Command in 1941 wore First World War medal ribbons and were rarely seen in a modern fighter.

Fortunately for all concerned, things were changing, and according to my old friend Duncan Smith,* who often flew as Broady's number two throughout that spring and summer, the Station Commander led the Hornchurch Wing on more occasions than the Wing Leader.

The Luftwaffe did not ignore the bombing and sometimes reacted strongly to our daylight thrusts. During the late spring and summer of that year, there were daily air battles over France, and the air fighting was tougher than before because we had to fight over enemy territory. Apart from Messerschmitts, we had to contend with light and heavy flak and a two-way sea crossing on each mission.

The Hornchurch Wing flew hard during that high summer and early autumn of 1941. The Squadrons were averaging over 600 hours operational flying a month, and most experienced pilots averaged well over 30 combat missions. Duncan Smith recalls that he flew 84 missions over northwest Europe in two and a half months:

Duncan Smith – 'Smithy' to many – led from the front at home and overseas for as long as any of the other successful Wing Leaders ... one of the Service's real 'characters'

> The summer wore on, with almost continuous offensive operations. Harry Broadhurst led 54 Squadron one day on a wing escort cover to Blenheims bombing St. Omer. Over the target area, about fifteen to twenty Me 109s carried out a determined attack on the bombers. In the following dogfight, Broady shot down one of the 109s in flames. The Wing was split up in this affray and Broady and his number two, 'Streak' Harris, became separated from the others. They had to lose height and fight a defensive battle all the way to the coast, where a very determined attack was launched upon them by six 109s. No matter which way they turned they were attacked in strength and 'Streak' Harris was shot down and killed.

*Squadron Leader, later Group Captain, W. G. G. Duncan Smith

Me 109s being wheeled out at Wissant, in the Pas de Calais

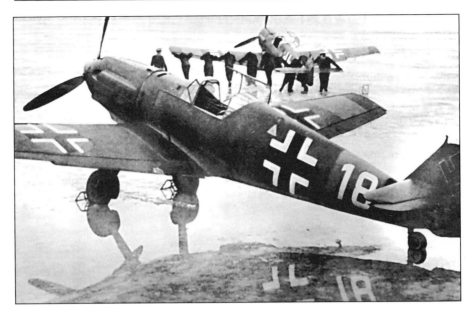

I heard Broady's voice on the radio – his call sign was 'Taipan' – asking for assistance and luckily some of us saw the 109s and raced to his aid. However, one of the 109s detached himself and made a determined head-on attack on Broady. Two other enemy fighters stationed themselves above and on each side of Broady's Spitfire, cutting off any chance of escape. He promptly flew straight at the oncoming 109, the guns of both blazing at each other on a collision course. When the 109 was almost on top of him it exploded and he flew right through the wreckage. The 109 pilot had scored hits on Broady's wing and along the side of the cockpit, wounding him. One of the German's shells had actually gone up the barrel of his Spitfire's port cannon, buckling it like a hairpin and ripping a large hole across the upper wing surface. By this time the rest of us had driven off the remaining 109s, destroying two of them. We all got back to Hornchurch without further incident, much relieved by the outcome of the battle. Broady had his hydraulic system shot up as well, so he had to carry out a wheels-up crash-landing. His Spitfire was a write-off. The Tatler later stated 'he managed to fly home despite being wounded and rendered unconscious'. It was interesting to note, on examining the Spitfire, that Broady, in flying through the enemy's wreckage, had had his Spitfire splashed with oil from the enemy fighter. After climbing out of his crashed aircraft he gave strict instructions that the oil-splashed propeller spinner was to be transferred to his new machine when it was ready, to remind him of the fight. We heard later that the intrepid German pilot who had met his end at Broady's hands was one of Germany's leading aces, with a large number of combat victories to his credit.*

*Duncan Smith, *Spitfire into Battle* (John Murray, London, 1981)

Harry Broadhurst spoke about the incident when we both appeared, in 1982, in a *This Is Your Life* programme featuring Douglas Bader. Eamon

Andrews said to Douglas: 'A Station Commander friend attacked an enemy aircraft in front, only to be fired upon by another from behind. He gets his aeroplane back, is treated for his wounds and then, like you, he has to attend a top brass meeting. You are already seated in the conference room when he walks in and has to pass you. And suddenly he lets out a yell of anguish.' From behind the curtain Sir Harry said: 'That's because you hit me exactly where the blasted Messerschmitt hit me.'

Sir Harry walked on stage, was introduced by Eamon and continued: 'It was a classic dog-fight situation. Dangerous, because when you are concentrating on shooting one chap down, his little friend comes along and does the same to you. And in the process this one filled my ample backside with debris. I got home and someone telephoned me in hospital and said would I attend a very important conference for Wing Leaders and Station Commanders. I was late, walked down the aisle and might have guessed what would happen.

'"Hello, hello, hello," said Douglas, "running away from your enemy again!" And slapped me exactly where the Messerschmitt got me!'

• • •

Having recovered from his wounds, Dutch Hugo rejoined his Squadron, which, early in 1941, was sent to Valley in Anglesey, where most of their time was spent on 'convoy patrols' over the Irish Sea. After the excitement of the previous autumn, they were bored by their convoy duties – they never saw an enemy aeroplane – and here is the South African's account of how they left Valley.

'While there we were mainly employed on convoy patrols – deadly dull existence. After putting up with this for what we thought long enough, it was decided to write a petition to our Honorary Air Commodore to ask to be posted back to more active fighting in 11 Group. As Senior Flight Commander I decided that the new CO (Denys Gillam) had better not know about it otherwise it would never be sent, so we wrote it, all the pilots signed it and I took it to London on my next 48-hour leave, accompanied by an Australian called Dave McCormack and a chap from Singapore called John Slade. When we walked brazenly up to No. 10 Downing Street the very solid bobby nearly had a fit, but we were adamant – the PM had told us we could come and see him at any time and we were going to see him. After a lot of functionaries had tried to shoo us off without success, we eventually got as far as his Private Secretary, who took the letter to the PM and came back almost immediately to call us in to see him. I explained why we had come, and he immediately asked why the CO had not signed the letter. I told him rather tactfully that as a Permanent Force Officer I thought the CO might get into trouble if he was party to such a petition, but that we, mostly Colonials, were expected to do such unconstitutional things, whereupon he roared with laughter. He then explained that he made a point of never interfering with the day-to-day conduct of the war, and so he was sorry he couldn't help us. We must have looked very glum because he gave us tea and chatted for a few minutes before we left.

'When we got back to Valley, travelling by the night Irish mail, we found the place in turmoil, as orders had come through late that afternoon for the Squadron to move to Manston for anti-shipping strikes. A few days after we got to Manston I received a personal letter from him to say that he was pleased to hear that we had been posted back to 11 Group, and hoping that we liked our new assignment. In a postscript in his own hand writing he said that he would be coming to Maston soon to see us.'*

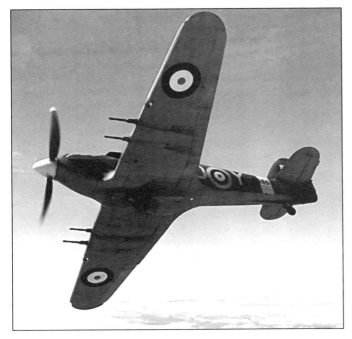

Their Hurricane IIs were armed with four 20 mm cannon, and their primary duty was to attack any German shipping they could find in the Channel, including the heavily armed E-boats and R-boats. When there was little activity in the Channel, they would fly over the ports and countryside of north-west Europe beating up targets of opportunity, usually anything that moved. Many fighter pilots, including me, did not relish beating up ground targets; 'Dolfo' Galland thought it a basic contradiction of the beautiful symmetry of a well-designed fighter. Douglas Bader said that he could always take care of himself in the air, but, like me, hated the thought of being downed by some half-baked Kraut with a machine gun.

Dutch, too, would much rather take on an enemy fighter than beat up a flak battery, when so many outstanding and experienced fighter pilots, including Bob Tuck and Paddy Finucane, were brought down. However, they were at Manston to do a job, but there were very few sorties during which the Squadron, under Denys Gillam, did not lose one or more pilots, or have

Piet Hugo (*left*), outstanding fighter leader, one of a small and élite band of South Africans in the RAF who came to Britain pre-war to make our cause theirs

some Hurricanes badly damaged by flak. By November 1941, when the CO left the Squadron, there were only three of the original pilots left who had started the anti-shipping attacks.

I remember seeing some of Gillam's cine films of that era, which were sent to all Fighter Command squadrons *pour encourager les autres*. How-

*The Johnson papers

ever, some of us would have required much encouraging to press home those low-level cannon attacks against enemy shipping in the Channel. You could see the masts looming up, sailors racing for cover on the decks, and always streams of coloured lights like golf balls directed at your fighter, travelling slowly at first and then suddenly hurtling at you.

A leader of these missions tried to achieve surprise by diving fast out of the sun on his strafing run. Sometimes he got surprise, but the Germans were excellent and alert gunners and usually fired at the remainder of the Squadron, who, of course, came in after their leader. Obviously, if a leader spent too much time attacking a target, especially the heavily defended variety like flak ships, the rest were in for a hard time. Gillam had the reputation of being 'expensive on number twos'!

The losses in 615 were heavy and many pilots were killed and wounded: Pilot Officers Hamilton and Roberts, an Australian, were lost. Sergeant Chaloupka was missing and the CO wounded. Flying Officer Aldous was lost and Flying Officer Strickland and Sergeant Potts were both killed. Flying Officer Ford was wounded ...

On 22 November 1941, Flight Lieutenant Hugo, now a Flight Commander, was awarded a Bar to his DFC, and the following day Gillam was hit by flak in the arms and legs during an attack on a distillery. Hugo went in and silenced the flak battery. Gillam, however, was in trouble and had to part company with his faltering Hurricane off Dunkirk – not an attractive prospect in late November. Hugo's Hurricane was damaged too, but leaving two pilots over his CO's dinghy, who soon tangled with four 109s, he alerted our air-sea rescue organization. A launch from the Goodwins soon collected Gillam and brought him safely to Ramsgate harbour.

The Squadron, said the AOC, had cleared the Channel. Congratulations poured in when Denys Gillam got the DSO and Dutch, aged 21, was promoted to command 41 Squadron at Tangmere, who had Spitfire Vs. Dutch was not unhappy about returning to the air fighting role after the highly dangerous 'Channel Stop' missions, but his tour as Squadron Commander was short-lived. In the following April, after a fairly quiet winter, he took over the famed Tangmere Wing.

The winter of 1941–2 was not an easy time for the pilots of Fighter Command, especially those on front-line airfields like Tangmere, for the redoubtable Focke-Wulf 190, designed by Kurt Tank, completely outclassed and outfought our Spitfire Vs. Suddenly, they were obsolete. Consequently, we lost many good men, and towards the end of April the now-experienced Hugo was also shot down and wounded by FW 190s in a fierce running fight off Dunkirk. The South African had to bail out but was eventually rescued by a Navy gunboat. His wounds were fairly serious and he was in hospital for several weeks.

When he was fully recovered, Dutch was posted to Headquarters, 11 Group at Uxbridge, where he met the redoubtable Harry Broadhurst, now responsible for fighter operations and training throughout the Group. His

'rest', however, was short-lived, for when the controversial Paddy Finucane was killed in July 1942, the South African succeeded him as Wing Leader of the Hornchurch Wing. Later, he followed Broadhurst to North Africa, where they both continued their distinguished fighter careers.

NOS 10 AND 12 GROUPS: THE FORBIDDING SEA

The operational demands of 10 and 12 Groups, based respectively in the western half of southern England and in East Anglia, were exacting but set in a lower key than those of 11 Group, whose Squadrons were only separated from the Luftwaffe by a relatively narrow strip of water. For Laddie Lucas, however, they still represented a formidable start after, first, surmounting an unlikely hurdle on returning to the UK from Canada.

Flying about in the murky smoke of industrial and urban Britain in those pre-smokeless zone days was in disturbing contrast to the bright, clear, unpolluted atmosphere of Canada. It presented some early navigational tests for the embryo fighter pilot. Debden, the Essex airfield lying to the north-east of London on the (seemingly always) downwind side of the capital's enveloping smog, was typical. Here, for a few months in 1941, was stationed No. 52 (Hurricane) OTU, the last port of call for those of us who had trained overseas before joining a front-line Squadron in Fighter Command.

George Barclay, of the banking dynasty, who had fought throughout the Battle of Britain, earning a Distinguished Flying Cross in the process, was my instructor. George, a former schoolfriend, had checked me out in a Master, an easy, single-engine, low-wing monoplane. 'That's all right,' he said airily, as we walked away from the aeroplane, 'you won't have any trouble.'

After a short pause, he led me over to an old Hurricane parked at our Flight's dispersal. 'Get in,' he said, 'and I'll just run over the tits for you.' He omitted to tell me how to retract the undercarriage after take-off.

Having completed his survey, he polished off (if that is the phrase) his patter. 'There you are, there's nothing to it. You've got a good half-an-hour or so before last light. Just do a couple of circuits and bumps and then come over to the Mess. Better to get it over now than wait till the morning. A glass of beer will be ready for you.'

By the time I had finished fiddling about trying to raise the undercart after getting airborne, I had lost the airfield in the gathering gloom. The radio was dead. A few ever-widening circles failed to disclose the secret of my whereabouts. Then, just as I was beginning to turn over the unpleasant alternatives, I spotted, away down below on the port side, the faintest set of funnel lights – pinpricks, nothing more – showing up in the dusk. I guessed they were probably leading in to a dummy airfield, of which there were plenty in East

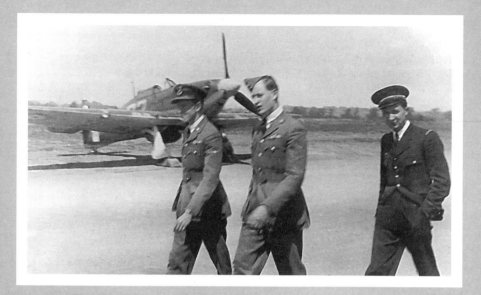

52 OTU, Debden, June 1941: *left to right* – Raoul Daddo-Langlois, Peter Anderson and Freddie de Pelleport. All were later killed with their Squadrons

The magnificent Czechs contributed their special talents to the course. The ageless and able Causky is seated in the chair on left

Passing out! *Left to right*: George Barclay, instructor, later killed in the Western Desert, Flight Sergeant Suki, Peter Anderson and Sergeant Skarvada

Anglia in 1941. Anyway, there, I thought, in desperation, was where I was going to put down.

To my astonishment, the Hurricane seemed to land itself lightly on three points on a grass airfield. Debden had concrete runways.

A waving torch beckoned me to the control tower, still just faintly visible against the fading western light. A corporal fitter jumped up on to the port wing. 'Good evening, sir. Had a good flight? Don't see many of these kites here.'

I undid my straps and removed my flying helmet. 'By the way, corporal, where is this?'

'Oooh, sir, don't you know? It's Marshall's, at Cambridge. Only got Tiger Moths here.'

Fifty miles away from base, I telephoned George Barclay in the Mess at Debden. 'I'm at Marshall's, at Cambridge, I'm afraid – '

'You're where? For God's sake, Marshall's, at Cambridge! Is the aircraft all right?' George usually got his priorities right!

A month later, I was judged to be sufficiently competent for a posting to 66 Squadron, based at Perranporth, a new airfield on Cornwall's north coast. Sixty-six had Spitfires.

• • •

'Clickety-Click' had plenty going for it. It enjoyed success in the Battle of Britain, based mainly at Gravesend, in Kent. Subsequently, it had put up a few blacks and had been unceremoniously moved to the extremity of the Cornish peninsula, well away from 11 Group. The spirit of its battle-tested pilots and groundcrews was however unaffected.

The CO, when I joined the Squadron, was Athol Forbes, who had flown with exceptional distinction in the battle as a Flight Commander in 303, the highly competent Polish Squadron, based at Northolt to the west of London. The Poles had awarded him their Virtuti Militari, Poland's equivalent of the Victoria Cross.

Here was an officer of special worth. Good looking and personable in a dark, suave, well-groomed way, Athol had his uniforms made in Saville Row, his shirts in Jermyn Street, his cap and shoes in St James's. He had a wife of classical beauty and elegance. The two made a pair. Lorrainne Forbes had breeding and character on her side. She was an asset in the Squadron's balance sheet. Her husband, nevertheless, had a lively eye for the girls, who, on the whole, found him irresistible. He spoke French fluently with a good accent, which greatly appealed to the Free French officers in

From Debden, Pilot Officer (on probation) Lucas joined 66 Squadron at Perranporth, Cornwall, in July 1941. Here, with the CO, Athol Forbes (*right*), a successful Flight Commander of 303 (Polish) Squadron in the Battle of Britain

the Squadron. He was an able pilot and an all-embracing leader, strict but tolerant. He drove his staff car, a Humber shooting brake, with genuine skill and verve – like a mixture of the late Ayrton Senna and Nigel Mansell rolled into one. All round, the CO of 66 Squadron was a very smooth operator …

• • •

Quite soon after joining 66, I was drafted into flying number two to the CO. This, I found an exacting and yet, paradoxically, a reassuring assignment. He allowed little room for mistakes in his wingman and yet, in all my inexperience, I felt he was unusually concerned for my safety: he watched over it. Athol was, for me, a first-class Squadron Commander, precise, professional and thoroughly resourceful.

When the unit moved to Perranporth – it was the first Squadron to be based there – the cliff-top airfield had few facilities, only a few Nissen-hutted administrative buildings. The aircrew were therefore billeted comfortably and advantageously in the local town.

Initially, the officers were accommodated on the ground floor of the Droskyn Castle Hotel, a welcoming hostelry, attractively sited, overlooking the Atlantic to the west and the magnificent golden sands to the north.

The remaining floors were occupied mainly by quite well-off families who had evacuated themselves from the London blitz, and whose appealing daughters had yet to throw in their lot with one of the women's voluntary services. This was an altogether happy – and much coveted – arrangement for Clickety Click's young and virile heterosexuals. Never were we at a loss for female company. Indeed, many were the times when a warm and inviting bed had, reluctantly, to be vacated in favour of the sterner demands of dawn readiness.

• • •

The Squadron's Spitfires were of the Mark IIA, 'long-range' variety with an extra 30-gallon, non-jettisonable tank slung under the port wing. This spoilt an otherwise satisfying aeroplane. But with 130 miles of sea separating Perranporth from Brest at the western end of the Brittany peninsula, where the German battlecruisers *Scharnhorst* and *Gneisenau*, soon to be joined by *Prinz Eugen*, were lying menacingly alongside, the extra gravy came in handy.

Periodical daylight attacks on the ships, with 66 escorting the four-engined Stirlings and Halifaxes of Bomber Command, formed part of the Squadron's regular diet. As a result of this onslaught, we were assured that the battlecruisers would never again be capable of putting to sea. No more than three months later they had slipped out unnoticed from Brest and were steaming up the English Channel and through the narrow Straits in full daylight in one of the great epics of the war!

There were also diversionary forays with our 'long-range' aircraft up to Coltishall, in Norfolk, and other bases in East Anglia. From there, we escorted the low-level daylight sorties by the Blenheims of Bomber Com-

mand's 2 Group against the strongly defended enemy convoys sailing west round the Frisian Islands off the north-west coast of Germany and then southwards parallel with the Dutch shore.

What a line! Spitfire LZ-R for Robert carried Laddie Lucas's family crest

The mortality of the brave Blenheim crews on these missions across 140 and 150 miles of turbulent North Sea (and sometimes more) was appalling – probably the worst of the war – for so little gain. Squadrons were being turned round in three and four weeks with these and the low-level daylight operations against targets in western Germany and enemy-occupied Europe. It was a hideous carnage.

The first time I witnessed one of these dreadful missions was in September 1941. I was flying number two to Athol Forbes, who was leading six of our Spitfires escorting a box of four Blenheims attacking a large convoy of ships – with a full complement of flak ships – rounding the north Dutch coast from the east and heading south.

Two of the bombers were hit by flak before they reached the ships and were left blazing on the water. They hadn't dropped their bombs. A third aircraft was also hit by flak and went into the drink on the far side of the convoy after dropping its load wide of a tanker. The fourth limped home, 'winged' as it left the target.

I was unashamedly moved by the apparent uselessness – senselessness – of this slaughter, when so little was achieved for such terrible loss. If this was the hard face of war, it was also murder of the first degree. I doubted whether it would be allowed to go on indefinitely …

The horror of this sortie was compounded for me in one of my earliest and inconclusive brushes with some Me 109s low down over the water on the land side of the ships. Guns were smoking and flashing as we tried to out-turn one another. I hardly knew what was happening in the mêlée: all I was really conscious of was a nasty gaggle of black crosses on grey-green backgrounds and trying to get the hell out.

My log-book entry afterwards was at least honest: 'I lag behind [after the fight with 109s] and Squadron Leader Forbes says over the RT: "Laddie, you're lagging. I'm coming over to cover you." What ignominy! What humiliation! What a black!'

• • •

Meanwhile, the Battle of the Atlantic, with its wrecking U-boat warfare, was beginning to hot up. Naval intelligence disclosed that the Luftwaffe's super-long-range Focke-Wulf Condors, the FW 200, based in the Bordeaux area of

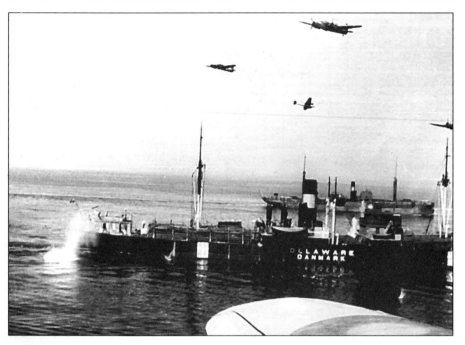

Sixty-six Squadron, with its 'long range' Spitfire IIAs, moved up to East Anglia in the summer and autumn of 1941 to escort 2 Group's Blenheims on their hideous, low-level daylight attacks against enemy shipping

south-west France, were posing a mounting threat to Allied shipping using our western ports.

These formidable reconnaissance aircraft were said to be flying out over the Bay of Biscay and well to the west of Brest, then heading deep into the Atlantic before turning north across the western approaches and thence east-wards above the Shetlands and so back to their bases in northern Norway. It was quite a round trip during which shipping sightings were passed directly to the U-boat packs prowling along the convoy routes.

Ten Group put the question to our CO: 'Would 66 stand a chance of intercepting these "milk runs" west of Brest at first light?'

Whatever the answer, the question was quite enough to jerk Athol Forbes into action. He at once took personal charge of these long missions. Several

Sixty-six also flew fruitless hours far out into the Atlantic in pursuit of the Luftwaffe's Focke-Wulf 200 Condors operating with the U-boats from south-west France

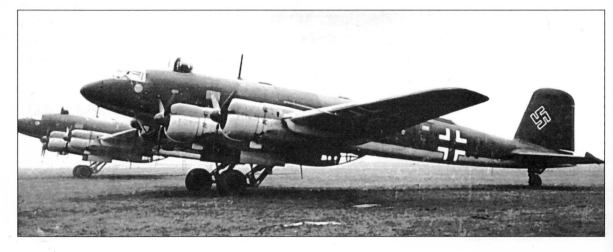

The mercurial, 21-year-old Hubert R. 'Dizzy' Allen, another Battle of Britain 'veteran', took over 66 from Athol Forbes

mornings a week, for the next month, he would himself lead a pair of aircraft, taking off in the dark with navigation lights on to enable station to be kept, and reaching a point miles west of Brest as dawn broke.

Athol often took me along as his number two on these sorties. I found few things more uncomfortable and disagreeable than these extended flights low down over the Atlantic waves, listening, on edge, to the hum of a single 1175 hp Merlin XII Rolls-Royce engine operating at the extremity of its fuel range. They were the stuff of which nightmares were made. We never saw an enemy aircraft, nor did I feel we ever would. They were a waste of time and nervous energy in exchange for endless miles of ocean covered. But Athol would never have stopped them had he not, in the end, been ordered by Group to do so: such was the application of the man.

In any case, his operational time was now more than up, and the leadership of 66 passed to the 21-year-old 'Dizzy' Allen,* the senior Flight Commander, a mercurial and controversial character and a brilliant fighter pilot who had lived with the Squadron all through the Battle of Britain.

Dizzy could fly aeroplanes better than most and he was, in fact, far more able and intellectually sharper than his critics gave him credit for. I served him for several weeks as a junior and highly inexperienced Flight Commander, an appointment in which you quickly came to know the strengths and weaknesses of a CO. I learnt plenty of the tricks from Dizzy Allen. His problem was that he said exactly what was in his resolute mind – and he didn't give a damn to whom he said it.

• • •

After seven months with the Squadron, and now in my twenty-seventh year, I was convinced that the time had come to seek a new challenge, preferably overseas – a view which I was pleased to find my close friend in 66, Raoul Daddo-Langlois, then fast developing into a first-rate fighter pilot and leader, also shared.

One morning late in January 1942 a signal came through from Group HQ. 'Post two pilots to Air Headquarters, India, for service in Burma.' Raoul and I seized the chance to volunteer. The Japanese were driving on in Malaya. Singapore was about to fall. 'Burma,' we cried, 'here we come!'

A fortnight later we were in Malta!

The crucial Mediterranean battle – the third decisive island battle of the Second World War, upon which so much would depend – was then about to escalate to its peak.

We didn't realize it, but life thereafter would never be quite the same ...

*Squadron Leader, later Wing Commander, H.R. Allen

CHAPTER 6

SUSSEX-BY-THE-SEA

The Tangmere Wing, led by Douglas Bader in the spring and summer of 1941, had a pride in itself which was reflected in its success. Its work rate was high and so, too, was its morale. It was stamped with resource and had a personality of its own. From this lively stable emerged a string of successful Squadron and Wing Leaders who profited from seeing Bader at work. Johnnie Johnson, one among them, was quickly into his stride.

At the beginning of 1941, 616 Squadron was sent to Tangmere, a well-appointed airfield at the foot of the South Downs. Although I had been with the Squadron for some six months, I spent three of those in hospital and had only twice fired my guns in anger. I was still short on Spitfire hours and sometimes slept at dispersal so that I could be available whenever Spitfires wanted air testing. Early one morning the Flight Sergeant told me that Bader's Spitfire was flying left wing low; he had balanced the ailerons and would I test it? I did so and told the Flight Sergeant it was OK. Soon after, Wing Commander Douglas Bader, highly decorated, handsome, forceful and exuding confidence like light from a lamp stumped into the dispersal hut. It was a meeting that would shape my life to come.

'Where is everybody?'

'They have been flying and have gone for breakfast, sir.'

'Who are you?'

'Pilot Officer Johnson, sir.'

'I don't suppose anyone knows if my bloody Spitfire is serviceable?'

'As a matter of fact it is serviceable, sir.'

'How do you bloody know?'

'Because I've just bloody flown it!'

'What did you say?'

'I said I have just flown it, sir!'

'Well get into your Spitfire and I'll show you how to get on the tail of a 109!'

And so we split-arsed across the sky together, and when we got down, I helped our legless leader struggle out of his cockpit.

'What did you say your name is?'

'Johnson, sir.'

'Christian?'

'Johnnie, sir.'

'Well, Johnnie, that was not bad. Not bad at all. Never forget that we can turn well inside the 109s, and if they stay to fight we can be on their tails in about three turns.'

It was on that day that I became one of Bader's men – for ever. It was on that day that I learned something of those intangible qualities of leadership given to so few …

• • •

Our style of fighting in the air has changed a lot since the Battle of Britain. Then we were on the defensive and rarely had enough time to get above the German formations. All of this year, however, Fighter Command has been on the offensive, and daily we escort a few bombers attacking marshalling yards at Lille, Béthune, Hazebrouck, Albert, Chocques, Mazingarbe and Lens.

The air fighting is tougher than before because we always fight over hostile territory and, apart from the Messerschmitts, have to contend with light and heavy flak and a two-way sea crossing on each mission.

The imperturbable 'Woody' Woodhall, a monocled, grey-haired, leathery faced veteran of the First War, is our Station Commander, who, from his operations room, always controls the Tangmere Wing. Woodhall's controlling is brilliant, and he and Bader, his Wing Commander Flying, have a perfect understanding.

The irrepressible Bob Tuck – Wing Commander Robert Roland Stanford-Tuck, CO of 257, Leader of the Duxford and Biggin Hill Wings, raconteur extraordinary and one of the best shots in the Air Force. Shot down and taken prisoner, 1942, by which time he had collected 27 enemy aircraft destroyed, eight probably destroyed – and four bale-outs…

The Woodhall/Bader team came to the fore during the Battle of Britain, when Woodhall controlled, and Bader led, the Duxford Wing; 'controlled' is hardly the correct word, since the legless pilot, knowing our radars were sometimes unreliable, often disregarded Woodhall's instructions if he thought he could manoeuvre his Wing into a better tactical position. Since he got results neither Woodhall, nor his AOC, Leigh-Mallory, denied Bader his freedom of action.

The genial Leigh-Mallory visits Tangmere and there are long tactical discussions with Woodhall, Bader and the three Squadron Commanders. The great fighting leader, 'Sailor' Malan, from South Africa, drops in from Biggin Hill; Bob Tuck flies in for lunch; and Victor Beamish, a staff officer at 11 Group, often flies with the Tangmere Wing, and is an invaluable link between Group and the Biggin, Tangmere, Kenley, Hornchurch and Northolt Wings. There is a constant flow of information and advice up and down our simple chain of command. Leadership at all levels is excellent and consequently morale is very high.

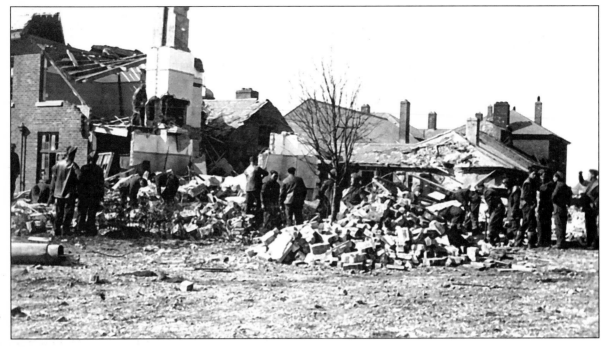

The new concrete runway at Tangmere is taking far too long to camouflage. On moonlight nights the white surface attracts German bombers, and we are lucky not to be hurt when part of the Officers' Mess is demolished. Bader is incensed by the civilian workmen and invites the journalist and golfing friend, Henry Longhurst, to see the disgraceful runway. We all spill the beans to Longhurst and soon an acid article appears in the *Sunday Express* about Squadrons being put at peril by idle workmen. The Air Council is not amused and soon no less than the Under-Secretary of State arrives at Tangmere to deliver a half-hearted rocket.

Indecent intrusion: the Officers' Mess at Tangmere after intervention by the Luftwaffe, March 1941

Life is good at Tangmere. Several of us who joined the Squadron about the same time are no longer novices. We average between 400 and 500 flying hours and know it all. We are at the most difficult stage of a pilot's career. We are grossly over-confident and, like our leader, begin our aerobatics far too low. We want a spell of ops to tone us down, and this was soon to come.

When the flying is over for the day we drink pints of beer in the Unicorn at Chichester, where Arthur King is our genial host – a good friend to countless pilots. Sometimes, when funds permit, we dine well under the cool rafters of the Old Ship club at Bosham.

The doors of the Bay House, some five miles from Tangmere, are always open to us, for here live our Wing Leader, his wife Thelma, and her sister Jill. We often drive over to the Bay House to find the hard core of the Wing grouped about its leader. The granite-faced, pipe-sucking Canadian Stan Turner, CO of 145 Squadron, is invariably there – a 'prickly pear' if ever there was one, but devoted to Douglas. The conversation never wanders beyond our limited world of air fighting. Sipping his lemonade, Bader talks about our

recent fights, straight shooting, guns and cannon and about our opponents. He is an easy, sparkling speaker and we junior officers feel greatly privileged to be taken into his confidence.

Sometimes, when the Wing is released to one hour's availability, Bader takes a foursome to the rolling Goodwood golf course. Sometimes I caddy for him and am astonished to see the accuracy and strength with which he smacks them down the fairway. Back at Westhampnett, a pilot stands by the ops telephone, and should the Wing be called to readiness he will fly over the foursome and fire a red Very light. I will race to the clubhouse, get the Wing Commander's car and drive across the course to collect the golfers and have them back at Westhampnett within half an hour.

The South Yorkshire Squadron has changed a lot since I joined it in the autumn of 1940. Ken Holden, steadfast and experienced, has been promoted and commands 610 (County of Chester) Squadron on the other side of our grass airfield at Westhampnett, near Chichester. Recently Ken was somewhat startled when, fully occupied with some dangerous in-fighting, either a fragment of flak, or a bullet, severed the goggles on his leather flying helmet and they fell on his knees! Bader thought it very funny, but it took Ken a few hours to regain his Yorkshire sense of humour.

Six-one-o have been in the thick of the fighting since last year and have lost several experienced pilots, including a good friend of mine, Larry Robillard, a tough French Canadian, who (unknown to us at the time) was making his perilous journey back.

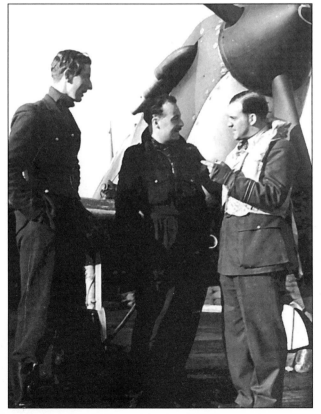

Tangmere trinity: left to right, Cocky Dundas, Buck Casson and Ken Holden

'Cocky' Dundas, shot down the previous autumn, has done it again. This time he was second best in a duel with a 109 over the Channel. He struggled back to one of our airfields on the coast, Hawkinge, crash-landed, walked into the Mess and asked for a large pink gin. Now, at twenty-one, he is our Flight Commander, with a well-earned DFC and half-engaged to Diana Stuart-Wortley, daughter of a hunting, shooting, fishing, hard-drinking Yorkshire squire. She arrives for our summer ball on her motor cycle in MTC uniform wearing a haversack containing her red and white ball gown ('for the Poles'), and a toothbrush.

Like me, Whaley Heppell, from Newcastle, has survived the danger period of the first dozen missions and now, aged twenty, is halfway through his first tour of operations. Whaley, son of a Royal Flying Corps pilot, handles his Spitfire with masterly panache and always keeps his cool in a maul.

Roy Marples, from Stockport, blond, handsome, earthy, extremely keen on the girls, shot down and wounded the previous autumn, crossed the Channel so low a short time ago that his wooden propeller hit the calm water and sheared off about nine inches from each of the three blades. He managed to reach one of our coastal airfields, but Billy Burton, our Squadron Commander, was not amused.

Buck Casson, a Sheffield steelman, and one of the few Auxiliary Air Force pilots left in the Squadron, commands B Flight, and is utterly dependable in the air. His operational tour is almost finished.

Billy Burton rarely gets the chance to lead his Squadron, since Douglas Bader always leads the three Squadrons of the Tangmere Wing from 616 Squadron. He is dogmatic about this, and never flies with either of the other two Squadrons, 610 and 145. Bader insists that Sergeant Alan Smith, 'Cocky' and I always fly with him in the leading finger-four of the Tangmere Wing. Our Wing Leader has flown more fighter 'sweeps' than anyone else in Fighter Command. At Tangmere, he has won both a Bar to his DFC and DSO. He is a national hero, figures regularly in the press and is not averse to the publicity. He has flown on operations since the previous spring and is getting tired and stubborn. The *Daily Mirror* columnist, Cassandra, writes that Bader has done enough, is too valuable to lose and should be taken off operations.* Others have noticed the signs, and Leigh-Mallory has decided to take him off operations in the autumn.

Sergeants McDevette, Crabtree, Brewer, Jenks, McCairns, Morton and Mabbitt are missing, some believed killed. Squadron Leader Gibbs (supernumerary to the Squadron), a fine aerobatic pilot, but inclined to fly with his 'head in the office', is missing. Colin McFie baled out over France and is a prisoner of war.

One-four-five Squadron, commanded by that tremendous 'prickly pear', Squadron Leader Percival Stanley Turner, has been taken out of the front line, and the Tangmere Wing, much to Bader's and Turner's displeasure. Despite hot debates and long telephone calls to Leigh-Mallory, during which it was hinted darkly that Bader was about the only chap who could handle the unruly Canadian, Stan and his chaps were dispatched to the north, where they vented their displeasure by beating up the Mess on their first night in their new home. Stan had fanned his six-shooter, others followed suit, and several shots rang out.

The somewhat orthodox Station Commander, who had never fired a shot in anger, was not amused by the unruly behaviour of Turner and his Canadians, and the incident undoubtedly influenced his subsequent departure for Malta.

The Squadron was replaced by 41 Squadron, inexperienced in the tough cut and thrust over northern France, and the Tangmere Wing was never the same. It had lost some of its cohesion.

• • •

*Paul Brickhill, *Reach for the Sky* (Collins, London, 1954)

High summer at Tangmere. We shall review those stirring days of great endeavour, when we crossed the Channel and fought over France. When the sky always seemed blue and clear. When the rays of the fierce sun hid 'Dolfo' Galland and his Abbeville boys in their higher, glinting, yellow-nosed Messerschmitts …

It is Saturday, 9 August 1941, and orders come from Leigh-Mallory's HQ that the Tangmere Wing is the target support for bombers attacking Gosnay, near Lille.

There is ample time to check my Spitfire and for a chat with the fitter, Fred Burton, and rigger, Arthur Radcliffe, both pre-war members of the Squadron and staunch Yorkshiremen. A special word or two with the armourer, 'Dusty' Miller, for Lille is a long way, and I shall be firing my guns in anger.

Burton, Radcliffe and Miller have been with the Squadron since its formation and have seen its changing fortunes, and many pilots come and go. They well know that, for me, these last few moments on the ground are full of tension, and as they strap me in the cockpit, they maintain a steady chatter to ease the pressure. The usual cockpit smell, that strange mixture of dope, fine mineral oil, gun oil and high grade octane, assails the nostrils and is vaguely comforting. I tighten my helmet strap, swing the rudder with my feet on the pedals, watch the ailerons when I waggle the stick, think about Lille and the 109s and switch on my gun sight.

Ken Holden starts his engine on the other side of the field, and the 12 610 Spitfires trundle awkwardly over the grass. Bader's propeller begins to turn. I nod to Fred, the engine coughs once or twice, I catch her with a touch of throttle and she booms into a powerful bass until I cut her back to a fast tickover.

Chocks away, and we taxi over the hard-baked grass. Cocky and I jockey our Spitfires alongside Bader's starboard wing. Bader's usual pilot on his port side, the leech-like Alan Smith, is about to be commissioned and is on leave for a few days, so Jeff West, a sturdy New Zealander and first-class fighter pilot, is flying in Smith's position.

Our 12 Spitfires, in three finger-four sections, are lined up diagonally across one corner of Westhampnett. Bader waits until 610 are half-way across the meadow. He nods his head, we open our throttles together, and the deep-throated roar of the Merlin engines thunders through our leather helmets and slams against our eardrums. Airborne, and the simple, almost automatic cockpit drill. We take up a fairly tight squadron formation; I drop my seat a couple of notches and trim my beautiful machine to fly with the least pressure from hands and feet.

A slow, easy turn parallel to the coast so that Ken and Elmer Gaunce, leading 41 Squadron, can position their Squadrons. Ken drops neatly into position about half a mile away, but I cannot see 41 Squadron, our top cover Squadron.

We slant into the clean sky. No movement in the cockpit except the slight trembling of the stick as though it is alive and not merely the focal point of a

superb mechanical machine. Gone are the ugly tremors of apprehension which plagued us before take-off. Although we are sealed in our tiny cockpits and separated from each other, the static from our radios pours through the earphones of our tightly fitting helmets and fills our ears with reassuring crackles. When the leader speaks, his voice is warm and vital, and we know full well that, once in the air like this, we are bound together by a deeper intimacy than we can ever feel on the ground. Invisible threads of trust and comradeship hold us together, and the mantle of Bader's leadership will sustain and protect us throughout the fight ahead. The Tangmere Wing is together.

Woodhall calls from his operations room to check radio contact: 'Dogsbody?'

'OK, OK.'

Bader calls his Squadron Commanders: 'Ken?'

'Loud and clear.'

'Elmer?'

There is no reply from Gaunce. Perhaps, I think, he was late taking off from Merston, just south of Chichester, and we may be short of one-third of our fighting strength. Bader thinks so too and makes some terse, acid comment to Woodhall, who replies calmly that Bader's message is received and understood.

In a slanting climb, we cross Beachy Head and steer for the French coast. Bader rocks his wings, we level out for the climb, slide out of our tight formation and adopt wider battle stations. We are flying at 25,000 feet, with Ken's Squadron stacked up behind.

The yellow sands of the enemy-held coast are now plainly visible, and behind is a barren waste of sandhills and scrub. Well hidden in these sandhills are the excellent German gunners who man that outstanding gun of the war, the 88 mm. The black, evil flowers of flak bloom in the sky, and it seems that more than the usual amount of ironmongery is being thrown at us. Here and there are red marker bursts intended to reveal our position to the Me 109s. We climb and twist about the bed of flak. I miss Stanley Percival Turner's usual coarse observations about 'putting your corks in, boys!' But I wish he was here, flying top cover, and always in position.

Bader speaks to his Squadron Commanders:* 'Ken and Elmer. Start gaining height.'

'Elmer's not with us,' from Ken.

We hear another voice on the radio. Reception is very poor, but Bader thinks it is Elmer Gaunce: 'Elmer from Dogsbody. I cannot understand what you say, but we are on our way. You had better decide for yourself whether to come or go back.'

Another garbled message from Elmer, and Woodhall, studying the plots on his table, advises: 'Walker leader. Dogsbody is 20 miles ahead of you.'

Bader tells Woodhall that he heard the message, and it is good to know that 41 are somewhere behind us.

*These are the actual, verbatim radio transmissions, logged at the Beachy Head Forward Relay Station

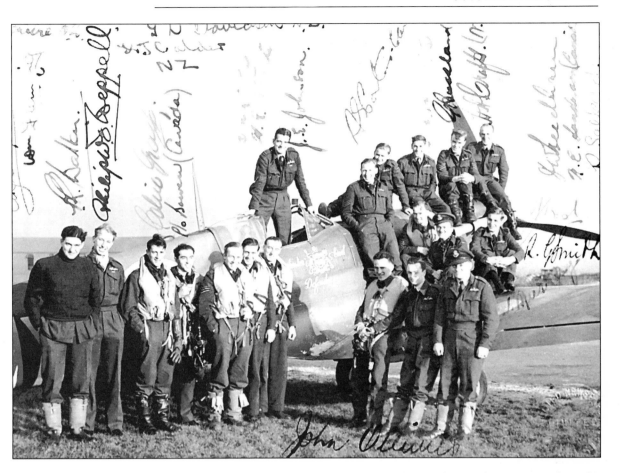

Six-one-six go north to Kirton-in-Lindsey, December 1941. Johnnie Johnson, a Flight Commander, soon to command 610 Squadron, is standing in the cockpit of the Spitfire, while third from the left is the exceptional Colin Gray, another fine shot, who rose to be New Zealand's top-scoring fighter pilot with 27½ destroyed

*Code name for the bombers and their escorting fighters

Over the Pas de Calais, and the battlefields of a previous war against the same foe, Woodhall speaks in clear and measured tones: 'Dogsbody from Beetle. The beehive* is on time and is engaged.'

'OK,' from Bader.

A 610 pilot says, 'I can see trails above and on our left.'

'Yes, I have seen them. I think we might get up a bit,' Ken replies.

'Dogsbody from Beetle. There are 20 plus five miles to the east of you.'

'OK, but your transmitter is quite impossible. Please use the other.'

'Dogsbody. Is this better?'

'Perfect. Ken, start getting more height.'

'OK, Dogsbody. But will you throttle back? I cannot keep up.'

'Sorry, Ken. My air speed indicator is u/s. Throttling back, and I will do one slow left-hand turn so you can catch up.'

'Dogsbody from Ken. I'm making smoke at this height.'

'OK, Ken. I'm going down very slightly.'

Woodhall advises that more bandits are nearby. Roy Marples is the first to see them.

'Three bandits coming down astern of us. I'm keeping an eye on them. Now there's six.'

'OK,' from Bader.

'Douglas. Another 12 plus ahead. Slightly higher,' from Woodhall.

'Eleven of them now,' Roy advises.

'OK, Roy,' replies Bader. 'Let me know exactly where they are.'

'About one mile astern. And slightly higher.'

Woodhall continues to paint the broader canvas. 'Douglas, there is another 40 plus fifteen miles to the north-east of you.'

'OK, Beetle. Are our friends where they ought to be? I haven't much idea where I am.'

'Yes, you are exactly right. And so are your friends.'

Someone reports: '109s at nine o'clock. Above.'

'Dogsbody from Roy. Keep turning left and you'll see 109s at nine o'clock.'

'Ken, can you see them?' from Bader.

'Douglas,' says Ken, '109s below. Climbing up.'

Bader dips first one wing and then the other to look below. Our formations waver as we try to spot the lower Messerschmitts. I think about those above, take my eyes off Cocky and search above. I see 109s 1000 feet higher. Waiting for the ideal attacking position. I check my own gun switch is on 'fire'.

Bader says to Ken: 'I can't see them. Will you tell me where to look?'

'Underneath Bill's section now. Shall I come down?'

'No. I have them. Get into formation. Going down. Ken, are you with us?'

'Just above you.'

We fan out alongside Bader. For the first time I see the lower Messerschmitts. We are overtaking four 109s with others on either side. Cocky is taking the extreme starboard 109, so I skid under Cocky, Bader and West to get a 109 on the port side. I am rapidly overtaking my opponent, but before opening fire I have a swift glance to either side. For the last time I see Bader in the air, firing at a 109.

'Blue two here. Some buggers coming down behind. Astern. Break left.'

I recognize Whaley's voice. My 109 pulls into a steep climb. I hang on and knock a few pieces from his starboard wing.

Ken watches the fight below and sees two bunches of 109s below his own position, but above us. He decides it is time to lend a hand.

'Crow from Ken. I'm taking my section down. Stay here and cover us.'

'OK, Ken,' from Crow.

'109s coming down behind. Keep turning.'

'Line astern. Keep turning.'

'109s coming down again,' from Roy.

'Keep turning,' from Billy.

'Break. For Christ's sake break!'

No call sign. I break hard. We all break hard. I tear through a twisting, tumbling mass of Spitfires and Messerschmitts. I look behind. I have three 109s astern. The nearest is about 100 yards behind. I hold my steep turn, losing height as I spiral down towards the safety of the cloud. I see his cannon

ports flicker as he tries to get me in his sights. Tracer bullets flash over my canopy, and then I am in the concealing white vapour.

I am clocking nearly 400 mph, still diving and turning. My instruments have toppled in the dog-fight, and it will be several minutes before they can be used again. I pull back the throttle and centralize the controls. The altimeter stops unwinding and the speed drops to 100 mph, and continues to drop. My Spitfire stalls and spins.

I spin to the left out of the base of the cloud. Full right rudder. Count three. Centralize the controls and I am in charge again. I change radio frequency and check my course for Dover.

'Dogsbody four to Swallow. Emergency homing, please.'

'Dogsbody four from Swallow. Steer three zero five degrees. Out.'

I switch back to our operational frequency and listen to the South Yorkshire and County of Chester Squadrons fighting their way out.

'Get into formation or they'll shoot down the bloody lot of you.'

'Spitfire going down in flames at ten o'clock.'

'YQC. Form up on me. I'm at three o'clock to you.'

'Four buggers above us,' from Whaley.

'All Elfin aircraft withdraw. I say again. All Elfin aircraft withdraw.'

An order from Billy: 'Use the cloud if you're in trouble.'

'Are you going home, Ken?' from Billy.

'Yes, withdrawing,' replies Holden.

'Ken,' from Crow. 'Are you still about?'

'I'm right behind you, Crow.'

'Are we all here?'

'Two short.'

'Dogsbody from Beetle. Do you require any assistance?'

'Beetle from Elfin leader. We are OK and withdrawing.'

'Thank you, Billy.' A pause. 'Douglas, do you require any assistance? Steer three four zero for the coast.'

A nicely judged force landing: an Me 109F finishes the war in a Sussex field, May 1941

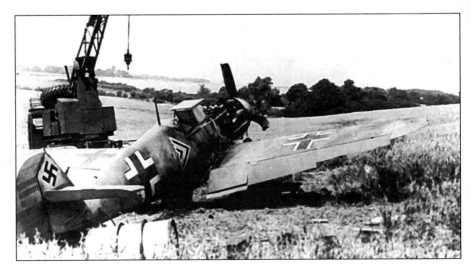

A solitary 109 flies below me. Probably one of the three who gave me such a shaking a few minutes ago. Where are the other two? Is this a decoy, a trap? Or is it my turn now? I yaw the tail of the Spitfire to cover the blind spot, kick on rudder, drop each wing and search the area below. No sign of his comrades and I drop from the cloud base well below the 109 and stalk him so that I climb towards his soft belly, where there is no armour plate but only a complicated mass of engine and petrol, oil and hydraulic lines. One more look behind. All clear. He is probably flying back to his base at Wissant, but he will never get there, for the stick shakes in my hand as the Spitfire spews cannon shells into the thin fuselage, and soon only a tell-tale plume of thick black smoke marks his fall to the earth below.

Good shooting! One more for Johnnie Johnson, now well on the way to an unequalled 38 confirmed destroyed on the Western Front

I come out of France low and fast. Sometimes below the tree-tops. Hugging the contours of the ground. Swerving to avoid a flock of wood pigeons. Weaving to cover the blind spot behind. Streaking over the sand dunes. Across the Channel, and when I see the white cliffs I climb to 2000 feet.

Woodhall is still calling, 'Douglas, are you receiving?'

There is no reply so I call the Group Captain: 'Johnnie here, sir. We've had a stiff fight. I last saw the Wing Commander on the tail of a 109.'

'Thank you, Johnnie,' courteously replies the Group Captain. 'I'll meet you at dispersal.'

We land back at Westhampnett, but carefully because we have been exposed to a considerable amount of German hardware, and we may have been hit by flak, bullets or cannon shells. Several fighter pilots had discovered to their cost that a fractured wing could fail if stressed too much in a victory roll or a low-level beat up.

We gather together, the combat sweat drying from our young bodies – all except Bader and Buck Casson. Woodhall is there trying to conceal his anxiety. We reconstruct the fight. We cannot say what happened to our leader.*

*A few days later, we heard from the International Red Cross that Douglas Bader was in hospital at St Omer

Bader, with Adolf Galland and other officers of JG 26, soon after the Tangmere Wing Leader had been shot down by Oberfeldwebel Max Mayer on 9 August 1942

Smith could have done no better than Jeff West, who, like Cocky and me, had to break or be shot down. If only Stan had been with us, flying above Ken and keeping the high 109s off our backs.

CHAPTER 7

MIDDLE EASTERN MISSION

The spring of 1942 heralded the prospect of renewed and more rigorous activity in North Africa and the Mediterranean.

Field Marshal Albert Kesselring, Bavarian aristocrat, C-in-C South and commander of the Luftwaffe's air fleet in Sicily, *Luftflotte 2*, supported by the German and Italian general staffs, appeared to have persuaded Hitler that Malta should be invaded and finally knocked out (Operation Herkules).

In the event, the assault was superseded by General Erwin Rommel and the Afrika Korps' lightning mid-summer advance eastwards across the Libyan desert to the Egyptian frontier. Invasion was indefinitely postponed. Instead the tiny Mediterranean island was to be neutralized by bombing.

Almost fatally extended, the Axis forces faced the British Eighth Army standing on the Alamein line. At this point, the strategic importance of Malta, with its strike capability of aircraft and submarines straddling Rommel's supply lines from southern Europe to Libya, in the Allies' grand design for North Africa and beyond became overwhelming.

From Churchill, the Chiefs of Staff, Defence Committee and the War Cabinet in London, the cry went out to the military chiefs in Cairo: 'Malta must, at all costs, be held.'

None could have foreseen it at that moment, but such was the scenario which would confront a bunch of fifteen Spitfire pilots from Fighter Command in the UK when they landed by Sunderland flying boat one February dawn in Kalafrana Bay. The Deputy Chief of the Air Staff in London described the party to the AOC Malta as 'a really choice lot'. Laddie Lucas was among them.

A MONTH OF HURRICANES

Stan Turner, the Canadian Squadron Leader and former lifeguard from Toronto, was in charge of our Malta party, described as 'the advance guard of Spitfire pilots' destined for the Island.

Stan, with twelve enemy aircraft destroyed and two DFCs to his credit, had already had a wealth of experience. A member of 242 (Canadian) Squadron in the Royal Air Force with a pre-war short service commission, he had fought in the abortive Battle of France and then, with Douglas Bader at Coltishall and Duxford, in the Battle of Britain. Right afterwards, in the busy operational season of 1941, he had taken his place in the Tangmere Wing – again flying with Bader – in the offensive sweeps over northern France. During that summer, he had, on merit, been given command of 145 Squadron, one of 11 Group's most successful units. He had, by now, had a basinful of operational flying.

Due for a rest rather than another battle, his instructions from the Air Ministry were clear-cut. 'With the arrival of the Spitfires, take hold of the flying on the Island. After months with the Hurricanes, it will need turning upside down. Do what's necessary to bring it up-to-date. Group Captain Woodhall, whom you know well, will be there when you get there and the AOC knows about you. You'll have a fight on your hands ...'

Quietly aggressive, opinionated and often outspoken – particularly about senior officers – Stan was, paradoxically, quite shy and withdrawn until you came to know him. He was, by nature, something of a doubter, slow to be convinced about quality. But once reliability and trust were established, confidence was dispensed to the full. Here was an accomplished and competent officer, fully capable of discharging the remit he had been given.

Few Canadians could match the record of Percival Stanley Turner in World War Two. Combatant in the Battles of France and Britain and Squadron Commander in Bader's Tangmere Wing and then Malta, Stan Turner became, on merit, a Group Captain commanding a Wing in the 2nd Tactical Air Force in North-west Europe before the war's end

When, six months later, the defensive battle for the Island had been won and the story could be told, Percival Stanley Turner had earned a chapter to himself. He had stamped his mark on our operational style. For my part, I had become devoted to him and his fairly unpredictable ways.

The start together was, however, far from promising. We had been ordered, by signal from the Air Ministry, to report – all fifteen in the party – to the Grand Hotel in Plymouth, commandeered by the Royal Air Force in the old west country seaport, on 13 February. We were to leave Mountbatten for Gibraltar by flying boat at first light the next day.

Most of our number had flown down from 11 Group and were known to one another. Raoul Daddo-Langlois and I were the only ones from 10 Group, having travelled down by train from Paddington with R.A. (Bob) Sergeant, another 11 Group pilot of solid worth.

The three of us were the last to arrive on a cold and blustery winter's afternoon. Turner was standing near reception as we reported. He looked me in the eye, said he didn't think we had met before and flicked open my greatcoat, which I hadn't by then removed.

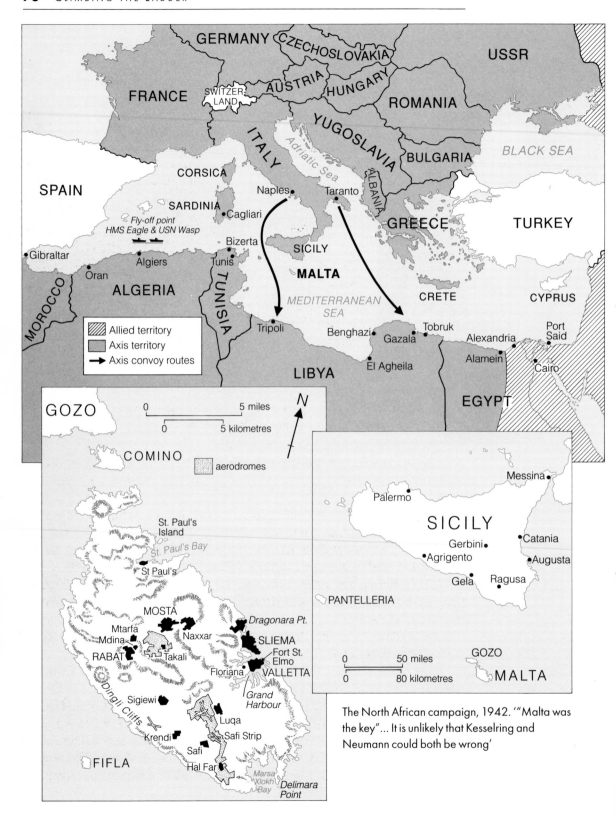

The North African campaign, 1942. '"Malta was the key"... It is unlikely that Kesselring and Neumann could both be wrong'

Pilot Officers here, but, within a year, they were to make a pair in 249 Squadron, the top-scoring unit in the Malta battle. Laddie Lucas, Squadron CO, with Flight Commander Raoul Daddo-Langlois (*right*)

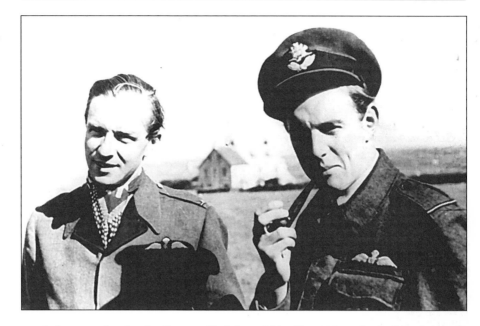

A deprecating look of some disdain said it all … What the hell had the Air Ministry sent him! A Flight Lieutenant without a DFC! His transparent mind was quickly at work. 'Who have you been operating with, and where?'

'With 66, sir, based at Perranporth.'

'Where's that?'

'In Cornwall, sir, in the Portreath Sector of 10 Group.'

'Oh, right down there. Seen many Huns?'

I can't say the conversation exactly flowed.

• • •

The news in Gibraltar was bad. Stan took some of us aside in the bar of the Bristol the evening we arrived.

'I'm told,' he said, 'there aren't any Spits on Malta yet and won't be for some while. There's some goddam delay. But they'll be flying them off the carriers – 300 miles out from Gib and about 50 north of Algiers, 650 or 700 miles from the Island – as soon as they can. In the meantime, it looks like Hurricanes against the 109Fs … Shit.'

The CO didn't attempt to put any gloss on it, that wasn't his way. He knew too well what to expect.

• • •

If the 9 hours 30 minutes' flying time to Gib had seemed tedious, the 11 hours 30 from Gib to Malta felt like an eternity. The blacked-out Sunderland, with its interior decks stripped to make more accommodation, ploughed its way, mostly at around 3000 feet, through headwinds and a violent electric night, thumping about in the excessive turbulence. I could not recall a more uncomfortable or unpleasant flight …

In contrast, dawn was just breaking as we reached the Island and put down beside the seaplane base on the still waters of Kalafrana Bay in the south-east of Malta. It was a windless, early spring morning of transfixing beauty. As we stepped on to the jetty from the tender and began to make our way along the path to the Mess, the sirens started to wail out the warning of an approaching raid.

Turner, walking by himself at the head of the party, empty pipe turned upside down in his mouth, stopped and waited, his eyes traversing the powder-blue heavens.

In a moment or two, five clapped-out Hurricanes, strung out in an antiquated vic formation, appeared out of the haze, their engines racing as they clambered for height. We could feel the vibration of the aircraft through our feet.

As the fighters disappeared eastwards into the rising sun, a couple of *staffeln* of Me 109s, 10,000 or 12,000 feet above, came racing across the sky from the north, flying their beautiful, wide open fours in line abreast, crossing over in the turns, as they swept in ahead of the incoming raid.

Turner, gazing incredulously upwards, removed his pipe from his mouth. 'Good God!' he exclaimed, and strode on for the Mess.

Later that morning, a civilian bus of doubtful vintage and repair (station transport had long since been destroyed by bombing) took us the eight or nine miles north-eastwards across the central plain, past Luqa, to Imdina, high on the hill beside Rabat, overlooking Takali, the Island's principal fighter airfield. Here, in the courtyard outside the Xara Palace, a lovely fourteenth-

Bombed, blitzed, hungry, yet defiant... Valletta, capital of Malta, held out against all the odds, spring 1942

and fifteenth-century villa, we spilled out with such light baggage as we had. This was to be our Mess for the next six months, set in Malta's ancient capital with its exquisite architecture and narrow cobbled streets. From the 300 and 400 feet high bastions, it held a commanding view north, east and south-west across the Island's historic scene with Valletta and Grand Harbour outlined on the eastern horizon. It was a classic sight. As we bid farewell to our spirited driver, he offered a comforting salutation. 'You, signors, will be safe here in the Holy City. The Holy Father will not allow the enemy to bomb it ...'

I noticed Stan Turner gave him one of his quizzical looks.

• • •

The news, again, was bleak. No one knew when the Spitfires would be arriving. It could be several weeks. Meanwhile, if there were 25–30 serviceable Hurricanes on the operational strength of the three airfields, Takali, Luqa and Halfar, reading from north to south, that was the extent of it.

It became instantly clear to us that the battle-worn pilots of the calibre of Cass Cassidy, George Powell-Sheddon, Jack Satchell, Mortie-Rose, Don Stones, James MacLachlan, Rags Rabagliati, Innes Westmacott, Ron Noble, Philip Wigley, Tony Boyd, the Australian, Sonny Ormrod and others, many of whom had survived the Battle of Britain and some the contest in France before it, had been putting up heroics in the face of the Luftwaffe's gathering strength.

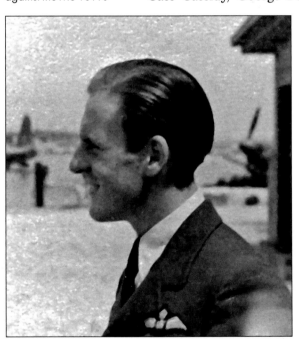

Mortimer-Rose, after seeing out the Battle of Britain, was pitchforked, like a number of others from the earlier battle, into the Malta cauldron in 1941, there to fly, with incredible fortitude, the obsolete Hurricane IIs against the Me 109Fs

Outperformed daily (but never outflown) by the 109Fs with their slow-revving, fuel-injection Daimler-Benz 601 engines, they had held the line until now – just. But, plainly, it couldn't go on like this. Unless the Spitfires could be flown in in strength from the carriers very soon, the day-fighter battle could not be contained. Lose that, and the strike and bombing capacity at Luqa – with the Wellingtons, Blenheims, Marylands, Beauforts and Beaufighters, whose crews, like those of the Fleet Air Arm squadrons at Halfar, had been performing wonders against Rommel's convoys and ports – would surely go with it. And so too would the Royal Navy's Tenth Submarine Flotilla – the Fighting Tenth – at its base at Lazaretto, on Manoel Island, one of the truly great fighting formations of the Second World War. In such a scenario much of the *raison d'être* for holding Malta would be lost.

Moreover, invasion, it was felt, must be a real possibility as soon as the spring weather began to improve. February's rainfall had been a record five-and-a-half inches, double the normal average. Mud and slush were everywhere: with the tractors and the petrol bowsers either bombed or

unserviceable for lack of spares, aircraft were having to be manhandled to and from dispersal points. Life for the groundcrews, working a twelve-hour day, whose performance under the bombing and the appalling conditions defied superlatives, was hell …

Fuel and ammunition, now being brought in by submarine, were short and getting shorter; spares likewise. Food – endless bully beef, Maconachie's stew, hard biscuits and bitter, 'half-caste' bread covered with a nasty spread which the squadrons called gharry grease – was monotonous and becoming scarcer. The February convoy from Alexandria, on which so much store had been set, had had to turn back after being hammered in the narrows between Crete and the Benghazi blister; another convoy attempt could not be expected for about another month … Water and baths were rationed.

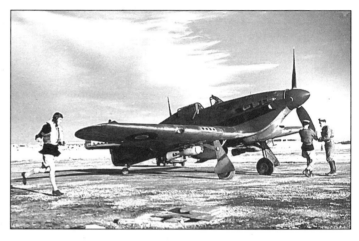

Such was the catalogue of woe which greeted us … The comfort and orderliness of the Fighter Command stations we had just left seemed part of another world. Yet one could tell at once that the morale among the Squadrons and Army gunners around the airfields was still high. Moreover, the Maltese people, who had done nothing to bring this all-out war and its consequent privations to their happy island, still remained resolute in the 30,000-strong Garrison's defence. The astonishing courage of the women and the children matched that of the menfolk. But we wondered how long they could stick it – and what would happen – if things got worse …

• • •

What we weren't told was that a report of signal import had been made only a month before. With the turn of the year, the AOC-in-C, Middle East, the brilliant Air Marshal Sir Arthur Tedder,* had, in an enlightened stroke, dispatched Group Captain Basil Embry,† an officer of exceptional experience and courage, pungent views and a searching eye, to Malta to make an objective, on-the-spot assessment of the true state of the Island's fighter squadrons.

This suited our AOC, the redoubtable Air Vice-Marshal Hugh Pughe Lloyd,‡ a John Bull of a senior officer to a T. He and Embry had been colleagues together in 2 Group – the Blenheim Group – in Bomber Command in the UK at a time of particularly heavy casualties. The two came out of much the same mould.

The Group Captain had laid the discrepancy between the respective performances of the Me 109F and the Hurricane II right out on the line for the benefit of his C-in-C in Cairo and the Chiefs of Staff, the Air Staff and Churchill's Defence Committee in London:

Standing beside the Royal Air Force on the Island were the crews of the Fleet Air Arm with their Albacores and Swordfish. Here, a Naval pilot prepares to mount his bombed-up Hurricane at Halfar to maintain the offensive

*Later Marshal of the Royal Air Force Lord Tedder of Glenguin

†Later Air Chief Marshal Sir Basil Embry

‡Later Air Chief Marshal Sir Hugh Lloyd

First World War pilot and leading contributor to Malta's victory, 1942: Group Captain A.B. Woodhall – 'Woody' to one and all – was to become the Service's unrivalled Operations Controller of World War Two

The Messerschmitt 109F is superior *in every respect* (author's italics) to the Hurricane II ... I am informed that German fighter pilots often fly in front of our Hurricanes to show off the superiority ... Every step should be taken to make Spitfire Vs ... available ... with the least delay

He sprinkled a pinch of salt into the open wound:

Spitfires could climb to 25,000 feet in 15–20 minutes. Hurricanes could only reach 15,000 feet by the time a raid had crossed Malta's coast from Sicily

Then he posted another governing point:

A first-class [operations] controller should be appointed.*

The last recommendation had already been acted upon by the time we reached Malta ... Group Captain A.B. Woodhall – 'Woody' to every pilot on the Island – the Royal Air Force's outstanding fighter controller of the war, was in place.

To Woody and the AOC together, Turner made his meaning characteristically plain: 'Either we get these goddamn Spits here in a matter of days, not weeks, or we're done.' To a fresh, uninhibited mind, the need was obvious.

●　　●　　●

Stan Turner, who had now assumed command of 249 Squadron at Takali and was very much in the Island's driving seat operationally, had casually asked to see my log-book. What he saw couldn't have eased his sceptical mind ... Total hours flown, 433.50; total Spitfire hours, 200.30; total operational hours on Spitfires, 118.35. Even so, I felt I had just began to crack a small hole in the Canadian's outer crust.

On our second or third morning together he took me out on to the terrace of the Xara Palace. Things were relatively quiet and no aircraft were airborne from Takali. Stan looked round, as he always did, to be sure he wasn't being overheard. His words are as clear to me today as they were fifty years ago.

'Look here,' he said, and there was no mistaking his purpose, 'if you're going to become one of my goddamn Flight Commanders you'll have to learn this line abreast flying at once. We're not having any of this effing vic and line astern cock round here, that's for sure. Otherwise we'll all get bumped.'

He took his empty pipe from his mouth and, with the stem, started marking out on the dusty surface of the terrace all the various sequences – the crossing over in the turns, the 'breaking' through 180°, the maintenance of the 200 yards spacing between aircraft, the whole gamut of the drill. He added a rider as an aside. 'And remember to tell your guys to effing well keep up. I shall be flying fast around here and I don't want any of this hanging back or any of that sort of crap. Let's see if there are two aircraft available.'

*Air Historical Branch Draft Narrative – Malta (unpublished)

He went to the ops telephone and got on to Woodhall. 'Any plots on the table, sir?' he asked. 'Nothing? Right then, I'm going to get a couple of aeroplanes and have a swing round with Laddie Lucas for half an hour or so. I'll call when we're airborne.'

I hadn't flown a Hurricane for eight months, so I didn't attempt a formation take-off with Stan across the quite short and rough pockmarked airfield. There were pools of water about after all the rain.

Just as I had got myself nicely into position for the climb, with our aircraft a couple of hundred yards apart in line abreast, Woodhall acknowledged the CO's call on the RT. 'OK, Stan, there are now some little jobs [109s] at angels 20 [height 20,000 feet] approaching from the north over St Paul's Bay. They're going fast and will soon be at eleven o'clock from you. You should see them soon.'

We saw them almost at once, way above us, two sections in loose fours. 'OK, Woody,' said Stan, 'I can see them. We'll try to get after the bastards.' With that he pushed the boost up another two or three pounds to increase the rate of climb. I had to 'go through the gate' on my old Hurricane to keep up: the aircraft was vibrating all over.

It was a hopeless chase, and was always going to be. We went straight back to Takali to land without doing any of the manoeuvres Stan had drawn out on the terrace. Back in the broken-down dispersal building, we took off our Mae Wests. 'That's all right, old cock. That's all you've got to know. Just tell these guys that it's only line abreast from now on and that they've got to fly fast and keep up. You didn't have any trouble keeping up just now?'

I was glad it was a rhetorical question. There were times with Stan Turner when silence was golden. He looked round for some transport to take us up the hill to the Mess. There was none. 'If it's not these clapped-out effing Hurricanes, then it's no effing transport.'

As we started to walk, I thought nothing about the aircraft or the lack of transport. I felt only relief that our 30 minutes or so together had gone off without a hitch and that I seemed to have been accepted into the fold. It was like getting one's 1st XV colours at school …

Such was the authority and command of this exceptional Canadian.

• • •

We had a month flying the old Hurricanes against the yellow-nosed 109Fs, based at Gela and Comiso in Sicily, as the raids began to hot up. It was an unsettling – and yet salutary – experience played out against all the odds. Mostly, the CO flew with my flight. I learnt more from him about the day-fighting art than from anyone else. Those fraught days taught us exactly what our gallant predecessors had been enduring for months to hold the line. Outperformed they may have been, but they left an imperishable mark on the Island's second Great Siege in 380 years.

• • •

It is, of course, a fact that it should never have taken so long for the Air Staff in London to arrange for Malta to be reinforced with Spitfire Vs. It was an unrealistic and unimaginative piece of planning which failed to take account of future needs. Discussions had been going on for nine months between the Air Ministry and the Admiralty on the use of the Royal Navy's hard-pressed carriers for the reinforcements. This was the only way that these aircraft could be delivered to the isolated and beleaguered central Mediterranean island.

True, all this came at a difficult time in the war at sea; but a sense of urgency was lacking, and it should certainly not have taken Embry's critical report to inject some realism into the Chiefs of Staff about the daunting task which was now confronting the Squadrons. The Air Historical Branch of the Royal Air Force, in its factual account of the circumstances, written years later with the details before it, went to the heart of the issue:

> During the first three months of 1942, only 151 daylight enemy sorties were flown over the UK and a substantial proportion of these were reconnaissance flights ... Between February and April ... at the height of the assault ... more than 17,000 sorties were flown against Malta [whose] fighter defence consisted of three squadrons of Hurricanes [with] 26 aircraft serviceable [at peak strength]. Against this, Fighter Command disposed of 102 Squadrons comprising 2,395 aircraft ... of which ... 1370 were Spitfires [with] 886 serviceable ... This grave lack of balance ... at a time when Malta was about to be subjected to such a severe ordeal can find no reasonable justification.*

The agony of waiting for the Spitfires was compounded by some acts of gross inefficiency in the initial planning from London and an unforgivable failure on the part of the Air Staff in Whitehall to ensure that the detail of these early reinforcing operations was properly gripped. All this was down to the Royal Air Force, none of it to the Royal Navy, who were justifiably irked by the uncharacteristic slipshod work of the junior Service.

When, after numerous hiccups, the Spitfires did start to filter through to the Island in wholly inadequate numbers, Tedder, in Cairo, made an apposite comment: 'Too little and too late.'†

Charles Portal,‡ meanwhile, with all the authority befitting the Chief of the Air Staff, gave his verdict on what Stan Turner was calling 'these goddam cock-ups'. In a suitable minute on the file he wrote four caustic words: 'It's quicker by rail.'§

Astonishingly, further heinous shortcomings, arising from a lack of supervision in the UK, would have to be faced before these hazardous operations could find their just reward.

BELEAGUERED ISLAND

If there were still reservations about the validity of Basil Embry's earlier contention that the Me 109F was 'superior in every respect' to the Hurricane II,

*Air Historical Branch Draft Narrative

†Air Historical Branch Draft Narrative

‡Air Chief Marshal Sir Charles Portal – Peter Portal to the Royal Air Force. Later Marshal of the Royal Air Force Viscount Portal of Hungerford

§Air Historical Branch Draft Narrative

Critical Mediterranean moment: pilots of Spitfire Vs, with each aircraft carrying an extra 90-gallon slipper tank, prepare to take off from the Royal Navy's carrier, *Eagle*, on their 700-mile

and that 'every step should be taken to make Spitfires available with the least delay',* they were certainly dispelled with the surprising arrival from Egypt at the end of March of 229 Squadron with its twenty-four Hurricane IIcs. Why Middle East Command sent them at this juncture, in the face of Embry's advice, when it was Spitfires we needed, is difficult to comprehend. The most charitable explanation is that the Staff in Cairo thought that, with the critical shortage of fighters, these aircraft, with their four cannons, could take on the Luftwaffe's bombers while the newly-arrived Spitfires dealt with the 109s. In practice, however, these Hurricanes weren't as fast as the Ju 88s even after two of their four cannons were removed!

To make matters worse, 229's pilots, with one or two notable exceptions, were operationally inexperienced. It was inevitable, therefore, that the Squadron would suffer in the island cauldron; but we hardly expected that it would have to be taken out of the line so soon after its arrival at Halfar. By then, it had, in only a few weeks, lost half its pilots, killed or wounded, and two-thirds of its aircraft strength. Moreover, it could not show, in return, even one enemy aircraft *confirmed* destroyed.

The unit would remain 'non-effective, sick' throughout the summer until well after the defensive battle had been won. Then, in August, under the able command of Bill Douglas,† a Scot, it absorbed 603 Squadron's Spitfires when the City of Edinburgh's accomplished entity moved on to Egypt, there to continue its fine work newly-equipped with Beaufighters.

The unfortunate 229 saga had been an unworthy debit in the Hurricanes' hitherto commendable balance sheet.

• • •

The reasons for the hold-up of Spitfires in Gibraltar became more and more bizarre and ever more incomprehensible.

Having been sent down to the Rock from the UK, with the pilots, in a thoroughly uncomfortable merchant ship, the aircraft were then assembled and loaded aboard the carrier *Eagle*. The initial plan, agreed with the Royal Navy, was for *Eagle*, supported by strong elements of the Mediterranean fleet (a bat-

*Air Historical Branch Draft Narrative

†Squadron Leader, later Wing Commander, W.A. Douglas

tleship, a cruiser and nine destroyers – 'H' Force under the command of the estimable Vice-Admiral Sir Neville Syfret), to proceed to a point some 300 miles east of Gib and 50 miles or so north of Algiers.

From there, the aircraft, each carrying a 90-gallon slipper tank slung under the belly, would be launched on the 700-mile sea crossing to Malta. In normal conditions, the extra fuel (it added noticeably to the all-up weight of the aircraft on the very short take-off run from the carrier) would give a margin of around thirty minutes' flying time, which was tolerable, but tight if there happened to be headwinds, errors in navigation or erratic leading by those at the head of the formations. With the enemy controlling the north and south Mediterranean coastlines, there was no room for mistakes.

The Air Ministry in London had judged – wrongly, as it turned out – that even capable Squadron and Flight Commanders could not be relied on to navigate formations of single-engined fighters over 700 miles of sea without assistance.

In fairness, it should be said, however, that there had earlier been a serious cock-up in November 1940, right at the start of the island Siege, when eight out of twelve Hurricanes – 66 per cent – had been lost in a reinforcing operation from the carrier *Argus*. None perished as a result of enemy action. All fell into the sea well short of Malta after running out of fuel, the result of some imprecise planning between the two Services. (It was alleged that one error had been a failure to recognize the difference between the nautical miles to which the Navy adhered and the statute variety to which the Air Force owed its allegiance!) Thereafter, the planners in Whitehall had become understandably apprehensive …

Now, under the aegis of 2 Group of Bomber Command, eight – repeat eight – Blenheim medium bombers were dispatched from the UK down to Gibraltar to lead in the Spitfires. Four of these aircraft would rendezvous with the fleet at first light and shepherd the reinforcements from the carrier eastwards, out of sight of the North African coastline, past Pantelleria, to the beleaguered island.

The quality of the Blenheims' crews and the serviceability of the aircraft were demonstrably poor. Two of these aeroplanes crashed on landing at Gib – one due to engine failure, the other with faulty hydraulics. The first-class groundcrews on the Rock could hardly credit the condition of the Blenheims' engines and airframes when they started to work on them.

As for the Spitfires, no one in the UK seemed to have thought about the need for spares, nor had anyone attempted to test-fire and adjust the armament – the 20 mm cannons and .303 machine guns – before being crated and loaded aboard the 5000-ton *Cape Hawke*. The catalogue of errors and omissions was seemingly endless.

When all the aircraft had been lifted aboard *Eagle* at the Rock, and the carrier and its escort were well under way for the launch point, a fault was discovered in the fuel line from the 90-gallon overload tanks. It was found in the middle of the night as the engines were being run up and tested before the

dawn take-off. Without this additional fuel, the aircraft would never have a hope of reaching Malta. Captain Lachlan Mackintosh, in command of *Eagle*, a naval officer of special character and merit, had no alternative but turn about and, with the carrier's impressive escort, head back to Gib.

The Royal Air Force's embarrassment had yet some distance to run. When the reinforcing operation did eventually get under way again (*Eagle* had to make three runs eastwards down the Med in March with our aircraft aboard – 15 on the 7th, nine on the 21st and seven on the 29th) another ludicrous skeleton started rattling about in the cupboard.

It was revealed in Gibraltar that only one of the eight Blenheim crews possessed a properly experienced operational navigator, while the two whom Bomber Command claimed had been 'specially selected'* were actually found to be 'much below average'† when tested by competent, class exponents of the art among other Squadrons at the Rock.

Such glaring limitations were bound to be exposed when the ultimate trials came. They were further exacerbated when it was found that four of the eight crews were actually incapable of taking off from the Rock at night, flying through two or three hours of darkness and making a precisely-timed, pin-point rendezvous with the fleet at first light!

Beyond this, and almost more regrettable still, was the decision of the captain of a Blenheim during the second reinforcing operation not to proceed to the Island from the rendezvous point on account of what was alleged to be an excessive headwind. The Air Historical Branch's Draft Narrative speaks of 'an unwarrantable error of judgement'. Others, less generous, could well have seen it as a plain lack of guts. Whatever it was, it denied the completion of the second supply mission. *Eagle*, therefore, had to make a third run eight days later.

Two forthright comments, made at the time, underscored the extent of the shortcomings which were exposed at the beginning of what would eventually become one of the truly great combined operations of the war. The first came as a signal to the Admiralty from the staff of the Admiral commanding 'H' Force:

> Connecting up of Blenheims with Spitfires was always giving cause for anxiety despite excellent visibility. Inability of Blenheim crews to take off from Gib in dark, irregularity of time-keeping ... and *Eagle's* inability to communicate with them, and their small margin of endurance, created difficulties any of which might have jeopardised the operation.‡

Nearer home, an Air Staff minute sent by Air Chief Marshal Sir Wilfrid Freeman, Vice-Chief of the Air Staff, to the Deputy Air Member for Supply and Organization, under whom the plans had originally been formulated, hit the bullseye:

> CAS had great difficulty in obtaining the use of a carrier for this operation. These failures are unfortunate, put CAS in an impossible position and bring discredit to the Service.

*Air Historical Branch Draft Narrative

†Air Historical Branch Draft Narrative

‡Air Historical Branch Draft Narrative

Apart from this, it is clearly wrong to expect pilots to take off on a hazardous flight, under abnormal conditions, with an untested petrol system and unsatisfactory armament.*

• • •

It was scarcely surprising that, with all the to-ing and fro-ing up and down the Med, the Axis radar and intelligence antennae should have been monitoring the progress (or otherwise) of this ill-starred venture. Indeed, listeners to Rome radio were entertained with the news, complete with all the relevant details, that a major and top secret reinforcing operation, involving the supply of Spitfires to Malta, was under way!

The fact was, of course, that General Bruno Lörzer and his staff at Fliegerkorps II's HQ in Sicily had an accurate picture of these movements, their timing and their potential, and were poised to act accordingly.

The arrival of the first Spitfires on the Island and the subsequent reinforcing attempts, embracing an altogether more formidable and weightier process, now touched off an all-out assault on the Allies' Mediterranean outpost. Mounting week by week, it came within an ace of bringing the Island's people and its Garrison to their knees. Well might Winston Churchill write years later, 'During March and April all the heat was turned on Malta, and remorseless air attacks by day and night wore the Island down and pressed it to the last gasp.'†

• • •

Apart from more Spitfires, the greatest need now was for a seaborne convoy to be run through to the Island. More than a month had passed since the February attempt from Alexandria had been aborted. Another try to force the passage from the east was overdue. The presence of the new fighters, even in their small and fast-dwindling numbers, stimulated the hope that, with this better cover for the ships as they neared Grand Harbour, the Royal Navy and the Merchant Navy might be encouraged to accept the risks and try again. Malta's critically low – and reducing – stocks cried out for replenishment.

The next sortie, involving four cargo ships with an escort of five cruisers, sixteen destroyers and six submarines, under the command of Rear-Admiral Philip Vian – 'Vian of the *Cossack*'‡ – set sail from Alexandria in the third week of March determined to break the eastern blockade which the Luftwaffe and the Italian fleet, between them, had fastened on the Island.

However, before the convoy could drive a way through the narrows between Crete and the Libyan coast, two serious reverses rocked us in 249.

First, Douggie Leggo, a fine Rhodesian pilot officer of obvious promise, who had just begun to make his mark with the Squadron, was gunned down one morning, high up over the Island, by Hermann Neuhoff, a Luftwaffe 'ace', who was himself to fall a victim of a mission against Malta and be taken prisoner.

Douggie, flying out on our left flank, dropped easily out of his aircraft as it flicked over on to its back and started to float safely down in his parachute.

*Air Historical Branch Draft Narrative

†Winston Churchill, *The Hinge of Fate* (Cassell, London, 1951)

‡Later Admiral Sir Philip Vian

Just then, in a cruel thrust, the pilot of a lone Messerschmitt, diving unnoticed from behind a cloud bank, fired a short burst at the canopy, at the same time collapsing it with his slipstream as he passed, before diving away northwards for Sicily and home.

It was a sickening gesture, and a rare exception to the hard, but clean, fighting which was a feature of the cut and thrust of the Island battle.

Nothing, not even the most draconian discipline, will prevent pilots in a Squadron from seeking revenge when once they have seen a well-liked comrade cut down by a heartless act of war. I quickly sensed that, in the Squadron's fury, it would only be a matter of days before someone in 249 would seize a chance to square the account.

It came late one afternoon, within the week, when the Squadron, after an abortive interception well west of the Island, was losing height fast before crossing the coast at about a thousand feet and returning to base. A dinghy with three of the crew of a Ju 88, known to have been shot down earlier in the day, was spotted bobbing up and down on the sparkling sea eight miles or so south-west of Delimara Point. The occupants must have thought their chances of being picked up by one of their own Dornier 24 float aircraft or by an Air Sea Rescue launch from the Island were good.

A Spitfire from a section away to my left peeled off from the formation to make a fast diving run over the dinghy. With guns blazing, the pilot sent geysers of water leaping up around the highly-coloured rubber craft. A second run from the opposite direction closed the account. Back in the dispersal at Takali no one mentioned the incident, preferring to regard the affair as closed … We knew too well that in war one bad turn will always – always – beget another.

The next day – it was 21 March – disaster struck a second time, when a single bomb from some Ju 88s, attacking Takali unusually from the southwest, undershot the airfield and scored an almost direct hit on the Pointe de Vue, the local hostelry up on the hill in Rabat which served as an Officers' Mess for both 249 and 126 Squadrons.

At a stroke, five pilots and an intelligence officer were wiped out in a reverse which, strangely, made a greater impact upon the two Squadrons than would have been the case had the victims died in actual combat. It was the shock of so grievous a loss which cast such a shadow …

• • •

Accidents and set-backs had a habit of coming in threes in wartime. After these two strokes, which had hit 249 particularly hard, we now had to turn our attention to the convoy which, we knew, had been taking a pounding as it battled its indomitable way towards the Island. It was coming within extreme range of our fighter cover.

Lörzer and his cohorts in Sicily were again fully aware of what was at stake. They knew well enough what even a diminishing handful of Spitfires could do to sustain the three merchant ships – *Talabot*, *Pampas* and *Breconshire* (*Clan Campbell* had already been lost) – as the crews braced their

exhausted bodies for the final run-in to harbour. The Luftwaffe therefore turned up the screw and made Takali its prime target. This at once forced 249, now led by Stan Grant – Squadron Leader Stanley B. Grant* – Turner's smart and thoroughly professional successor, to slip over to Luqa and operate temporarily from there. 'Jumbo' Gracie's† well-drilled 126 Squadron, with its one predominately American flight of Eagle Squadron pilots, among whom Jimmy Peck and Don McLeod had got quickly into their stride, was also obliged to follow suit.

These two Squadrons, with 185's fighting Hurricanes from Halfar, went to the limits of human endeavour to defend the ships and their destroyer escort. As so often happens when the odds are stacked against you, the weather worsened and the enemy began to be favoured with a crucial couple of days of conditions in which sneak raids against what remained of the convoy might prosper.

A Mediterranean *mistral* started blowing a gale out of the east, bringing with it low cloud, poor visibility and heavy seas – just the sort of elements which were 'made' for the Ju 88s, and even the bomb-carrying Me 109s, as they kept repeating their 'dirty darts' at the ships ploughing their way ahead to Grand Harbour, while their agile destroyer escort was busying itself around them.

Neither the defending fighters, nor the brave crews in the merchant ships, nor the splendidly disciplined officers and men aboard the destroyers yielded a millimetre in the face of the relentless onslaught. Nevertheless, the outcome, although hard to bear, was probably predictable.

*Later Air Vice-Marshal S.B. Grant

†Squadron Leader, later Wing Commander, E.J. Gracie

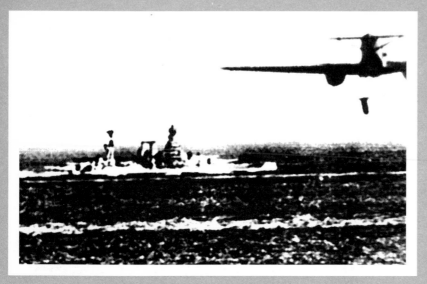

Aircrews of Italy's Regia Aeronautica pressed their attacks in the ferocious battles over the Malta convoys. Here a torpedo bomber lets its 'fish' go at a British battleship in the June 1942 convoy from Gibraltar

Italian Cants, usually from 16,000 to 17,000 feet, supplemented the Luftwaffe's onslaught against Grand Harbour

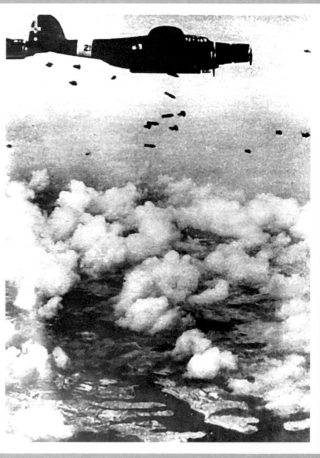

Meanwhile, the captain of one of Kesselring's Ju 88s in Sicily records his crew's successes in the convoy battles

Breconshire was eventually immobilized some eight miles or so to the south-east, the result of a 'lucky' hit in the engine room from a 250 lb bomb dropped by a 109 making a fast pass over the ship. With resolute seamanship she was taken in tow by two tugs and drawn into Marsaxlokk Bay, there to receive direct hits from a Ju 88 as she sank down in the water. Even so, some 500 tons of precious fuel oil were pumped out of her before she became a write-off.

Pampas and *Talabot* struggled on into Grand Harbour, but after a couple of days of being tied up alongside, the weather cleared on 26 March, allowing the Luftwaffe to mount attack after attack until the two ships were finally sent to the bottom. It was the same day as *Breconshire* met her end, beached in Marsaxlokk Bay.

Sadly, there had been problems with the unloading of the two freighters as they lay alongside in Grand Harbour during the vital two days before the weather opened the way for the Ju 87s and 88s to press their attack. The upshot was that, out of the 26,000 tons of supplies which had left Alexandria six days before, no more than 5000 tons were recovered to ease the Island's plight.

In the teeth of this daunting disappointment, the AOC offered the forthright advice to the Squadrons that another convoy attempt could not be expected until renewed (and successful) efforts had been made to build up our Spitfire strength. It might, he said, be mid-May before the gauntlet could be run again from either Gib or Alex. It was a sombre prospect ... Six weeks can seem like an eternity in war.

Meanwhile, we could only rely on our friends, the submariners of the Fighting Tenth, down at Lazaretto, and on the crew of the Royal Navy's *Welshman*, the fast minelaying cruiser, to brave the hazards of the run to and from Gibraltar to bring in the bare necessities – medical supplies, fuel and ammunition – without which we would hardly have been able to remain in the game.

We now began to wonder seriously about invasion and about the stocks of such food as we and the groundcrews, and the Maltese people, were presently getting. We hadn't yet learned to live with hunger: that would come later. Strangely, surrender never crossed our mind as a possible option ...

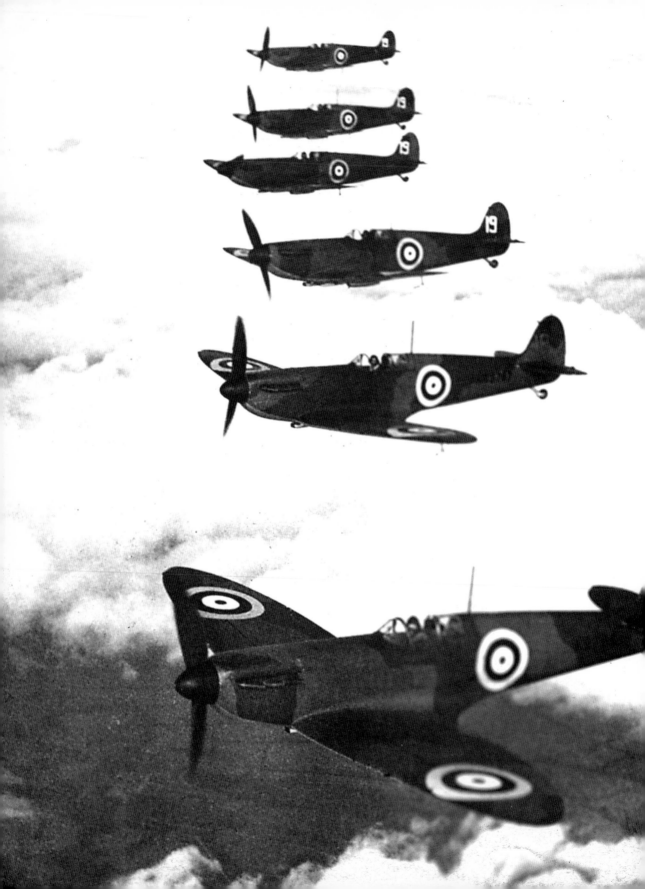

COMMAND AND LEADERSHIP

The first three individual flying commands in the Royal Air Force – Flight Commander, Squadron Commander and Wing Leader – reflected to a degree the ability and authority of the officer holding the appointment. There can have been few instances in any Service where a man had a better opportunity of making a mark on a unit than in one of these three commands. The Group Captain commanding a Sector Station in Fighter Command or a Wing in the Tactical Air Force also had a comparable chance of establishing his personality over his entity.

It was remarkable how quickly and clearly the true, all-round worth of the leader shone through. The average Squadron could be lifted up in a fortnight by a commander of exceptional quality. Conversely, the standing of a good Squadron could slip back in much the same time with a commanding officer who did not possess, as the cliché has it, 'what it takes'. There were few operational leaders in the Air Force who were not of proved and undoubted calibre. Those without these credentials seldom made it. Leading, in the pit of the fighting, was a testing business.

It is at least arguable whether there was a more satisfying operational command in the Service than that of the Squadron Commander. He had it within his power, via his two Flight Commanders, to shape the unit in the air and on the ground to his design. It was his show, his total responsibility, and the results would bear testimony to his competence and ability.

An alert and able Wing Commander Flying, with two or three Squadrons in his Wing, could instantly measure their individual worth. After an operation or two he could recognize their strengths and their weaknesses – and where changes in command would need to be made. A Wing Leader's remit was lonelier and less intimate than that of his subordinate Squadron Commanders. It was a matter of judgement for him to decide when to step in and when to stand back. Generally, it was for a Wing Commander Flying to stamp his style and authority on the Wing at the outset, to tell the Squadron Commanders what he wanted – in the air and on the ground – and that, provided this was forthcoming, it would be up to each CO to get on and run his Squadron according to his diktat, without interference from above.

Aggression, opportunism, command and judgement – these were the attributes to look for in the accomplished leader. There was a high premium to pay for good leadership for the morale of a unit rested upon it. The spirit in the first-class, front-line Squadrons in the Royal Air Force remained at an exceptional level throughout the war. This was achieved naturally, without special effort. Pilots would follow an outstanding leader anywhere, and rise to his lead.

All this was handed down from the top – from the very top – through a simple yet direct chain of command. Every commander knew his job on the operational side. If a 'ringer' slipped through the net, he didn't last. By the second half of the war, there were few of these in any theatre. By then, the cream had forced its way to the top. Encouraged by example, others were ready to step into the lead.

'GET THEM OR THEY'LL GET YOU'

The paucity of Spitfires in Malta in the critical spring and early summer days of 1942, as the Island battle moved to its climax, meant that, at Takali, 249 and 126 Squadrons had to pool and interchange their aircraft and take turns with readiness. It was unsatisfactory, but it was the only practical way of dealing with the deficiency.

This limitation of aircraft also had the effect of compelling the units to operate with small formations in separate Flights and Sections. It followed that both in the air and on the ground the Flight Commanders were left to carry a greater responsibility than would have been the case on, say, the Western Front, where, with an abundance of fighter aircraft, units were normally operating at Squadron strength with the Squadron Commander usually leading.

Certainly this was Laddie Lucas's experience in 249 Squadron as the Flight he was then commanding waited anxiously for news of fresh reinforcements.

The pilots of 249 sweated out their readiness among the ruins of what was once their Takali dispersal

Air Marshal Sir Arthur Tedder, the AOC-in-C, Middle East, visited Malta on 12 April 1942, the only time he came to see us on the Island during my six

Giving Intelligence (*extreme right*) 'the gen' on the previous interception. *Left to right:* Laurie Verrall (New Zealand), Les Watts (UK), Chuck Ramsay (Canada), Frank Jones (Canada) and Raoul Daddo-Langlois (UK) (*sitting*)

months' stay. Fifty-odd years on, I can still recall precisely the impression of imperturbability, calm and intellectual grip he left behind on that sunny, mid-Mediterranean morning.

Attended by the AOC and the Station Commander, Takali, he met us informally on the terrace of the Xara Palace just before lunch. He held a generous pink gin in his left hand; in his right he gripped his pipe, the stem of which he then used to prod home a point. Apart from popping the occasional, telling question or injecting a shaft of humour, generally he listened – listened intently. He was the most unpompous C-in-C I met in wartime and also the most convincing. He didn't have to work at 'authority', it was there naturally. You could sense it in his being. Despite a little mild banter about 'the Hun', he never left us in the slightest doubt about his concern for the gravity of our – and the Island's – lot.

I found his obvious inner confidence comforting; so was his personal serenity, the more so because the Luftwaffe had selected that morning to mount one of its very best displays against Takali – a good bombing attack finished off with a splendidly aggressive, low-level beat-up of the airfield by a *staffel* of Me 109s squirting right, left and centre as they went, while the gallant Bofors gunners gave them some pretty unpleasant chasers as they headed for home.

As we all stood together in a little group looking out across the central flatland of Malta, an Air Force photographer, on our left, was manoeuvring precariously on top of the wall, trying to find a position for a suitable shot. At that instant, a single 109, in a last flash of Teutonic defiance, came very close to the bastions, spraying cannon shells and machine gun bullets about haphazardly.

The photographer, in some fright, overbalanced and fell off the wall, fortunately on to the terrace, to the guffaws of the company – but not, I noticed, Tedder. He seemed much more concerned that the wretched man hadn't damaged himself. I found this instructive ... A mental calm and, with it, an easy intellectual mastery over our problems, these were the memorable features the C-in-C left with me on that historic spring day. Had I not then had a flying role, I felt it would have been a privilege – and probably enlightening – to serve him on his Air Staff.

• • •

We thought it was specially fortunate that the Luftwaffe had turned up the heat for Tedder's visit. It might have been pre-arranged. The insolent beat-up of the airfield before his very eyes must have told him that there wasn't much scope left on the Island for things to get worse. The attacks on 249's Spitfires, as they were in the circuit preparing to land, underscored the way things were going.

The gunners round the airfield stood to their posts magnificently as they attempted to pump up a ceiling of steel under which the likes of Pete Nash, Johnny Plagis, Norman MacQueen, Buck McNair, Paul Brennan, Ray Hesselyn and others among the Squadron's alumni might land. They made things thoroughly hot for the single-engine strafers. But in increasing numbers the Luftwaffe seemed bent on chancing the ground fire to find a Spitfire, out of petrol and out of ammunition, with its wheels and flaps down, a sitting bird committed to a landing. It was an unnerving development for the defending fighters and led one morning to a light exchange between Buck McNair and his relatively new number two.

'The heavenly twins' – inseparable on the ground and in the air: 249's Paul Brennan from Brisbane and Ray Hesselyn from Invercargill, NZ. Between them they destroyed 22 enemy aircraft over the Island

With both on their last gallon or so of fuel, Buck sent his number two in to land first while he provided the cover against any marauding 109s. The number two, obviously agitated with so much enemy activity about, came in too fast on his approach, overshot and had to go round again.

Buck, with his own petrol gauge now nudging zero, couldn't believe it. 'For Christ's sake, Blue two,' he said over the RT, 'what the hell are you playing at? If the 109s don't get you, I will!'

The need for Spitfires and still more Spitfires was now evident for all to see. I thought the C-in-C, in the short time we had with him, was more positive (without giving anything away) than the AOC had been after the disas-

trous outcome of the March convoy. It was obvious he understood that a quite exceptional effort with further reinforcements would very soon have to

be made if we were to stand any chance of redressing the imbalance between the increasing confidence of the Axis air force and the Island's aerial defence.

Squadron Leader Lord David Douglas-Hamilton, youngest of four celebrated Air Force brothers, all of whom became Squadron Commanders, led the City of Edinburgh's 603 Squadron throughout the 1942 Island battle with verve and judgement

To our surprise (and surprise and the security surrounding it posed the problem) the attempt came no more than eight days after the C-in-C's visit.

Churchill had made a deal with Roosevelt whereby the US Navy would release the massive carrier, *Wasp*, for a much larger fly-off of Spitfires than would have been possible with *Eagle* or any other of the Royal Navy's available carriers. *Wasp* could handle a reinforcement of 48 Spitfires while still having room to retain her own Squadron of Grumman F4F Wildcats.

All was therefore laid on for the mission, code named Operation Calendar, to take place on or about 20 April. Two of the Royal Air Force's best-known Auxiliary Squadrons, Nos 601 (County of London) and 603 (City of

Presiding over RAF, Takali, was E. J. 'Jumbo' Gracie, an officer of grip and purpose, who worked on an exceptionally short fuse

Edinburgh), were detailed for the task and embarked in *Wasp*, with Squadron Leaders John Bisdee and Lord David Douglas-Hamilton respectively in command, at Greenock, near Glasgow, on Scotland's River Clyde.

The plan was for *Wasp* to sail down to Gibraltar and through the Straits. Then, after picking up her additional escort, she would proceed to the usual point fifty miles or so north of Algiers for the fly-off soon after first light the next day.

All followed the pre-arranged plan save for two rather curious episodes, both of which we subsequently found hard to credit.

The Squadrons' take-off down the length of *Wasp*'s 'long' flight deck was uneventful. Forty-seven Spitfires became airborne and formed up ready for the flight eastwards to Malta some 700 miles away.

Jumbo Gracie, a Malta Squadron Commander and a pilot of considerable experience, with the Battle of Britain behind him, who had been sent

back to London by Lloyd to inject some urgency into the mandarins in White-hall, led the first group from the carrier. For some reason, which he was later at a loss to explain, this determined character started off by committing the elementary sin of putting what we called in the Royal Air Force 'red on black', that is, flying a reciprocal (or opposite) course to the one intended.

For a few moments he was blissfully heading westwards back towards Gibraltar with his flock following. An irreverent sergeant pilot, flying out on one of the flanks (he was acutely aware of the probable fine petrol margin), couldn't stick it any longer. With an accent which could be placed somewhere between Auckland and Sydney, he switched on his RT to transmit to break the strict radio silence. 'Say, Red Leader, when do you expect to be setting course for base?'

Poor Jumbo! At such a moment it was the black to end all blacks. Once back on the Island, he was never allowed to live it down. Although the gaffe had nothing to do with it, it wasn't long before he was surrendering command of 126 Squadron to become a quite outstanding Station Commander at Takali.

The second incident took on a very different and doubtful form. Each pilot taking part in the operation had it drilled into him that if, after take-off, an air-craft was, for some reason, unfit to make the flight to Malta, two options were open. Either he could climb up to 10,000 feet, bale out and trust to the Royal Navy to do the rest; or else he could fly south into North Africa, force land, destroy the aircraft and do his best to make it back home.

When David Douglas-Hamilton, leading the third formation, noticed one of his number breaking away from the pack and, for no apparent reason, heading south for the mainland, he assumed the aircraft was giving trouble.

When Prime Minister Churchill struck a deal with President Roosevelt to make the vast USN carrier *Wasp* (below) available for a second run down the Med, this time with *Eagle*, the Island battle was turned in the Allies' favour, 9 May 1942

Not a bit of it! The pilot, an American sergeant named Walcott, had seemingly confided in his Canadian cabin mate on the voyage down from Scotland that he had no intention of finishing up in Malta. What is more, he had also consulted the ship's padre without success about his desire to withdraw from the operation.

Every member of aircrew was a volunteer, and this was an American who had volunteered before the Japanese attack on Pearl Harbor and the United States' entry into the war. So what possessed him none could say.

The story was that he flew south across the Atlas mountains and force landed in the desert. Having destroyed his aeroplane, he then made off for the nearest US Consulate, where he claimed he was a lost civilian airline pilot and was promptly repatriated back to the United States to take no further part in the war.

It was an incomprehensible and uncharacteristic act far removed from his countrymen's wonderfully dedicated contribution to the Malta battle.

● ● ●

The initial success of the fly-off from *Wasp*, which resulted in 46 Spitfires landing safely at Takali and Luqa some three-and-a-half hours later, served as a temporary blood transfusion for those of us who had been draining our reserves in the face of the enemy's steadily increasing pressure. But its benefits did not endure.

Such was the secrecy in which Operation Calendar was cloaked that few of us on the Island knew about it until twenty-four hours before. Rumours had, of course, been circulating since Tedder's visit, but confirmation didn't come until too late. As a result the reception arrangements on the two airfields were quite inadequate.

Without petrol bowsers to hand for quick refuelling, sufficient armourers detailed to attend to guns and cannons and suitable numbers of fitters and riggers allocated to ensure immediate adjustments to engines and airframes, the time taken to turn round each newly-arrived aircraft was fatally long. Moreover, this delay was compounded by the poor all-round condition of the aircraft, which had been allowed to leave the UK far below the customary top line.

On top of all these difficulties, no methodical system was in place to direct the arrivals to designated dispersal points and nor were Malta-based pilots detailed to take over the aircraft from the deliverers as they became serviceable.

The truth was that the rigid security of the previous forty-eight hours had taken its full toll in prejudicing adequate planning.

In sum, it took roundly three hours to turn each of these new aircraft round and bring it on to the operational strength. By then, Kesselring and Lörzer in Sicily, after monitoring the progress and timing of the reinforcements as they neared the Island, had their answer well in train. Within about thirty minutes of the time it was taking to ready each new Spitfire, an assault

had begun against the airfields and their dispersal points. The first attack by Ju 87s and 88s came around mid-day, with two further raids following between lunch and dinner. The damage to the grounded aircraft was pitiful.

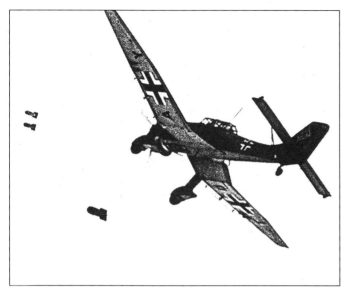

None could doubt the courage and accuracy of the Luftwaffe's vulnerable Ju 87 crews as they drove home their assaults on the Island's three airfields in the face of the Army gunners' rugged defence

Two-four-nine and 603's indomitable groundcrews at Takali, the main fighter airfield, could testify to the enemy's precision

Hugh Lloyd, with Woodhall at his side, addressed the Squadrons in the Xara Palace the same evening. If he had already been given details of the effect of the bombing on the day's arrivals, he never showed it.

His ten-minute talk was a virtuoso performance, delivered, as was his custom, without notes, with a whisky and soda in one hand and a lighted cigarette in a long holder in the other. It was a model of clarity, balance and directness. His sense of theatre and timing was always evident ... A pause here to give him time to pick the precise word he was after ... The occasional wave of the hand to sweep away a superfluous argument ... I suspect, in his years of service, he had carefully cultivated his speaking style with its staccato sentences and the intermittent glances into the eyes of his audience. The AOC was always worth hearing ...

He was half-way through his talk when the guns near Takali, less than a mile away, started to crack and bark, rising to a crescendo as the Ju 87s and 88s began to dive on the airfield in their last raid of the day. He continued through the din. 'With the arrival of these new aircraft today, the Hun must now be expected to mount a major offensive ... He will want to knock the Island out

once and for all ... Your job – gentlemen, your duty – is to seek out and destroy the enemy wherever he may be found ... Get in close before you shoot, see the whites of his eyes ... Then just pop him in the bag – pop him in the bag ... Believe me, gentlemen, if you don't get him he'll get you –'

The rest of the sentence was drowned by the screech and shriek of a 2000 pounder hurtling earthwards. It seemed as if it must hit the Mess. The old hands, led by the Aussies and New Zealanders, made a concerted dive for the cover of the billiard table. The bomb missed – just.

As the storm died away, the pilots sheepishly emerged from their hiding place to find the AOC still standing erect, with Woodhall beside him, whisky in one hand, the cigarette in the other. A slightly deprecating grin stretched across his face: 'You will now see, gentlemen, what I mean!'

The call to arms was almost done. He looked round the room and paused. 'Win this battle, gentlemen, and all the rest of your life you will be able to look back with pride and say, "I was there."'

Hugh Pughe Lloyd was unbeatable at that kind of melodramatic stuff.

• • •

Lörzer's attacks on the airfield and aircraft dispersals continued the following day with predictable ferocity, beginning about breakfast time. The pilots of 603, who were to operate at Takali with 249, were temporarily billeted under canvas in an olive grove close to Imdina. It was a novel experience for them to be woken by the sirens and then to hear the Messerschmitts powering down from altitude to strafe targets around the airfield not far from the tents.

Tony Holland,* who would soon cut a niche for himself among 603's successes, was sharing a tent with John Buckstone,† one of the Edinburgh Squadron's two Flight Commanders, and Paul Forster. He recalls that Buckstone had only just been married before the unit left the UK. Feeling somewhat vulnerable under canvas as he lay on his camp bed with bullets from the 109s whistling about, he had stretched out a languid hand for his tin hat and placed it slowly, and with infinite care, over his genitals.

'We told him,' said Tony, 'that we reckoned he had got his priorities exactly right!'

Three weeks later, Buckstone, as capable in the air as he was on the ground, was dead, felled as he followed the 109 which he and Holland had been shooting at too fast and too steeply, and both hit the sea.

• • •

Forty-eight hours after 601 and 603 had landed with their 46 new Spitfires, only seven of the aircraft were left in a fully operational state. Kesselring's Luftflotte 2 had done its worst.

With its front-line strength of some 650 aircraft, which, with the addition of the Regia Aeronautica's Squadrons, was now approaching its peak, it was beginning to dictate the fighting. For the pilots of the newly-arrived

*Flight Lieutenant A.C.W. Holland

†Flight Lieutenant J.W. Buckstone

A time for laughter... Laddie Lucas on the terrace of the Xara Palace, his Squadron's Mess in Imdina, the early capital of Malta

Squadrons, many of whom had had little operational experience, it was a ruthless baptism.

For the rest of us, who for weeks had been facing deteriorating service-ability in 249 and 126, it was a pulverizing reverse.

To add to the bad news, I had myself been wrestling with a debilitating bout of sand-fly fever, the result, the locals said, of being bitten around the ankles by ticks which lay in the sand and dust. 'Malta Dog', an obnoxious form of dysentery, was bad enough, but it was usually (but not always) relatively short-lived. This fever, however, tended to be unyielding and altogether more obstinate.

For more than a week, my temperature had hovered between 101 and 102°F accompanied by an incessant pain which pierced into the back of the head at the base of the skull like a gimlet. Desperate not to have to go to the MO and be taken off flying, I had been dragging myself with leaden steps up the hill to Imdina as we came off readiness each day in the gathering heat of the noonday sun. This made a contrast after shivering in the cold of the cockpit at 25,000 feet as we waited poised to strike at the 87s and 88s while Woodhall read the raid for us from the Ops Room and placed us to perfection.

Normally 'safe' doses of aspirin would not touch the pain and the fever. After ten days of it, I couldn't take it any longer: it was now 'make or break'. After struggling up to the Xara Palace from the airfield, I went straight to the bar at lunchtime and asked the barman to pour me out a generous treble whisky. Down it went taking five aspirins with it. I then repaired to my bed, lying under the mosquito net, there to await results.

Four hours later, I woke. Never had I perspired like it, nor since. Soaked sheets, blanket, mattress and pillow might have been lifted out of a tub of water. Then, suddenly, an extraordinary sensation struck me. Had I dreamt it or was it real? Could it just possibly be true? The pain – the appalling pain – which had been drilling into the back of my head for seemingly an eternity,

had gone … Could it really have been dispelled for good or would it return? I hardly dared to contemplate the downside.

Then, as I came properly out of my doctored sleep, I remembered the dreadful loss of the Spitfires … Only seven left out of forty-six in forty-eight hours … Yet, strangely, the thought no longer depressed me. The pain which had been worse than the loss of aircraft, had gone. Depression gave way to joy …

The sirens started wailing again as the Luftwaffe mounted its third and final assault of the day. Once more the Harbour barrage and the batteries round the airfield began barking out their welcome as the Ju 87s and 88s prepared to dive. Soon the bombs would be screeching and shrieking and hurtling earthwards again.

But I didn't care. They could hit what they liked. The only thing that mattered to me now was that the pain had gone … Banished, I was now sure, for ever … The relief overrode every other thought.

• • •

It was not long before we became horribly aware of two consequences which followed in the train of the set-back with this latest delivery of aeroplanes.

First, we recognized that it must surely delay, perhaps by as much as a month, the timing of the next convoy attempt either from Alex or Gib. The prospect of more belt-tightening for the already suffering Maltese people, and the Garrison, loomed large.

Second, there must now be doubts about the preparedness of the US Navy, with the Pacific war entering a decisive stage, to allow *Wasp* to be used a second time for a further fly-off of Spitfires.

For no one were these two crucial considerations of greater moment than the Governor, Lieutenant General Sir William Dobbie. None had shown a greater resolve to hold firm in these last rough weeks than this devout Christian and member of the Plymouth Brethren, whom Churchill would call 'a Cromwellian figure at the key point'.*

Exhausted from the long siege and its continuing burdens, Dobbie had drawn heavily upon his religious faith to maintain the will which had become synonymous with the Island's defence and of the office which he adorned.

The Governor, who was also C-in-C of the Island's armed forces, was sustained by his wife, who was devoted to her husband and to his cause. She had, however, gathered an endearing reputation for a slight vagueness and even distraction from the realities of Malta's daily life.

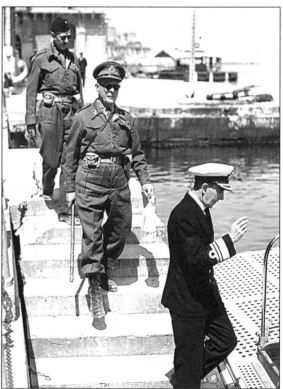

At this crucial moment, the 55-year-old Lord Gort, Grenadier Guards, sixth Viscount, holder of the Victoria Cross, three DSOs and the Military Cross, took over from Sir William Dobbie as Governor. Gort (*centre*) is here seen with Vice-Admiral Sir Ralph Leatham, Flag-Officer, Malta (*leading*)

*Churchill, *The Hinge of Fate*

The Royal Air Force would always recall the celebrated dinner party at the Governor's Palace in Valletta at which two or three of its officers had been guests. Lady Dobbie had found herself sitting next to A.C. 'Rags' Rabagliati, a Battle of Britain 'veteran' and one of the Island's most successful Hurricane Squadron Commanders.

Not quite catching his name the first time, she asked him to repeat it – slowly. She paused momentarily for reflection. 'Dear me,' she said, 'HE never seems to tell me anything. I quite thought we were *at war* with the Italians!'

However, it would not be for her upright husband to witness the next decisive round in the Island's struggle. By now, his health had been seriously impaired by months of stress and demanded that a successor soon be found.

In his stead came the 55-year-old Lord Gort – John Standish Prendergast Vereker, sixth Viscount, holder of the Victoria Cross, three Distinguished Service Orders and the Military Cross. Formerly Governor of Gibraltar, he had commanded the British forces at Dunkirk two years before. Churchill would refer to him as 'a warrior of the truest mettle'.*

I met Gort but once – one summer's dawn at Takali as I sat in the cockpit of my Spitfire waiting for a raid, which Woodhall had already reported, to move south from Sicily. Red tabs and all, the Governor had just *bicycled* the seven or eight miles from his Palace in Valletta with his ADC.

A highly-trained Guards officer, Gort led from the front. His attributes matched Malta's needs in the Island's moment of crisis.

* Churchill, *The Hinge of Fate*

AMERICAN WASP

As the Malta battle rose to its climax, much would turn on Churchill's ability to persuade Roosevelt to allow the USN carrier, *Wasp*, with a further complement of 48 Spitfires, to make a second sortie down the Mediterranean

Aerial reconnaissance – 'the eyes of Malta' – was now becoming an increasingly important feature of the Island's operational remit. The New Zealander Harry Coldbeck,* commanding the PRU Flight in 69 (General Reconnaissance) Squadron at Luqa, and supported by his two subordinates, Sergeant Les Colquhoun† and Flight Sergeant Jo Dalley,‡ had pushed the work rate of the unarmed blue Spitfires up to new and demanding levels.

The era of the remarkable Adrian Warburton and his crew in the twin-engine Marylands and Beaufighters was over for the time being, as this flamboyant former commander of the PRU Flight took a so-called 'rest' in Egypt. In place, the single-engine Spitfires, with their trusted Rolls-Royce Merlins, their vertical and horizontal cameras and excess fuel tanks, were flying their long sorties northwards at altitude far up the Italian mainland, as well as over hundreds of miles of the Mediterranean Sea. Round trips of 800–1000 miles were commonplace. The bread-and-butter short-haul missions to the heavily defended airfields and ports of Sicily and southern Italy were thrown in for good measure. Coldbeck and his competent supporters were painting on a broad canvas.

The New Zealand Flight Commander was cast in a wholly different mould from his pencil-thin, flaxen-haired predecessor. Methodical, painstaking and calmly professional, he had been marked down when he left his native country in the early part of the war as a bomber pilot. That was indeed a part for which his unruffled, equitable temperament would have been well-suited. However, when he reached the UK he was, by some quirk of posting, reclassified as a fighter pilot and, in due course, came to join us in 66 Squadron, in Cornwall, in the summer of 1941.

A Spitfire Squadron in Fighter Command was hardly Harry's meat, but, by the strength of his character and resolve, this likeable man adapted himself to the work until, by unusual choice, a signal reached the unit asking for a

*Flight Lieutenant, later Squadron Leader, H.G. Coldbeck

†Sergeant, later Squadron Leader, L.R. Colquhoun

‡Flight Sergeant, later Group Captain, J.O. Dalley

volunteer for photographic reconnaissance. Very sensibly, he at once put in for the job. It was a well-judged move, for, by his work in Malta in the spring, summer and autumn of 1942, Coldbeck established himself as one of the outstanding wartime successes of his trade.

Curious and sometimes clandestine things happened to Harry during his eight months' run on the Island before being shot down and taken prisoner while photographing elements of the Italian fleet in Augusta harbour.

Mostly, he received his operational instructions from the Intelligence Section at Luqa, where Raoul Daddo-Langlois and I, friends from his 66 Squadron days, often used to visit him. Now and then, however, he was surprised to have to deal direct with the Royal Air Force's Senior Air Staff Officer, Air Commodore Bowen-Buscarlet, or his successor, Air Commodore Riley. When this happened, it was always to be given the likely position of an Axis convoy heading south for Libya to replenish General Erwin Rommel and his Afrika Korps. On these occasions, instead of reporting the details on his return to base, he was required to spell out the information over the RT after sighting and photographing the ships. A strike was then laid on.

One of the most successful of the war's photographic pilots: Squadron Leader Harry Coldbeck, from Auckland, NZ, writing up his log on the wing of his blue Spitfire at Luqa

Harry, who always used to wonder at the extent of our convoy knowledge, never learnt, until his return from captivity at the end of the war, what the reason was behind this perplexing procedure.

Ultra, the hyper-secret intelligence organization based at Bletchley Park, in the south Midlands of England, was then regularly busting the Germans' Enigma cyphers and, among its many other revelations, was obtaining vital details of the sailing of Axis convoys, plying their way from southern Europe across the Med to Libya. Via its wonderfully effective Special Liaison Unit (SLU) in Malta, Ultra was passing this information to the Island's Service heads. Such was the secrecy surrounding this process that no more than three or four of the Garrison's most senior officers were privy to these details. Coldbeck's verbal reporting was thus designed as a cover plan to convince enemy intelligence that his sighting of the convoy was pure luck – chance – and was in no way the result of obtaining secret information.

The effect of the subsequent losses in convoys was catastrophic for the Axis, and ultimately became a major factor in Rommel and the Afrika Korps' defeat by Montgomery's Eighth Army in the critical battles of Alam Halfa and Alamein. In this and in other crucial ways, Ultra was a match-winner for Malta.

• • •

Another curious episode occurred during one of Coldbeck's sorties up the Italian mainland to the port of Naples. He was asked by Air HQ in Valletta to

drop a well-secured bundle from his Spitfire as he passed at low level – 2000 or 3000 feet – over the heavily defended airfield of Catania. The parcel would contain papers and personal effects of the crew of a captured Italian Cant seaplane.

Showing understandable apprehension at his likely reception at 2000 or 3000 feet over Catania, the New Zealander was assured by a senior officer that there would be no retaliatory fire; and so it proved.

When Harry was eventually shot down and had given his captors no more than the usual barest personal details, he inquired of a seemingly friendly and well-informed Italian officer when they were alone whether, perchance, the contents of a parcel dropped on Catania some weeks before did, in fact, reach their destination.

'Yes,' came the brief reply, 'they did.'

• • •

With our fast diminishing Spitfire strength, the increasing weight of the Luftwaffe's attacks and the widening odds against the defence, the Squadrons at Takali, Luqa and Halfar were now right back against the ropes. It was with this deteriorating picture that the genius of Woodhall's controlling from the Ops Room – the Ditch, as it was called – deep under Valletta, really shone forth.

Woody was, of course, up to all the tricks of the business. On a day when the fighter defences were necessarily grounded to conserve our aircraft strength, he played his ace.

Some off-duty pilots (there was now a large excess of pilots over serviceable aircraft on the Island) were visiting the Ops Room one afternoon as an enemy raid, preceded by a fast-flying fighter sweep, was approaching the Island. Woody, with a chuckle, put one of our 249 Canadians, whose accent must, by now, have been well known to the German listening posts, on to the end of a spare RT set.

In his own inimitable style, his measured, resonant voice exuding confidence, the Group Captain talked 'Tiger leader' on to 'contact' with the incoming sweep. 'Hello, Tiger leader, 20 plus little jobs approaching St Paul's Bay, 12 o'clock from you, at angles seventeen, just below. You should see them soon. They may be trying to work round behind you, up sun, so watch your tails when you come in: and come in fast. There are other 109s about.'

'OK, Woody,' came the fictitious, transatlantic response, 'we can see them.'

Advised, no doubt, by the listening posts in Sicily, the Luftwaffe controller was offering his *staffeln* cautionary warnings of impending 'enemy activity'. In no time, shouts of '*Achtung Spitfeurer! Achtung Spitfeurer!*' were issuing over the Luftwaffe's channels as the pilots became evidently jumpy, scanning the sky, up-sun, for the defending fighters.

The raid passed. Two Messerschmitts were seen by the ground gunners to have collided at altitude in their self-made mêlée and fallen into the sea.

Woody, well satisfied with his *ersatz* work, lit a cigarette. 'There,' he reflected, 'two confirmed destroyed for Pilot Officer Humguffrey!'

The legend was soon to take its place in Malta's imperishable folklore.

• • •

In such a climate, we had plenty of time to kill. We found diversions to colour the uncommitted hours. Raoul Daddo-Langlois, Norman Macqueen (soon, sadly, to be killed) and I often used to walk across the valley from Imdina to the general hospital at Imtarfa, there to see the wounded Germans whom the Squadron had shot down. We did this not to try to extract information from our adversaries, but rather to compare notes as fishermen do of an evening after a day by the river. These hospital visits made for entertaining interludes.

Daily combat against numerically superior odds brought severe losses. None was felt more acutely than that of Norman Macqueen (*above*) from Rhyl, Wales, one of 249's early stars in the battle

There was one engaging southern German named Kurt Lauinger whom we liked particularly to see, not least for his ready humour. He had been shot down by Macqueen in an unguarded moment, having himself just destroyed a Spitfire. He had broken his leg after baling out.

We told him one afternoon that, in a late raid on the previous day, one of the experienced formation leaders from his Jagdgeschwader 53, Hermann Neuhoff, with some forty victories to his name, had been shot down, as we then thought, by 'Zulu' Buchanan,* a former Rhodesian policeman, and one of our stalwarts in 249.

'Neuhoff shot down? Never!' exclaimed Lauinger, 'No one will shoot down Neuhoff.' His belief in this Squadron Leader was unshakable.

'All right, Kurt,' I said, 'if you don't believe us, write out a note to Neuhoff and I'll see that it is delivered to him in hospital over the other side of the Island. He'll send back a reply.' I still have the note he wrote stuck into my flying log-book.

A day or two later, we returned with Neuhoff's reply. Lauinger's face lit up. 'Well, well, Neuhoff shot down! He's in good company ... And to think of the things he used to say to me about my flying!'

• • •

Group Captain Woodhall now came over to the Xara Palace to give us in person the news we had been hoping for. Churchill had agreed with President Roosevelt that *Wasp* should make another run loaded with Spitfires, this time joining up with *Eagle*, similarly laden, at Gib.

In the interim, the most elaborate plans would be laid for some sixty new aircraft to be received on the three airfields and turned round in the minimum time. There could be no possible question of the catastrophe which had befallen the last reinforcements from *Wasp* being repeated.

*Flying Officer G.A.F. Buchanan

The incoming aircraft would be refuelled, rearmed and made fully operational on touching down, not only by the Royal Air Force's devoted ground-crews, but also by Royal Navy and Army personnel, who would, by then, be thoroughly practised in their respective tasks.

Each aircraft would be designated to a numbered blast pen where a battle-trained Malta pilot would be standing by to take over. With this tightly buttoned-up procedure, the turn-round time was estimated to take roundly thirty minutes to complete – quite adequate to allow the Squadrons to be got ready and scrambled with sufficient height to cut into Lörzer's formations as they made their expected thrust against the new arrivals …

Moreover, Jumbo Gracie, now well dug-in as Station Commander at Takali, was buttoning everything up – tightly. Two measures, recently introduced, were typical of his spirit and grip.

He issued every member of groundcrew who wanted one with a rifle. What's more, he set up machine gun posts around the airfield within easy reach of the Squadrons' dispersals. These he encouraged the airmen and NCOs to man during a raid. In each case, to have the means physically to shoot back when under attack worked wonders for morale.

Much more controversial, however, was his decision to have erected telltale gallows near the caves at Takali where stocks of aviation fuel and other stores were kept. Five-gallon cans of 100 octane, for which there was a ready sale on the black market, had been 'disappearing'. Accusing fingers were being pointed at likely suspects.

Jumbo went to town in Daily Routine Orders, announcing openly that anyone caught pilfering, sabotaging or otherwise interfering with Service property would, if found guilty, be shot and then strung up on a gibbet. It did the trick, but it caused a terrible row when the Air Ministry discovered that pictures of the gallows were being offered to the *Daily Mirror* in London!

Meanwhile, Woody said that five of us from 249 were to be flown back to Gibraltar at once to lead in the new batch of reinforcements – Stan Grant, our thoroughly competent CO, the two Flight Commanders, Buck McNair and myself, plus Daddo-Langlois and Ronnie West. We felt proud to think that the Squadron had been picked out to supply the leaders for this vital job. I can still recall the gist of Woodhall's words as he wished us well for our departure the next day.

'You fellows know what is at stake. Quite simply it's for the Island's future. This operation has got to succeed if Malta is to be held. There can be no question of failure. Each of you will therefore be carrying a big responsibility. The AOC and I have picked you five out because you are leading members of a first-rate Squadron which has strength in depth. Others like Norman Macqueen, Pete Nash,

Jumbo Gracie's gibbets at Takali. They were to deter would-be pilferers of aviation fuel which commanded a high price on the black market. An appalling row followed the passing of pictures to the offices of the *Daily Mirror* in London!

EXTRACT :- D.R.Oˢ DATED 14.5.42
R.A.F. STATION, TA-KALI, MALTA

A GIBBET HAS BEEN ERECTED ON THE CORNER OF THE ROAD LEADING TO THE CAVES. ANY MAN, WOMAN OR CHILD, CIVILIAN OR SERVICE PERSONNEL, FOUND GUILTY OF SABOTAGE, THEFT, OR IN ANY OTHER WAY IMPEDING THE WAR EFFORT AND SUB- SEQUENTLY SHOT, WILL BE HUNG FROM THIS GIBBET AS A WARNING TO ALL OTHERS.

Canada's Robert 'Buck' McNair, spirited Flight Commander of 249 Squadron, and later an aggressive and successful Wing Leader on the Western Front, led a strong Spitfire formation from *Eagle* on 18 May 1942

Johnny Plagis, Zulu Buchanan, Paul Brennan and Ray Hesselyn are fully capable of leading while you are away. So you take with you our confidence and our best wishes.'

Each of us knew that this was the crunch for Malta. While we had been waiting anxiously for this news, the German High Command's intention of neutralizing the Island by bombing had been given a fresh impulse. The regular three raids a day had been stepped up to four with all the regularity of a pre-war railway timetable.

In the two months of March and April, twice the tonnage of bombs had been dropped on Malta as fell on London in the worst twelve months of the blitz: and Malta, with its four prime targets – the three airfields and Grand Harbour and Valletta – was a shade smaller than the Isle of Wight.

Without any immediate prospect of a convoy in sight, stocks of food, ammunition and fuel were dwindling alarmingly. Belts, already pulled in tight, were having to be taken in another couple of notches. We were hungry, but the strange thing about hunger is that you get used to it provided you know that, for the time being, the best is being done to combat it.

It falls to a few of us in a lifetime to feel that we are about to play a part, albeit a humble one, in a great – even momentous – event. This was the first time that I had personally experienced the reality …

• • •

Gibraltar, after the privations, the endless air-raid sirens, the gunfire and the bombings of Malta, was like what our American friends call 'a resort loca-

By May 1942, the reinforcing of Malta with Spitfires from the carriers had reached an advanced art. Everything was made ready for loading at Gibraltar under the shadow of the Rock

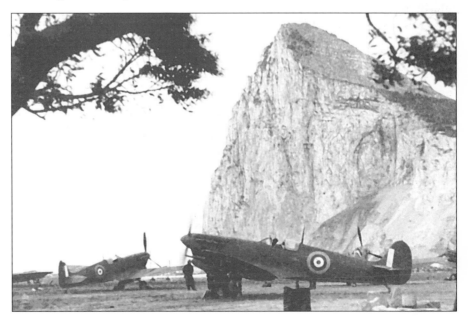

tion'. The shops were full, lights blazing, the local population well fed and without fear, while the quiet – the overwhelming quiet of the place – made us feel we were on a visit to another world … Talk about a haven in the storm!

Moreover, under Wing Commander John McLean – 'Mac', inevitably, to one and all – the officer in charge of the reinforcements at the Rock, everything had the feel of being ordered and, in his well-worked and repetitive phrase, 'a piece of cake'. After our knife-edge life in Malta, the confidence and authority which he purveyed gave us an impression of safety and even, for the first time for weeks, the feeling of being relaxed.

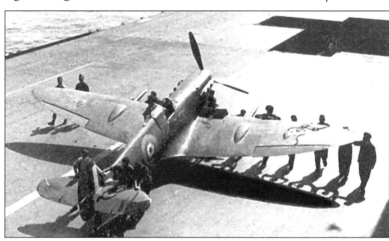

The stacking and manhandling of the aircraft on the flight-deck followed an automatic and efficient pattern

The plan for the operation was simple. A maximum of seventeen Spitfires would be hoisted aboard *Eagle*, which would then join up with *Wasp* as the US Navy carrier sailed through the Straits for the usual fly-off point, 700 miles from the Island, the next morning. *Eagle* would then turn about, load up again with a further seventeen Spitfires and, on her own, make another run down the Med nine days later. In this way, around eighty aircraft would reach the Island within ten days – a hitherto undreamt-of accession of aerial strength.

With the Royal Navy and the US Navy right up on their toes, and with McLean's comprehensive supervision, the plan worked, and worked brilliantly. On arrival in Malta, the reception and turn-round of the Spitfires (only three didn't make it, a loss of no more than 3.6 per cent) was accomplished, not within the anticipated thirty minutes, but at an average of ten to twelve minutes per aircraft. An astonishing feat …

A unique incident studded the take-off from *Wasp*. Jerry Smith,* the elder of two exceptional Canadian brothers, found, on becoming airborne, that his 90-gallon overload drop tank wasn't working. Against every instruction – and all the odds – he went for a landing back on *Wasp* without any arrester gear, and made it with a foot or two to spare on the flight deck. This was the first time a Spitfire had been landed on the deck of a carrier without a tail-hook.

After receiving the plaudits of the US Navy flyers aboard *Wasp*, Smith was taken down to the wardroom of this supposedly 'dry' US warship by Douglas Fairbanks Jr, the liaison officer aboard the carrier. An unseen button in the wall was pressed and a small cabinet full of liquid assets clicked open. Fairbanks poured out a large neat whisky and pressed it into Jerry's hand. 'Here,' he said, looking furtively round the wardroom, 'drink this – quick!'

*Pilot Officer J.A. Smith, later killed, was the elder brother of Roderick Smith, one of the RCAF's decorated Wing Leaders.

Another engaging Canadian from the Dominion, Jerrold 'Jerry' Smith (*above*), elder brother of Roderick, the RCAF's Squadron and Wing Leader, landed his aircraft back on the flight-deck of *Wasp*, a feat never before accomplished without a tail-hook

On 9 and 10 May, and for the next twelve days, the Luftwaffe threw in attack after attack. Furious battles were fought over the Island, but now the raiders met an altogether more formidable and resourceful defence. Axis noses were properly bloodied for the first time. Arrogance gave way to caution. An old Malta hand, returning to the Island after days away, could sense instantly that the ethos of the fighting had changed. The place felt quite different.

The daylight contest would continue with varying intensity for the rest of the summer and into the autumn; but this was the pay-off, the moment when the great defensive air battle was turned – and turned irrevocably. It was the time, too, when Malta regained its all-important capacity to strike hard at Rommel's convoys. For Kesselring and Lörzer, and their cohorts in Sicily, it was 'never glad confident morning again'.

• • •

Paradoxically, the enemy still largely dominated long stretches of the Mediterranean to the east and the west. The June convoy from Alexandria, Operation Vigorous, defying its code name, was obliged, in the face of cruel bombing from Crete and Libya and the imminent attention of the Italian fleet, to turn back – another hard reverse for the Maltese.

Operation Harpoon, run concurrently from the west, left Gibraltar with six merchant ships and a vast escort. Despite the heroic efforts of the crews only two of the six cargo vessels reached Grand Harbour; but it was enough to allow the Island to survive until August, when the Santa Maria convoy, again from the west, delivered five out of fourteen merchant ships to Malta after a final three days of devastating carnage. One thing was now quite plain. The sea passage to the Island could not be secured until North Africa was cleared of the enemy.

• • •

A young Canadian Spitfire pilot named George Beurling – 'Screwball' to 249 Squadron – was now beginning to make a recognizable mark in a unit of all the talents and in the cut and thrust of aerial combat.

Beurling had come to my Flight as a Sergeant, fair hair flopping about, makeshift khaki tunic and shorts, stockings not properly pulled up, with a pair of piercing blue eyes set in a sallow skin. I was then on the point of taking the Squadron over. I knew that he had come from England with a doubtful reputation. Always an individualist, his propensity for slipping off on his own in 11 Group's operations over France had put him at odds with his leaders. But I was also told that he could shoot, and fly aeroplanes. I felt, in this theatre, he might be worth a try.

'Screwball,' I said, 'you start with a clear charge sheet here. But let's be in no doubt about this: in 249 Squadron in Malta, where the odds are stacked against us, we fight in small formations, in pairs and fours in line abreast, and, as far as it is possible, we stick together. The pair is basic for the number one and the number two. Start going off on your own and you will be on the next aircraft into the Middle East.'

George 'Screwball' Beurling, from Verdun, PQ, Canadian genius for whom Malta – and Malta alone – was made, came to 249 Squadron with a poor reputation from Fighter Command in the UK. Given his head, under firm direction, his individualism and sheer ability earned him 27 enemy aircraft destroyed over the Island – and $31\frac{1}{2}$ in total in World War Two

Those penetrating eyes never left mine. 'Yes, boss,' he said. It was always 'boss'. I don't recall Beurling ever calling me 'sir'.

I found that Screwball flew aeroplanes with the angels. Those gentle, coaxing hands allowed him to get the maximum out of a Spitfire as a stable gun platform. His striking eyes enabled him to see a distant aircraft precious seconds before the rest of us – a blessed attribute. His judgement of distance was acute, his positioning that of a talented Rugby half-back. His shooting, which he had learnt from that master, 'Ginger' Lacey, was accurate. He did not waste ammunition shooting from long distances. Our guns were synchronized at 250 yards, which he normally never exceeded. He preferred to be closer and to close very fast. He fired short bursts: that was all that was usually necessary. In a word, he had flair, and Malta was made for him. It suited his individualistic style – just as it could never have been suited to the large Wing operations flown by Fighter Command over the Western Front: that could never be his scene – nor was it.

In the four months that Screwball operated with 249 on the Island, he destroyed $26\frac{1}{3}$ enemy aircraft. I never heard anyone in the Squadron question his honesty. A one-time member of the Plymouth Brethren and brought up in a strict, religious family background, he always flew with a small edition of the Bible tucked inside his battledress.

One sortie in particular personally convinced me that he was straight.

Woodhall, with his usual innate skill, had positioned us perfectly to strike at a strong fighter sweep of mainly Me 109s, but with a leavening of Ital-

ian Macchi 202s, as it approached St Paul's Bay. It was high summer with the sun blazing down out of a clear blue sky. With altitude and sun on our side, we achieved a lethal 'bounce', unseen by the enemy until it was too late.

After dealing with a 109 myself, my eye caught Screwball, way out on my right, pulling up fast and close underneath another unsuspecting Messerschmitt to send it spinning earthwards.

Breaking away downwards to starboard, he then performed a clinical job on a Macchi, which flicked over on to its back before plummeting down out of control. I saw both these kills and they were confirmed by the ground gunners.

Beurling now spotted a Mc 202 apparently heading home alone, just east of Gozo. Two quick squirts produced strikes down the port side of the aircraft from the tail unit up the fuselage to the engine. That was all he saw, for he had to break hurriedly away for Takali as a *schwarme** of 109s passed overhead and looked menacing. He made no additional claim to his two aircraft destroyed.

A couple of hours later, John Lodge, our careful intelligence officer, reported to Screwball that a Mc 202 had force landed on Gozo. Strikes had been found along the port side of the fuselage up to and including the wing root and cockpit, but not as far as the engine cowlings.

The Intelligence Officers serving 249 and 603 Squadrons at Takali – John Lodge and Keith Aitken – were dedicated to the task, always to be found down at dispersal when the going was rough

'It can only be yours,' said Lodge. 'No one else shot at an aircraft near Gozo. That makes it three destroyed.'

Screwball listened attentively and without emotion. 'Dammit,' he murmured, 'I was quite sure I had hit that goddam screwball up in the engine!'

• • •

Woodhall, accompanied by Stan Turner, came over to Imdina once more early in July. Over his customary sundowner, he told us that both he and the AOC were soon to be posted. They deserved and needed a rest. Winning the third decisive island battle of the Second World War, with all its pressures, had been a testing time for both. No AOC of this war had had to carry a heavier burden for fourteen months than Hugh Lloyd. As for Woody, he was palpably all in, having by now established himself as the Royal Air Force's outstanding operations controller of the war. It is at least arguable whether we could have won the Malta battle without him.

When he told us that Keith Park,[†] victorious commander of 11 Group in the Battle of Britain, would be taking over from Lloyd on 14 July, I noticed

*A section of four aircraft in line abreast – a finger-four

†Air Vice-Marshal, later Air Chief Marshal Sir Keith Park

that Turner put his gin down on the bar and went quiet. Stan, like Douglas Bader, his leader in the Battle of Britain, had had a brush or two with Park and was hardly *persona grata* with the incoming Air Marshal.

'The guy,' he said, 'will have me off this island inside a month.'

As things turned out, it took little more than a week.

• • •

Half a century on, when I was researching my book on the Malta battle,* my good friend Eduard Neumann, commander of Jagdgeschwader 27, the German Air Force group supporting Erwin Rommel in the Desert battles, came to dinner with me in London.

'Edu,' I said, 'you were specially placed to judge the real impact which Malta had upon the fighting in Libya and the outcome of the North African campaign. How did you see its importance?'

Neumann, an experienced and widely popular commander, put his knife and fork down on his plate and held up a cautionary finger. 'Malta,' he said decisively, 'was the key. In any case, read Kesselring.'

I read Kesselring and I found this. 'The abandonment of this project [Operation *Herkules*, the invasion of Malta] was the first death blow to the whole undertaking in North Africa ... Strategically, the one fatal blunder was the abandoning of [this] plan ... When this happened, the subsequent course of events [in North Africa] was almost inevitable ...'†

It is unlikely that Kesselring and Neumann could both be wrong.

Malta – The Thorn In Rommel's Side (Stanley Paul, London, 1992)

†*The Memoirs of Field Marshal Kesselring* (William Kimber, London, 1953)

CHAPTER 10

A GATHERING
OF EAGLES

By the summer and autumn of 1942, the Allies' campaign in North
Africa and the Mediterranean was critically poised. On the Western
Front, the air war blazed up over the abortive cross-Channel raid on
Dieppe. Johnnie Johnson, now a Squadron Commander in Fighter
Command, recalls the outcome:

In the high summer of 1942, I was promoted to command 610 (County of
Chester) Squadron at Ludham, hard by Hickling Broad, in Norfolk. We
had a farewell party at a local pub when I said goodbye to all the ground-
crews who had served 616 Squadron so well. Pilots continually came and
went but the groundcrews, the backbone, would remain with the Squadron
throughout the war.

With the help of Fred Varley, who looked after a few officers, we loaded
my old Morris Minor, including 'Pusher', my eight-week-old Labrador, and
set course for Newmarket, where I stayed with Hugh Dundas and his 56
Squadron in their wooden huts at Snailwell. That evening there was the
annual summer ball at Wittering, and so we repaired to that famous fighter
airfield on the Great North Road to be welcomed by the already legendary
Basil Embry, his radar operator Peter Clapham (on loan from MI6), and the
equally legendary Jamie Jameson, one of a handful of survivors from the car-
rier *Glorious*.

Later that evening, I danced with Hilda Jameson and asked her how she
managed to find her way from New Zealand to the UK to marry Jamie in
wartime. They were, she explained, childhood sweethearts, and when Jamie
left New Zealand to join the pre-war Royal Air Force they were 'unofficially'
engaged. When she heard about the sinking of the *Glorious* and Jamie's con-
valescence, she applied to Prime Minister Fraser for permission to leave New
Zealand. The Prime Minister gave her various letters of introduction and,
with her ticket to Liverpool, the statutory limit of £50 from her father and her
wedding cake, she set forth to join her man. Her passage across the Pacific,
with America not yet at war, was uneventful, and the journey across the
United States by Greyhound Coach cost £10. She survived the journey by
living on raw carrots and by making considerable inroads into her wedding
cake to save on meals.

She had to conserve her money or the authorities would declare her destitute and return her to New Zealand. She found free lodgings with a family friend in Pennsylvania and on most days travelled to New York to enquire about her passage, returning to Pennsylvania the same day to save the cost of staying in New York. Eventually, she embarked on the SS *Mendoza* and in mid-summer sailed from Montreal in a convoy of forty merchantmen escorted by three destroyers to face the perils of the North Atlantic. Happily, Hilda reached Liverpool safely, and a month later she married her brave fighter pilot.

On the following evening, Cocky and 56 organized another party to celebrate my promotion, which was attended by John Grandy (later to become Chief of the Air Staff), the resolute Denys Gillam, the well-decorated Max Aitken and the most amiable Paul Richey, author of *Fighter Pilot*,* one of the best books ever written on the subject.

On Monday, 13 July 1942, feeling slightly jaded, I reported to Group Captain Ronnie Lees, the Sector Commander at Coltishall, who told me that my predecessor at 610 Squadron was shacked-up with his girl friend somewhere, but the acting CO, Denis Crowley-Milling, would introduce me to the pilots and senior NCOs. Most of our operational flying, Lees told me, would be on convoy patrols, enemy shipping reconnaissances off the Dutch coast, a few odd sweeps from 11 Group and (I knew it was coming) plenty of Rhubarbs.

Two days later, I led the Squadron on a practice line abreast formation, which we had copied from the Luftwaffe in 1941 after our disastrous, tight vic formations had cost a lot of young lives in 1940. 'Crow', aged twenty-three, a veteran of France and the Battle of Britain, knew all about finger-fours, which 610 Squadron had flown for over eighteen months. Later Crow and I had long-range tanks fitted to our Spitfires and after tea took off on a 'Jim Crow'† from Texel to Ijmuiden.

We flew a long, long way over the cold heaving North Sea to the Wadden Zee, listening to the song of our single Rolls-Royce Merlin engines. There we found a small convoy hugging the coast and faced considerable flak from an E-boat as we strafed it with our cannons. Then followed the long three-quarters of an hour home, still listening to the steady beat of the Merlins, until we saw the Norfolk coast and could relax.

Rhubarbs were even worse than 'Jim Crows', because we had to fly well into Holland and face more flak when we strafed defended targets… Dangerous work, so that I was not surprised when, a few days later, I heard on the radio that Paddy Finucane, Wing Leader of the Hornchurch Wing, was missing after beating up a machine gun post in France. His Spitfire was hit by return fire. He tried to make it back to England, but over the Channel his engine failed and he went straight in. Some of his mates circled over his grave for as long as they dared, but all they saw was a patch of oil on the surface. So the cost of this particular Rhubarb was one very experienced and highly decorated Wing Commander. For what?

To make matters worse, at least for me, Ronnie Lees said we should try Rhubarbs by moonlight; and also it would be a good thing if we tried format-

*First published by Batsford, London, 1941

†Shipping reconnaissance

ABOVE: An immortal from the Southern Seas: New Zealand's Patric 'Jamie' Jameson, who, after surviving days and nights on a Carley float in the Arctic following the sinking of the carrier *Glorious* in June 1940, achieved distinction as the Norwegians' Wing Leader at North Weald

ABOVE RIGHT: The unacceptable face of formation flying: line astern – wonderfully safe and comfortable for the leader, but hell-in-the-sky for 'arse-end Charlie' at the back

ing, by moonlight, on Max Aitken's Beaufighters. He, Max, was getting a lot of trade at night and what better than to pass on some information to a for-mating Spitfire who could peel-off and hack down a German bomber or two!

I began to wonder whether I was commanding a day-fighter outfit or lead-ing some all-weather, multi-purpose, Jack-of-all-trades flying circus. Thus it was with some relief that I heard from the enterprising Ronnie that we were to fly south and, hopefully, participate in some good old-fashioned air fighting.

• • •

We were to take part in Operation Jubilee, a big raid on the French town of Dieppe. More than 6000 troops, most of them Canadian, would make the attempt. The Naval Force Commander had a fleet of 237 ships and landing craft. Leigh-Mallory would control the air effort from his HQ at Uxbridge. My Squadron (610) would form part of the 12 Group Wing led by Jamie Jameson.

Jamie was undoubtedly one of the finest and bravest fighter pilots ever to strap a Spitfire on his back. Also, he was a skilful leader of big formations, but he had a serious blind spot – he still flew in the antiquated line astern forma-tion.

Squadron in line-astern formation

On several occasions, I had pleaded my case to Jamie for line abreast, as we had flown it throughout the previous summer in Bader's Tangmere Wing. Now I said it again; gone was the old-fashioned, line astern formation, reminiscent of France and the Battle of Britain, where the three unfortunate 'arse-end Charlies' were always the first to go when the lean, fast 109s came and slashed at you in their well-proven *schwarme*, crossing over and guarding each other in their fighting manoeuvres, and always seizing upon the unfortunate chaps at the back. Instead, the pair should be our basic element, flown in line abreast about 200 yards apart with each pilot usually looking inwards towards his mate and guarding the sky from twelve to six o'clock.

Squadron in line-abreast formation

The 'finger-four' simply consisted of two pairs and was so-named because the relative position of the four fighters was similar to the tips of the fingers of an outstretched hand. It was devised, and continued, by the Germans in Spain, and had been highly successful ever since. In line astern, the three wretches at the back always felt vulnerable, while those at the front felt cosy and secure. In line abreast, I concluded, everyone stood the same chance of being hacked down.

Jamie, a polite and patient man, listened and said, 'We've been through all this before, and whenever your Squadron is in my Wing you will fly in line astern. Good morning.'

My senior Flight Commander, Denis Crowley-Milling, had also been through this before and thought we should stick to the line abreast style; and

The best ship-buster in the business: the highly decorated and versatile Denys Gillam at work with the rocket-firing Typhoons

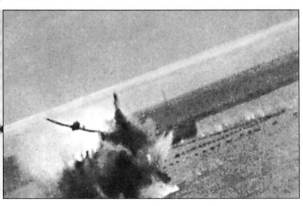

so it was arranged that we would fly across the Channel in line astern, but once we reached our operational height of 10,000 feet, I would waggle my wings and the lads would slip into line abreast. Since we were flying top cover to the Wing we would be 3,000 feet or so above Jamie, and it was unlikely that he would spot the switch. If he did, I was in trouble.

The fighter airfields in the south began to fill as Fighter Command reinforced with Squadrons from the north, the Midlands and the west. Wings were led by fliers of great experience who had fought in France and in the Battle of Britain... The North Weald Wing, led by David Scott-Malden, a classics undergraduate at Cambridge and not yet twenty-three; the Hornchurch Wing, led by the South African, Dutch Hugo; the Debden Wing, led by a Cranwell man, Duke-Wolley, and the newly-formed Typhoon Wing, led by Denys Gillam. Their immediate subordinates – the Squadron Commanders – included Americans 'Pete' Peterson and Don Blakeslee; Dolezal and Cermak from Czechoslovakia; Kowalski and Stan Skalski from Poland; Mehre and Mohr from Norway; Bernard Duperier from France; Guillaume from Belgium; Hodson, Ford and Chadburn from Canada; Reg Grant from New Zealand; and homebred Bobbie Oxspring and Peter Brothers ... Veterans of scores of fights; men forged and tempered in the heat of battle and resilient as the finest steel. I was proud to be included in their company.

Leigh-Mallory had seventy-four Squadrons available for this ill-conceived raid. With forty-eight Spitfire Squadrons, including three manned by Americans, he had a far greater fighter force than Dowding had two years previously in the Battle of Britain.

• • •

'We took off,' related Jamie Jameson, 'at first light and for the greater part of the journey across the Channel I flew low, just above the choppy sea, to avoid enemy radar detection. About ten miles off Dieppe I began to climb to our allotted height of 8000 for 485 Squadron, 9000 for 411 and 10,000 for 610. A heavy pall of black smoke hung over the town and I heard someone say, "Fight your way out, now! Get out. Watch those 190s above and behind!"

'On arrival over Dieppe the Wing was immediately bounced by 100 FW 190s and a few Me 109s, and I heard Johnson fucking and blinding as he broke 610 into a fierce attack. I was hard at it dodging 190s, but I found time to speak sharply to Johnson about his foul language.

'My section was attacked at least twenty times in as many minutes. Our situation was rather critical as we had to maintain position over, or near, the ships and beaches to protect them from air attack. After about ten minutes a further fifty FW 190s were seen coming in from the east to reinforce the first bunch. We were attacked continuously from above and out of the sun. Fortunately, the Germans seldom pressed their attacks home to close quarters, often opening fire at 800 yards range. I saw one Spitfire spinning down and the pilot bail out; he was from 411 Squadron and was later picked up. I shot down one FW 190 in flames and had several bursts at others. I found from experience that the best way to attack the German fighters was from astern and slightly below, shooting into the soft underbelly of the aircraft. The fuel tank was in a vulnerable position, and when hit nearly always resulted in a flamer. Our total score was three and a half FW 190s (one being shared with a pilot of another Wing), two Me 109s destroyed and three FW 190s damaged. We lost five Spitfires, but three pilots were picked up out of the sea. I saw one Spitfire dive into the sea, half-way back across the Channel; the pilot did not get out, and perhaps he had been seriously wounded earlier.'

One of the most dangerous jobs at Dieppe fell to the close support Spitfires of 129 Squadron who had to strafe the 'Hess' battery to the west of the town, which, immediately after, would also be attacked by Lord Lovat's Fourth Commando. Squadron Commander Tommie Thomas, making landfall by a convenient lighthouse, led his Squadron five or six miles inland, about-turned and made his low-level approach. At 0620 they strafed the battery with their cannon and machine guns, and 'Arse-End Charlie', Harold Groombridge, was the last to go in. Groombridge closed to about 150 yards and was still firing when he was attacked and hit by a FW 190 – one of about a dozen who fastened upon the slower Spitfire Vs. There followed a vicious dog-fight, when friend and foe dodged about the roofs and spires of the town, and Groombridge only escaped his adversary by flying under some electricity cables. The Squadron returned without loss and that evening received Lovat's congratulations on the timing and accuracy of their strike.

Group Captain Harry Broadhurst, now Deputy Senior Air Staff Officer at 11 Group, had voiced his views about Wing patrols at a planning conference before the raid. He thought that Wings of three Squadrons (36 Spitfires) too cumbersome for such an operation, but he was overruled by 'Mr Big Wing' himself, Leigh-Mallory, who, however, gave permission for Broady to fly on the raid.

'I took off,' Broadhurst stated in his combat report, 'from Northolt at about 0600 on a reconnaissance patrol over Dieppe. Whilst at 25,000 feet I noticed that the Huns were working their aircraft in pairs, some being FW 190 fighter-bombers. The enemy aircraft were flying out about five miles north-

Aftermath of battle: the beaches of Dieppe in August 1942, following Mountbatten's ill-fated cross-Channel operation

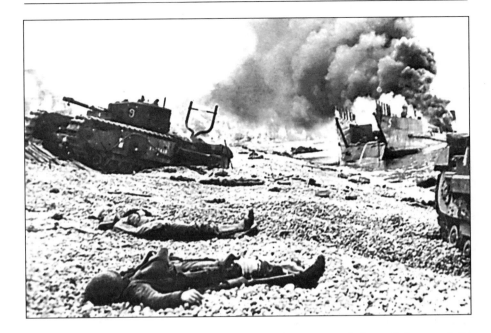

east of Le Tréport and getting well up into the sun and then diving straight down through our patrols, and towards the ships lying off Dieppe. Some would attack these ships, and some would attack our Spitfires on patrol. I circled for about ten minutes, and gradually lost height down to 20,000 feet. Enemy aircraft were operating from 15,000 feet downwards. Eventually I selected an isolated pair of FW 190s which were about to commence their dive, and dived on the rear one, giving him a long burst of cannon and machine gun. This enemy aircraft gave off large clouds of black smoke, spun and hit the sea. After a short burst at his leader I broke off and climbed back into the sun.'

Harry Broadhurst noticed that immediately our Wings reached the French coast they, like Jamie's Wing, were bounced by the higher, faster FW 190s, split up and never reformed. He knew that we would be far better flying in pairs and fours, and, on landing, telephoned Leigh-Mallory and put his case. His advice was refused.

We flew four times that day, and later Leigh-Mallory hailed Dieppe as a great victory for his fighter squadrons with no less than 271 enemy aeroplanes destroyed or damaged; but, as usual, we over-claimed, for the actual number destroyed was 72 and our losses were 106 of which 88 were fighters. On the ground the Canadian soldiers were slaughtered.

The debacle, whitewashed at the time, was well assessed by two people who were there: A Royal Navy officer called it a 'sea version of the charge of the Light Brigade', and the commander of a Germany battery said, 'We felt very sorry for the enemy because he had no chance. He was a mouse in a trap.'*

*T. Murray-Hunter, *Canada at Dieppe* (Canadian War Museum, Ottawa, 1982)

CHAPTER 11

WING COMMANDER FLYING, KENLEY

A fighter Wing in the Royal Air Force tended to reflect the personality and spirit of its leader. Nowhere was this more true than at Kenley, in 11 Group, where Johnnie Johnson was to make his idiosyncratic mark as an exceptional exponent of the Wing leading art. Read on, and it is not difficult to see why:

In the early spring of 1943, I still commanded 610 Squadron. We were based at Westhampnett and our Spitfire Vs were outclassed by the FW 190s. On one mission, as close escort to Ventura bombers attacking a target at Caen, I lost four experienced pilots, and a few days later Reg Grant, commanding 485 (New Zealand) Squadron, lost three pilots, including his youngest brother.

Our Wing Leader left and, pending the appointment of his successor, I led the Tangmere Wing. Our penetrations into France were considerably less than those of two years ago, and when the controller called up and told me of enemy gaggles five and ten miles away, my reaction was to avoid combat unless sun and height would give us the perfect bounce. Such was the superiority of the Focke-Wulfs over our Spitfires.

One day the AOC, 11 Group, Air Vice-Marshal 'Dingbat' Saunders, telephoned to say that I was posted to Kenley as Wing Leader of the Canadian

Canadian pilots of 421 Squadron in Johnnie Johnson's Kenley Wing, before take off, spring 1943

Wing who had the new Spitfire IXs. This good news was tempered by having to leave 610 Squadron at such a critical time.

On the drive to Kenley in my small Morris, with my Labrador Sally curled alongside, I thought of my duties at Kenley. The post of Wing Commander Flying (often abbreviated to Wing Leader) was the ambition of every fighter pilot, for I would be following in the steps of the great and unflappable Sailor Malan, the carefree yet highly efficient Bob Tuck, the steadfast Jamie Rankin.... And next door, at Biggin Hill, was the fearless New Zealander, Al Deere, who had parted with his Spitfire nine times and was still pressing on.

Fighter leadership, in my book, consisted not in scoring personal victories but in the achievement of success with the whole Wing. My job would be to lead and fight; to bring the greatest number of guns to bear against the enemy in the shortest possible time; to keep down losses and to avoid the bad bounce; and to control the progress of the fight and to keep the Wing together and not get split up into isolated, ineffective packets. The goals could only be achieved through good flying, perfect discipline and strict radio drill.

I parked the small Morris outside the Mess, much to the amusement of a party of husky Canadians who were obviously comparing it to the monsters they used at home. After lunch, I met the two Squadron Commanders and some seventy pilots: the lean, slightly balding Syd Ford of 403 (Wolf) Squadron came from Nova Scotia, held the DFC and Bar and looked tired; Foss Bolton, of 416 (City of Oshawa) Squadron, hailed from Alberta and was an open-faced, friendly character who had spent the best part of his flying career in Canada.

I was horrified to learn that they still flew in the obsolete line astern formation. We had a long talk when I pointed out all the benefits of the finger-four style. Ford favoured the line astern despite what I had said. Bolton seemed to waver. I felt it was time for a decision: 'For the first few Wing shows I'll lead Foss's Squadron and we'll fly finger-fours. You, Syd, will hold your position down-sun, 3000 feet higher, and you can fly in what formation you like providing you do your job. We'll see how it goes for the first few times and then decide one way or the other for the whole Wing.'

A new Spitfire, EN 398, had arrived a day or two previously and was undergoing her acceptance checks in the workshops. I found the engineer officer and together we had a look at her, gleaming and bright in a new spring coat of camouflage paint. Later, I took her up for a few aerobatics to get the feel of her, for this was the first time I had flown a IX. She seemed very fast, the engine was sweet and she responded to the controls as only a thorough-bred can. I decided that she should be mine, and I never had occasion to regret the choice.

During the next few days the weather continued very poor and it was quite impossible to operate the Wing. But we could fly individually during some temporary breaks in the weather, and I flew several times to test the two cannons and four machine guns. It was standard procedure for our guns to be harmonized to give a fairly large 'shotgun' pattern at the best firing range. The

Two sections of Spitfire IXs in line astern (not from the Kenley Wing!) returning to base

theory behind this was that, since the average pilot was not a good shot, the open pattern would give him the best chance of hitting the Huns. But a far more lethal method of obtaining a kill, provided the pilot could aim and shoot, was to harmonize the guns to give a 'spot' concentration of fire. Ford's guns were set on the spot principle, and since his combat films were some of the best ever taken, I followed his example.

Some three weeks passed and we had only flown together on two or three occasions. Once, well inside France, we saw a large gaggle of FW 190s in the far distance, but our petrol was running low and we had to return without firing a shot. My Canadians flew extremely well and their air discipline was excellent, which says much for the Empire Air Training Scheme (later called the British Commonwealth Air Training Plan) which Laddie Lucas has described in a previous chapter.

One Saturday in early April, we were having lunch when the Tannoy announced that the Wing would come to readiness in one hour's time. I walked over to the ops block to study the details so that I could brief the Wing. It was only a small show, but far better than idling away the afternoon on the ground. My friend Denis Crowley-Milling was to lead his Squadron of Typhoons across the Channel at low level, dive-bomb the Abbeville airfield and then withdraw at a high rate of knots. Our job was to climb over France as the Typhoons came out and knock down any Messerschmitts and Focke-Wulfs flushed by the bombing.

We crossed the French coast just south of Le Touquet. The flak stained the blue sky and I thought of the Tangmere Wing, Douglas and Stan Turner's acid comment: 'Put your corks in, boys!'

What wouldn't the Kenley Wing Leader have given for such a bounce! A Focke-Wulf 190 over Abbeville in northern France

Hunter, an excellent and reassuring controller in the Woodhall tradition, gave me several vectors to intercept an enemy formation and warned of another hostile formation above and behind. I had, I thought grimly, been in the same situation before. But then I saw our quarry. One bunch of twelve 190s just below and a mile ahead, and a further ten 190s as well out on the starboard side. We had the makings of a perfect bounce, and I had to take a chance on how far behind was the other enemy formation.

'Greycap to Wing. Twenty plus Huns below from twelve to three o'clock. Syd, I'm taking the left-hand bunch. Come down and take the right-hand gaggle. Get in!'

The first – and for some the last – thing the enemy pilots knew of our presence was when our cannon shells tore their fighters apart. My victim fell burning, and as I climbed away I saw another 190 in flames and a parachute. Hunter, however, was still concerned and said the second enemy formation was above and very close.

I ordered the Wing to withdraw, and we poured across the Channel at high speed in pairs and fours. Back at Kenley I counted the Spitfires as they joined the circuit. Within a few minutes twenty-three had landed, but Flying Officer Watson failed to return. We claimed six FW 190s destroyed.

The next day we met some seventy B-17s after they had bombed the Renault factory at Paris. They were being savaged by a bunch of aggressive FW 190s and a running fight ensued, during which we destroyed five enemy aeroplanes and lost Sergeant Deschamps and Pilot Officer Ed Gimbel from the United States.

The good spring weather was here and we flew almost every day on fighter sweeps, beating up ground targets in the Pas de Calais and escorting both Royal Air Force and US Air Force bombers to targets as far as Antwerp – and no further, for our Spitfire IXs, thanks to the pig-headedness of Sir Charles

Portal, Chief of the Air Staff and normally a good thinker, still carried the same amount of internal fuel as our Spitfire Vs of two years ago. The Spitfire IX was a thoroughbred, but it was still a defensive short-range fighter. Thus, when the B-17s of the 'Mighty Eighth' got into their stride and fought their way into Germany, they were, for many miles, without fighter escort and took some hard knocks.

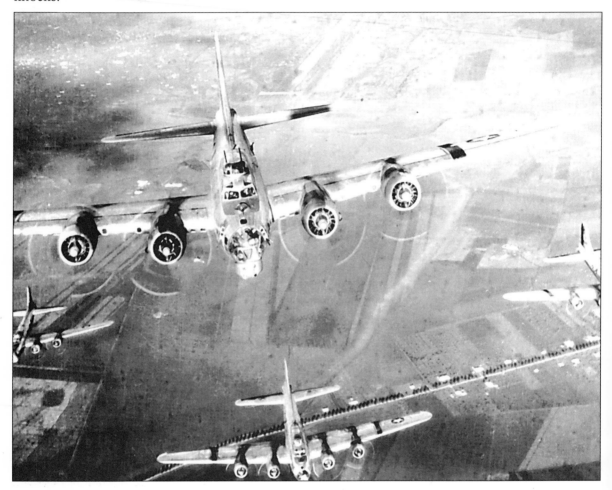

I always tried to control the air battle and would not necessarily go down myself. I remembered the unnecessary loss of Douglas Bader when he wasted precious seconds after Ken Holden had warned him of 109s below. Immediately Ken spotted the Huns, the Wing Leader should have allowed Ken to attack with 610 Squadron whilst Douglas and 616 Squadron circled above. Seconds in the air are precious, often making the difference between success and failure. Thus, when leading the Kenley Wing and Huns were spotted below, I often sent down the best-placed Squadron or Section and guarded them myself.

I always remembered, too, my agonizing search for tactical knowledge, and how Billy Burton had admonished me for talking 'shop' in the Officers'

'They flew the basic vic formation.... The tougher the going the tighter they flew....' Johnnie Johnson on the B-17s (above) and the B-24s during the US Eighth Bomber Command's daylight offensive

Mess. Those dreadful amateur days had gone for ever – we had become pro-fessionals. I had a lot of Canadian pilots who had never fired their guns in anger, so I made sure that we had plenty of informal discussions about deflec-tion shooting, formation flying, staying together, the vulnerability of a lone pilot and how adept the Germans were at picking off stragglers.

Whenever there was a set-piece Wing show as opposed to a scramble (few and far between in 1943), I briefed the pilots on the mission, including enemy dispositions, flak defences and, if we were escorting B-17s, the impor-tance of staying out of range of the American gunners, who fired at friend and foe alike. Unlike Douglas, who always flew with the same Section (Smith, Bader, Dundas and Johnson) of 616 Squadron, I flew with different Squadrons and different wingmen, although I limited my wingmen to half a dozen I knew would stay with me through thick and thin.

After each fight I held a lengthy de-briefing to find out if we could have done better. Losses were analyzed in great detail, but sometimes, when we got into a big dog-fight, we lost pilots and just did not know whether they were dead or alive until we heard from the International Red Cross. Sometimes there was no news, and we hoped that our missing man was making his per-ilous journey home and that he had memorized the addresses of the 'safe' houses in Belgium and France.

● ● ●

The Luftwaffe, seeing the writing on the wall, always reacted to the B-17s, and we began to see gaggles of upwards of fifty Huns. In these engagements my twenty-four Spitfires fought at a disadvantage and, remembering Douglas and his famous 'Big Wing', I went to see our friendly AOC, Air Vice-Marshal Dingbat Saunders, and recommended that we build up our fighter formations to about the same number so that we could meet the Germans on equal terms. The AOC agreed to my proposal and decided that the Hornchurch Wing should fly with me.

I flew to Hornchurch to work out the tactical details with the dashing Bill Compton from New Zealand. He agreed that I would lead the Balbo of sixty Spitfires, and that if we came across a big gaggle I would control the air battle. Bill said, 'If you lead all the time, you'll be getting all the fun and my boys will just be top cover guarding your lot.'

'I'll lead the first few shows,' I replied, 'and then you can lead and I'll be top cover.'

'Sounds fair to me,' said the New Zealander. And that is how we left it – but I should have known better!

On our first Balbo, the controller brought us over a mixed pack of about fifty enemy fighters. We had height, sun and surprise so I told Bill that I was taking my Wing down to attack and he was to cover us. However, just as I was about to open fire, the gallant Compton and, it seemed to me, the best part of his gang, came split-arsing down into the fight, and my greatest concern became avoiding a collision with the milling, twisting fighters.

Back at base, I telephoned Bill and asked him why he had not stayed above my Wing. He said he thought there were too many Huns for me to handle and he'd better lend a hand. He, Compton, had got one. How had I fared?

I could have made it awkward for the Kiwi, but Bill was a friend, and, in any case, my Balbo concept for fighter versus fighter was wrong. Balbos, as Douglas and Galland discovered, were correct against large, unwieldy bomber formations who had to hold a steady course, but they were far too cumbersome against fast-moving, highly manoeuvrable enemy fighter formations.

• • •

In early August 1943, we left Kenley and established ourselves at Lashenden, a landing strip in Kent. We lived under canvas, our food was prepared in field kitchens and all our workshops and equipment were housed in specially built trucks so that we could break camp at short notice and move to another airfield. We were rehearsing for the long-awaited invasion of France.

In the late summer, Screwball Beurling joined 403 Squadron. We all knew his history. He had joined the Royal Air Force after being turned down by the Royal Canadian Air Force. He was a remote, brooding lad who showed great individual promise, but he was a loner and his temperament was not suited to team fighting. So he was sent to Malta where he joined Laddie Lucas's renowned 249 Squadron and found fulfilment in his solitary yet brilliant exploits.

Fighter pilots are by their very nature individualistic, and it is perhaps the outstanding trait in this breed of fighting men. It is also the reason why some appear to be rebels – 'prickly pears'. I thought I knew about 'prickly pears', who are often so bloody obstinate that they are in there, still fighting, when the rest of us have fled, but I could not handle Beurling. I talked to him, made him the Wing Gunnery Officer and told him he could soon have a Wing of his own.

However, he was not interested in promotion or leading fighter formations, but only in his own solitary, fearless crusade against the Germans. Off-duty, he often 'borrowed' my shotgun and Sally and wandered across the countryside dispatching anything that moved, including a brace of rare wild-fowl on the moat of a nearby castle. The owner was not amused and our CO, Group Captain 'Iron Bill' MacBrien, had to do some fast talking to keep him out of serious trouble.

After I left the Wing, my successor got rid of this strange man. Beurling was sent back to Canada and left the Service before the end of the war.

During the spring, summer and early autumn I led the Kenley Wing on 120 missions, and this tour of operations ended, after more than three years with the fighter Squadrons, on 9 September 1943. My successor as Wing Leader was Hughie Godefroy, an engineering student from Toronto, who kindly summed up my stewardship of the Wing when he wrote: 'As a leader,

Johnnie Johnson was like the Pied Piper. We found ourselves bounding out of bed repeating his catch phrases. "OK chaps, get into them!" ... In the air, he was Greycap Leader, cool, commanding and aggressive as a bull terrier.'*

On the credit side, we destroyed well over 100 enemy aeroplanes and damaged many others. We had flown 'free-lance' sweeps and had escorted light, medium and heavy bombers. Perhaps our greatest contribution was to help the US Eighth Army Air Force get started on their great pioneering adventure over Europe. On the debit side, we had lost some good men, including Foss Bolton, happily a prisoner of war, and Syd Ford, killed attacking a flak ship.

Saviour of the stricken: a Walrus being catapulted from the cruiser HMS *Mauritius*. The crews of these amphibians picked up Allied aircrew even under the guns in enemy-dominated waters

Thanks to the gallant Walrus crews, we had rescued some good men from the sea, including Squadron Leader 'Buck' McNair, a well-decorated Malta veteran, who bailed out just off the French coast when his engine caught fire. I left Tommy Parks, his wingman, over Buck's dinghy while we hared back to Manston to refuel and relieve Parks. On the way, the Kenley controller told me that a section of Spitfires would soon relieve Parks and a Walrus was on its way (at a steady 70 knots). We landed at Manston and I was soon in the air again after some splendid refuelling by the groundcrews, who knew about our mission. I called the Walrus on a common frequency and recognized the voice of Squadron Leader Grace, the brave CO of the Hawkinge rescue flight. Grace found the dinghy, dropped a smoke marker and flew a long, slow circuit as if he was practising on some peaceful loch instead of trying to land on a rough sea two miles from the French coast.

At long last, the amphibious aircraft landed safely and taxied to our pilot. Buck was hauled on board and the Walrus swung into the eye of the wind for its take-off run. It gathered speed and bounced from crest to crest with the sea cascading from the hull. It reminded me of an old swan beating its wings along a stretch of river to get up the right speed for take-off. Once the Walrus was in the air I called Grace: 'Greycap to Walrus. How's our pilot?'

'Not too bad,' answered Grace. 'He's burnt a bit and swearing a lot!'

We flew with the Walrus all the way back to Hawkinge, and I was alongside the amphibious aircraft when Buck was transferred to the waiting ambulance. His face looked pretty grim, but he was cheerful and recognized me. 'Don't let me lose the Squadron, chief,' he said. 'This is nothing. I'll be back in a day or two. Promise I won't lose the Squadron!'

Such was the quality of the Canadians I was privileged to lead during the air fighting season of 1943.

*Hugh Constant Godefroy, *Lucky Thirteen* (Croom Helm, London, 1983)

CHAPTER 12

WING COMMANDER FLYING, COLTISHALL

For Laddie Lucas, promotion to command the Coltishall Wing came suddenly and unexpectedly. A posting to lead a wing in North Africa was cancelled at the eleventh hour for reasons of which, at the time, he had no knowledge.

Arthur Donaldson,* Station Commander at Ibsley, the youngest of the Royal Air Force's three celebrated brothers, sent for me after breakfast. It was Saturday, 3 July 1943 and I had then been commanding 616, the South Yorkshire Auxiliary Squadron, for three months at the start of my second operational tour. It had been a mellow summer spent hard by the banks of the River Avon in the heart of Hampshire's famous mayfly country.

Arthur Donaldson *(right)*, youngest of three exceptional Royal Air Force brothers, and a Malta 'veteran', was lucky still to be alive after an enemy bullet had ripped his flying helmet

Arthur, fair, engaging and strikingly good-looking (particularly to the other sex), came out with the news as soon as I had reported. 'I've had a signal from Fighter Command – good for you, but a loss for 616. You're promoted and posted to lead a Wing in North Africa. No more flying here, but get off on your embarkation leave as soon as you can and here's the address in London where you're to get your medical jabs. You'll be flying out in ten days' time …'

Two days before the end of my leave, an unexpected signal, relayed from Ibsley, reached me at home. 'Overseas posting cancelled. Proceed immediately to Royal Air Force, Coltishall, Wing Commanding Flying.' A message from Group Captain Vere Harvey,† the Sector Commander, whom I hadn't then met, followed within the hour. 'Be here by 1600 hours tomorrow, if you can. Important as SASO,‡ 12 Group wants to see you.'

I wondered what all the hurry was about. I was relieved not to be going overseas again so soon and the thought of being based for a while in Norfolk appealed. I felt a family affinity with East Anglia, where my forbears, with a broad record in the grain and wool trades, and with Church and State, had

*Wing Commander, later Group Captain, A.H. Donaldson

†Later Air Commodore Lord Harvey of Prestbury

‡Senior Air Staff Officer – Air Commodore A.S.G. Lee

lived, without interruption, since the twelfth century. Moreover, the old house at Filby, 15 miles east of Norwich, home of the family for a couple of centuries until the 1920s, lay equidistant, south-east of Coltishall, between the airfield and the sea. I felt I would be in friendly territory.

Against this, I knew nothing of recent operations in Norfolk or their impact upon the Wing. I hadn't been there since the summer of 1941, when, with 66 Squadron, we had done the escorts for the Blenheims of 2 Group, Bomber Command, in their hideous low-level attacks against shipping off the north-west German and north Dutch coasts ...

Tea in the Mess with the SASO and the Station Commander was a fairly stiff formality. As he got up to leave to go back to Group, the Air Commodore took me by the arm. 'Now Lucas, you know why you've been sent here? You're quite clear about this?'

It was intended as a rhetorical question, designed to emphasize what, in less trenchant terms, he had already been saying about the Wing and the job of leading it. I made no response.

'You've been sent here, Lucas, to stop the rot. As you now know, the last two Wing Commanders Flying here – Rabagliati* and Blatchford† – have both been shot down and lost in as many months, and we don't want another.'

They were hardly comforting words for the newcomer.

The Wing, I found, was still mindful of a disastrous mission which had been flown two months before, on 3 May, when ten out of eleven Ventura bombers of 487 (New Zealand) Squadron from 2 Group of Bomber Command were lost during an attack on a power station north-west of Amsterdam. This was the operation on which the bomber leader, Len Trent,‡ a superlative New Zealander and the last of the attackers to be shot down, was to win the Victoria Cross.

The mission had been cocked up by 11 Group's operations staff whose Hornchurch Wing of Spitfire IXs was to have provided a diversion, high up to the south – to Flushing – designed to draw off the Luftwaffe's fighters, of which there were plenty in Holland. Having gone forward to Martlesham, in Suffolk, to refuel, the Wing got off twenty minutes early, started climbing too soon and eventually finished up away to the north of its intended track. When 11 Group woke up to what was happening, the Spitfire IX Wing was recalled, but not before it had roused all the Me 109s and FW 190s around the Dutch capital.

When the Venturas crossed the coast with the Coltishall Wing, led that day by Bertie Wootten,§ the CO of 118 Squadron, with Blatchford flying as his number two in close attendance, upwards of 30 plus 190s and 109s were waiting to pounce. Only an immediate recall (which Harvey, in the Coltishall Ops Room, had sought but was denied by 12 Group) could have prevented a massacre.

In the mêlée, Blatchford was thought to have been hit in the fuel tank and crashed in the sea 30 or 40 miles off the Norfolk coast on the way home. He was never found despite endless searches.

*Wing Commander A.C. Rabagliati

†Wing Commander H.P. Blatchford

‡Squadron Leader, later Group Captain, Leonard Trent VC

§Squadron Leader, later Air Commodore, E.W. Wootten

Rabagliati, who had fought all through the Battle of Britain before being sent out to the Mediterranean to take part in the Malta conflict of 1941 and early 1942, arrived at Coltishall to take over the Wing on 14 May, eleven days after Blatchford's demise. Surprisingly, he made it a practice to lead, first with the Spitfires of 118 and 167 Squadrons and then, perhaps, the next day with the Typhoons of 56 and 195, based at nearby Matlask, the Coltishall satellite. I eschewed this procedure when my turn came to command the Wing. Better, I thought, to stay exclusively with the Spitfire Squadrons to get the flying properly buttoned up.

It was on 6 July, less than eight weeks after taking over the Wing, that Rabagliati's luck ran out. He was leading seven Typhoons of 56 Squadron in a similar aircraft of 195 against some formidable M Class minesweepers three or four miles off the Dutch coast. Hit by flak from the ships, and streaming black and white smoke, his engine called it a day half-way back across the North Sea. The chances of 'ditching' a Typhoon successfully in the sea were small. Ragbags was never seen again.

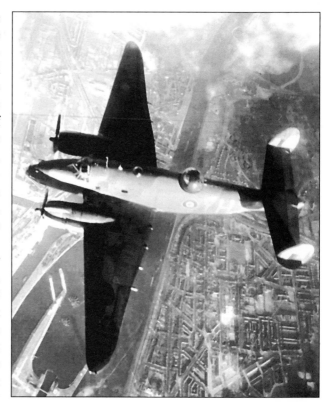

Venturas hit production at the Dutch steel works at Ijmuiden

To lose two such accomplished Wing Leaders within a couple of months was a demoralizing reverse for such a busy operational sector of Fighter Command. It was against such an unhappy background that, on 12 July 1943, I slipped, at forty-eight hours' notice, into Coltishall's sadly vacant saddle.

As I took up the challenge, I knew I started with two signal advantages. First, I didn't know a soul on the station. Bertie Wootten, whom I had known from earlier days in 10 Group, had been promoted and posted away on rest after a long run commanding 118, at the end of which he had earned a Bar to his DFC. The blackboard was thus completely clean. I would be able to chalk up my plans exactly as I wanted them 'without', as the cliché has it, 'fear or favour in the common interest of all'.

Second, I now felt that all my operational experience and training had been a preparation for this hour. Since I first joined a Squadron, I had been lucky to have flown with exceptional and able mentors – Athol Forbes in 66, Stan Turner and Stan Grant in Malta and, most recently, with Tom Morgan,* a Wing Leader of undoubted quality, at Ibsley.

I was certain I could do the job, and I knew how I was going to set about it. I sensed again that confidence I had first known when Woodhall had told me on the terrace of the Xara Palace in Imdina that I was to take over 249 Squadron forthwith at the height of the Malta battle. I didn't harbour a doubt or a fear.

*Wing Commander, later Group Captain, T. Dalton-Morgan

Even so, I was dismayed when I got to Coltishall to find that the Squadrons were still adhering to the antiquated, line astern formations, which, even a year before, we had regarded as obsolete and lethal in the Mediterranean. I told the Squadron and Flight Commanders, when I met them for the first time, that this must stop at once. From now on, a pair of aeroplanes, flown fast, in line abreast, 200 yards apart, would form the basis of everything we did. Wide-open sections of four – which was how I would fly the Wing – would flow from there.

I was met with something less than enthusiasm. Old ingrained practices die hard. But I was utterly resolved to put my stamp on the Wing from the start. I would stand no nonsense and see the thing through. If anyone didn't like it, he could ask for a posting and I would see that he didn't suffer. The *status quo* had gone forever.

It took maybe a fortnight to get the drill accepted and properly flown. As the change was absorbed I could actually feel the morale in the Wing improving – particularly among the more junior pilots. Within a month, there wasn't a pilot in the Wing – officer or sergeant – who would have gone back to what he had known before. Stability and confidence began to grow. Even the most fervent doubters had been won over after a few brushes with the enemy.

The need for an altogether new look was heightened by the Wing's equipment. The Squadrons' largely obsolete Spitfire VBs had been rejuvenated by Rolls-Royce's engineers 'cropping' the superchargers in the Merlin 45 engines. This, together with the associated 'clipping' of the aircraft's wingtips, meant that up to 12,000 or 13,000 feet we had an aeroplane which was a match for anything. Above that, however, it just 'fell out of the sky'. With the enemy usually above us, it followed that we had to be on our guard against

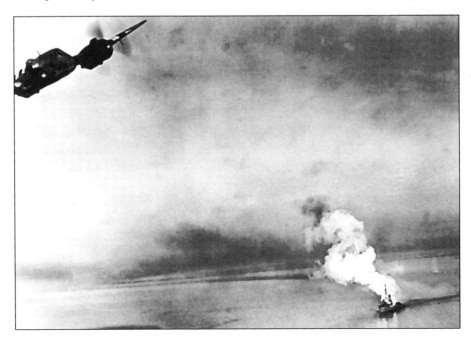

Vigorous attacks on shipping off the German and the Dutch coasts were pressed by Neil 'Nebby' Wheeler's North Coates Wing of rocket-firing Beaufighters

being 'bounced' out of the sun. Pairs and fours, flying well apart in line abreast, with every pilot feeling that the whole sky was covered, were the answer. The number twos found this infinitely preferable to keeping their eyes glued on the tail of the man in front.

Beyond this, the role of the Coltishall Wing was now changing. In addition to the low-level shipping strikes with Nebby Wheeler's* admirably led North Coates Wing of Beaufighters to the Dutch coast and the Frisian Islands, and the usual fairly mundane work, more and more supporting missions were being flown across the 140 miles of swirling North Sea to targets in enemy-occupied territory, as the B-17s and the B-24s of the US Eighth Air Force mounted their stirring daylight offensive against the Third Reich.

Johnny Plagis, CO of 64 Squadron at Coltishall, and another 'veteran' of the Malta battle, was in van of Fighter Command's medium bomber escorts

The Wing was also being required to move south, a couple of times or so a week, to 11 Group's busy stations – Tangmere or Westhampnett, Manston, Bradwell or Martlesham – to join the offensive which the medium bombers of the British and US air forces were waging against targets in France and Belgium. Sometimes we stayed overnight for an early show in the morning, but more often, attracted by the comfort of our own beds, we would fly back to base after an operation, making full use of the long hours of daylight.

It was an exacting schedule which made me feel, increasingly, the need to bring into the Wing, if I could, two new Squadron Commanders who had also themselves been through the fighting in the Malta battle a year before. This feeling was strengthened when Jack Charles, the Canadian leader of 611 Squadron, who had recently survived an extraordinary pick-up operation with a Walrus amphibian only a mile or two off the Dutch coast, was posted away to lead the 10 Group Wing in Cornwall.

I was elated when I found that, first, Johnny Plagis,† the formidable Rhodesian, and, second, Bill Douglas,‡ the stalwart Scot from Edinburgh, both of whom had prospered in the cut and thrust of the fighting in the Mediterranean sun, were available to come to us if we could get Fighter Command to play.

Vere Harvey, whose influence both with Command and Group was important to us, played the leadership card. Within days, Plagis had fastened his grip on 64 Squadron, while Douglas, without apparently working at it, had quickly secured the loyalty of 611. With this accession of strength, I now felt comfortable with the Wing. Here were two assured leaders, proven in the cauldron of battle, to whom I could delegate responsibility …

*Wing Commander H.N.G., later Air Chief Marshal Sir Neil Wheeler

†Squadron Leader, later Wing Commander, J.A. Plagis

‡Squadron Leader, later Wing Commander, W.A. Douglas

• • •

While, in 1943, B-17s and 24s of the US Eighth Air Force began to take the daylight offensive into the heart of the Third Reich, Allied medium bombers struck relentlessly at targets in enemy-occupied Europe. Marauders hit the busy Luftwaffe airfield at Schipol in Holland

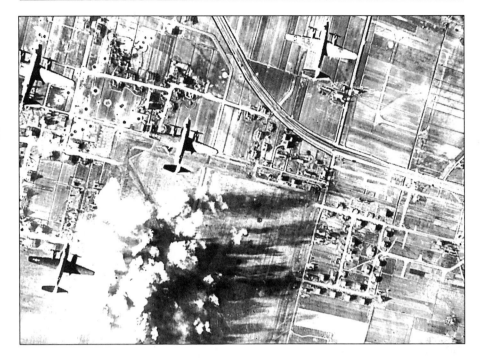

It was now just past high summer. The occasion was marked indelibly in my mind by the visit to Coltishall of the Kenley Wing of Canadians, a bunch of spirited marauders, equipped with the coveted Spitfire IXA with its Merlin 61 series Rolls-Royce engine and led by the co-author of this book, the irrepressible Johnnie Johnson. This first meeting between the two of us was to prove the start of a lifetime's friendship, valued, I like to think, as much by the one as by the other.

The details are still clear. The Kenley Wing had stayed with us overnight for a morning attack by some Bostons of 2 Group on Schipol, now Amsterdam's principal airport, but then a strongly defended and active Luftwaffe base.

Johnnie, senior to me, had briefed his Wing first. I was standing in the doorway of the briefing room awaiting our turn as he was rounding off his instructions with a few pungent and jocular sentences. The Bostons, he said, would be at 12,000 feet and the Coltishall Wing, 'with their sawn-off Vs', would be acting as close escort and 'going through the flak with the bombers'.

He added a rider. '... And just remember, the close escort will serve as decoys for the 109s and the 190s, so we'll be picking anything off the moment it starts down on our friends below ...' Johnnie paused for effect as he held his two Squadrons' attention. 'Maybe we'll leave a crumb or two for the poor man's table ...'

It was the same banter I was to hear over and over again that summer and autumn as the two Wings moved about East Anglia and the south; but the Canadians' response to Johnnie's lead on that first mission we flew together to Holland was unmistakable. And unforgettable.

Here were these beautiful IXs high up above us, flashing about the sky as the bombers ran up to the target. As the gaggles of Me 109s and FW 190s jockeyed for position to start down and invade our preserve, down after them would come the Kenley Wing Leader, closely pursued by his followers, guns smoking and aircraft falling. This sort of aggressive jousting always reminded me of a good, hard game of open Rugby football, played out 10,000 feet above, with the ball, after a quick heel, being run by the half and three-quarter backs all over the sky, slipping through an opening here or selling the dummy and passing a wrong-footed defender there. It was an exhilarating example of opportunist endeavour with the inevitable pickings falling to the leader's guns. Here was the stuff of which thrustful, tactical Wing leading was made.

Bostons of 88 Squadron head out for the airfield at St Omer in northern France

• • •

As I look back now, half a century on, I doubt whether there was a better-administered sector station in all Fighter Command than the Coltishall I knew in 1943 – the overall responsibility of the Sector Commander, Vere Harvey, who, in a long life, would become a distinguished figure on the country's industrial and political stage.

Vere had, of course, the administrative capacity to run a tight station. In the early 1930s, he had spent years in China working in the aviation business, where one had to be alert to survive. Thereafter, on returning home, he had

formed 615, the County of Surrey Squadron in the Auxiliary Air Force and persuaded Winston Churchill to become its Honorary Air Commodore. Post-war, he was to rise, via various directorships, to head Ciba-Geigy, the British end of the Swiss pharmaceutical giant. Quarter of a century as a Member of Parliament took him to the chair of the Tory Party's powerful 1922 Private Members' Committee and thence to a seat in the House of Lords. For ten years in the 1950s, we sat side-by-side on the backmost bench of all in the House of Commons.

Worldly and urbane, Vere acted as a buffer between me and Group HQ. If there was criticism, he absorbed it. Having led 615 in the shambles in France in 1939 and '40, he knew the form and brooked no interference with the Coltishall Wing or its leader. He left me free to get on and run the show and make what I could out of it. This was the way I wanted it. And when my time was up after five months in the van, he simply said to me one day at lunchtime in the Mess. 'We're both posted, old cock. We're going on the Staff at Stanmore.* You've had enough and it's time to stop. No more flying here. You understand that.'

I always felt that ours was an ideal Station Commander–Wing Leader relationship. Vere never got in my hair. I reckoned he had earned his promotion to Air Rank.

• • •

The environment of Coltishall and Norfolk, an operational area if ever there was one, cast in the great Anglo-US air force mould, suited me to a T. As the weather deteriorated towards winter, scaling down flying activity, the kindly landowners round about offered the few guns among us happy, off-duty days with the partridges and pheasants. Our ability to provide, at a moment's notice, eight or ten fit and eager beaters from among our number of thoroughgoing countrymen, encouraged these generous invitations.

For the airmen, familiar with the coverts, the chance of a day walking through woods, roots and over stubble, with freshly-made sandwiches and a couple of bottles of beer each at lunch, was a desirable alternative to hours spent at dispersal, working on the aircraft.

On one of those lovely days out, I stood next to an elderly gun who well recalled shooting with my father in other days. There was none better in Norfolk, he said, at high pheasants coming on the turn down a brisk November wind. I had remembered, as a child, hiding with my father on winter evenings on the marshes at Sandwich Bay in East Kent, waiting for the teal, widgeon and mallard to wing their way in from the sea. The smoothness of his style and the cleanliness of his kills had been riveted on my mind forever. So I understood what my neighbour meant, and felt very proud …

• • •

*Stanmore, in Middlesex, the HQ then of the Allied Expeditionary Air Force and the Air Defence of Great Britain with Air Chief Marshal Sir Trafford Leigh-Mallory and Air Marshal Sir Roderic Hill respectively in command

We were lucky with the characters we had with us during my time with the Wing. One among them was Colin Hodgkinson, who, like Douglas Bader

before him, was legless. As a nineteen-year-old midshipman bent upon a career in the Fleet Air Arm, he had lost both legs as a result of a terrible flying accident when he had rather less than twenty hours in his log-book.

Against all the odds, he had recovered and talked himself into a transfer to the Royal Air Force, plainly a more suitable Service for him with his two tin pins. Later, with persistent application, he had flown his way into 611 Squadron, the West Lancashire Auxiliary unit, in Fighter Command. The Squadron came to us from Biggin Hill and often, when I led the Wing with it, Colin – or Hoppy as many called him – used to come and fly with me.

He did so one August morning when we were operating from Tangmere, on the Sussex coast. We had been briefed to take a force of 36 US B-26 medium bombers to attack Bernay airfield, near Evreux, north-west of Paris. It was one of those days when things had began to run ill from the start. A Czech Squadron which had been detailed to link up with us failed to make the rendezvous over Beachy Head. Then, just as we approached the French coast, my number two was obliged to turn back with engine trouble. Colin's section, or a part of it, then joined up with me.

An uneventful run up to the target gave no hint of what was to follow. As we turned for home with the bombers, some fifty plus FW 190s, waiting up sun and particularly aggressively led, came down fast on the escort. Telling Johnny Plagis, leading 64 Squadron, to take the bombers back to the coast, I turned 611 into the German attack. Round and round and up and down we went, with guns flashing and smoking. As we fought the 190s every mile of the way back to the sea, breaking into each onslaught as it came and turning ever tighter, Colin, with a well-fashioned beam-into-quarter attack, picked off a 190 and sent it spinning earthwards, just as the German pilot was fastening on to the tail of the preoccupied Wing Leader. It was an uncommonly quick and accurate piece of shooting.

Eventually, with a surprising five FW 190s down against two Spitfires lost, the Luftwaffe called off the assault as we settled down into pairs and headed out to sea. Fuel tanks had begun to run ominously low.

In ten or twelve rough and eventful minutes, Hodgkinson had demonstrated that, despite his massive disability, he could match his skills against the best that General Adolf Galland and his Jagdgeschwader 26 had to offer, and survive.

A couple of months later, Colin had been promoted to command a Flight in 501 Squadron, with its specially equipped Spitfire IXs, at Hawkinge, within hailing distance of the enemy across the Dover Straits. A further few weeks later still, he had survived yet another horrific crash landing after passing out with oxygen failure on a weather reconnaissance high up over northern France, and been taken prisoner.

Of such mettle are some men made …

THE MIGHTY EIGHTH

'The great questions of the day are not decided by speeches and majority votes, but by blood and iron.'

OTTO VON BISMARCK TO THE PRUSSIAN HOUSE OF DELEGATES

Those who saw the US Eighth Air Force's daylight offensive against the Third Reich at first hand will never forget the resolution of its bomber crews or the resilience of its wide-ranging fighter pilots. They accomplished a task which Hitler, Göring and the German High Command believed to be outside the compass of a modern air force.

Johnnie Johnson was as well placed as any Wing Leader in the Royal Air Force to form a judgement upon this extraordinary enterprise.

'Maintenance of the Aim' is one of the great principles of war and there is no finer example of it in the Second War than the US Eighth Army Air Force's daylight bombing of Germany.

At the beginning of the war, one of the Royal Air Force aims was also the daylight bombing of Germany, but because of heavy losses this had to be abandoned, and when the Americans brought their bombers to Britain, our leaders, firmly convinced that there was little future in daylight bombing, tried hard to make the Americans think again. They made a shaky start when on 17 August 1942 a dozen B-17s bombed some marshalling yards near Rouen. Their formation flying was poor, their navigation was not accurate and half their small bomb load fell outside the target area. Later, they suffered appalling losses when, lacking escorting fighters, they attacked targets in Germany, but they persevered until the 'Mighty Eighth' not only roamed the length and breadth of the Third Reich but also flew over Germany to land at bases in Russia and Italy.

During the summer of 1942, we began to escort the four-engined B-17s to targets within our miserable radius of action of about 170 miles. Americans like guns; the B-17s bristled with weapons, and we discovered that their gunners were very trigger-happy and merrily blazed away at friend and foe alike. We did not fly alongside, as we did when escorting Blenheims, but stayed well out of gunshot and let the American gunners deal with those enemy fighters which slipped through our screen.

'The Mighty Eighth,' wrote Johnnie Johnson, 'had some excellent leaders and none better than the bluff, strong-willed Curtis "Old Iron Pants" LeMay...' Here seen (*right*) with members of his 305th Bombardment Group

They flew in the basic vic formation, four vics to a Squadron and three Squadrons to a phalanx of thirty-six bombers. Their lives depended on holding their formation, and the tougher the going the tighter they flew, covering each other with their multitude of guns – not unlike the British infantry square of a hundred years ago.

'The Mighty Eighth' had some excellent leaders, and none better than Curtis 'Old Iron-Pants' LeMay, who brought his 305th Bombardment Group to Britain soon after the United States entered the war. Undeterred by the perils of daylight raiding and the inevitable losses, LeMay, a bluff, strong-willed, heavily jowled man, a cigar clamped in the jaw, forced his ample frame into the cockpit of a Fortress and set out to blaze a trail over Europe and shrink the globe.

The handful of American volunteers who fought in the Battle of Britain had so increased that the Royal Air Force had formed three Eagle Squadrons, which, in 1942, were transferred to the Eighth and became the Fourth Fighter Group. They included the tall, lean and vigorous Don Blakeslee, who joined the Royal Canadian Air Force before his country was at war, flew from Biggin Hill and commanded 133 (Eagle) Squadron. Don became one of the

Blakeslee of the Fourth: Colonel Donald J. M. Blakeslee (*left*), the nonpareil of the US Eighth Fighter Command's Group Leaders, seen here with the Commanding General of the US Eighth Fighter Command, Major-General William E. 'Bill' Kepner

best leaders ever to fight over Germany. At first, he was unhappy about changing his graceful Spitfire IX for the ungainly P-47 Thunderbolt, but her big radial engine and rugged air frame could take a lot of punishment and still fly home. Once, when he was briefing his pilots, he told his men that they should

Until the long-range P-51D Mustang, with its Rolls-Royce engine, arrived in strength from the US in late 1943 and '44, the P-47 Thunderbolt (*above*) could only provide limited penetration cover for the B-17s and the B-24s, but –

– almost daily, in 1943 and '44, the US Eighth sent its 'sky trains' into Germany

turn head-on into an attack and under no circumstances whatever should they deviate from this tactic.

One newcomer said: 'But Colonel, what if the German doesn't break either?'

'In that case, sonny,' replied Blakeslee with an icy stare, 'you will have earned your hazardous duty pay!'

An 'old' man when he led his 56th Fighter Group, Hubert 'Hub' Zemke was driven by an unremitting urge for combat. This aggressive fighter pilot led 'Zemke's Wolfpack', and told his men: 'A fighter pilot must possess an inner urge for combat. His will at all times to be offensive will develop into his own tactics. I stay with an enemy until he is either destroyed, I'm out of ammunition, he evades into the clouds, I'm driven off or I'm too low on gasoline to continue the combat!' Francis 'Gaby' Gabreski, friendly and unaffected, began his fighting career with Zemke and eventually commanded the 61st Squadron. He often led the Wolfpack and was to become America's top scorer in Europe with thirty-one victories.*

The Mighty Eighth therefore had some excellent veteran fighter leaders but they were short of experienced bomber leaders. However, with experi-

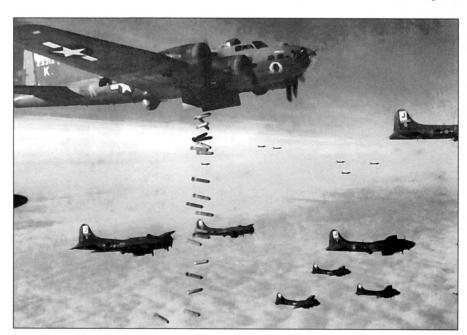

*Later Gabreski flew F-86 Sabres in Korea, destroying several Mig-15s

The 'Impregnable Quadrilateral' from the US Eighth Fighter Command: *(left to right)* Hubert A. 'Hub' Zemke, commanding the 56th Fighter Group, David E. 'Dave' Schilling, Francis E. 'Gaby' Gabreski and Frederick J. Christensen

ABOVE: Before and after the daylight attacks, high-flying photographic P-38 Lightnings of the US Seventh Photo Group, with their distinctive twin booms, provided air reconnaissance

ABOVE: Damage and casualties suffered by the 10-men crews of the B-17s were heavy

LEFT: A B-24 of the 814th US Bombardment Squadron releases its bomb load over Frankfurt, 29 January 1944. The retractable radrome of the GEE.H target-marking system is visible under the fuselage

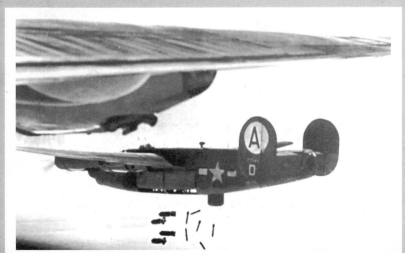

enced fliers and long-range navigators like 'Iron-Pants' LeMay, they set out, in the spring of 1943, to prove their doctrine of daylight bombing. Soon their twin-engined P-38 Lightnings and sturdy P-47 Thunderbolts escorted the B-17s and B-24s far beyond the range of our Spitfires. Sometimes – such was the determination of their bomber leaders – they made long penetrations beyond the range of their own fighter escort. It was on some of these missions that, in one black week, almost 150 bombers were lost.

• • •

Early in 1992, I landed a Cessna 210 at Homestead Air Force Base in south Florida, and as I switched off the engine a tall, lean, white-haired man strode across the tarmac to greet me. He was my friend, Colonel Don Blakeslee, legendary leader of the famed Fourth Fighter Group and, in my book, America's greatest fighter leader in our contest.

We talked, the Colonel and I, about those heady days of long ago, about James Goodson, John Godfrey, Gaby Hub and the other young American fighter pilots who gathered together in wartime Britain to help their bombers over Europe. We talked especially about a mission on 17 August 1943, 'Black Thursday', when my Canadian Spitfire Wing took off from Kenley, flew to Bradwell Bay, in Essex, refuelled and again took off to rendezvous with two combat wings of B-17s who were going to attack the Messerschmitt factory complex at Regensburg and ball-bearing factories at Schweinfurt. The Regensburg force, led by 'Iron-Pants' himself, would land at airfields in North Africa, but the Schweinfurt bombers would return to England.

We found the First Bombardment Wing in two big formations, separated by five or six miles. In all, there were 230 B-17 Flying Fortresses, led by Brigadier General Robert Williams, a dapper one-eyed pilot who had been in

The Messerschmitt factory, producing the Me 109G beside the Danube at Regensburg, was hit on 17 August 1943

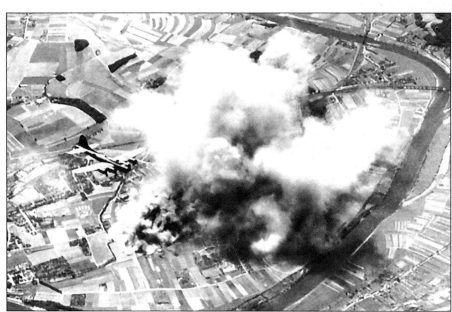

the Air Corps when Billy Mitchell was court-martialled for his controversial views about air power.

We took up our escort positions a few thousand feet over our 'Big Friends', flying with them to the Dutch border. Then, because of our limited range, we had to leave the bombers a few miles east of Antwerp escorted by only a few squadrons of P-47s, who would shortly have to return to England, leaving the B-17s to make the two-hour flight to Schweinfurt alone – against the redoubtable flak defences and the formidable enemy fighter squadrons. They would have no difficulty in telling friend from foe because there would be no friends.

The German ground controllers had watched the ponderous assembly of the B-17s over East Anglia and had already gathered their fighters from distant airfields. Peering into their radar scopes they saw my Spitfires turn back and ordered their fighter packs to attack. The higher B-17s were flying at 24,000, but one group, led by Colonel William Gross, dropped to a lower altitude to escape cloud; they were immediately set upon by a pack of enemy fighters, who, barrelling in from twelve o'clock high, from three, four and seven o'clock, soon destroyed ten bombers carrying 100 men. The fighter packs, defending their homeland, and urged on by their ground controllers and by 'Dolfo' Galland himself, the General of Fighters, drew away, reformed into their fighting echelons and came at the B-17s again and again. The bombers hung together, fighting to hold their self-defending formations, their crews knowing full well that if they fell behind they were dead men.

The navigator of 'Tondelayo' wrote:

I do not recall seeing a rocket actually hit a B-17. I remember only the fireworks and the gust of wind. The smell and sight of the battle are still with me – the acrid gunpowder and the disordered plexiglass cabin – but I cannot recall a sound of battle except the clump and clatter of our own guns.*

Two hours after leaving Antwerp they made their bombing run against Schweinfurt.

We saw Colonel Mo's door swing open as he rode towards the column of smoke … The flak was all about us, but the fighters were gone. We heard the ping of fragments rattling like pebbles against the flank of 'Tondelayo'.

The bombers banked and flew to the west. They faced another two-hour leg alone, before Spitfires and P-47s could rendezvous with them near Antwerp. Enemy fighters, having refuelled and rearmed, came at them again and again from dead ahead, from their flanks and from below – into their soft underbellies. The same navigator wrote:

All across Germany, Holland and Belgium, the terrible landscape of burning planes unrolled beneath us. It seemed that we were littering Europe with our dead.*

*Elmer Bendiner, *The Fall of Fortresses* (Putman, New York, 1980)

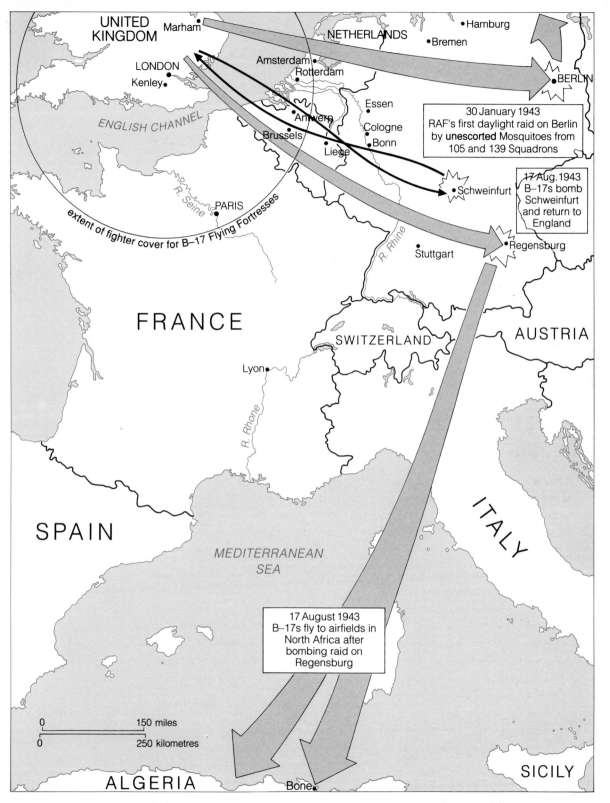

UNITED KINGDOM
Marham
LONDON
Kenley

ENGLISH CHANNEL

extent of fighter cover for B–17 Flying Fortresses

R. Seine

PARIS

FRANCE

SPAIN

NETHERLANDS
Hamburg
Bremen
Amsterdam
Rotterdam
Antwerp
Brussels
Essen
Cologne
Bonn
Liège
BERLIN

30 January 1943
RAF's first daylight raid on Berlin
by **unescorted** Mosquitoes from
105 and 139 Squadrons

Schweinfurt

17 Aug.1943
B–17s bomb
Schweinfurt
and return to
England

Regensburg

R. Rhine

Stuttgart

SWITZERLAND

AUSTRIA

Lyon

R. Rhone

ITALY

MEDITERRANEAN
SEA

17 August 1943
B–17s fly to airfields in
North Africa after
bombing raid on
Regensburg

0 150 miles
0 250 kilometres

ALGERIA Bone SICILY

The daylight offensive against the Third Reich: 30 January 1943 – unescorted Mosquitoes raid Berlin; 17 August 1943 – B-17s attack Schweinfurt and Regensburg

Over Belgium, in the middle of the afternoon, I saw them coming from afar. They looked like skeins of geese. They were heading westward into the declining sun. The sky was an intense blue and their windscreens and silver bodies glittered in the clear air. Lean, angular Me 109s set upon them like wolves after straggling sheep. It was a sight I shall always remember.

About ten miles separated the two bomber formations, which had already been harried by flak batteries and fighters for more than four hours. Here, between Liège and Antwerp, the enemy fighter attacks intensified as the depleted bomber formations fought their way home – Me 109s, 110s and FW 190s leaving white contrails which disappeared as the aeroplanes hurtled down into the warmer air. Heavy flak bursts fouled the sky. Stragglers, miles behind their parent formations, were being picked off. Zemke's Thunderbolts fought valiantly over the rear bomber formation but were about to withdraw. Here and there, amid this raging battle, parachutes blossomed. Fortresses fell to the ground and two great columns of black smoke rose from the bombers' pyres.

Yet these ragged but majestic legions still ploughed on, unflinching, somehow drawing and holding together and closing the gap between us until they were almost beneath us and I was able, at long last, to lead my Canadians into the arena.

But, because of our limited range, we were too late. Of the 230 Fortresses that left England, 36, for one reason or another, aborted. Of the remainder, 33 were lost to fighters, one to flak, and two fell to the sea. Many were damaged beyond repair and carried dead and wounded crews. The loss rate, nearly one-fifth of the bomber force, was clearly unacceptable.

Shaken from these disasters, the Eighth, for the time being, had to retreat to less distant targets until long-range fighters could be found. Fortunately, some three years earlier, the RAF had bought some P-51 Mustangs with Allison engines; but, because of their disappointing high-altitude performance, these aeroplanes had been used only for reconnaissance and close support. However, the famous Rolls-Royce Merlin engine was being built under licence in the United States and this gave the Mustang a much-improved high-altitude performance. Clever engineering gave her a tremendous amount of fuel and more than 2000 were ordered. They were capable of escorting the B-17s to distant targets, and could still meet enemy fighters on equal terms after jettisoning their external fuel tanks. The Eighth's first Mustang escort mission was flown to Kiel in December 1943, and a few weeks later they accompanied B-17s on the 1100-mile round trip to Berlin; and when Göring saw them over Berlin he said, 'We have lost the war.'

There was great competition among American fighter pilots to get their hands on the P-51, and Don Blakeslee pleaded with his General to exchange their old P-47s for them. But a great daylight offensive was planned and the Normandy invasion would take place within three months, and so the General answered that he did not see how Blakeslee's Group could become non-operational for several weeks while they retrained on to the new fighter.

'That's OK, General, sir,' replied Don. 'We can learn to fly them on the way to the target!'

Don's remark was not made out of sheer bravado, but because he, and many others like him, had fought from Britain for a long time and knew something of the odds which their countrymen faced in Fortresses and Liberators on their ten-hour flights. There was something very inspiring about the sight of 1000 bombers joining up over East Anglia, sorting themselves into great trains of aeroplanes and setting a steady course across the North Sea for Germany. To the escorting fighter pilots, the bombers looked serene, unflinching and eminently worthy of the great country whose star they bore.

Blakeslee got his Mustangs and always led his Group on the big shows, when some 800 Mustangs and Thunderbolts sometimes supported 1300 bombers to Berlin and back. From his still expanding fighter force, Göring could defend with about 900 interceptors, and the number of aeroplanes taking part in these air battles far exceeded those involved in the Battle of Britain.

There was little subterfuge about these great contests fought over Germany in 1944, for the Americans did not want their bombers to spend more time over hostile territory than was absolutely necessary, and usually routed them straight to the target, except when they were detoured to avoid heavy flak concentrations. There was, of course, some jamming and 'spoofing', but it was difficult, to say the least, to disguise the straight approach of some 2000 aeroplanes, and the Germans had ample time to reinforce the threatened area with plenty of fighters. The Americans were fully aware of the enemy's ability to switch squadrons from one area to another, and countered by routing their sweeps hundreds of miles ahead and on the flanks of the bombers. German fighters, especially the twins, tried to avoid Mustangs and Thunderbolts so that they could make concentrated attacks against the bombers, while American fighters were out to break up the German formations before they got to the bombers. With such numbers of attacking and defending aeroplanes, with such tactics and with such deep penetrations, the stage was set for the biggest air battles of all time.

For fighter pilots, this was the toughest air fighting of the Second War. In their small aircraft, which could be brought down by a bullet from a machine gun, they had to cross the North Sea twice. They flew over heavily defended areas, and if they ventured over the Ruhr, it meant crossing the greatest concentration of flak in the world. Moreover, German civilians began to maltreat and sometimes kill Allied airmen who crashed or baled out. Sometimes, their own downed fighter pilots suffered at the hands of angry mobs who mistook them for Americans. After the war, Galland told us about a German pilot who was hanging from a tree in his parachute and shouted to a man with a shotgun, 'Help me down, you fool.' But the man raised his gun, saying, 'So! The pig even speaks German!'

American fighter pilots were encouraged to follow evading enemy aeroplanes down to the ground and to fight above the tree-tops. The Royal Air

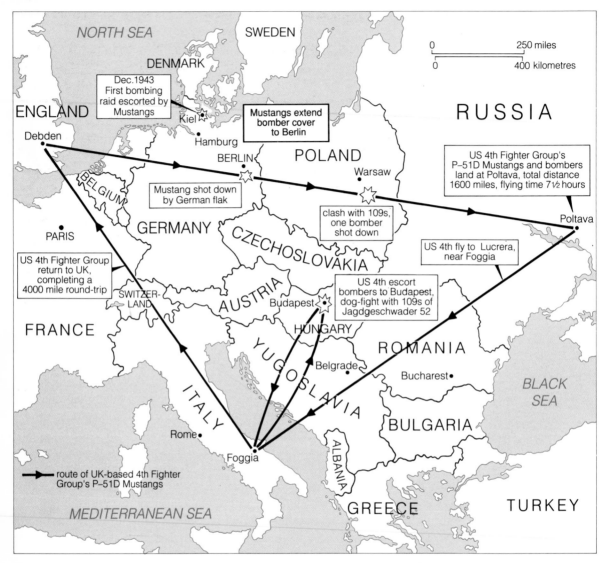

Dec.1943
First bombing
raid escorted by
Mustangs

Mustangs extend
bomber cover
to Berlin

US 4th Fighter Group's
P–51D Mustangs and bombers
land at Poltava, total distance
1600 miles, flying time 7½ hours

Mustang shot down
by German flak

clash with 109s,
one bomber
shot down

US 4th fly to Lucrera,
near Foggia

US 4th Fighter Group
return to UK,
completing a
4000 mile round-trip

US 4th escort
bombers to Budapest,
dog-fight with 109s of
Jagdgeschwader 52

route of UK-based 4th Fighter
Group's P–51D Mustangs

Force discouraged its pilots from similar tactics, because German fighters could outdive Spitfires, and too many British pilots were last seen half-rolling after a 109. But once she had jettisoned her drop tanks, the lively Mustang could out-dive and out-turn both the Me 109 and the FW 190, and the Americans were not slow to exploit this superiority in performance. Thus, for the first time in the Second War, German fighter pilots could no longer get out of trouble by the famed half-roll and dive tactics. The Americans dived after the Germans and fought them just above the ground. When the Germans did not come up to oppose the bombers, the Americans went down and strafed their airfields. When the weather was too bad for the bombers, the Mustangs and Thunderbolts went out on low-level attacks, called 'Rhubarbs', and destroyed hundreds of enemy aeroplanes. The Germans tried to intercept these low-flying strikes, but they were too low for their radars, and the enemy's other

Transformation! The advent in late 1943 of the long-range P-51D Mustang fighter (see photograph on p.233) transformed the USAAF'S daylight offensive. Its fighter squadrons could cover the B-17s and B-24s to every target in the Third Reich – and beyond

method of reporting hostile aeroplanes, by ground observers, took too much time.

These long-range fighters pioneered well beyond Germany's eastern borders. On one famous occasion, known as the Russian Shuttle, Don Blakeslee's Group escorted bombers from England across Europe to Poltava in Russia. From Russia, they took the bombers to Foggia, in Italy, and eventually returned to England, attacking targets in France en route.

There were 15 Fighter Groups in the Eighth Air Force, and Blakeslee's outfit claimed the most victories, with $1006\frac{1}{2}$ enemy aeroplanes destroyed for the loss of 241 pilots; but the 56th Fighter Group, led by fearless Hub Zemke, were beaten into second place only by the narrow margin of half an aeroplane. Blakeslee, with fifteen victories, was not an outstanding shot, but his greatness lay in his brilliant leadership of his Group. He fought from Britain, without respite, for more than three years, and so stayed on continuous operations longer than any of his American contemporaries. He and his comrades of the Eighth won a mighty victory, for they wrested command of the daylight skies from the Luftwaffe and exposed the heart of Germany to bombing.

CHAPTER 14
WALTER'S TALE

The courage of the men and women who formed the Resistance in enemy-occupied Europe surpassed belief. In helping aircrew to avoid captivity by passing them 'down the Line', they knew they risked the firing squad if caught. One who experienced this clandestine bravery at first hand was Walter Conrad,* a Canadian of special mettle, then a Flight Commander in Johnnie Johnson's Kenley Wing. Johnson had a high regard for this officer who was to win the Distinguished Flying Cross and Bar.

'Jimmy Fenton, the Station Commander at Kenley, had served in the Western Desert with Walter and his inseparable fellow-Canadian, George Keefer. He was greatly impressed with both of them and when they completed their tours in Libya he had them posted to Kenley. Both Wally and George brought a strength to the Wing.'†

The circumstances of Conrad's escape and subsequent return to operations – and his own telling of the story – bear testimony to this exceptional character.

Walter Conrad baled out of his Spitfire below 3000 feet over the Pas de Calais, just south of the Franco-Belgian frontier, on 17 August 1943. He had collided with his number two Flight Sergeant Shouldice as he pulled away fast after destroying a FW 190 low down near the ground. The Kenley Wing of Canadians, with Johnnie Johnson in the van, had met the stricken B-17s of the US Eighth Air Force near Antwerp, as the surviving crews fought their way back after the carnage of the assault on the ball-bearing factories at Schweinfurt, in southern Germany. The Wing was covering the Fortresses on their last leg home.

Conrad, in extricating himself from his aircraft, had lost a flying boot, which hindered his progress as he made his precarious and painful way inland from the enemy's searching troops.

He found succour in successive farmsteads, reaching one as night was beginning to fall. Here, he spied an empty concrete pill-box, which, with a layer of straw on the floor, would serve as a haven for the night. Hearing a woman singing among the farm buildings, he took a chance and approached her, using his 'best schoolboy French'. Conrad recalled the scene.

*Later Wing Commander W.G. Conrad

†The Johnson papers

She squatted beside me. Striking a match, I could see she was old, roughly dressed and obviously very poor. She calmly said the Germans were looking for me and did I know I had blood all over my face after the bale-out? Then she made off and was soon back again with bread, butter and a large bottle of Calvados. I blessed this grand old lady and went back to the pill-box to sleep.*

The tenant farmer, Gerard Vanbestin, alerted by the old lady to their 'new arrival', came in the morning with eggs and bacon and wine. A naturally timid man, he was clearly uneasy as he told Conrad that the Germans had taken seventy-five hostages and were threatening them with execution if the Spitfire pilot was not turned over to them. A reward of 75,000 francs had been offered for his return.

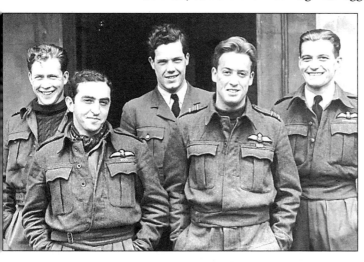

None had better reason to thank the clandestine efficiency and fortitude of the French Resistance in aiding his escape than the Canadian, Walter Conrad (*second from right*). Here he is with Johnnie Johnson (*extreme right*), the Kenley Wing Leader, and three other Canadian stalwarts from the Wing: (*left to right*) Dean Macdonald, 'Trapper' Bowen and Hugh Godefroy, CO of 403 Squadron and, later, a successful Wing Leader

A day of acute suspense passed in the little valley of Bambecque, and Vanbestin, still agitated but palpably resolved to help 'the visitor', returned at midnight with a large plate of stew and wine. The next evening, he said, Conrad would meet 'Michael' – the Big Man, as he called him – the landlord of the farm and principal farmer in the district. Provided the Canadian's credentials were satisfactory, he would fit him out with clothes, shoes and a bicycle.

That evening, over food and wine, Gerard Vanbestin and his wife, still at great risk, introduced Conrad to Michael Fossaert, alias the Big Man. Here, the plan of escape was hatched. The Canadian never forgot its detail nor would he ever forget the courage of the Vanbestins in giving him shelter.

Michael Fossaert explained to me that the next move was to get me to Armentières, 60 kilometres away. As he had a saw-mill on his farm, and sold timber, he proposed to hide me in a large load of wood, covering me with a tarpaulin. He introduced me to Mon Lievois, a friendly middle-aged man, who would drive the truck.

Two bumpy hours after setting out, and having been stopped twice en route, when I heard muted voices, we reached Armentières. The wood was removed and a grinning Michael Fossaert lifted the tarpaulin which had been covering me.

Conrad was taken to a small pharmacy in the centre of the town. There, the chemist, Georges Vankemmel, having checked Walter's identity, introduced himself as a member of the Resistance and a friend.

Michael and Lievois then left and Georges led me to the living quarters at the back of the shop where I met Marcelle, his wife. My next journey,

*The Conrad papers

Georges explained, would take some days to arrange so I settled down to wait. We had a few visitors, including an attractive young widow who seemed to like me, but Marcelle never left us alone. Another visitor was a Captain in the Belgian Army who, a few days previously, had parachuted into his homeland from England, visited his wife and was about to return by Lysander. There was some talk of me going with him, but this fell through. Another was an engine driver, a short butter ball of a man, who told me about the many rocket sites the Germans were building locally and, indeed, brought me photographs of them.

I was given papers, complete with labour permit and identity card. To be on the safe side I was described as a deaf mute. One evening I went out with Georges and visited a nearby house where two American airmen were hiding – a tail gunner and a pilot from a Fortress crew. The pilot was Bill Middledorf, tall and dark, of whom I was to see a lot.

The following day there was much excitement when a young man and his pregnant wife arrived on bicycles from Lille. He was the editor of the Underground's paper, *Voir du Nord*. On the previous day the Gestapo had just missed him on a raid. He was very much afraid that an old Englishwoman, long resident in Lille, and an active member of the Resistance, had been captured and might talk. If so, we were all in great danger.

A US paratrooper acknowledges the courage of members of the French Resistance in contributing to the success of the Normandy landings and, later, to the liberation of Paris, end-August 1944

That night, it was decided that Middledorf and I must leave and, later, he was brought to the Vankemmels' house. Long before dawn, we were introduced to a dark and very handsome French girl who was to take us by train to Paris. Georges gave us our last-minute instructions. The girl would walk to the station and we were to follow. She would buy three tickets and give us ours on the platform. We were to stay near her on the train and copy everything she did. When we arrived in Paris she would be met by a man carrying the German paper, *Signal*, and we were to follow him.

It was raining when we said goodbye to the Vankemmels and, again, I was upset by the great risks they were taking. Shortly before dawn, we boarded the crowded Paris train, being jammed in the corridor next to our stunning escort. When the conductor came for our tickets we aped her every motion. Shortly before noon, we pulled into the Gare du Nord and got out. Our escort stopped in front of a man carrying the *Signal* and kissed him. We then followed our new guide into the Metro and left at Montmatre where he led us to a ramshackle building and into a very humble flat.

Our new guardian was Albert, who had lost both legs in a tank battle. His big, stout wife fed us and Albert said that tomorrow we would be escorted to Bayonne, right down in the south-west corner of France, near Biarritz, and then over the Pyrenees into neutral Spain.

Our next guide, Jean, arrived after breakfast. He had only one arm and one eye in his cruel face. Nevertheless, we were in his hands and, about noon, pulled out of Gare de L'Est. Only two other people were in the compartment, an elderly woman and a girl of about 16 who was probably her granddaughter. There was little conversation, but when they got out the old lady passed close to me and whispered, 'Good luck!'

Just outside Bayonne, we had a close call. Jean was in the toilet when a Gestapo officer entered and asked for our papers. We played the part of deaf mutes, but the German got more and more exasperated until a seamy-faced little Frenchman explained that we were deaf. The German left and the Frenchman said he had probably gone to get help to arrest us and we had better leave the train. Jean reappeared and said we were only a minute or two outside the station. The Frenchman kept watch in the corridor and when the train stopped we were out of the door and mingling with the crowd before you could say Jack Robinson.

We changed to a local train and went on to Biarritz, arriving at dusk. Jean led us into the countryside and we walked for a long time until we found a camp of tough, villainous-looking Maquis. They gave us a hearty welcome with plenty of food and apple-jack. The occasion seemed right for a mild celebration so Bill Middledorf and I drank too much and woke the next morning on the forest floor with severe hangovers!

The next day, we walked into Biarritz and Jean introduced us to the man who would take us over the Pyrenees. Jean said that when we crossed the border the British Embassy in Madrid would have a car waiting for us.

Crossing the Pyrenees was a rugged and tortuous business for Conrad and Middledorf. They picked up other evaders as they struggled, with their guides, up and over the main range. Exhausted, they were only kept going by a shot of Benzedrine and the frequent exhortations of their minders that they were 'nearly there'. It was as if, right at the end of their tether, they were now subjected to the final, most exacting test of all.

The gallant Maquis leave nothing to chance. Papers have to be seen to be in order in the Loire valley of France

Darkness came, the climbing got harder, but soon after eight o'clock, in the light of the full moon, we saw a rough sod hut ahead. We sank to the ground while our guides went to parley with the shepherd.

Soon we were inside the shepherd's rough home – a large room with a cow and some poultry at one end and an enormous open fire with a big kettle simmering at the other. Sitting on the earthen floor, we were each given a loaf of bread and told to help ourselves from the kettle, which held white meat, vegetables and wild herbs. This we washed down with rough red wine from a skin bottle. It was delicious and satisfying.

After supper, our host explained that it wasn't safe to continue until the moon went down. Then we were to follow an old smugglers' trail across the heavily-guarded frontier.

We came to a river, 25 yards wide, spanned by a single strand of rope with two parallel lines of wire above. Holding a wire in each hand, I crossed quietly and safely as did Bill, but one of the Frenchmen made a lot of noise which could be heard for a mile in the still air. There was no reaction from the border guards and we walked on till dawn. We still had to evade the Spanish border patrol, but the guide said that if we followed the path ahead we would come to a road where the Embassy car would be waiting.

At this point on the frontier, the escapers were nearly foiled by a narrow neck of Spain which extends like a 'U' back towards France. They pressed on having left their good shepherd behind.

Soon we came to a wooden bridge over another stream and I led the way across. In the half-light, I did not notice that I had already passed a small sentry box and I was well across when I heard a loud 'Alto!' Looking back I could see a uniformed guard with his rifle levelled at me. I walked back and he pointed to the other end of the bridge. 'Aleman!' he said and I could see the German guard on the other side. We had nearly walked into his arms!

Eventually, half-a-dozen Spanish soldiers arrived and marched us off to a broken down truck. We piled in and finally finished up in a sort of transit concentration camp at Irun on Spain's northern coast only a few miles from San Sebastian.

After ten days in what turned out to be a windowless cellar of an old factory, the British Consul from San Sebastian told the evaders that they were being moved to a more central French Red Cross hostel where they would be on parole.

The hostel was a modest establishment with indifferent food, but we were free to come and go. The hotel next door was occupied by the German Gestapo and one day an officer, in full uniform, mistakenly

entered our hostel. He said something to Bill Middledorf in German who smartly replied, 'I don't speak pig-talk. But the pig-fucking outfit you're looking for is next door.'

The German raised his eyebrows and said in perfect English, 'Oh, an American, I see. What a pleasant surprise. I do hope you are comfortable!'

Strange people passed through Irun. One day an elderly Englishman named John Job came into the hostel. Before the war, he had been a civil engineer living in Paris. When the Germans came he and his wife were interned at St Denis. After his wife died, he escaped and made his way over the Franco-Spanish frontier. He was waiting in Irun en route for Portugal and England to see his crippled twin brother. Through the good offices of the British Consul, to whom Walter Conrad introduced him, his papers came through within a fortnight.

We were sorry to see him go as he boarded the train for Lisbon. We had accepted him as a friend. Later, I learned he was a German spy and had been executed shortly after arriving in England.

But now the Canadian fighter pilot's long journey was almost at an end. The British Consul visited him one last time to say that arrangements for the last lap to Gibraltar were complete.

The following day I was escorted by two Spanish Air Force officers to Valencia on the country's Mediterranean seaboard. After a night's rest, I was taken to Alama, an assembly point for all Allied evaders. The next day we were put into trucks and late the same evening we rounded a bend to see a large, majestic Union Jack flying over the Rock of Gibraltar.
Comme Lafayette, nous sommes arrivés!

To complete the story, Shouldice, Conrad's number two never made it back to base after the collision, his badly damaged Spitfire diving into the Channel on the way home, killing the pilot. The handsome French girl who had escorted the evaders from Armentières to Paris was eventually captured and died in the infamous Buchenwald concentration camp. Walter Conrad himself returned to operations to lead 421 Squadron of the Royal Canadian Air Force during the Normandy invasion, eventually finishing the war as a Wing Commander with a DFC and Bar.

In the peace that followed, he and his wife Katie returned to France to thank those heroes who had helped him to evade. He died in 1987 after a long and typically brave fight against cancer.

NORMANDY: A TRIUMPH OF TACTICAL AIR POWER

To play a leading role in one of the truly great operations of military history conveyed a special privilege. In Johnnie Johnson's case, however, flying in the van of one of the Allies' foremost fighter Wings conferred, despite the hazards and the responsibility, another signal advantage. By his observations in the air and his contacts on the ground, he could sense the daily ebb and flow of a momentous battle:

On D-Day, I led 144 (Canadian) Wing four times over the beaches and on 10 June 1944, we landed at St Croix sur Mer, and had the honour of being the first Allied fighters to return to France since 1940.

It was to be a long trek from the Normandy beaches, northwards, through France and the Low Countries into Germany ...

Initially, we saw little of the Luftwaffe, but after they had reinforced their French airfields we met and fought them daily over the Normandy countryside. When the weather was good, they were active over the battle area, and we ranged far to the south to cut them off before they could attack our ground troops. The standards of German fighter pilots had declined; they were nothing like the aggressive, highly trained men we had fought over Britain; and in Normandy they rarely stayed to fight it out. We soon had their measure and had them on the run. On the ground, however, it was a different story, which was brought home to us after we had downed seven enemy fighters without loss.

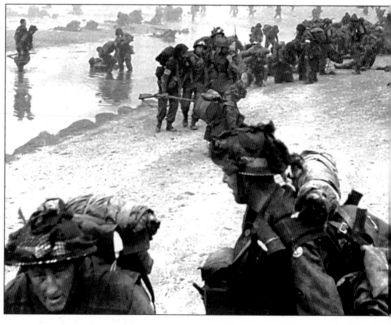

Gathered round my Spitfire, we were talking about the fight when Air Vice-Marshal Harry Broadhurst, the 'Soldier's Friend', drove up with General Montgomery sitting alongside. Broady saw that we had fired our guns and, after the introduction said, 'Tell the General what you have done today.'

The only picture ever taken of 'JEJ Junior', an unarmed, private enterprise, 'contraband' Spitfire, assembled at Johnnie Johnson's behest by his Wing engineers from crashed aircraft around St Croix-sur-Mer. Alas, it was soon written off!

Johnnie Johnson, now a Group Captain commanding 125 Wing, meets the GOC, 21 Army Group and the victor of Alamein

'Well, sir, thanks to some excellent controlling we bounced a bunch of enemy fighters and shot down seven without loss.'

'I wish,' replied Monty, 'you could have told me, instead, that you had destroyed seven Tiger tanks!'

Montgomery spoke the truth, for the German Tiger tank, with its superb 88 mm gun, could kill an Allied tank at 2000 yards, and its superiority over our tanks was well demonstrated by Germany's outstanding and audacious tank commander, SS Obersturmführer Michael Wittman, who, at the village of Villers Bocage, on the morning of 13 June, attacked forward elements of our 14th Armoured Division (the famed 'Desert Rats'). Our main tank-infantry column, consisting of half-tracks and tanks, had halted when they were spotted by the young captain, who decided to attack single-handed.

> The high velocity gun was laid, aimed and fired. The half-track, swung across the road by the force of the impact, caught fire and began to pour out dense clouds of black smoke ... the heavy Tiger thundered towards the British, shuddering only slightly as the heavy gun fired shell after shell into the mass of machines. Half-tracks, carriers and tanks were smashed by 8.8 cm shells, and then, with a final burst of speed, the 55-ton steel monster, destroying in its rush a British tank which it met on the narrow path, crashed through the junction, was swung in a tight arc onto the roadway and began its descent upon the vehicles lined up outside the village and along the narrow high street.*

*Carlo D'Este, *Decision in Normandy* (Collins, London, 1983)

Wittman's Tiger snarled into the main street and knocked out more tanks, whose crews, once again, were dismounted. Thus, within a few minutes a lone Tiger had shattered the leading elements of our 22nd Armoured Brigade.

Wittman, however, had not finished with the British. Taking advantage of all natural cover, and undetected from the air, he returned to his unit, rearmed and refuelled, and in the early afternoon led six tanks against what was left of our tank-infantry force. They were soon overwhelmed and only one survivor got back to tell the dreadful story of how this brilliant German tank commander had, almost single-handed, humiliated the British and stemmed their advance at Villers Bocage.

The British Army was bogged down in the lush bocage. Corps and divisional commanders were sacked. Two of Montgomery's veteran divisions from the Eighth Army were not performing well in Normandy.

> Neither the Highlanders [51st Division] nor the Desert Rats [7th Armoured Division] seem to have been prepared for the difficult fighting … where they appeared weary and frequently over cautious … Time and again they had been asked to perform difficult tasks and none was to prove more difficult than Normandy, where they found themselves in a strange environment that offered none of the freedom of manoeuvre they had enjoyed in the desert. Instead they found a hostile land and an even more hostile enemy.*

To try and break the deadlock on the ground the 'heavies' of both Bomber Command and the Eighth Air Force pounded German positions, leaving behind hundreds of dead and wounded Allied troops and proving (if proof was needed) that the 'heavies' were not sufficiently accurate for close support operations.

Caen, according to Montgomery's 'master plan', should have been captured on D-Day, but in mid-July the old Norman city was still in German hands. On 18 July, Operation Goodwood called for Bomber Command, the US Eighth and Ninth Air Forces, to attack the positions of Panzer Group West, who were deployed south-east of Caen. After some 4500 Allied aeroplanes had bombed, the plan was for Dempsey's Second Army to force a way through, but after two days the British attack was called off.

Bogged down, Montgomery turned to Broadhurst for help from his fighter-bombers – Spitfires and Typhoons – and although we flew several times each day we could not find the deadly Tigers because they were well hidden in the forests, apple orchards and high hedgerows in the dense bocage country between the Orne and Vire rivers.

The outcome of the battle in Normandy therefore depended on whether or not the fighter-bombers of the 2nd Tactical Air Force could get at the German armour. Our foremost fighter-bomber was the much-maligned Hawker Typhoon, originally designed as an interceptor fighter to replace the Hurricane, but its original performance at height was disappointing. Also, it

*D'Este, *Decision in Normandy*

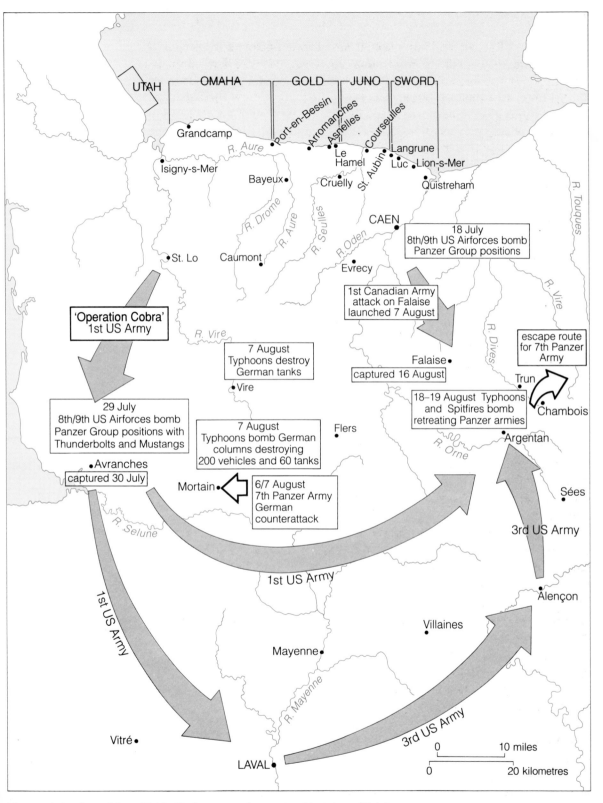

UTAH OMAHA GOLD JUNO SWORD

Grandcamp

Isigny-s-Mer

Port-en-Bessin
Arromanches
Asnelles
Le Hamel
Courseulles
St. Aubin
Langrune
Luc
Lion-s-Mer
Quistreham

R. Aure

Bayeux

Cruelly

CAEN

Evrecy

St. Lo

Caumont

**18 July
8th/9th US Airforces bomb
Panzer Group positions**

**1st Canadian Army
attack on Falaise
launched 7 August**

**escape route
for 7th Panzer
Army**

**'Operation Cobra'
1st US Army**

**7 August
Typhoons destroy
German tanks**

Vire

Falaise

captured 16 August

Trun

Chambois

**29 July
8th/9th US Airforces bomb
Panzer Group positions with
Thunderbolts and Mustangs**

**7 August
Typhoons bomb German
columns destroying
200 vehicles and 60 tanks**

Flers

**18–19 August Typhoons
and Spitfires bomb
retreating Panzer armies**

Argentan

Avranches

captured 30 July

Mortain

**6/7 August
7th Panzer Army
German
counterattack**

Sées

3rd US Army

1st US Army

1st US Army

1st US Army

Alençon

Villaines

Mayenne

3rd US Army

Vitré

LAVAL

0 10 miles

0 20 kilometres

Normandy landings, 6 June 1944 – Typhoons attack armour at Mortain and Falaise

had a lot of teething problems: a design fault caused excessive elevator flutter and sometimes the complete trail unit broke away from the fuselage when pulling out of steep dives. It killed a lot of people, and in 1942 Cocky Dundas, commanding 56 Squadron, thought it would be a good thing for Squadron morale if Johnson took to the air in his Typhoon. I protested, saying I had to get back to Wittering for readiness, but Cocky calmly replied that it would be quicker to fly back to Wittering in his Typhoon rather than in my Spitfire.

His Flight Commanders, Mike Ingle-Finch, and the Norwegian, Eric Haabjoern, poured me into the large cockpit with much advice about watching that particular light, and if it came on it was much better to bale out as the Tiffy burned very easily, old boy, and went down very fast, etc. Ingle-Finch tightened the straps, and Haabjoern adjusted the trim and pressed the starter button, which, unfortunately for me, worked and the big Napier coughed and spluttered its way to life.

The subsequent flight was something of an anti-climax because the Typhoon behaved perfectly, and the only incident of note was the expression on Basil Embry's face when I climbed out of the cockpit at Wittering.

In Normandy, our Typhoon wings were led by men of great experience and flying ability, and the two outstanding Wing Leaders in Normandy were Desmond Scott, from New Zealand, Wing Leader of 123 Wing, and Charles Green, from Rhodesia, Wing Leader of 121 Wing. Both Scott and Green knew that once the Tigers left the sanctuary of the bocage and came out into the open they would have them at their mercy. Their opportunity came in early August. The Americans had captured Avranches and were heading for Paris when Hitler ordered what proved to be his last counter-attack in Normandy.

Field Marshal von Kluge was told to group together all Panzer forma-

Two Typhoon Wing Leaders from the Commonwealth bore the brunt of the attacks on the German armour – Charles Green (right), the Rhodesian, and Desmond Scott (left), thoroughgoing countryman and farmer from New Zealand, who, at 25, became the youngest Group Captain in the RNZAF

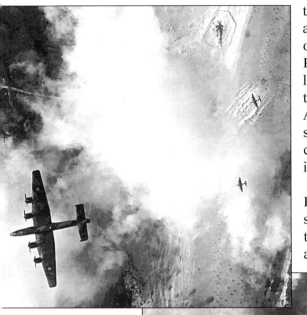

tions, whether fighting or resting, and to counter-attack between Mortain and Avranches and cut off US forces from their supply bases. Four Panzer divisions, with some 280 tanks, were collected for this thrust, and the Luftwaffe promised the support of 300 fighters. Fortunately for the Allies, Ultra had intercepted the vital enemy messages, and on the night of 6/7 August our senior commanders knew that the Panzers were clattering towards Mortain.

It was arranged that P-47 Thunderbolts and P-51 Mustangs of the US Ninth Air Force would sweep well to the south to keep enemy fighters off the backs of our Typhoons. Broadhurst had alerted his 'Tiffy' Wings, but the early morning of

Meanwhile Bomber Command Lancasters (*above*) attacked air storage depots in the Garonne estuary in daylight and Halifax crews (*right*) dropped their massive loads on the German garrison's positions at Calais

7 August brought mists and low fog, ideal for the attackers, whose 2nd SS Panzer Division, 'Das Reich', had by noon re-captured Mortain from the US 30th Infantry Division; meanwhile the 2nd Panzer Division had advanced to Mesnil Adlee. The ground situation was critical.

Wing Commander Charles Green, leading a pair of Tiffies from B5, Fresne-Camilly, on a weather reconnaissance paid particular attention to the Mortain area and spotted a large number of tanks. The Rhodesian radioed this information to his airfield, and 174 Squadron, followed by other squadrons, were soon in action.

Over Mortain their leader, Squadron Leader Willy Pitt-Brown, spotted some 60 German tanks and about 200 vehicles lining the road between Cherence and Saint-Barthélemy. The Tiffies were flying in pairs, number twos on

the starboard of their leaders, when Willy, flying at 2000 feet, half-rolled to port and plunged down at 450 mph towards the head of the compact column of armour. At a range of about 400 yards he and his number two fired all their anti-tank rockets, followed by bursts of cannon fire for good measure. They were followed, at ten-second intervals, by the remaining pairs. The leading enemy vehicles were set on fire and others were overturned and knocked sideways by the force of the rocket salvoes. Using classic fighter-bomber tactics, other Tiffies attacked the rear vehicles, thus sealing both exits of the German column so that they could set about those between. Meanwhile, other squadrons were getting airborne, and by the early afternoon a 'shuttle' service had developed over the stricken legion.

Squadron Leader Michael Ingle-Finch, an experienced Typhoon pilot, who led 175 Squadron against the column said: 'We could see Tiger tanks and armour on a track through the woods. We attacked with our rockets and then strafed with our cannon and did a fair amount of damage. We knew that some of our rockets had not exploded on impact, and after the battle we drove to Mortain to see the damage. We found that although some of our rockets had not exploded when they hit the gun turret, the impact knocked a big hole in the turret, the metal inside the tank flaked and pieces of hot metal flew all over the place and killed the crew. We met officers of the US 30th Division who were loud in their praise of our Tiffies and some told us how they actually saw German crews jumping from their tanks before we opened fire.'*

Geoffrey Murphy, 245 Squadron, wrote:

During the first sortie ... two aircraft, flown by Flying Officer Temple and Flight Lieutenant Lee, were shot down. Temple was killed ... Lee was wounded and, with his engine put out of action, force-landed in open country between the German and Allied fronts. After touching down, his aircraft turned over on its back and he was trapped inside, hanging from his safety straps, with a broken leg as well as minor wounds. With some difficulty, he managed to turn himself in the cockpit so that he was eventually sitting upright. Unable to get out of the aircraft because the cockpit sides were flush on the ground, he banged on the sides of the fuselage to try to attract the attention of possible rescuers. German troops in the vicinity fired on the wreckage and Lee sustained further slight wounds. Some five days later, having managed to exist on the emergency and survival rations carried at that time by all pilots, he heard voices speaking English and once more, although very weak, managed to bang on the sides of the cockpit loudly enough to attract the attention of some advancing American troops who dug a hole under the cockpit and managed to extricate him. In desperate need of medical attention, he was in very poor shape and after being taken to a field hospital, was evacuated by air to England where he made a satisfactory recovery, having been awarded the Distinguished Flying Cross for his exploit.†

Usually, the Typhoons flew in Squadron strength of 12 fighter-bombers,

*The Johnson papers

†Geoffrey Murphy and Jean-Pierre Benamou, *Normandie 1944: La 2nd Tactical Air Force* (Editions Heimdal, Bayeux, 1985)

but Broadhurst did not want his Squadrons to waste time on the ground whilst all twelve aeroplanes were being rearmed and refuelled. He therefore ordered that the Tiffies were to operate in pairs and fours, keeping a 'shuttle' service over the enemy armour.

Murphy, flying on another sortie in the late afternoon, wrote:

> I remember the sky being almost black, the haze of the lowering sun being intensified by the smoke from the burning oil and fuel of tanks and trucks and appearing to press down on the earth all around, like a dark shroud. On this sortie, eleven large trucks, trapped between others burning at either end of a convoy, were either badly damaged or set on fire.*

After hours of repeated Tiffy attacks, Charles Green told Broadhurst the battle area was so covered in dust and smoke that their targets were almost invisible. However, at about the same time, Broadhurst heard that a control car near Vire was asking for immediate air support against a German attack. He immediately switched some Typhoons to Vire. The tanks were destroyed and the attack petered out.

In the late afternoon, the Mortain countryside was punctuated with black columns of smoke rising into the blue sky. It was the first occasion in Normandy when the Typhoons had the opportunity of attacking a German column. It was a situation requiring flexibility and concentration of fire power, and the Typhoons were equal to the task. 'As the tempo of the attacks increased,' wrote Coningham, Commander of the 2nd Tactical Air Force, 'so did the morale of the tank crews diminish, and at the height of the battle … the enemy were not waiting to stand our fire.'†

For the opposition, Generalmajor Rudolf von Gersdorff, Seventh Army Chief of Staff, reported: 'The air situation in the afternoon of 7 August stopped the whole counter-attack against Avranches … any movement in the combat area was made impossible.'‡

<p style="text-align:center">• • •</p>

After Mortain, our 21st Army Group pressed south towards Falaise, while Patton's Third Army advanced northwards towards Argentan, thus attempting to trap the German Seventh Army. The front-line situation was, in military parlance, 'fluid' and no one knew the exact whereabouts of the leading elements of the Fourth Canadian Armoured Division, the Polish Armoured Division and the almost encircled Germans; for example, British Army wireless sets were notoriously unreliable, and the only means of communication available to the GOC of the Fourth Canadian Division was dispatch riders.

On 16 August, Broadhurst began to get reports from his reconnaissance Mustangs that German armour was retreating eastward. He therefore telephoned Crerar, commanding the First Canadian Army, to get his agreement to fighter-bomber attacks, but Crerar, who had recently lost some of his Cana-

*Murphy and Benamou,
Normandie 1944

†*Despatch: Operations Carried out by the 2nd Tactical Air Force.*

‡*Manuscript No A-921 German Report Series,* US Army History Institute

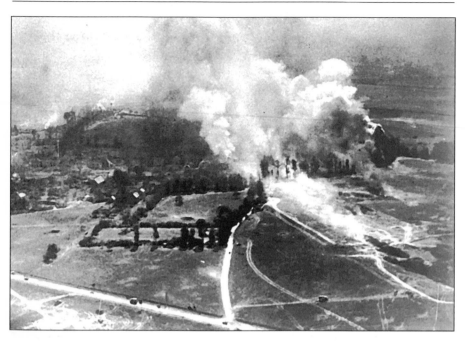

The Allied advance was to give the Typhoon Wings their great chance to smash von Kluge's armour at Mortain and (*left*) Falaise

dian troops to attacks by Bomber Command and the US Eighth Air Force, declined. Broadhurst immediately dispatched the valiant Charles Green, who soon reported that the retreating columns were indeed German, and on being pressed by his AOC made his classic reply: 'I saw their black crosses and the square heads of their drivers!'

Broadhurst telephoned Montgomery, explaining the golden opportunity, but also pointing out that since the Canadians were so close to the Germans there would be casualties on our side. Montgomery said he would call back in fifteen minutes, which he did, saying, 'Go, there will be no recriminations.'

When we arrived over that small triangle of Normandy bounded by Falaise, Trun and Chambois, the Typhoons were already hard at work. As at Mortain, they used the tactic of sealing off the front and rear of a column by accurately dropping a few bombs, thus compressing the desperate enemy on the narrow, dusty lanes. Since the transports were sometimes jammed together four abreast, this made the subsequent rocket and cannon attacks comparatively easy. Some of the armoured cars and tanks attempted to escape their fate by making detours across the fields and wooded country, but these were soon spotted by the Typhoon pilots and accorded the same treatment as their comrades on the highways and lanes.

Immediately the Typhoons withdrew from the killing ground, the Spitfires raced into the attack. The tactics of the day were low-level strafing attacks with cannon shells and machine guns against soft-skinned transports, including all types of trucks, staff cars and lightly armoured vehicles. Here and there amongst the shambles on the ground were a few of the deadly Tiger tanks, and although the cannon shells would have little effect against their tough armour plate, a few rounds were blasted against them for good mea-

sure. As soon as the Spitfires had fired all their ammunition, they flew back at high speed to their airfields, where the groundcrews worked flat-out in the hot sunshine to rearm and refuel the aircraft in the shortest possible time. The Typhoons did far more damage with their rockets than our Spitfires.

Faced with losing their forward airfields, the Luftwaffe were fully occupied withdrawing to bases in the Paris area, thus failing to provide any real assistance to their hard-pressed ground forces. Our greatest enemy was the flak, which became more and more concentrated as the noose tightened. Geoffrey Murphy wrote:

> The ground attack and the German flak gunners were constant daily adversaries since on every operation, in order to hit their targets, pilots had to dive into a cone of concentrated flak, remaining within it until their weapons were aimed and released and being perhaps most vulnerable when pulling out. We had armour plate at our backs and underneath the cockpit, but the engine and flying control systems were unprotected and in a steep climb away from the target, as speed was rapidly reducing, it was advisable to turn the aircraft rapidly from side to side to spoil the gunners' aim. Alternatively, keeping the aircraft very low and using the maximum speed attained at the bottom of the dive to get away from the target at roof-top height, made it very difficult for the gunners to keep their sights on the aircraft. This technique led however to the risk that when a climb to height to join up with the rest of the Squadron was eventually commenced, airspeed was lower and the rate of climb poorer, so that any other flak batteries within range in the area had a greater chance of hitting you. We were normally briefed before flight by our formation leader as to how we were to exit from the target, depending on weather conditions, position of the sun and the danger of collision with ground obstacles or with each other.*

During these few days of the late summer, the fighter-bombers maintained their relentless pressure against the Germans, and on 19 August thousands of transports were destroyed or damaged. Afterward, our efforts in the Falaise Gap gradually petered out, for the armour, transports and personnel of the German Seventh Army had either been eliminated or had withdrawn across the Seine.

After the fighting had ebbed away from Falaise, some of us drove to the killing grounds to see the result of our attacks at first hand. The slaughter has been described over and over again in graphic detail, and no one who saw it will ever forget it. The Supreme Commander, Dwight Eisenhower, said it could only be described by Dante.

Always there when it was wanted, whether in the thick of the ground fighting, facing the murderous flak, or seeking out and destroying reinforcements moving up to the front, the rocket-firing Typhoon was decisive in Normandy. Later the wise, astute Harry Broadhurst said: 'I suppose that flying

*Murphy and Benamou,
Normandie 1944

one of these aircraft was the most dangerous task the Royal Air Force has ever asked anybody to do.' We had some 400 Typhoons in Normandy; 130 pilots were killed and five are still missing to this day.

From time to time the rich Norman soil yields evidence of the cost. On 18 June 1944, six Typhoons of 198 Squadron attacked German transports near Caen. As usual, the flak was intense and Dick Armstrong's Typhoon was set on fire and he crashed in a field. Don Mason, from Australia, said that his Typhoon was on fire and that he would try and make it to the British lines. Bill Stratford's fighter-bomber had been hit and was streaming smoke, and Paul Ezanno, a Frenchman, and Timmy Milich, both reported they had been hit. Dick Armstrong was later reported a prisoner of war but Don Mason was not seen again. Bill Stratford was shot down a few weeks later, and Timmy Milich, a Maori, was killed in Holland.

In 1992, Dr Jean-Pierre Benamou, Director of the Battle of Normandy Museum at Bayeux, was told by a farmer that a British aeroplane had crashed on his farm and still lay buried there. Dr Benamou and his team found the wreckage of the Typhoon and Don Mason was identified by his uniform and a wallet. Forty-nine years after his death, Pilot Officer Mason was buried, with full military honours, by the French Air Force at St Charles-de-Percy War Cemetery in Normandy.

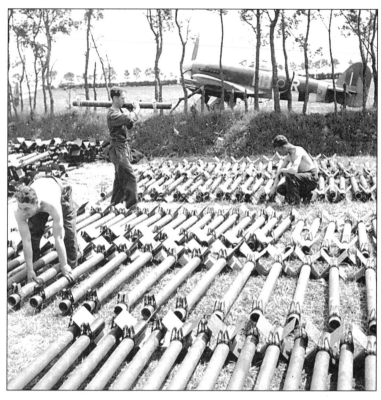

Lethal weaponry: armourers make ready the rocket projectiles to sling under the wings of the Typhoons

So ended the Battle of Normandy. A triumph of tactical air power, especially for the Typhoons, which were flown by the bravest of the brave, who came into their own at Mortain and made history at Falaise.

THE LONG TREK

The Allied armies' relentless pursuit of the enemy north-westwards through France, across the Low Countries and thence over the Rhine and into Germany, called for the maximum air support. For Johnnie Johnson, first as the Wing Leader of 144 Wing and then, later, as the Group Captain commanding 125 Wing, it was a time of intense activity as his units moved forward from base to base.

In his own mind, he saw the Long Trek, lasting, as it did, for only a month short of a year, as being divided into two clear-cut stages: first, the run up to the Rhine and then, second, the final leg of the advance into Germany. He deals here, successively, with each.

NORMANDY TO THE RHINE

Life in Normandy was vastly different from the comforts of Kenley, where we were often 'released from ops' until the following noon, and there was ample time to drive to London, where, at the Kimmel Club, presided over by the generous and hospitable Captain Bobbie Page, ex Royal Flying Corps, you could always meet a few kindred spirits from Biggin Hill, Hornchurch or North Weald. Sometimes Bobbie, who was well-off from his florist's business in Covent Garden, would take us and our girls across the road to the Savoy to wine and dine and dance to the splendid music of Caroll Gibbons and his Savoy Orpheans; when the Savoy closed, we staggered back to the Kimmel where Caroll played a battered piano and sang. We would get back to Kenley with the dawn, snatch a few hours sleep and come to readiness at 1300 hours.

One night we were carousing away at the Kimmel when, about midnight, an ops officer phoned from Kenley to say that I was briefing at 0400 for a take-off at 0500. I protested, but the man said it was a special show and the Kenley Wing was required.

After the briefing – not one of my best – the Senior Intelligence Officer, a dour yet observant man, took me aside and said something about my fitness to fly. I told him to get on with his job, but once in the cockpit, I made sure that the oxygen was fully on. Fortunately, it was a spanking morning with excellent visibility, and, south of Rouen, I spotted a bunch of FW 190s well below. Leaving 403 Squadron as top cover, I led 416 Squadron on a perfect

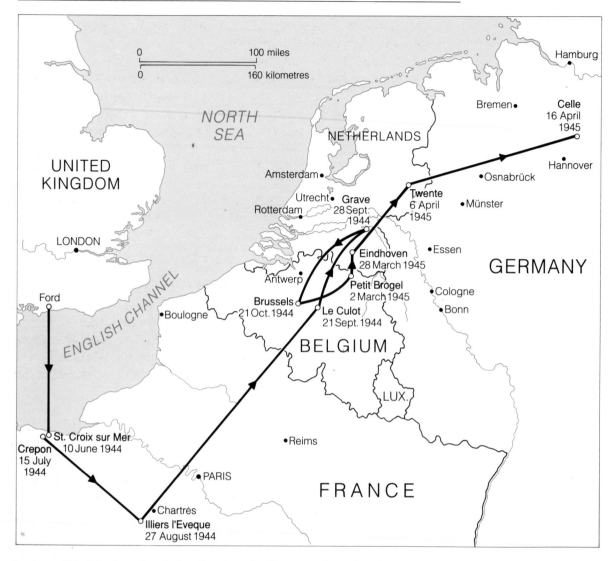

bounce. We hit them hard, leaving four in flames, while the survivors half-rolled and dived away.

By 0700 we were all safely back at Kenley, where I got some sardonic pleasure from telling the SIO about our little encounter, and that I had personally accounted for one of the enemy. He replied that more black coffee was about to be served!

Some days later, a new and apprehensive young Canadian said to a Roman Catholic padre, 'I think Wing Commander Johnson and Squadron Leader Browne drink too much to fly properly.' The holy man, who had been with us some time and took a dram or two himself, replied, 'Just you stick with those two old drunks, my son, and they'll get you through your tour!'

Johnnie Johnson's long trek, June 1944 to April 1945, Wing Commander Flying, 127 Wing, and Officer Commanding, 125 Wing

• • •

In Normandy, we were confined to the beach-head and parties were few, except for the odd game of craps, when, at dusk, we had flown our last mission. But Tangmere was only thirty-five minutes away in your Spitfire, and another ten would see you in Arthur King's Unicorn pub in Chichester, where there was always a warm welcome with a lobster and wine for lunch – a welcome change from the 'compo' rations. Moreover one of our staff cars had somehow got left behind and was based in a garage at the Unicorn, handy for a quick trip to London.

Such excursions were only for those who possessed their own aeroplanes – Group Captains commanding Wings and their Wing Leaders. Broadhurst, however, was soon aware of these pleasure flights to and from Tangmere and let it be known that his Group Captains could not leave their airfields without his permission; despite this a well-known, highly-decorated Group Captain flew to Tangmere, without permission, for an extended alcoholic lunch at the Unicorn.

Hours later the wayward, highly-decorated officer arrived overhead, turned downwind on to base-leg and then finals watched by his astonished Airfield Controller. For the Group Captain, despite red Very lights and radio warnings, failed to put his undercarriage down, belly-landed on the pierced steel planking, swung off the runway and came to a grinding halt in an adjacent field! He was relieved of his command and was back in England the next day.

• • •

You could not get much luggage into your Spitfire – an over-night bag at the back of the armour plate and a bottle or two strapped to the oxygen bottle at the rear of the fuselage. If you removed all the ammunition from the gun bays, you had plenty of room for all your personal kit plus a few bottles of champagne. There were quite a few crashed Spitfires strewn around St Croix-sur-Mer, and I asked our senior engineering officer if he could assemble an unarmed Spitfire from the wrecks. The next evening he reported that 'JEJ Junior' was ready for air testing. My private Spitfire performed beautifully, and I had visions of shooting and fishing in Scotland when operations permitted. Alas, 'Junior' only flew a few times before some wretched French-Canadian, laden with goodies and trying to land on a short airfield, forgot to lower his undercarriage and wrote her off.

• • •

It was four years since I had joined 19 Squadron, and now, I suppose, I was one of the most experienced fighter pilots in the Royal Air Force; I was also grossly over-confident, and towards the end of August nearly came to grief. Ops phoned to say that the Luftwaffe were operating a fighter screen over the Seine to protect their retreating troops. The controller suggested that if two squadrons patrolled well to the south of Paris and then approached the Seine from the east, down-sun, we might bounce the Krauts.

I led 443 with 421 stepped-up down-sun. It was a brilliant, sunny day with excellent visibility. We flew in our well-proven finger-fours, but after a few minutes my number two called to say that he had a rough engine and was returning. Larry Robillard, a tough French-Canadian who had flown with me in Bader's Wing, asked if he should detach a number two from his section, for the golden rule was that you never flew alone. However, for some reason I declined his offer and we pressed on to the City of Light.

We were heading westwards over the Seine, at 20,000 feet, when I spotted a gaggle of at least sixty aeroplanes well ahead, the highest of which were at our altitude. I eased our Spitfires into the sun and flew over the top of the enemy gaggle – a mixed bunch of Me 109s and FW 190s. Above our Spitfires the sky was clear, so I decided to attack with both Squadrons in one fell swoop and led 441 Squadron against the highest enemy aircraft and told the leader of 416 Squadron to attack the lower bandits.

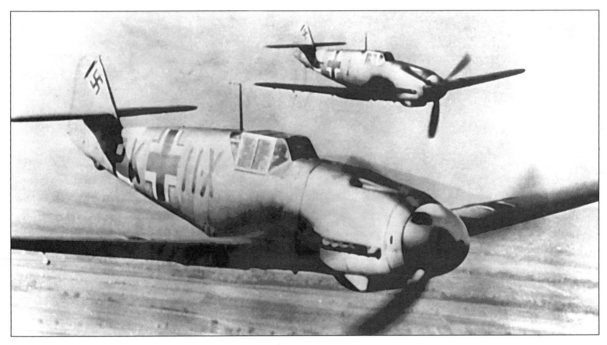

We had complete surprise. I lined up my sights and fired at an unsuspecting squat 190, which carried a long-range petrol tank below the fuselage. My cannon shell smashed into the tank which exploded. Burning fuel engulfed the Focke-Wulf in a blinding sheet of flame and screened it from my sight. Not having a wingman, I turned steeply to clear my tail and saw seven or eight questing Messerschmitts at about the same height. This was no place for a lone Spitfire so I half-rolled and dived to the fields below.

At 1000 feet I again turned steeply and saw a solitary FW 190 just below me. I turned in behind and below him and fired a three-second burst into his dark-grey belly. The 190 stalled, fell into a slow spin and exploded when it hit the ground. The burning fighter would attract others, so I circled warily,

The Messerschmitts were still active as their pilots covered the German withdrawal but...

always clearing my tail and avoiding small gaggles of enemy fighters here and there. When I saw my opportunity, I climbed at full throttle to 8000 feet and called Larry Robillard, who said he was over the big bend of the Seine at 15,000 feet and should he come down? I told him to stay where he was and I would climb to him.

At 15,000 feet I saw a few fighters circling over the big bend of the river and made my second and near-fatal mistake when I called Larry to say I could see him and to re-form on me. I learned of my error the hard way when speeding golf balls of tracer flashed over my cockpit. Instinctively I broke to port in a desperate tight turn, and over my shoulder saw the lean nose and belching cannons of a Messerschmitt as its pilot tried to hold a bead on my turning Spitfire. My fate would be decided by the tightness of our turns, and I pulled the stick back until the Spitfire shuddered with a warning of the flick-stall. I blacked out. I eased the turn to recover a grey and dangerous world.

Keep the height, at all costs, I thought. The leader of the Messerschmitts knows the form. He has placed a pair of aircraft on either side of me whilst he and his number two stick grimly to my tail. The flanking Messerschmitts

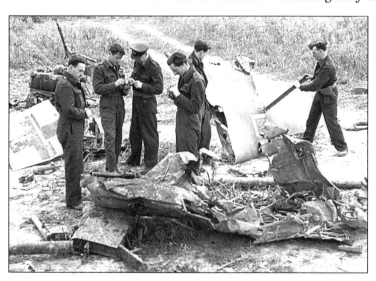

Allied air superiority took its full toll

whip into action with head-on attacks. But they are not good shots and the greatest danger lies from their leader. The moment I ease out of the turn he will nail me. But I cannot turn for ever, and if I am to live I must somehow climb and so get the extra power from the blower. The sun is at its zenith and I wrench the Spitfire in a steep climb into the sheltering glare. The blinding light will hide me. My Spitfire quivers as she takes a cannon shell in her starboard wing root. Another turn. Another soaring climb into the sun until the blower cuts in with an unpleasant thump. Now I have sufficient power to draw away from my pursuers, and I am able to increase the gap with another long haul into the sun. Soon I am out of range of the Messerschmitts, but they continue to climb steadily after me. Now that I have reached comparative safety, I toy with the idea of a stall turn followed by a fast dive and a head-on attack against their persistent leader. But I dismiss this scheme. Fortune has already smiled upon me, and there will be another day ...

• • •

Two days after our fight over the Seine, Paris was liberated, and we moved to an airfield at Illiers L'Evêque, but soon the leading elements of our ground

forces were out of range. Broadhurst telephoned to say we were stood down until a more suitable airfield could be found.

Our airfield lay in the midst of some good farming country. The corn had been reaped and there were a lot of partridge about. I had my old BSA, and, almost daily, Sally and I wandered over the stubbles. One fine afternoon we were walking up a large field, my haversack bulging with game, when I saw about a dozen people, also with shotguns, advancing in line abreast towards me. They were perhaps barely half a mile away, so I broke my gun, removed the cartridges and pressed on with the best *savoir faire* attitude I could assume.

Eventually I came face to face with the leader of the shooting party, a middle-aged man in a green shooting suit and a hat of the same material with what looked like a shaving brush sticking out of the side. I was hatless, but wearing a Royal Air Force battle-dress with rank badges and decorations. His party included two British Army officers, junior to me, who, however, eyed me coldly and with little, if any, deference. Bloody staff officers, I thought, they should be at their desk sorting out the bumph …

'Shaving brush' explained, in faultless English, that he was the Comte de something and the owner of the land and would I care to join his party for the remainder of this fine afternoon.

That, Johnson, I thought, is indeed *savoir faire*.

• • •

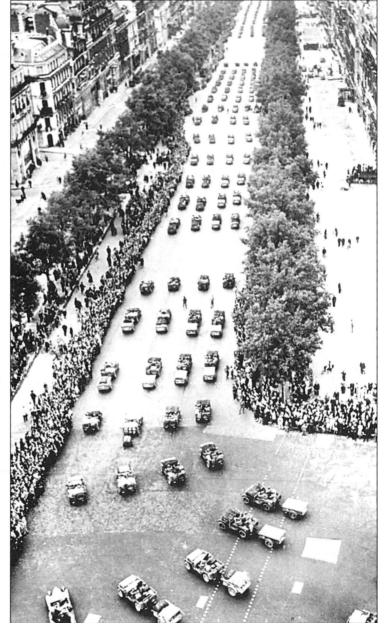

Paris celebrated its liberation in appropriate style – but much heavy fighting still lay ahead

Larry Robillard was very useful during those lazy days of the fading summer. Since he spoke fluent French, had a polite and charming manner, was well decorated and had escaped from France, he received a hero's welcome wher-

ever he went. I gave him a temporary jeep and he became our roving ambassador who supplemented our tedious rations, liberated great quantities of wine and cognac, arranged excellent parties in Paris and reconnoitred places we simply had to visit, like the Ritz and the notorious *Maison de toutes les Nations.*

Among Johnnie Johnson's Canadians was a young French-Canadian from Ottawa, Flight Sergeant Larry Robillard. After being shot down over France in 1943, and evading capture thanks to the Underground, he returned to continue the fight

The Luftwaffe were making a remarkable comeback after their poor showing in Normandy, and we heard ominous reports of the first sightings of fast jet aeroplanes. Broadhurst ordered us to Le Culot, in Belgium, and Larry came to see me and said that if he made the journey by road he could visit those brave people in the Pas de Calais who, at the risk of their own lives, had nursed his wounds and helped him escape after he had been shot down in 1941.

I knew that the monks of the Benedictine monastery at Fécamp still made their excellent liqueur, and it was rumoured that since they were short of sugar some barter trading could be done. So the French-Canadian was provided with a jeep, two sacks of sugar, French francs from my own pocket and told to report to Le Culot in about a week's time. Since there were still isolated pockets of German troops on his route, I told him to take a couple of mates. Larry's account of their journey is worth recounting.

'Our trip was through ravaged countryside with military traffic and roadblocks, but it was, for a while, along the beautiful Seine Valley to Rouen, where we dined and visited the Cathedral. At Fécamp we soon found the monastery but had some difficulty in persuading the monks to part with their product. However, the sugar did the trick and eventually they let us have three cases at 150 francs a bottle. Since we were getting 1000 to 1500 francs for one English pound we were quite happy with the deal.

'We continued our arduous and slow trip till it was quite late and getting dark. Since there were still many pockets of German troops about we finally decided to stop at Dieppe, by now in Canadian hands. It turned out that several Canadian Field Hospitals were there. We remembered some of the nurses from the beachhead days and hoped to be put up for the night and to get food and refreshment.

'There was very little booze in the nurses' quarters so we had to break into Johnnie's Benedictine. We found somewhere to sleep and the next day we drove to the village of Lillères, carefully picking our route because of the German pockets. We travelled through famed Abbeville, badly devastated; and I remembered the young Curé there who provided me and my escape party with false papers and documents to cross the Somme Bridge separating

'La Zone Interdite' from the rest of Occupied France. I was sad to hear that, in 1941, he had been executed by the Gestapo. I had spent over a month in Lillères recuperating and preparing plans to escape to England. My friends couldn't believe it was me and gave us a tremendously enthusiastic welcome. We had to visit everyone who had known about me and who had in one way or another helped in my escape. Everywhere we went there was food and champagne and wine. We laid a wreath for M. Rousseau, the brewer, who on 2 July 1941 took me, disguised as his assistant, in his brewer's lorry through German roadblocks – this just a few hours after I had been shot down.

'Here we were in 1944, laying a wreath for him, and others who were killed just days before; widows and children were still in shock. There was Jean Coudert, without whose quick thinking and help I would never have escaped. He was now 16 and had in the last few days captured many Germans. His parents and brothers and sisters had all been active in the Resistance. Our arrival was the first vindication and proof of the success of their efforts. Then there was the Protais Dubois family, wife and seven young children. Protais had been the leader of the area Resistance group in 1941, and it was he who put me in touch with British Intelligence. He died in 1941 in a Dresden gas chamber.

'The highlight of the visit was a dinner given, the day following our arrival, by the Mayor of Lillères and his wife (M. and Mme Jules Godfrin), in whose farm I had hidden in 1941. There were probably twenty to twenty-five guests, all of the Resistance, and we sat down to dinner at about 1 p.m. It was a great meal; they must have started preparing it the moment we arrived in the area. There must have been ten courses, with different wine for each and loads of champagnes and brandy. It was quite a party. Needless to say, we drank more of the Benedictine and greatly reduced the stock, but we did get back to the Wing, albeit late. To this day Johnnie Johnson does not allow me to forget what I did with his Benedictine.'*

• • •

Operation Market Garden – the Arnhem venture – the greatest airborne operation of the war, when Lieutenant Colonel Jack Frost and his valiant paratroopers were fighting desperately to hold the northern end of the great river bridge, was doomed from the start. The plan had been made in the UK without advice from Coningham and Broadhurst on the continent. Paratroopers were dropped far from their objectives and their vital wireless sets did not work; the reinforcing airlift was delayed; the German counter-attack was heavier than expected; and the Luftwaffe had reinforced the area with fighter-bombers, including jets. It was against this sombre background that we moved to Le Culot, near Louvain, on a blustery autumn day and I called the pilots together for a briefing from our Army Liaison Officer.

On the late afternoon of 21 September, four days after the first drop, we were told that the situation on the Arnhem bridge was bad, but the leading elements of the Guards Armoured Division were over the Nijmegen Bridge

*The Johnson papers

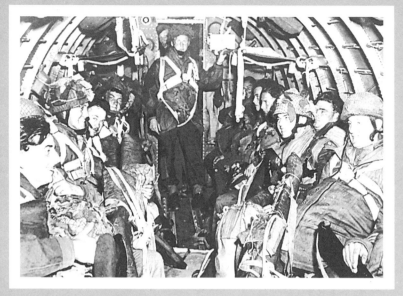

Operation Market Garden or A Bridge Too Far: British troops of the 1st Airborne Division prepare to drop at Arnhem, 17 September 1944

A PRU Spitfire took this picture of the gliders after they had landed in the target area

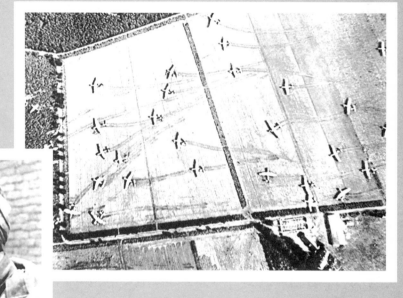

A German photograph of a captured British paratrooper tending a wounded comrade

and were halted but six miles from Arnhem. What about our Typhoons, I asked? We had several Wings nearby and surely they could cope with Tiger tanks and self-propelled guns as they had in Normandy? The Liaison Officer did not know the answers so I phoned the man who could tell me.

Air Vice-Marshal Harry Broadhurst said he had just received a report from Max Sutherland, who was in a Royal Air Force Contact Car with the Guards, who, when they were attacked on the Nijmegen–Arnhem road, had asked for air support. A Typhoon 'cab rank' was circling overhead but Sutherland's wireless set did not work and the soldiers were out of coloured smoke to mark the target. He had no wireless contact with the beleaguered para-troopers, who, he thought, would soon be withdrawn. Meanwhile, my Wing was to patrol over Arnhem and fend off enemy fighters.

During the next few days, the Spitfire Wings fought the enemy fighters over Arnhem whilst, below, the Typhoons flew their armed reconnaissances. On these flights the pilots searched for, and identified, their targets, which were hard to find in the thick woods surrounding the town. The leaves had not fallen from the trees and hid the feared German tanks and guns. At Arnhem, the Typhoon pilots wanted up-to-date briefings from the contact cars, or from their army liaison officers, and coloured smoke to mark the hidden targets. These aids were not provided and when we flew low over the town we had little idea of the desperate situation below.

One day I was leading Wally McLeod's 443 Squadron near Arnhem with a thick cloud base at 12,000 feet, but below this height visibility was excellent. The controller said that enemy aircraft were around and he hoped to find me some trade. I thought about the weather and remembered Bader's dictum that you should never follow an enemy fighter through cloud because, as he put it, once you got through the cloud, 'You stood out like a sore thumb.' I ham-mered this lesson into my Canadians time and time again, and, because he ignored it, Squadron Leader Wally McLeod, DSO, DFC and Bar with 20 victories, veteran air fighter of Malta and Europe, lost his life.

The controller broke the silence: 'Kenway to Greycap. Bandits active in the Emmerich area. They appear to be flying down the Rhine towards you. Steer 130.'

'Greycap to Kenway. Roger. How many?'

'A small gaggle, Greycap. Not more than a dozen. Out.'

I held our height at the very base of the cloud so that we could not be bounced from above. The great river was swollen by heavy rains. To the east, the evil empire looked dark, foreboding and sinister. The ever-vigilant Don Walz broke my reverie: 'Greycap from Red Three. Nine 109s below!'

'OK, Don. I have them. Wally take the starboard gaggle. I'll take the fokkers on the port!'

The enemy were in two small line abreast sections. We were twelve Spit-fires and had height and surprise. Just before I opened fire, I looked at Wally and saw the leader of the enemy starboard section pull his Messerschmitt into a vertical climb with Wally behind him like a leech. My own target was very

close, but before blasting him with my cannons I found time to say, 'Watch that brute, Wally. He knows the form!'

My opponent began to burn and I climbed into the cloud, making quite sure that I did not emerge into the sunshine above. My Spitfire was out of control, upside down, but once she fell out of the cloud, I had plenty of height to get her on an even keel. As always, I turned steeply to clear my tail, but there was no sign of either Spitfire or Messerschmitt, and Wally didn't answer to my repeated calls on the radio.

Back at Le Culot I found Wally was missing, and at the de-briefing we concluded that he had followed the higher 109 through the cloud into the bright sunlight where he would have been at a serious disadvantage. Later, we heard that he was found dead in the wreckage of his Spitfire near the scene of our fight.

THE FINAL THRUST

The airfield at Le Culot was overcrowded so we moved to a damp grass meadow at Grave alongside the River Maas. It was here that we were bombed by Messerschmitt 262s – the first jets we had ever seen. They came in very fast

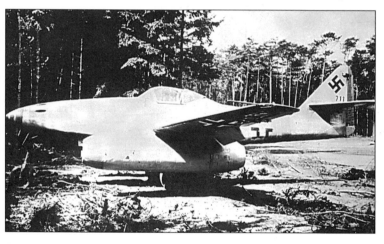

from the east, and although I ordered standing patrols, our Spitfires were far too slow to catch the intruders. Suddenly, we were outmoded but, fortunately for us, the Germans only possessed a few of these remarkable fighter-bombers.

One evening, Wing Commander Dal Russel phoned to say that some pilots of his 126 Wing had destroyed a Me 262, and, later, an engineer officer brought me a cannon from the wreck. Then a very polite officer phoned to say that his

Towards the end of 1944, the Luftwaffe introduced the Me 262, a quality, twin-engined jet fighter. Had it appeared in greater numbers a little earlier, it could have had a profound effect upon the air war on the Western Front

401 Squadron had destroyed the jet and please could he have the cannon. Thus, the tall and distinguished Squadron Leader Roderick Illingworth Alpine Smith, DFC, journeyed to Grave to claim his cannon and become my lifelong friend.

They were, Rod told me, over the Nijmegen bridge at 13,000 feet when Kenway called to say there was an aircraft to the north-east. Rod spotted the jet coming towards them very fast, head-on, and turned to his right and then sharply back to his left to give him the chance of a small deflection shot from astern. The jet obligingly held its course so that Rod's tactic worked, and he was about to open fire when another Spitfire, flown by John MacKay, appeared quite close and between Rod and the jet. Rod, of course, did not fire and the 262 pilot half-rolled and dived, followed by the tenacious MacKay

and the rest of the Squadron. MacKay was within range, and Rod saw cannon strikes on the 262's wing and a thin stream of smoke from its trailing edge.

With the whole Squadron tunnelling down on the 262 there was danger of a collision, and wisely the Squadron Leader and Tex Davenport left the circus at 7000 feet and watched the jet streaking away at 3000 feet. Suddenly, they were astonished to see it zoom into a near-vertical climb towards their two Spitfires. As its speed fell away, Rod was able to close to 200 yards and smashed his cannon shells into it. The Texan, unseen by but somewhere behind Rod, also fired. The 262, by this time on fire, stalled, fell away into a steep dive and crashed south-west of Nijmegen, sending up a billowing column of fire and smoke.

• • •

As winter approached, our airfield became too waterlogged for safe operations and we fell back to Brussels Evère with its hard runway and ample accommodation for all and sundry. We were able to requisition private houses, provided they had previously been occupied by Germans or Belgian collaborators. So, we moved into winter quarters and, for the present, gave up our pleasant nomad life and its buccaneering environment. Now, we returned to hot baths after the day's flying, 'best blues', frequent visits to Lady Coningham's elegant Officers' Club (where the current girl-friends were well scrutinized) and other less salubrious establishments, such as that frequented by Lance Corporal Eric Sykes.

Eric, later to win much fame on stage and screen, had a girl-friend who ran a *maison de rendezvous*, a social establishment frequented by warriors and local young ladies in search of an evening's entertainment, including a few drinks, some dancing and, hopefully, other pleasures.

These happy sessions went on night after night and it was often very late when Eric and his lady got themselves to bed. One night the party, including a few colonels and the odd brigadier, went on and on until the weary Lance Corporal shouted to Madame: 'Let's throw these buggers out and close the place, so that we can get to bed!'

The Duke of Wellington, it will be remembered, was also quartered in Brussels, and when, at the Duchess of Richmond's Ball, an aide arrived with the news that Napoleon was nearby, at Quatre Bras, the Duke said they would finish the party before dealing with the Frenchman. Alas, at our party on New Year's Eve, also in Brussels, no one warned us of the Luftwaffe's plans for the morrow.

There had been a sharp frost during the night, then it had rained, and the frozen surface of our single runway was dangerous. Accordingly, the early morning patrols which usually went off at first light were delayed until we could get some grit on the runway. Shortly before 0900 hours a pair of Spitfires took off, followed by another pair, and 416 Squadron was called to readiness. Dave Harling led his 12 Spitfires along the icy perimeter track and began a slow turn on the runway. This was the setting at Evère when a mixed force

New Year's Day, 1945: the German Air Force, in a massive, coordinated strike, took the Allies unawares. Brussels (Evère) was on the receiving end

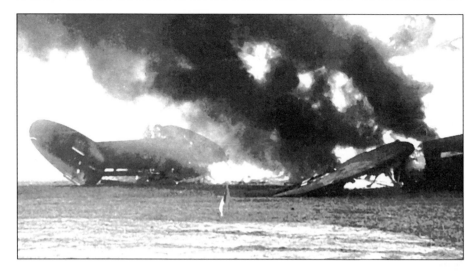

Danny Browne – Squadron Leader J. Danforth Browne – post-war a distinguished US attorney, elected to fight Hitler and the Nazis long before the US entered the war. He cut a telling and effective figure in Johnnie Johnson's aggressive Canadian Wing

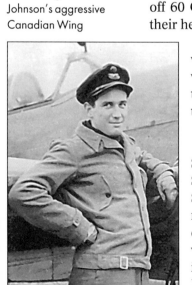

of about 60 German fighters appeared overhead and proceeded to beat up our Spitfires.

The three Spitfires behind Harling were badly hit, yet Dave, fully aware of his danger, roared down the runway with wide-open throttle, turned into the enemy fighters and shot one down. But the odds were far too great, and our young Canadian was killed before his Spitfire had gathered combat speed.

Fortunately, our two pairs of Spitfires arrived back over Evère and the highest German fighters turned to meet them. Three of my pilots shot down six of the attackers, Steve Butte getting three. But they were too few to drive off 60 Germans, and after using all their ammunition the Spitfires took to their heels.

The Luftwaffe withdrew as abruptly as they had appeared and we were left to our burning airfield. One airman was killed and nine wounded. Eleven of our Spitfires were written off and 12 damaged. On the west side of the airfield some transports still blazed. We had, I thought, escaped lightly.

• • •

Soon after, Coningham's ADC phoned to say that on the following Sunday I was invited to lunch with the C-in-C and I was to bring a Squadron Commander. Thus, the American, Dan Browne, was with me when we reported to Coningham's lavish mansion in the Avenue des Nations. A white-coated corporal showed us into an anteroom where half a dozen guests were already gathered. The C-in-C, vain and impeccably turned out, made the introductions to the Comte of this, Baroness that ... and so on. A white-coated sergeant offered champagne in expensive-looking fluted glasses from a silver salver, while Coningham explained that the house had been occupied by a high-ranking German officer who had 'collected' the priceless paintings on the walls. The food was superb – oysters from Bergen-op-Zoom, roast

partridge from the stubbles and profiteroles all served with fine wines. Mary Coningham was an excellent host, keeping the conversation flowing round the table and very attentive to his Belgian guests. After coffee, we were preparing to leave, but our host asked us to stay, and, after the other guests had left, put some searching and intelligent questions to us about air fighting, heights, turning circles and the remarkable Me 262.

We drove back to Evère talking of the superb meal we had had whilst our brother officers had lunched off tinned stewed beef and hard biscuits. I thought of Montgomery, who, in his old corduroys and a jersey, had probably munched some bread and cheese in his bleak caravan and, like others, I decided Mary was over-doing it.

• • •

During the early spring of 1945 we left the comforts of Brussels for Petit Brogel, in Belgium, and prepared for the Rhine crossing and the final thrust into Germany. The lessons of the Arnhem disaster had been well heeded and Harry Broadhurst and his staff gave all group captains and wing leaders a thorough briefing about Operation Varsity, which, on 24 March 1945, placed Allied troops across the Rhine at Wesel.

With the war drawing to its end, I was beginning to think that I should not, like Dundas, Jameson, Hugo, Green and Co., make Group Captain and have a Wing of my own, but, just after Varsity, Broadhurst phoned and said I was to take over 125 Wing from David Scott-Malden at Eindhoven. He congratulated me on the promotion, not forgetting to stress the fact that it was only an acting rank which I should soon lose once the contest was over.

My Wing Leader was the Canadian George Keefer, who had flown with the Kenley Wing. We had a long chat about the Squadrons 41, 130 and the Belgian-manned 350. George said, 'I suppose you'll want your own Spit, just the same as when you were a Wing Leader?'

I knew what he was getting at; he was proud of his job and thought that if I led the Wing too much it would weaken his authority and damage the important chain of command between the Wing Leader and the Squadron Commanders. So I told him there was only one Wing Leader – Keefer – but occasionally I would head a Section or a Squadron and reserved the right to lead the first show over Berlin. We were both happy with the deal.

Broadhurst phoned to say that the Army had just captured a good airfield, Twente, in Holland, and we were to be the first fighters over the Rhine. The airfield had been bombed many times, so I arranged with George that I would fly to Twente, and if the runway and the dispersals were serviceable, I would call him on the radio and he would follow with the Wing.

That afternoon found me over Twente in my Spitfire XIV. I cleared my tail before turning on to finals, for we were near to the front and I didn't want to get bounced with wheels and flaps down. I landed safely and an airman waved me to a dispersal point. I had just switched off the engine when a lean, grey Messerschmitt roared a few feet overhead. The Hun saw us and turned

back for his strafing run. What a way to buy it, I thought, as, parachute still strapped on, I fell out of the cockpit and tumbled down the wing root. I hit the ground and, with the airman, grovelled under the Spitfire. I heard the fighter boring in. What a way to buy it … after five years … and just made Group Captain!

We heard two crumps in quick succession and then a large explosion when the 109 hit the deck. The boy and I scrambled to our feet, shook hands and laughed together. Someone produced a jeep and I drove across the airfield to thank the Royal Air Force Regiment crew of the Bofors gun who had saved our lives.

We only remained at Twente for a few days before being moved for the last time on our long trek from Normandy. This time we were to go to the pre-war Luftwaffe airfield at Celle, north of Hanover, and six miles from the death camp at Belsen. George and I flew there together, and, as we taxied across the grass, a dozen Bofors guns chattered at four FW 190s which streaked over Celle at high speed and disappeared to the east.

From Celle there began a stirring bout of air fighting which was a fitting climax to the war. What remained of the Luftwaffe operated from a few airfields east of the Elbe, and these squadrons fought desperately as their airfields fell either to our Army or the advancing Russians. I flew a dozen times with George, more often than not leading a finger-four, which was not the same as leading the Wing because I was always at George's behest, not mine. I had a few combats, sharing kills with other pilots; but I did not file any combat reports for these shared victories. The rule was that five victories merited a DFC, and by not claiming I helped other pilots get their gongs.

I led 125 Wing just once – to Berlin. We took the first team, George leading a Squadron and Tony Gaze, from Bader's Wing of four years ago, leading another. We flew there at 2000 feet, over a changing sunlit countryside of barren heathland, small lakes and forests, with the empty autobahn on our starboard side.

Thick cloud covered the capital and I had to take the Wing down to about 1000 feet. The roads to the west were filled with refugees. We flew over the burning city and the Falaise stench of death hit us again. The Russian artillery was hard at it: as we flew towards the east we saw the flashes of their guns and the explosions of their shells. Russian tanks and armour rumbled into the city from the east. You bastards, I thought, reap where you have sown.

Tony Gaze said, '50 plus at two o'clock, Greycap. Same level. More behind.'

'Are they Huns, Tony?'

'Don't look like Huns to me, Greycap. Probably Russians.'

'All right, chaps,' I said. 'Stick together. Don't make a move.'

They were Yak fighters and they began a slow turn which would bring them behind our Spitfires. I swung the Wing to starboard and over the top of about 100 Russian fighters. We circled each other for a couple of turns. Both

sides were cautious and suspicious. I narrowed the gap as much as I dared and waggled my wings when opposite the Russian leader, and hoped he would do the same. He paid no regard, but soon after he took his ragged formation to the east.

There seemed to be no pattern or discipline to their flying. The pack followed the leader, rising and falling as they quartered the rubble like buzzards. Every few moments a handful broke away, circled leisurely and then swooped on something below. Thus they worked over the doomed capital.

• • •

In those closing days of the war Celle was our most easterly airfield so that ex-prisoners of war and refugees arrived in their hundreds. They came in a variety of vehicles, from Mercedes and BMWs to horses and carts, so that Celle began to look like a scrap-yard and I let it be known that I would like a suitable car – to go with my new 'scrambled egg' cap.

It was the Army's responsibility to get these men back to England, but since numerous Dakotas landed daily with petrol supplies, it was a simple matter to fill the returning transports with ex-prisoners, including aircrew from the infamous Stalag Luft III and soldiers taken at Dunkirk. I thought I had better let the Army know what we were doing; they were delighted and sent a small team to Celle to help with our mini-evacuation, and I was told that the Corps Commander himself was coming to see the set-up and would stay to lunch.

The General, charming and enthusiastic, and his young ADC spent a couple of hours at Celle, and when, after lunch, I saw him to his jeep, he asked if there was anything I wanted for my personal use? From our lunchtime conversation, he knew I was a shooting man and shotguns could

The spoils of war! This 540 K Mercedes (note the roundel!) became the transport of the Group Captain commanding 125 Wing based now at Celle, in Germany

George Keefer rose, on record and performance, to become the Wing Leader of 125 Wing as the Allies' final advance to victory gathered pace

be obtained from the local town mayor, to whom all German sporting guns and rifles were being surrendered. But perhaps a suitable car …? The General never flinched when I said that if he came across a decent Mercedes Benz I could find it a good home.

That same evening I was having a pre-dinner drink with Terry Spencer, who had just returned from being brought down by flak over Lübeck Bay, when the ADC appeared and said he had brought a present from his General. We walked outside the mess and there stood, in all its glory, my gleaming, supercharged 540K Mercedes Benz.

The next day I went to see the town mayor, an old gentleman of First War vintage. He was not a shooting man and told me that at that very moment some shotguns were being bulldozed into the floor of an old quarry. We soon put a stop to this and a helpful Royal Engineers sergeant helped me examine the weapons. I left with half a dozen, including a Purdy with slightly pitted barrels and a scratch or two on the fine French walnut stock – but then beggars cannot be choosers!

MOSQUITOES – BY DAY AND NIGHT

For Laddie Lucas, the fighting in north-west Europe and Germany in 1944 and '45 provided an opportunity for a late – and rare – change of role. Denied by his C-in-C the chance of a third operational tour on single-engine, day fighters, he opted instead for a switch to twin-engine Mosquitoes, operating by day and night in 2 Group of the 2nd Tactical Air Force, in support of the Allied ground forces.

He found there a different ethos from the one he had come to know so well in the past three years of combat at home and abroad.

I wasn't quite blinded by the light on the road to Cambrai/Epinoy in northern France, but it was certainly an unusual conversion …

Two operational tours on day fighters, with all the exhilaration which combat could bring, were hardly a conventional preparation for a spell on Mosquitoes operating at low level, mainly by night, but sometimes by day, ahead of the advancing armies.

It was August 1944. The planning for the Normandy invasion and, with it, the work on the ploys to counter Hitler's latest V-1 weapon, were behind. I had already spent eight months on the staff at Bentley Priory, the HQ of Leigh-Mallory's Allied Expeditionary Air Force and Air Marshal Sir Roderic Hill's Air Defence of Great Britain, at Stanmore.

My rest period was therefore up. By now, my day fighter friends were either in France with their Wings or preparing soon to go. I felt an irresistible

(*11212) Wt. 40572—2665 20,000 1/43 T.S. 700
(*12278—11212) Wt. 15036—517 50M 6/43 T.S. 700 No. 9 Course FORM 414 (A)

SUMMARY of FLYING and ASSESSMENTS FOR YEAR COMMENCING *SEPTEMBER 15 *1944

[* For Officer, insert "JUNE"; For Airman Pilot, insert "AUGUST."]

	S.E. AIRCRAFT		M.E. AIRCRAFT		TOTAL for year	GRAND TOTAL All Service Flying
	Day	Night	Day	Night		
DUAL			7.00	1.55	8.55	89.25
PILOT and 2nd Pilot			29.05	10.25	39.30	1096.20 1077.20
PASSENGER	—	—	—	—		46.50

ASSESSMENT of ABILITY

(To be assessed as :—Exceptional, Above the Average, Average)

(i) AS A Mosquito† PILOT Average

(to be shown attitude of) (ii) AS PILOT-NAVIGATOR/NAVIGATOR Yes

(iii) IN BOMBING Above the Average

(iv) IN AIR GUNNERY Above the Average

(v) IN S.B.A.

† Insert :—"F.", "L.B.", "G.R.", "F.B.", "Instructor", etc.

ANY POINTS IN FLYING OR AIRMANSHIP WHICH SHOULD BE WATCHED

NIL

Date 11 . N . 44

Signature

Officer Commanding Training Wing : 13 OTU.

The scene changed for Laddie Lucas in the autumn of 1944. In a third-tour switch, he transferred from single-engine day fighters on to Mosquitoes of 2 Group in northern France, taking in, first, the conversion course at Bicester in Oxfordshire

urge to join them and get away from the office. But having had two rests on the Air Staff at Command HQ, I guessed my release would not be readily granted.

Roderic Hill, an erudite and courteous commander, was sympathetic. 'We would much prefer to keep you here on the staff, but as you obviously feel so strongly about going back to flying you must go and have a talk with the C-in-C.'

The opportunity arose the next morning after I had taken some papers in to Leigh-Mallory. 'Sir,' I said, 'my rest is up, my friends are either in France or getting ready to go. Would you let me lead a Spitfire Wing again?'

L-M looked mildly irritated that I had broached the subject. 'How old are you, Laddie?' he asked.

'I'm twenty-eight, sir, twenty-nine next month.'

'That's too old to go back now and lead a Wing again after two tours. Besides you're much more use to us on the staff.'

Anticipating such a response, I had earlier consulted Basil Embry, the newly-appointed AOC of 2 Group, with its Mosquitoes, in the 2nd Tactical Air Force. Basil had served on the staff at Stanmore and I had struck up a trusting relationship with him.

'I'll give you a job,' he had said, 'provided you are prepared to go down to Squadron Leader, learn to fly Mosquitoes properly at Bicester and don't put up any blacks.'

It was enough to carry the day with the C-in-C. 'All right,' he said, 'go off and fly Mosquitoes with 2 Group. I like your spirit, but I still think you'd be more use on the staff.'

RIGHT: Based at Cambrai/Epinoy from the autumn of 1944 to the surrender in 1945, No. 613 (City of Manchester) Squadron's Mosquito VIs, with Laddie Lucas in command, supported the Allied advance by day and night. Here are some of the sorties flown – to the Ardennes, to the Ruhr and the Rhine and along the autobahns from Berlin to the Baltic ports

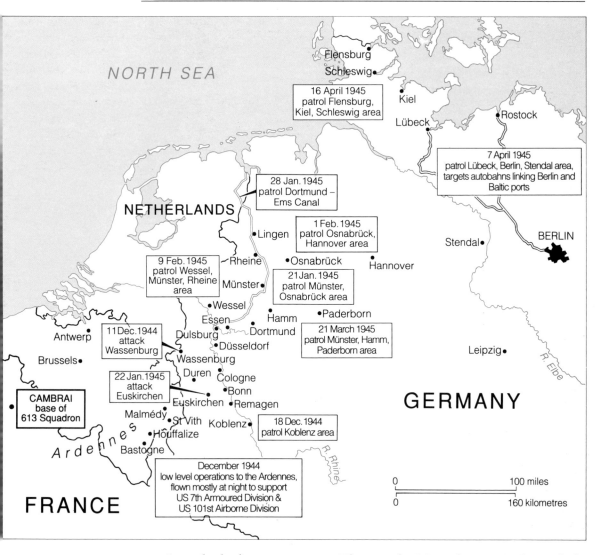

NORTH SEA

Flensburg
Schleswig●

●Kiel

16 April 1945
patrol Flensburg,
Kiel, Schleswig area

Lübeck● ●Rostock

7 April 1945
patrol Lübeck, Berlin, Stendal area,
targets autobahns linking Berlin and
Baltic ports

28 Jan. 1945
patrol Dortmund –
Ems Canal

NETHERLANDS

●Lingen

1 Feb. 1945
patrol Osnabrück,
Hannover area

Stendal●

●BERLIN

9 Feb. 1945
patrol Wessel,
Münster, Rheine
area

Rheine

●Osnabrück
●Hannover

Münster●

21 Jan. 1945
patrol Münster,
Osnabrück area

●Wessel

Essen●
Hamm

●Paderborn

21 March 1945
patrol Münster, Hamm,
Paderborn area

Leipzig●

Antwerp●

11 Dec. 1944
attack
Wassenburg

Duisburg●
●Dortmund

●Düsseldorf

R. Elbe

Brussels●

Wassenburg

GERMANY

22 Jan. 1945
attack
Euskirchen

Düren●
Cologne

●Bonn

CAMBRAI
base of
613 Squadron

Malmédy●
Euskirchen ●Remagen
●St Vith Koblenz●

18 Dec. 1944
patrol Koblenz area

●Houffalize

R. Rhine

A r d e n n e s

Bastogne●

December 1944
low level operations to the Ardennes,
flown mostly at night to support
US 7th Armoured Division &
US 101st Airborne Division

0 ———————————— 100 miles
0 ———————————— 160 kilometres

R. Rhine

FRANCE

I was lucky in one respect at Bicester, the Mosquito conversion unit, in Oxfordshire. My instructor there was Bomber Command's Charles Patterson,* who, earlier in the war, had gone through the gamut of 2 Group's appalling operations with the Blenheims, including some truly horrendous 'low-level daylights' into Germany. In one stretch of catastrophic casualties, Charles had gone from Pilot Officer to Squadron Leader in four weeks. Well-decorated himself, he had, moreover, flown alongside Hughie Edwards,† the great Australian holder of the Victoria Cross and much else besides, and had profited hugely thereby.

Teaching a day fighter pilot to fly Mosquitoes at night was clearly not an experience that he would have cared to repeat often. However, he succeeded in his mission so that when I arrived at Cambrai/Epinoy in the autumn of 1944, as the Allies were driving on into the Low Countries, I was sufficiently equipped to allow AOC, 2 Group, to keep his word. After a short supernu-

Squadron Leader C.E.
*atterson

Wing Commander, later
ir Commodore Sir
Iughie Edwards VC

merary spell with 107, Embry gave me command of 613, the City of Manchester Auxiliary Squadron, with its Mosquito VIs.

Cambrai, set in the flat lands of France's ugly industrial north, had been a Luftwaffe night fighter base during the German occupation. Well appointed with comfortable living quarters, constructed to high Teutonic standards, the airfield had been updated since the liberation with the latest landing aids. With these, the AOC expected the three Squadrons in the Wing to fly in most weathers.

I was fortunate in two respects in taking over this new and, for me, quite strange command. First, 613 had a fine mix of aircrew from the Commonwealth, including (then) South Africa, and from Europe. We had strength in depth. When I looked at the Canadian pilots' log-books, I found, to my surprise, that some of them had close to 3000 hours flying standing to their credit. They had been instructors in Canada for most of the war, piling on the hours in the Dominion's exceptional weather.

'For Christ's sake, Steve,' I said to our Adjutant, 'don't let these fellows see my log-

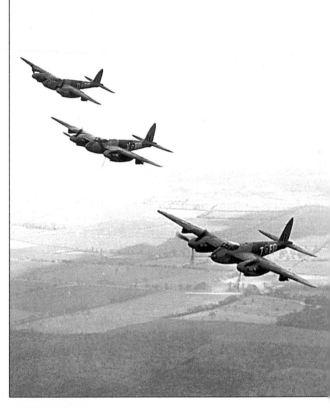

Embry's Mosquito VIs, flying at low level by day and night, offered succour for the advancing Allied forces and, in particular, for the hard-pressed US 101st Airborne Division making its heroic stand at Bastogne

Trying to smile their troubles away! Crews of 613 Squadron, with the usual 'needle', about to set out on a low-level daylight attack against a precision target

book. If they do they'll think I've only just learnt to fly.' Two tours on relatively short day fighter sorties had left me with rather less than 1200 hours flying.

The dedicated groundcrew – fitter, rigger and armourer – of the Squadron Commander's aircraft SY-L for London. 'Our kite', they called it

Second, I was given a thoroughly experienced navigator, Johnny Vick,* who wore the DFC ribbon and had been one of Cadbury's managers in Bristol pre-war. He was nearing the end of his own operational tour when he was freed to come to me for my first two or three months with the Squadron. And when Johnny had to go off on a well-earned rest, 'Jeff' Jefferies,† whose meticulous mind was later to take him to the higher reaches of the Civil Service, filled the void notably.

The lot of the navigators in Embry's 2 Group was a taxing one. On dark nights we were generally operating at little more than 1500 feet. With nothing except GEE as an aid (low down the GEE signals became so weak as to be virtually useless once we were beyond the Ruhr), the basic art of Dead Reckoning coupled with good map reading – picking out lakes and rivers in the dark, and even sensing familiar smells (Dortmund with the yeast and the brewing of beer was usually recognizable) – came acutely into play. Balloons, flak and rising terrain were the hazards on dark nights.

*Pilot Officer, later Wing Commander, J.W. Vick

†Flying Officer G.P. Jefferies

Given command of No. 613 (City of Manchester) Squadron in 138 Wing at Cambrai/Epinoy, Laddie Lucas was blessed with successive navigators of rare quality – first J.W. 'Johnny' Vick (LEFT) and then, second, with Patrick 'Jeff' Jefferies (CENTRE) who brought a meticulous Civil Service mind to bear upon an exacting task. Howard Simpson (RIGHT), one of 613's two Flight Commanders and a Canadian captain of undoubted worth, was another who made the switch from day fighters to 2 Group's Mosquitoes for a third operational tour

In the bright moon period, we pushed the height up to around 3000 feet, but even at this altitude we felt naked.

Navigational accuracy was especially demanded as the bomb line – the safe bombing distance in front of the advancing armies – was being moved eastward beyond the Rhine and deep into the Third Reich. Precision was needed, too, to find the interdiction targets which were our goal – marshalling yards, railway junctions and bridges as well as armour and troop concentrations, and motorized convoys moving with no more than pinprick lights along the autobahns.

A high premium had also to be paid by the leaders for first-class navigation and map reading on the low-level daylight missions to Wehrmacht barracks, Gestapo HQs, prisons and the like. To hit these small targets on the nose, often in built-up areas, and place our four 500-lb bombs where they hurt, demanded efficiency from each crew. I must confess that in these late days of the war there were times when I yearned for the single-engine fighter role, high up in the heavens, where combat, when it occurred, was over in minutes if not seconds.

• • •

Events still stand out plainly in retrospect.

There was a night when, with a little luck and some astute navigation, Johnny Vick and I caught a long motorized convoy gliding like a dark snake south-eastward down the autobahn from Lübeck to Berlin. The Germans were making good use of their Baltic ports to move supplies and this roadway often bore fruit.

The last Christmas of the war – and what a Christmas it was – with Field Marshal Gerd von Rundstedt's last great counter-attack through the Ardennes in eastern France. This camera still came from a captured German film

Aiming the nose of the Mosquito (these aircraft carried no bomb sight) short of the leading trucks and pulling up smoothly through the target we let our bombs go to score a bullseye right at the front of the convoy.

With the first vehicles spreadeagling off the autobahn, everything came to a sudden halt (except the fairly vigorous flak). Two or three runs back and forth along the length of the target, until all the ammunition in our four 20 mm cannons and four .303 machine guns was expended, drew good results. Fires, fanned by a strong wind, spread nicely along the full extent of the convoy – and so, too, did the explosions ...

In contrast, the last fortnight of the year, when Field Marshal Gerd von Rundstedt, in the Germans' last great throw of the war, was driving his Panzer armies through the snows of the Ardennes, was a hazardous time for 613 and the other two Squadrons at Cambrai. The enemy's major thrust was aimed broadly at driving a wedge between the British and the US armies and, through it, pressing on to Brussels and Antwerp, there to capture this vital port which succoured General Montgomery's northern armies. Had the plan succeeded – and with seventy divisions, fifteen of them armoured, on the Western Front it might well have done – things would have been grave indeed for the Allies.

Here, I must digress and interpose an important reflection upon von Rundstedt.

I have a lifelong friend, one Charles Pretzlik, a wartime Mosquito intruder pilot in the Royal Air Force, who lives with his wife, Susan, in an enchanting house – the Miller's House – in the little Hampshire village of Isington. For years, Field Marshal Montgomery lived nearby in the Mill House. On the day the Pretzliks moved in after the war, the Field Marshal invited them to dinner.

Montgomery showed Pretzlik his famous caravan which stood in the garden. Inside, a striking picture of Rommel, the Field Marshal's opponent at Alamein, sprang out amid all the memorabilia.

'I suppose,' said Charles, by way of comment, 'Rommel was the best of their generals?'

'Rommel? Rommel?' retorted the Field Marshal in his clipped and repetitive, staccato style, 'Rommel? Good cavalry officer, good cavalry officer ... No, von Rundstedt was the best. Unquestionably the best.'

I doubt whether any of us at Cambrai would have quarrelled with the assessment during that trying run up to Christmas and the New Year when the weather, with fog, snow and freezing temperatures, was atrocious at base and even worse up in the mountains on France's eastern frontier.

Night after night we went to the limit to aid the US 7th Armoured Division and, in particular, the US 101st Airborne Division then maintaining its heroic tenure of the important roads junction of Bastogne.

I was becoming much exercised at the toll which this unrelenting effort was taking of the Squadron – groundcrews as well as aircrews. Tiredness in such conditions, with onerous responsibilities resting on the navigators, was as much of a hazard as the enemy's ground defences.

Embry telephoned soon after mid-day, just as we had woken after the Squadron's fourth successive night on the trot. I knew the voice so well. There was an urgency in it as I listened … an urgency mixed with a touch of drama.

'Could 613 manage one more heave tonight in support of the gallant American stand in the mountains?'

Saying, 'Yes, of course, sir' (it was more than a Squadron Commander's life was worth to decline an operational call from the AOC), I nerved myself to add a cautionary rider. 'I'm a bit bothered, sir, about tiredness among the crews. They'd do anything, go anywhere in support of the Americans slogging it out in the mountains. But they're under the whip, sir, in this awful weather, trying to identify these pinpoint targets with so little distance between our forces and the enemy. Fatigue is a hazard in these conditions.'

The retort was immediate. 'Get the Doc to come over to the Squadron an hour or so before take-off and give the crews a shot. That'll help them …'

Doc Buckler* came over soon after 2100 and administered the doses. First off at 2240, neither Johnny Vick nor I felt in need of a stimulant.

Half an hour before we were due to be airborne, Operations called me. 'It's the AOC on the line.'

'Laddie, the weather's closed right in in the mountains. I'm not having your chaps operating in that. The Squadron's stood down. Let the crews get a good night's sleep and be ready for tomorrow night.'

With most of the crews now pepped up to the eyeballs, the party lasted till dawn!

• • •

Like Hugh Lloyd in Malta two years before, Basil Embry was, for me, a Squadron Commander's AOC. You always knew exactly where you were with

*Squadron Leader F.R. Buckler

Basil Embry encouraged his medical officers (and others) in 2 Group to fly. In 138 Wing at Cambrai/Epinoy, Squadron Leader Freddie Buckler, the MO, was one who needed no encouragement and was highly respected thereby by the aircrews

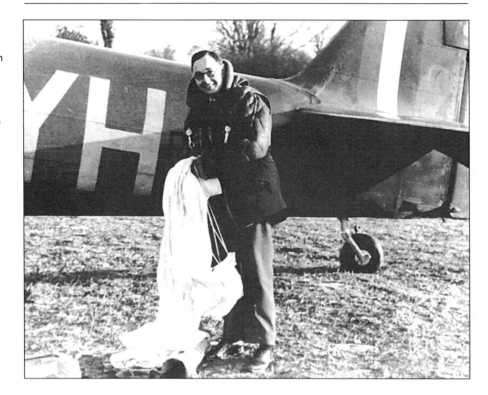

him. He was the most direct senior officer I encountered in the Service. More-over, he could gauge to a point the extremities to which crews should be driven – and then know when it was right to ask them to go a little further. Against this, I always felt he had, behind all the bravura, a generous under-standing of humanity which stood him apart. A first-hand experience left me in no doubt about it.

Quite a senior Squadron Leader, holding a pre-war short service com-mission, was sent to me in a supernumerary capacity by 2 Group HQ. I was to say in due course whether I thought he was 'Flight Commander material'. This officer had served in India before the European war, where he had suf-fered grievously from a horrible aircraft crash on the North-West Frontier. He was lucky to have survived. He had not flown operationally since.

We had him well crewed up with a good navigator, but I could see that, after his earlier experience in India, the operations which we were then engaged upon were trying his spirit to its limit. I spoke with him about it maybe a couple of times and left him in no doubt at all that if the burden became intolerable I would see to it that other arrangements were made which would not be to his detriment. His answer was that he was utterly com-mitted to seeing his operational tour through no matter how difficult that might be.

I admired his resolve, but then I began to wonder whether it was right to allow him to be subjected to such individual pressure; I thought, too, about his navigator. Was it fair to him?

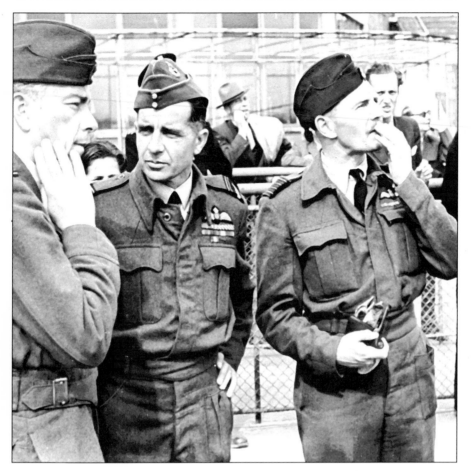

None gave the US forces greater support, high up in the Ardennes, than Basil Embry *(centre)* and his 2 Group. The AOC is seen here with two fine members of his Staff, *(left)* Peter Clapham (who also served as Embry's navigator on the 'low-level daylights' in which the two often took part) and *(right)* Bob Bateson, another exceptional formation leader

While I was turning these thoughts over, a vacancy arose for a Flight Commander in the Squadron. I told the Squadron Leader that I was recommending him to our AOC to fill the slot. However, before I did so, I wanted to be sure he felt equal to the challenge. I can still remember his answer. 'If I get the job, I can assure you I won't let you down.'

He saw out the war with a resolve which I will never forget. As a professional officer, he ran a first-class Flight. But I never doubted that he found the task harder to fulfil than others carrying the same responsibilities and facing the same hazards ...

We were now in the final stages of the war in Europe. The AOC visited the Squadron for the last time while I was in command. After a brief look round and a talk with the crews, he asked to see me in my office alone. As was his custom, he put his nose no more than six inches away from mine and fixed me with those dark-blue, unwavering eyes. There was a theatrical silence before he spoke.

'I just wanted to say, Laddie, that 613 is a credit to 138 Wing and to 2 Group. You have led a fine Squadron. Is there anything you want to ask me or say to me in confidence?'

'Yes, sir,' I said, 'there is one thing.' I then told him the story of the Squadron Leader. I ended by saying that I wanted to recommend him for the Distinguished Flying Cross. 'In all the time I've been operating, sir, I have not met anyone who deserved a gong more.'

Embry showed no emotion as I said my piece. His eyes remained drilled into mine, his nose still no more than six inches away. There was a pause which felt like fifteen seconds, but probably was no more than five.

'Do you want me to make it "immediate"?'

In my experience, the Air Marshal never went back on his word …

PART IV

THE FINAL RECKONING

With the Allied forces now across the Rhine and driving ever deeper into Nazi Germany, and with the Russian troops pushing hard from the east, enemy air space and potential targets were being quickly curtailed. Five long years of war stretched behind.

Those in the Squadrons and Wings of the Royal Air Force who had travelled the full journey could now begin to measure the true distance which had been covered since, on that sunny Sunday morning in September 1939, Neville Chamberlain had gone to the radio and, in his thin yet unambiguous voice, had told the British people that they were now at war with Germany.

Johnson and Lucas, in their respective roles, were among the fortunate ones who had seen the full gamut of operations unfold, and come through unscathed. In the run-up to the final surrender, and beyond, each could now look back – and forward – and take stock.

Between the two, their operational experience had been very wide. For one, there would be a future of advancement within the Service; for the other, peace would bring a return to civilian life. The final reckoning would soon be at hand. Meanwhile, there was an opportunity to reflect ...

CHAPTER 17

STAFF DAYS: FLYING A DESK

The Luftwaffe, in the normal way, had no system of rest periods for operational aircrew in the Second World War. The Royal Air Force, on the other hand, was quite definite about it. A tour of flying with one of the operational Commands was expected to be followed by six months on some less exacting pursuit.

Johnnie Johnson, by guile, subterfuge or disguised chicanery, contrived to avoid any but the briefest spells away from operations. Laddie Lucas, by comparison, was much less adept. For reasons which he here explains, his two rests were spent on the Air Staff at Command HQ from which escape was never easy.

To be posted, after a tour of operations, to a Command, as opposed to a Group, HQ staff, was generally regarded as literally the end of any chance of ever getting back on operations again. Once into the swim of that rarefied ethos, rubbing shoulders with the Service's alumni and handling secret plans and discussing them before they reached Group level, one was said to be doomed forever to 'flying a desk'. Talk about Blake's Dark Satanic Mills.

Things could hardly have turned out more differently for me. I actually enjoyed my time on the staff, where I occupied, during my first spell at Bentley Priory, the humble chair of Squadron Leader Ops 1 (b) in the Day Operations Branch of HQ, Fighter Command. I found it absorbing and, more surprisingly, fun. There were good reasons for this. As a peacetime journalist on the editorial staff of Beaverbrook's *Express Newspapers*, the digging out of detail, checking facts and leads, speaking with interested parties and putting the result together in a simple, clear and tightly-written piece tailored to space appealed to me. So this form of staff work, with its draft operation orders, minutes, memoranda and checking with the files, came easily.

Second, if one served on the Day Operations side of the Air Staff at Fighter Command in the autumn of 1942 one started with an absorbing set of personal circumstances.

The Group Captain Operations, one Theodore McEvoy,* 'Mac' to everyone everywhere, was, I suppose, as able and as accomplished a staff officer as Cranwell and the Royal Air Force had ever produced. That he finished his Service career, post-war, as Air Secretary at the Air Ministry confirms the con-

*Group Captain T.N., later Air Chief Marshal Sir Theodore McEvoy

tention. Cruelly bent by the onset of crippling spondylitis (curvature of the spine) which would have sapped the spirit of lesser men, Mac's morale never sagged. With his appealing wit and engaging little quips, he was always (outwardly) cheerful.

He would put his head through the hatch in the wall which separated our offices and announce with a twinkle, 'I'll be out for an hour. I'm off to see if the medicos can still slip a cigarette paper between my chin and the ground.'

The next day, around lunchtime, the same face might appear through the hatch to say, 'I'm off to Northolt to see if I can still fly a Spitfire for half an hour.' Mac was an able pilot. A one-time CO of the famous No. 1 Squadron, he had also commanded Northolt, the Battle of Britain fighter station and home of the Poles, west of London, where Fighter Command now kept its flight of ageing aeroplanes. There, despite his affliction (he had mirrors sewn on the backs of his flying gloves to help him see if there was anything behind), he kept his hand in.

Sharing the office with me, next door to McEvoy, and acting as a filter between my work and the Group Captain, was Wing Commander Ops 1 (a). In my months at Fighter Command, this chair was occupied by two exceptional officers of contrasting personalities and style, and of rare talent.

Between the HQ Staff of the USAAF's Eighth Fighter Command at Bushey, Hertfordshire, and the Staff at Bentley Priory there was a good rapport. Barrie Heath (*left*) and J.C. 'Jake' Stanley typified the closeness of the link

My first co-occupant, Barrie Heath,* had flown continuously from Dunkirk, all through the Battle of Britain and into Sholto Douglas's period of 'leaning out over France'. He had operated with 611 Squadron before becoming the CO of 64. His father, George Heath, was a director of the Rootes motor company, steeped in the industry and very wealthy. He gave 611 a Spitfire while his son was with the unit. It cost him £5000 in the money value of the early 1940s, maybe closer to £1.5 million today.

Barrie, possessing a chip or two off the old block, was tough, practical, not particularly good on paper, but businesslike. He had a mind which quickly got at the core of a problem. He enjoyed 'the fun of life' and he liked

*Wing Commander B., later Sir Barrie Heath

his practical jokes. He had been sent a calendar from the United States which he pinned up on the office wall. It had a painting of the Californian coastline on the front, an appealing promontory on which stood a lighthouse, proud and tall. The picture carried an unlikely caption: 'Old Point Comfort.'

We warmly invited any WAAF officer, when passing, to call in and see 'our fine new calendar'. Compliments were paid at the unusual beauty of the scene.

One evening, Barrie and I had to go back to the office to finish off a job for Mac. As we approached along the passage, we could hear girlish giggles coming from the half-open doorway. We tiptoed the last few yards. Inside were three WAAF officers – super girls all of them – from the Ops Room. Caught in the act, their embarrassment was complete.

They had taken the calendar down from the wall and given it a half-twist sideways. All of a sudden, the Californian promontory had become a man's naked front, the lighthouse an outsize and fully erect male member!

• • •

It never surprised me when, in the 1960s and '70s, Barrie Heath rose to the summit of, first, Triplex Glass and then, a little later, of the engineering giant GKN. The ability was always there.

In 1942, David Scott-Malden led the Norwegian Wing at North Weald with balance and resource. Subsequently, he applied an acute intellect to the work of the Day Operations Staff at Command HQ. It made a rare double in the Service

When he departed for the Middle East, his place was taken by David Scott-Malden fresh from a distinguished run as the leader of the Norwegian Wing at North Weald. Here was the quintessential staff officer, with one difference. Not only did he have the academic qualification – scholar of Winchester and King's, Cambridge, and then a 'First' in the Classics Tripos – he also knew the day-fighting art from A to Z. It was an unparalleled double. Moreover, David had a quiet and undemonstrative humour which complemented our Group Captain's nicely. There passed between these two on the files (often marked 'Top Secret'), a flow of minutes and memoranda which placed an idiosyncratic stamp on the Day Operations Branch at Fighter Command in the closing months of 1942. Examples linger in the mind even now.

There was the text of a lecture which came into the office for clearance. It was on the subject of air defence and was to be delivered at the Turkish Staff College. It had been endowed with a long and unnecessarily convoluted title. David passed it through to McEvoy, who at once cleared the content, but amended the title to two characteristically short and simple words – Air Defence. A minute accompanied it on the file: 'I have taken the liberty of amending your title on

the theory that your title, meaning little in English, might mean even less when translated into Turkish.'

Then there was the file presided over by David which dealt with correspondence from civilians outside. One letter came in from a correspondent named Robinson, leader of a Rescue squad on the south coast, who was suitably indignant at the enemy's tip-and-run raids on coastal towns. It was couched in familiar working-class English: 'What the bleedin' 'ell are you doing about these bastards wot keep dropping bombs along the coast? If it's aireydromes you're short of, me and my mates have got picks and shovels and will soon run you up some.'

Having seen the incoming letter, Mac minuted Ops 1 (a):

> *If Robinson's Rescue-men try*
> *Our fighters will darken the sky:*
> *They'll have strips to alight on,*
> *At Bournemouth and Brighton,*
> *And Ramsgate and Romsey and Rye.*

One telling sally on the staff usually begat another. Mac had a cherished friend, one Squadron Leader Laurence Irving, son of Henry Irving, who had inherited his distinguished father's talent for the arts. Laurence, a First World War pilot, was Chief Intelligence Officer of No. 35 Tactical Reconnaissance Wing. As such, he wrote and published a periodical, *News Sheet*. It frequently contained gems which Mac collected. Two come handily to mind.

One of the squadrons in the Wing had been sent up to York for an exercise with the Army at a time of very poor winter weather. The *News Sheet* accorded this movement an unusual slant:

> *Now is the winter of our discontent*
> *Made glorious summer by this sun of York*
>
> Richard III (who can't have known the place well!)

However, on reflection, I seem to recall that the piece of Irving's doggerel which perhaps appealed to Mac the most concerned the Wing's enforced departure from its temporary base at Sawbridgeworth, near Bishop's Stortford and Much Hadham, in Hertfordshire. Heavy rain had turned the airfield into a quagmire and made the tented accommodation virtually uninhabitable.

> *Move on you jolly campers!*
> *Farewell to Sawbridgeworth!*
> *Where everything is clampers,*
> *The dullest place on earth.*
> *Move out from winter quarters!*
> *If they exist as such*
> *The joys of Bishops Storters –*
> *We haven't Hadham Much.*

● ● ●

Sholto Douglas* presided over the Command as C-in-C for much of my first spell there on the staff until, towards the end of the year, he moved out to the Middle East. Trafford Leigh-Mallory† then took his place.

Sholto Douglas was a 'big' man in every sense – big in physique, big in mind. He had the ability to stand back from current events and take the long view. (Not many could.) He gave himself plenty of 'think time'. Some said too much 'play time'. Sholto certainly enjoyed the good life.

Not unlike Göring in appearance, his first-class mind had not been allowed to find its desert at Oxford in his undergraduate years, which were cut short by the outbreak of the First War in which he was to command the famous 43 Squadron on the Western Front.

A confident buccaneer, Douglas always seemed to me to have the measure of his masters whether at the Air Ministry or among Government ministers. He exuded authority: he certainly wasn't intimidated by it. He was rock-solid in defence of his own corner – and that of his Wing and Squadron Leaders. One instance of his stability under pressure still sticks in the memory.

It was a week-end – a Saturday – at the end of September 1942. In an operational nightmare, 133 Squadron, one of the three US Eagle Squadrons in the Royal Air Force, flying that day from Bolt Head, in south Devon, had been wiped out on one of the USAAF's early sorties with the B-17s, this time to Morlaix, an airfield on the Brittany peninsula. It was a short and straightforward mission: very elementary.

The met forecast had got it all wrong. Cloud, much of it 10/10ths up to 15,000 feet, extended across the southern English Channel to Brittany. The wind gradient which, at around 20,000 feet, had been given at some 40 mph from the south-west (i.e. off the right front going out), proved, in fact, to be nearer 100 mph from due north (i.e. very strongly behind on the outward leg).

When rendezvous was not made with the bombers, the leaders of the escorting Squadrons returned to base. However, 133 Squadron, led that day by a comparatively inexperienced British Flight Lieutenant, pressed on above cloud. Blown miles south, almost down to the Spanish frontier, and far out of radio contact with base, the Squadron was never going to have the gravy to make it back.

Tanks actually ran dry near the south-west French port of Brest – and that was that. An Eagle Squadron, equipped with the latest Spitfire IXs, was strewn all over the Brittany peninsula. Here was a military and political disaster of the first order.

We passed the rough news to Sholto Douglas, spending the week-end at Chequers with the Prime Minister and others among the Service chiefs. It was hardly the sort of tidings he wanted to hear on a visit to Churchill. There was no comment, no emotional reaction as he absorbed the catastrophe. He listened in silence …

After a longish pause came his instructions. He would be back the following evening: a full report must be on his desk. He would chair a meeting at

*Air Marshal William Sholto Douglas, later Marshal of the Royal Air Force Lord Douglas of Kirtleside

†Later Air Chief Marshal Sir Trafford Leigh-Mallory

0900 on Monday. He gave a list of the names to be alerted at once to attend ... That was all. It was an effective demonstration of mind control under the whip.

I never once saw Sholto flap or appear in any way deranged in the face of real pressure.

• • •

It was almost twelve months to the day when I returned to Bentley Priory to begin my second stint on the staff – this time as Wing Commander Ops 1 (a) to follow my two previous colleagues, Heath and Scott-Malden. A tour of operations had again intervened.

The place had changed utterly. Occupied by Leigh-Mallory's Allied Expeditionary Air Force, the invasion instrument, and by Roderic Hill's Air Defence of Great Britain, there had been an influx of staff officers, US and British. Accommodation was bursting and the staffs were buzzing with the planning of Overlord – the invasion of Normandy – and with the critical intelligence advice that the advent of Hitler's 'secret weapons', the V-1 and the V-2, could not long be delayed.

As the work went ahead, an unexpected divergence appeared in the staff methods of the British and the Americans. It caused unease on both sides. Secrecy was, obviously, paramount.

Problems arose when it came to passing a Top Secret memorandum from one department to another. The British, in the time-honoured fashion, attached the paper to the appropriate file and passed the whole *en bloc* to the next man.

The Americans, eschewing cumbersome files, opted for the single, superflimsy sheet marked 'Top Secret' in small letters in the top left-hand corner. The orderly would bring it into the office and place it lightly on top of the in-tray. As he withdrew, opening and closing the door after him, the draught lifted the sheet high into the air and blew it straight out of the open window!

Frantic searches followed, tempers became frayed – yet the D-Day secret remained secure ...

McEvoy had, by this time, departed for the Air Ministry and his place had been taken by 'Count' Stevens,* a popular Scot and a peacetime Auxiliary with the City of Edinburgh's 603 Squadron. Steve had moved over to Bentley Priory from 11 Group HQ, ten or twelve miles away – an easy transition. Sharing my office was an old Irish friend, the Dublin solicitor, Dermot Macgillycuddy,† one of a number of his countrymen who had foregone the safe, neutral life and joined the Service at the outbreak of war to make our cause theirs.

Events now moved on apace as D-Day and the Flying Bombs approached. Conferences abounded. I was in the C-in-C's office one morning when Dick 'Batchy' Atcherley,‡ one of the Royal Air Force's celebrated twins, answered a call from Leigh-Mallory.

'Dick,' said L-M, 'I've been discussing the idea with the Air Commodore.§ I feel we should have a landing strip here at HQ. C-in-C, Bomber (Sir Arthur Harris) tells me that the strip he has got at High Wycombe is

*Group Captain E.H. Stevens

†Squadron Leader D. Macgillycuddy of the Reeks

‡Group Captain R.L.R., later Air Marshal Sir Richard Atcherley

§Air Commodore K.B.B., later Air Chief Marshal Sir Kenneth Cross

The C-in-C of AEAF, Trafford Leigh-Mallory, wanted a landing strip at Bentley Priory to aid communications. Dick Atcherley provided it, *pronto*. He was warned about the surface before making the first landing. Here he is, extreme left, (*above*) walking away from it in some displeasure! (*right*) The ignominy is compounded!

invaluable and a great convenience for people coming from a distance to meetings: saves hours. Will you think about it?'

Batchy needed no encouragement. Within 24 hours, bulldozers, mechanical cross-saws, tractors, trucks and numerous US personnel from the Airfield Engineer Regiment, with the peaks of their caps turned up like American engine drivers, had moved in on site.

Scots firs and pines, some 100 feet high and as many years old, arboreal treasures, came crashing down in a great cacophony of noise, no more than 300 yards from my office window. In no time heavy implements of all kinds had cleared a good swathe through the forest and the undergrowth and had the strip ready for use.

Batchy had, however, forgotten one important element. The whole area was strictly Green Belt and no Planning Consent had been obtained to disturb it. The row embraced Bentley Priory, the local authority and Westminster for days!

Came the moment for the opening and the first landing. Batchy, a brilliant pilot in his own right, having borrowed a little Auster from a nearby Army AOP unit,* was determined to have the first shot. 'It'll frighten the life out of the staff,' he said, 'to see an aircraft at Bentley Priory!'

'Sir,' I had said to him, 'I don't fancy the surface. It looks much too soft for comfort to me. My guess is that the Auster might dig in and tip over ...'

'Rubbish!' he retorted. 'Put an Auster down on anything.'

I waited by the strip with my camera to record the historic landing. The aircraft finished on its back!

· · ·

Meanwhile the V-1s had started to rain down in limited numbers here and there around the capital. Operation Crossbow, the code name for the counter-measures to be employed against this weapon, had now come urgently into play. Great concern from the Prime Minister downwards was expressed for their success. Churchill had appointed his son-in-law, Duncan Sandys,† chairman of the Crossbow Committee with extensive power to act.

Staff days at Bentley Priory, the HQ successively of Fighter Command and then the Allied Expeditionary Air Force and the Air Defence of Great Britain. Few events caused the Air Staff more concern than the advent of Hitler's 'secret weapon'. Here is a pilot's view of a V-1

Duncan, who, years later, in our time together in the House of Commons, would become a friend, resolved to see everything at first hand for himself. (He became like that as a minister, exasperating civil servants and advisers alike.)

The C-in-C deputed me to take him and his two military assistants, Colonels Post and Wardell, to see for themselves the defences at work. We set out from Northolt early in the morning of 20 June in an old Airspeed Oxford (top speed circa 120 mph) bound for West Malling, Detling, Newchurch and Ford, key airfields in the defensive outer ring round London.

Between Detling and Ford, one of these pilotless aircraft passed in front of us, travelling at maybe three times our speed. 'Let's chase it,' said Sandys, 'I'd like to see one close to.'

Met with a discouraging look, he wouldn't be put off. 'We're obviously close to their track today, let's go up two or three thousand feet, get up speed and dive on the next one that comes in.'

One evening at dinner, more than four decades later, I recalled the experience. 'I remember it well,' he said. 'You weren't at all enthusiastic!'

· · ·

Brought up as a reporter in Fleet Street and trained to observe, to note and to listen, I found such pre-D-Day conferences as I was required to attend instructive. Much as I liked Leigh-Mallory personally, he never struck me as

*Air Observation Post
†Later Lord Duncan-Sandys

being an easy or relaxed, natural chairman of a meeting – not, for instance, as I had remembered Sholto Douglas before him. He always seemed to me to be on the alert, as if expecting something untoward to turn up.

It did – one afternoon when he was presiding over a discussion to consider the merits of some operational plan. It was attended by few with any up-to-date operational experience. It brought L-M into conflict with Desmond Scott,* an exception, and soon to become the resourceful and splendidly aggressive New Zealand leader of 123 Wing, the rocket-firing Typhoons. It was this Wing which later caused such havoc among Günter von Kluge's Seventh German Army in the battle for the Falaise 'pocket'. Scottie, whom I had known since earlier in the war, had by now become a close and dependable friend. He was as fearless on the staff as he was in the air, saying exactly what was in his head, never mind who might be listening.

The altercation came right at the end of a fairly desultory meeting. Scottie, sitting, bored, at the far end of the table, had not spoken – contrary to his usual opinionated style. The C-in-C caught his eye. 'Squadron Leader Scott, we haven't heard much from you this afternoon. Tell us what you think.'

It caught the New Zealander off guard, as he later recalled, 'Conscious of two rows of balding heads turning towards me, I hesitated before I blurted out my reply. "I don't, sir," I said. "The plan you are adopting is a lot of cock!"

'There was dead silence. The Air Marshal looked daggers at me and then pointed to the door which, thankfully, was at my end of the room.

'"Out," he thundered.'

Staff work at Bentley Priory in those busy days of 1944 had its moments.

*Squadron Leader, later Group Captain, D.J. Scott

CHAPTER 18

A SERVICE AT WAR: THE RESILIENCE OF THE ROYAL AIR FORCE

Many have pondered how it was possible for the Royal Air Force to administer its vast wartime expansion and so effectively bring under its wing volunteers from the Commonwealth and the United States as well as the escapees from Nazi-controlled Europe. Laddie Lucas saw much of the transformation in the units with which he served.

It says much for the command structure of the Royal Air Force that, when war came, the Service was able gradually to absorb – and go on absorbing – its massive operational expansion. Nothing was more remarkable than its ability to accommodate, in relatively short time, the various Allied nationalities – the Poles, the Czechs, the Norwegians and the Danes, the Dutch, the Belgians and the French. Many of them had braved real dangers to make their ways to the United Kingdom, as the enemy was overrunning much of Europe and Scandinavia, here to continue the fight against Nazi Germany.

There was also another side to it. Quite extraordinary, too, was the comparative ease with which, despite the language difficulty, the Europeans and the Scandinavians fitted into the operational mix. I well remember Karel Mrazek,* one of the most accomplished Czech leaders, telling me that when he escaped to this country in 1940 he could not speak any English. He was typical not only of many of his countrymen, but also of a number of the Poles. Yet, within the space of a few weeks, he – and they – had mastered the operational language and procedures sufficiently to be welcomed into our fighter Squadrons to take their places in the line, side by side with our pilots.

Many of these escapees had, of course, already been fighting the Luftwaffe in the Polish *Blitzkrieg* and in the Battle of France. Their experience was thus often as great, if not greater, than that of their British counterparts. They formed their own Squadrons and Wings but, as time went by, the exceptional ones' ability was such that a few were placed, on straight merit, at the head of Royal Air Force formations. There, they had no difficulty in asserting their authority and leadership. They were at once accepted by their subordinates.

*Group Captain, later Major-General, Karel Mrazek

The outstanding names come readily to mind.

There were the two Frenchmen, Bernard Duperier, whom we all called 'Skip' (why, I know not), and René Mouchotte. Duperier was thirty years old

Persona grata all round! Left to right: Jack Charles (Canada), René Mouchotte (France), Sailor Malan (South Africa) and Al Deere (New Zealand)

when, in 1940, he left his family in France and followed his precarious route to England. He became a Flight Commander in 242 Squadron at Manston during its disagreeable 'Channel stop', anti-shipping role; then, after commanding 341, the Free French unit at Biggin Hill, he was promoted to lead the Wing, the first French officer to command a Wing in the Royal Air Force.

René Mouchotte was cast in the classical French mould. His background and well-educated, cultured mind gave him a natural authority and ascendency. The tall, pencil-thin and erect figure, immaculate in his dark, well-cut tunics, made him a striking officer in any company. His slender hands and tapered fingers, often holding a cigarette in a long and delicate holder, were used sparingly in conversation to emphasize a point or dispose of an argument. Behind a modesty – almost a reticence – there was hidden a will which drove him unhesitatingly into the fight for the liberation of his beloved country.

When René was eventually killed, shot down during a skirmish over enemy-occupied territory, he was on his 408th operational sortie. He was leading the Biggin Hill Wing that August day of 1943, standing in for the brilliant New Zealander, Al Deere,* whose aeroplane had become unserviceable as he was taking off.

One suspects that Mouchotte may have been something of a fatalist, for he had earlier exposed his mind in his diary: 'If I am not to survive this war, let me at least have the satisfaction of falling to the enemy's fire ...'

Flying number two to René that day was a French sergeant pilot, Pierre Clostermann,† who became separated from his number one in the mêlée and had gone off, chasing after a FW 190. It was not the first time that the then inexperienced Clostermann had lost his leader and been sharply admonished by his Flight Commander and countryman, Captain Chris Martell. It provoked Deere, some years afterwards, into making a pointed criticism.

*Wing Commander, later Air Commodore, Alan C. Deere

†Later Wing Commander P.H. Clostermann

'[Clostermann] should have been aware of the golden rule in the wing: a number two must never lose his leader. This may sound a harsh rule, but it paid dividends ...'*

• • •

When, in January 1943, Leigh-Mallory, C-in-C of Fighter Command, detailed a few of us to establish at Chedworth, in Gloucestershire, and later at Charmy Down, near Bath, what was then called the Fighter Leaders' School, a number of the exceptional Allies came on the first two refresher courses. It struck me then that the Norwegians blended into the Royal Air Force idiom and made their mark as comfortably and effectively as any of their European counterparts. They seemed closer to our Anglo-Saxon mentality and temperament. They were easier to handle than the Europeans and yet none could doubt their intense desire to get to grips with the enemy.

Their two fighter Squadrons, 331 and 332, which formed the North Weald Wing in 11 Group, had, for a while, a highly competent Dane as the leader. Kai Birksted† – he became 'Birk' to one and all – had a flair for Wing leading in the sense of being, like the great US leader of the Fourth Fighter Group, Don Blakeslee,‡ a 'general' who preferred to oversee and control a whole operation rather than seeking out and creating personal opportunities for himself to score.

Birk once told me that he considered the 'bottom line' in a Wing's account as containing the vital statistic. The debits (losses) had to be set against the credits (victories) before sending off the balance sheet for audit. One of the Norges in the wing, Ragnar Dogger,§ with a bent for research, established from the operational records that, during the period in 1943 when Birksted was at the helm at North Weald, the two Squadrons shot down more enemy aircraft for fewer losses than any other wing in 11 Group. The ratio represented an earnest of the leader's philosophy.

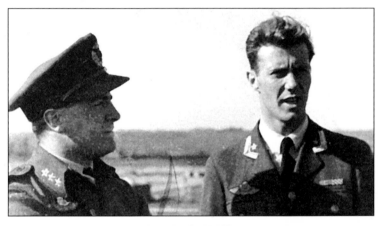

A pair of accomplished Scandinavians: *left to right* – Lt Col Rolf 'Ice' Berg, Norwegian Wing Leader, and Col Kai Birksted, Danish Leader of the Norwegians' North Weald Wing

And (*left*) from the ancient Norwegian House of Christie (a forebear had been Speaker of the Norge Parliament) came Werner of that ilk to lead the Hunsdon Wing of P-51D Mustangs on the long-range missions into Germany

Nine Lives (Hodder & Stoughton, London, 1959)

†Lieut-Colonel, later Colonel, K. Birksted

‡Colonel D. Blakeslee

§Major Ragnar Dogger

Another Norwegian who immediately caught the eye at Charmy Down, and upon whom the Royal Air Force was later to bestow the responsibility of leading British Wings, was Werner Christie.* Like Birksted, Christie, who came from an old-established Norwegian family (a forebear had been President – Speaker – of the country's parliament), won a DSO and a DFC on fighters. His brother Johan did the same with the Pathfinder Force in Bomber Command, while his sister Katrine rose to the summit of the Royal Norwegian Air Force's Women's Service, a unique family treble.

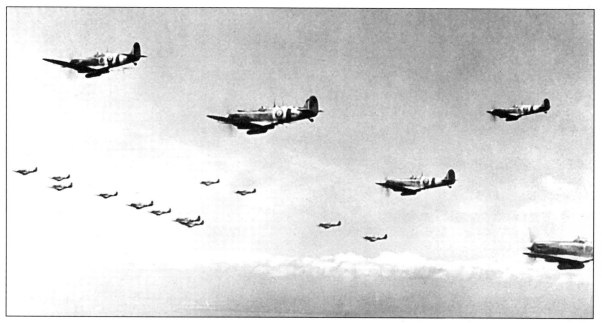

But the Norge Wing at North Weald owed its first allegiance to the Supermarine Spitfire IXs of 11 Group and Fighter Command

Late in the war, Werner, by now a proven leader, commanded the Hunsdon Wing of P-51D Mustangs, often as escort for the US Eighth Air Force's B-17 raids deep into the heart of the Third Reich. With his twinkling 'English' humour, he liked to tell the story of the two black Jamaican pilots who were posted to his Wing. He was anxious to preserve all the appropriate 'racial' courtesies even in those military days. The Jamaicans used to be called 'Fifty-eight' and 'Fifty-nine'.

He asked them one evening in the bar how it was that they came to be given the nicknames Fifty-eight and Fifty-nine.

Fifty-nine smiled. 'Can't you see, sir, that I am blacker than Fifty-eight?' Werner gave him the benefit of the doubt.

'Well, there you are, sir,' put in Fifty-eight. 'Fifty-nine is short for 2359 – one minute to midnight – whereas I am 2358 – two minutes to midnight!'

• • •

*Lieut-Colonel, later Major-General, W. Christie

Let me digress for a moment. In my time as a member of the House of Commons in the 1950s, I found it difficult to reconcile the Government's reluctance to take a lead in shaping the 1957 Treaty of Rome, which set up

what is now called the European Union, and becoming one of its original signatories.

Ten years or so after the victory in Europe, British stock still rode high. With our standing and diplomatic skills, we were well placed to be both the precursor and the architect of Churchill's concept of a 'United States of Europe'.

I had seen a blueprint of what we were capable of doing at first hand in the Royal Air Force in wartime. Given the leadership and a common denominator, as we then had them in the Squadrons, it would have been both feasible and practical. That Anthony Eden, Foreign Secretary at the time and soon to become Prime Minister, was not prepared to step in and act as a sort of 'Senior Officer Present' in Europe, shoulder the responsibility and set the example, will remain in my judgement as arguably the most damaging and certainly the most far-reaching diplomatic blunder since the war.

I had another reason for forming this opinion. I had also seen, in the context of the Malta battle of 1942, what could be achieved by putting representatives of the Commonwealth countries and the United States together in a dedicated English-speaking mix.

We had, in the Squadron which I commanded, an almost complete English-speaking blend with a common thread – a common purpose – tying us together. True, I and my two Flight Commanders were English; but, apart from us and one or two others from the UK, the rest of the unit's pilots came in roughly similar numbers from Canada and the United States, Australia, New Zealand, Rhodesia and South Africa. No one nationality was predominant; and yet we fought as one – just as the British and the Europeans did in Fighter Command's squadrons at home – because the resilience and the lead the Service provided promoted it.

Four decades later, we had a Squadron reunion at the Royal Air Force Club in Piccadilly. We numbered 87 and the members – aircrew and groundcrew – came from all quarters of the globe. Mostly we hadn't seen one another for more than forty years. Yet, as we gathered together, we were able to pick up the game just as we had left it in those torrid Mediterranean days four decades before: no shyness; no reticence; no hesitation. Within moments, the noise in the room had said it all.

One of our battle stalwarts, Gerry de Nancrede, the Canadian from High River, Alberta, recaptured, in a note to me around that time, the spirit that had animated us in wartime:

> I found I had joined a new family. Groundcrew and aircrew were drawn together … sharing the intensity of life and death. It took time to comprehend it – particularly for one who, like me, had come from the 'political scene' of a Royal Canadian Air Force squadron. The comradeship, concern, courage and fear have never been forgotten … There is something in those lines of King Henry which captures it. 'We few, we happy few, we band of brothers …'

• • •

Of course the Royal Air Force would never have been able to embrace its extensive wartime intake without the disciplines and technical knowledge – and the leadership – of the peacetime-trained senior NCOs. They were the salt and pepper of the Service. As time went on, many of them rose to commissioned rank.

Douglas Bader had early on found an affinity with them. 'They were lovely, lovely men ... I learnt more about being an officer from them than from anyone else ...' Three of them were particularly remembered – 'Tubby' Mayes* of Coltishall, 'Knocker' West† of 242 Squadron and, in Douglas's book, *primus inter pares*, Flight Sergeant Curtis‡ of Cranwell. ('The bugger kicked me round from pillar to post [as a cadet]. He never let up ... He became a great chum in my Service career.')

For me, 'Spanner' Hendley,§ the Station Engineer Officer at Coltishall and one of Fighter Command's ablest engineers, typified the breed. He had started as a boy apprentice at Cranwell between 1920 and '23 in the Boys' Wing of No. 2 School of Technical Training. He once sent me two faded and well-thumbed photographs of the old hutted buildings of the original College where the apprentices lived their spartan lives. The humour of the personal memoir which accompanied the pictures tells its story:

> I shared a royal suite in this 5-star Hilton with twenty other lifers. The padre told us to wait until we were married. The discip corporal told us we were a lot of 'orrible little boys who had never seen our fathers. The CO was a splendid fellow. I only saw him personally twice. The interviews were short. 'Seven days on fatigues and I do not want to see you again.'
>
> Our schoolmasters were dedicated men. I still write to one, Captain Fanshawe AFC. He must be in his nineties now. We ate hard biscuits for tea. They were surplus to World War I requirements.
>
> I got my wing colours for football and shooting and an average passing out mark. Most of us were very happy and proud to have been associated with Cranwell.

When the test came, the Service leant heavily on such men ...

*Warrant Officer J.W. Mayes

†Warrant Officer Bernard West

‡Later Wing Commander Curtis

§Wing Commander W.J. Hendley

CHAPTER 19

THE BIG SHOTS: A LEADER REFLECTS

To destroy aircraft successfully in combat a fighter pilot needed certain attributes ... A sense of position, judgement of distance and speed, acute eyesight, mastery over the aeroplane and a 'feel' for deflection. A few had an innate blend of these qualities and with it an aptitude for destruction. Far more shot haphazardly and surprised themselves when they hit anything.

Just as the good games player generally made an adept fighter pilot and leader, so the able game shot, who had been brought up to handle a gun from boyhood, seldom had difficulty in finding his target in the air. The thoroughgoing countryman in Johnnie Johnson enabled him to slip easily into the fighting syndrome – and to recognize ability when he saw it in others.

When I was 17 I persuaded the local hardware store to let me have a BSA 12 gauge, 'farmer's gun', for £1 down and nine similar monthly payments. £10 in all. Rabbits were fetching one shilling each, and if I could average two rabbits from three shots I was in business and could pay for the BSA. Thus, I learned about deflection shooting on the ground; later, when I took to wildfowling on the Lincolnshire marshes, I learned about deflection shooting in the air when I swung the BSA after flighting widgeon and pintail, and diving, twisting teal. The principles of deflection shooting against wildfowl and aeroplanes were exactly the same – except that aeroplanes could sometimes return your fire.

Scout pilots of the First War knew a lot about guns and deflection shooting. Albert Ball, VC, aged twenty, used to take his guns to his room for cleaning and checking; and when Freddie West won his Victoria Cross his wounded observer, Alec Haslam, wrote from hospital to a Squadron pilot: 'By the way if you want your observer to have a good pair of guns I recommend my old ones, 22395 and 22396; the latter is the "elder and better" if there is anything in it. They work at 111/2lbs tension not less.' He might have been writing about a pair of fine English shotguns.

With 616 Squadron I soon found that their shooting was poor. There was no gunnery training and the pilots hosepiped their opponents from absurd ranges and could not estimate the amount of forward allowance. The average

pilot of those days could usually hit an enemy aeroplane when he overhauled it from dead astern and sprayed his opponent with eight machine guns, but give him a testing deflection shot and he usually missed.

Because the average fighter pilot was a poor shot our machine guns were harmonized to give a fairly large 'shotgun' bullet pattern at the best firing range, and this 'area of lethal density', as it was called, gave the poor marksman the best chance of destroying his opponent. But good shots – Sailor Malan, Harry Broadhurst, Teddy Donaldson, Denys Gillam, Screwball Beurling, Hawkeye Wells and Wally McLeod – found that the shotgun grouping did not give them a good concentration of fire, so they harmonized their guns to give a 'spot' pattern, which, when used with the improved 20 mm cannon, tore enemy aeroplanes asunder.

Flanked by the Commonwealth: Dick Atcherley (centre), CO of RAF Kenley in late 1942, with the two New Zealanders (left) Reg Grant, CO of 485 (NZ) Squadron, and (right) Edward Preston 'Hawkeye' Wells, the complete Wing Leader, a first-class game shot, who became, by wide consent, the most accurate marksman in the Fighter Arm

The best fighter pilots were usually outdoor men who had shot game and wildfowl. The fighter pilot who could hit a curling, dropping pheasant coming at him on a strong wind, or a jinking head-on partridge, or who could kill a widgeon cleanly in a darkening sky, had little trouble bringing his guns to bear against the 109s.

The finest shot in Fighter Command was the New Zealander, Hawkeye Wells. Before the war he had won several clay pigeon championships and established himself as the country's number one marksman with a twelve bore. Aptly dubbed 'Hawkeye' during the Battle of Britain because of his amazing eyesight, he destroyed many opponents whenever he got within range.

Hawkeye and I became good friends when we were both resting from operations at Uxbridge during the winter of 1943. There were one or two ponds in the spacious grounds and sometimes mallard dropped in from the Thames and local gravel pits. Hawk made himself a suitable hide, fed the ponds with scraps from the Mess and when someone reported that the mallard were in, he slipped away from his desk and clobbered a brace. One day the Senior Air Staff Officer (SASO), an Air Commodore of First War vintage and a grinding bore, wanted Hawkeye. He peered into various offices, eventually coming into mine: 'Have you seen Wing Commander Wells? I want him rather urgently.'

'As a matter of fact, sir, he has just slipped out to get a brace of duck.'

The SASO was not amused, and neither was he when Hawkeye returned late from a wildfowling expedition with that other great fighter pilot and fellow New Zealander, Alan Deere. Al was commanding the Air Gunnery

School at Sutton Bridge, Lincolnshire, and the nearby Holbeach marshes provided some excellent wildfowling. So, when moon and tide were just right, Hawk, in the course of his duties as Wing Commander Training, flew to Sutton Bridge to confer with Al, and that evening, with a local expert, they established a record for the number of duck, mostly widgeon, shot on that particular marsh. The local ventured that the morning flight would be equally good and so it was arranged.

Thus, the gallant and highly decorated Wing Commander, laden with duck, returned to Uxbridge about noon, when he should have been at his desk. The SASO was on the warpath and passed word that Hawk was to report to him immediately – repeat immediately – he returned. It rather reminded me of some errant schoolboy who was up before his housemaster for some pettiness. He came into my office to describe the shooting. 'The SASO's been looking for you, Hawk,' I said.

'That's all right,' he replied, 'I'll fix the little bugger with a brace of duck.'

I watched him enter the SASO' office, a brace of fine widgeon held behind his back. After five minutes, Hawk backed out of the room, the duck still in place.

• • •

My friend and comrade-in-arms, Whaley Heppell, came from a well-established Northumberland family, and often, at Westhampnett, we walked the fields and marshes in search of rooks, pigeons, wildfowl and, as the autumn closed in, pheasants belonging, in truth, to the Duke of Richmond and Gordon. I figured he would not miss a brace or two, especially as his son, the Earl of March, had recently joined the Royal Air Force and told an amusing story about his first encounter with his Station Commander, who met all newly-joined officers. However, he did not properly grasp the Earl's name and thought he was addressing Flying Officer March.

'Welcome to Middle Wallop, March,' said the Station Commander, 'do you know this part of the world?'

'Well, I live just outside Chichester, which is not very far away.'

'Wonderful country, Sussex,' mused the Station Commander. 'In fact, I used to be at Tangmere. Good shooting there, you know. Plenty of pheasants. And if you drive past the Goodwood Golf Club and take the old road up the Downs you come to a stone wall where, of an evening, the old cocks stand before roosting in the trees. I've had three with one shot there. Know where I mean?'

'Yes,' answered the Earl. 'It's about two miles from our head keeper's cottage!'

When, in the autumn of 1941, we moved back to Kirton Lindsey, we were in the midst of good partridge country and Whaley and I made the most of it, especially as the authorities had issued fighter Squadrons with 12-bore guns and unlimited ammunition with which to improve our deflection shooting against clay pigeons.

When 616's Honorary Air Commodore, the Marquis of Tichfield, announced that he was coming over from Welbeck Woodhouse to dine with his Squadron, Whaley and I thought we ought to get ourselves invited to Welbeck from time to time so that, between drives, we could update Tichfield about the South Yorkshire Squadron. We had, however, rather overplayed our hand, for two days later there was a call from Welbeck inviting the Squadron to provide four guns next Thursday. I had exactly a week in which to select the team and teach them something about driven game and safety.

Our new Squadron Commander, Colin Gray, from New Zealand, was a natural shot and would lead the expedition to Welbeck. Whaley was a good shot and safe. For the fourth gun I selected Jeff West, also from New Zealand. He had never shot game before, but he could bring down Messerschmitts and therefore should hit plump pheasants.

We were confident that Jeff would be all right once we had given him some elementary training, so we began on the clay pigeon range, where he proved to be an above-average shot. Then we explained how the beaters brought the birds to the guns and told him the safety factors which applied not only to the beaters, but also to the guns themselves. I fell back on the time-honoured method of placing two sticks in front of him, on each side, so that when he swung his gun over either stick he remembered to bring it to a vertical position and didn't lower it until the birds were well clear of the line of guns.

We reported to Welbeck. It was a crisp, firm winter's day which promised well for the sport. The customary draw for positions took place and for the first drive Jeff found himself between our host and a famous amateur golfer, and I was next along the line of guns. The horn sounded and the partridges swung across the sugar beet, fast, jinking and very low. The first convoys came straight at Jeff and he went into action. The guns on either side fell silent and with good reason, for Jeff had his sights on the enemy and swung his gun from front to rear at shoulder height! His Lordship and his retinue – loader, under keeper and dog handler – took suitable avoiding action, as did the amateur golfer.

After the first drive, I had strong words with the New Zealander and suggested to our host that since West was very inexperienced at this sort of thing it might be wise to put him well behind the guns as a stopper. Lord Tichfield never batted an eyelid and said he was sure Mr West would soon pick up the drill, and that we had better get on to the next drive. For me, the day was not improved when one of our more enterprising airmen, acting in the temporary capacity of loader, decided to take a hand in the proceedings and brought down a wild duck!

I still have the game card for that long-ago day. Thirty-five brace of pheasants, a few partridge and some duck. The Honorary Air Commodore gave a brace to the golfer, another to his agent and kept a brace for himself; the remainder, he said, were to be taken back to Kirton for the Squadron.

A day later Lord Tichfield phoned: 'Next Thursday, four guns again, same place, same time and bring that nice young fellow from New Zealand!' *Savoir faire*, indeed.

• • •

By far the best shooting I ever saw was on 23 June 1944, when I was leading 443 Squadron looking for trouble over Normandy. It was a stunning day, the sun blazed down from a clear blue sky and below Normandy was a patchwork quilt of greens and browns. There was a great deal of fluffy white cumulus cloud at about 6000 feet, and I led the Squadron

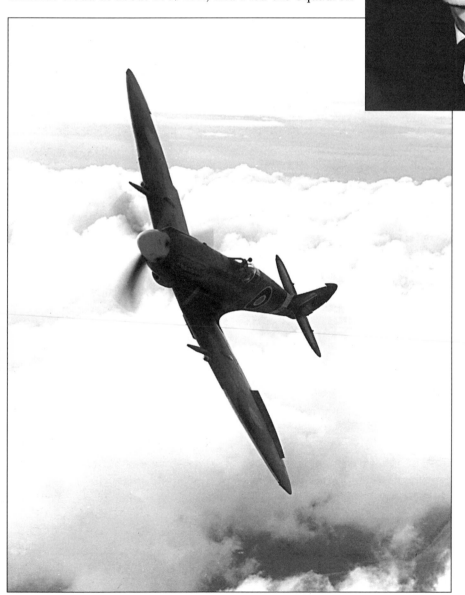

ABOVE: Henry Wallace 'Wally' McLeod, from Regina, Saskatchewan, with 20 enemy aircraft destroyed over Malta and the Western Front, took full advantage of the Spitfire as a stable gun platform

LEFT: When Johnnie Johnson took over command of 125 Wing in early 1945 for the final lap of the European war, he found the Wing equipped with the new Spitfire XIV, powered by the 2035 hp Rolls Royce Griffon engine

just below the base of the cloud, for I didn't want to be silhouetted from above against such a tell-tale background.

The CO of 443 Squadron, Wally McLeod, experienced, eager, a deadly shot and very fast on the draw, was leading a pair of Spitfires on my starboard side when I saw a bunch of Focke-Wulfs flying in the same direction as ourselves. I climbed the Squadron high above the 190s and got into a good attacking position. The 190s were flying in a line abreast formation, and, telling Blue Leader to attack the port aircraft, I took my six Spitfires against the starboard Huns. But before we opened fire the 190s turned to starboard and were now nearer to Wally than me. He was well within range and hit a turning Focke-Wulf with his first short burst of fire. Flames leapt from the cockpit; the fighter fell over on to its back and dived into the ground.

Surprise was gone, but the Germans remained milling about the combat area. There was a 190 ahead of me, turning to port, but not too steeply. An easy shot. Just a little deflection. I cleared my tail and was about to open fire when cannon shells from another Spitfire, attacking from below me, tore the 190 apart.

I had not fired a shot, and back at St Croix I walked over to Wally's Spitfire where the armourers were already busy. McLeod looked sheepish, as well he might. 'That 190 of yours was a piece of good shooting, Wally,' I said. 'I suppose you clobbered the second?'

'Yes, I got a couple of them. Did you see the second one, chief?'

'I not only saw it, Wally, I was about to shoot the bugger down!'

'Hard luck, sir,' Wally replied, tongue in cheek. 'I saw a Spitfire behind the 190, but I thought I'd better make sure of it. Of course, I didn't know it was you!'

Of course not, you bloody liar, I thought. But I curbed both my frustration and temper and, indeed, congratulated him again when the armourers told us that he had only fired thirteen rounds from each of his two cannon. Each gun carried 120 rounds, so Wally had used only about one-tenth of his ammunition. Throughout the war I never heard of better shooting.

●　　●　　●

During the autumn of 1942 we moved to Castletown, a bleak airfield, near Thurso, in Caithness. An official-looking letter was waiting for me from the Secretary of State for Air himself. It was handwritten and read: 'Dear Johnson, Welcome to Caithness. It is getting rather late for the salmon, but if you or your officers would like to fish please contact my River Superintendent, David Sinclair, on Thurso 39. David will also show you where you can walk-up a few grouse and flight the duck on Loch Heilen.'

I phoned David Sinclair and made arrangements to fish the Thurso the next evening. After tea, he collected me with a big fishing rod – the like of which I had never seen – strapped to the side of his van. We walked to a pool near the head of the river where David, a big, powerful Highlander, explained the big spliced Greenheart rod and the heavy reel with its greased line, at the end of which was some coloured object called 'the flea'.

He thought the height and colour of the water and the sun were about right and that 'himself' might be lying behind a stone on the far side of the river – about the length of a cricket pitch away. The River Superintendent said that I should make a cast across the river so that the 'flea' would come nicely downstream in front of 'himself'. He made as if to pass me the great rod, but since my fishing had hitherto been confined to small roach on a bent pin, I told him so and asked him to show me.

I watched the master-fisher punch his line across the Thurso to the pre-scribed place. Seconds later, I saw the big rod bend and ten minutes later a salmon of twenty pounds was on the bank. We walked to the next pool where David was soon into a fish, but once it was well hooked he insisted that I take the rod and play the fish until it was safely in his net. It weighed a mere fourteen pounds.

We sat on the bank of this beautiful, shining river and, as is the custom, took a dram while I reflected that I ought to learn more about this exciting sport which had produced two fine salmon in less than one hour. Back at the Mess, David gave me the two salmon, saying the Laird had instructed that we had whatever we caught or shot. I gave the fish to Mrs Mason, our house-keeper, who said they would do nicely for tomorrow's supper.

The resident officers at Castletown soon heard about 'my' two salmon and one especially, a fine old Highland kilted Major, dined with me that evening and wanted full details of our sortie. He said he was responsible for the ground defence of Royal Air Force, Castletown, which, of course, meant walking over the local grouse moors with dog and gun to inspect the lie of the land. He was, I soon discovered, an authority on anything that could be fished, stalked or shot in those parts. Thus our conversation, over a glass of port, tended to be untaxing, concerning the autumn salmon run, dogging for a few brace of grouse, golden plover, the excellent duck flighting and wood-cock shooting at Berriedale where Lord Tichfield had a fine deer forest.

The following day, I wrote to Lord Tichfield and explained that, although I was no longer with his Squadron, I wondered whether we might, please, avail ourselves of a little sport at Berriedale. He responded by return and we were to contact his head keeper, Mr George King, who would provide a stalker and rifles. We had great days after the woodcock in the woods, and stalked and shot hinds on the hills. Sometimes the whole Squadron, officers, NCOs and airmen supped on venison at the Dunnet Hotel, when we pilots had the opportunity to thank those excellent people who, at all times, and in all weathers, serviced our Spitfires and to whom we owed so much.

• • •

My friend Dolfo Galland, General of Fighters for the Opposition, was a first-class shot, as I discovered to my cost after the war. It was during the autumn and we were both in Calgary. The duck were flying south and our Canadian hosts arranged some shooting. We were flown north to a small village and accommodated in a modest bungalow whose occupants must have had a hur-

ried departure because the place was untidy and the beds unmade. I was changing into my shooting kit when a frowning Dolfo, doubtless thinking of luxurious hunting lodges in Prussia, poked his head round the door, looked at the crumpled bed and said: 'Not a gentleman's shoot, I see!'

We were both provided with identical Winchester automatics and the same cartridges, and, since we both fancied ourselves at this game, we had a bet of a dollar per bird. We took up our positions in hides on the side of a lake and, as the light began to fade, a single mallard flew over me well out of range, I estimated, and on to Dolfo at the same height. He dropped it stone dead. Half an hour later, he had ten, I had five and a five-dollar bill changed hands.

At dawn the next morning we changed hides, and, as the first high duck flighted in, I thought they were well out of range and best left to settle on the water to attract others. Not so Dolfo. He dropped two with two shots and proceeded to kill a dozen of the highest duck I have ever seen. As the dollars changed hands he grinned and remarked that, as we were now friends, he was pleased he had not shot me down – like the duck!

CHAPTER 20

THE LEGACIES OF WAR

War stamped its effects upon every surviving member of the armed forces, some for the better, but many more for the worse.

For Laddie Lucas, always a wartime amateur, a duration player – 'in at the beginning and out at the end' – five years of hostilities had left their indelible imprints, some of which would endure for a lifetime. Here he reflects upon the inheritance of war.

War bequeathed two legacies, one terminally bad, the other lastingly good. The first cut short a career in Fleet Street just as I felt my name was beginning to emerge. I was starting my fourth year as a journalist with Lord Beaverbrook's *Express Newspapers* when I left to join the colours. Among my many and diverse tasks at the time, I had been writing a sports column across half the inside back page of the *Sunday Express*. At 24, rising 25, I was considered young to have landed the slot.

I realized how lucky I was to have caught the editor's, and even the proprietor's, eye so soon after finishing at the university. Single, and devoid of ties save those of a loving, widowed mother and close family, I was free to go wherever I was sent, anytime, anywhere, at home or abroad. Moreover, I was allowed by the *Express* to write a weekly piece for a magazine and to do occasional broadcasts for the BBC. In a word, I was riding high.

Then came the war and my brave young world was abruptly ended. It was a stunner. I walked out of the great black glass building, which was the *Express*, for the last time around 11 o'clock one Saturday night. I felt instinctively that a door had closed behind me …

Six years later, with the war over, my life and its circumstances had changed utterly. Aged 30, and about to be married, I had to start all over again and quickly make a living. I had no private means. The *Express* wanted me to return, but the Street called Fleet that I had known had changed, too. It did not offer the same prospects with newsprint still in short supply and likely to remain so indefinitely.

'I walked out of the *Express* for the last time around 11 o'clock one Saturday night...I felt a door had closed behind me.' The *Express Newspapers* offices in Fleet Street, Laddie Lucas's pre-war place of work

I had other offers of work. So I turned instead to commercial life, where the money and the perks were better, but where I was never again so contented and, come to that, probably never again so well suited. That was the first legacy of war. It had ended what I like to think was a budding professional career which, but for Hitler and all his works, I would never have left. Such was one person's sacrifice ...

The second wartime bequest conferred benefits which, surprisingly, and perhaps paradoxically, would span a lifetime.

When I signed on for the Royal Air Force the day after war was declared, I had never before flown an aeroplane, nor was I certain that I ever could ... But being a games player, I was drawn to the concept of day fighting.

In the event, the experience which the wartime Service subsequently offered touched just about every human emotion and taught lessons which could not have been learnt elsewhere. We were dealing with Life and Death – a very different thing from the pursuit of profits and dividends in commercial life.

Living, as we were, in close and trusting accord with one another in the Squadrons and the Wings and on the Stations, we came to know men – and women – as they really are. The discerning commander learnt to understand the human frame – what it could take, how long it could endure, what was really in a person's mind and how he or she should properly be handled – these were some of the features which a commander had to sense and size up.

Moreover, he soon appreciated that one of the first and fundamental canons of command was decision – to be positive and decisive, one way or the other. I had an instance of this in the middle of the Malta battle. Group Captain Woodhall had told me one evening that I was to take over 249 Squadron forthwith. He then asked whom I wished to nominate for my vacant Flight. I had no doubt about my desired answer. 'I'd like to have Raoul Daddo-Langlois, sir. I know he's still a bit young and that he's not actually next in line, but I have no doubt ...'

Woody wouldn't let me finish. 'Tell him to put his stripe up tonight.'

Six months before, in 66 Squadron in England, Raoul had turned down the offer of a Flight on the grounds of inexperience. I had thought it ridiculous and told him so. In any case, the CO should never have allowed him to get away with it. I was determined to give him no such option.

As soon as the Group Captain had left, I faced the new Flight Commander with a *fait accompli*. 'I'm taking over the Squadron, Raoul, and you've got my Flight. Good show, you thoroughly deserve it and will do it well. "A" Flight will be on at dawn tomorrow and I'll be flying with you. Fix breakfast at 0445. And, by the way, the Group Captain says to put your stripe up tonight.'

He looked at me askance as if he didn't know what he had heard.

I knew if I had given him half a chance he would have found three good reasons why X or Y should have got the Flight instead. As it was, he became one of the successes of the battle.

• • •

I always found it refreshing that ability rather than class rose to the top in the operational units of the Air Force. Contrary to what we have sometimes seen on television or what selected writers have told us, it didn't matter a damn, by the middle of the war, whether a Wing or Squadron Commander had been to a British public school, Oxbridge or came from a distinguished family. If he was a product of that sort of background and could lead in the air and on the ground, he would probably do the job as well – and possibly with easier initial assurance – as others. But, make no mistake, far more leaders came from less privileged circumstances, whether in the UK, a Commonwealth country or the United States.

The truth was that, in the operational field, if a man had 'what it takes' he went to the front on merit no matter what might have been his antecedents. Far too much depended on leadership in the air – and the promotion of confidence – for things to be otherwise.

The tensions and stresses of operations certainly affected aircrew in different ways. Some felt them acutely while others – and I was pretty sure they were in a minority – were largely insulated against the pressures which built up as the screw was turned tight. Being sensitive to this sort of thing, I watched for it closely, for I felt that the majority of pilots and aircrew would rather have gone on until they dropped than have to admit that they'd had enough as they came towards the end of a long operational tour.

I often wondered what sort of legacies war bestowed on the Germans in the *staffeln* and the *gruppen* with the Luftwaffe's principle of no rest or breaks from operations unless wounds, illness or some other exceptional reason dictated it. I remember Werner Schroer, one of the German Air Force's ablest performers in North Africa, a fine fighter leader and an adept linguist, telling me long after the war that, in his judgement, their system, despite its rigours, had one advantage over ours.

'Our pilots always had their hand in. They were never, as you say, "rusty". Breaks from operations meant that when a fighter pilot resumed his place in the line, it took him a while to get acclimatized, to get back into fighting trim and regain his edge. His reactions were slower to start with and his eyes, initially, weren't so sharp. He was then vulnerable, it was a dangerous time and we were wary of it.'

All the same, it must have been a hard regimen.

The air (and aerial combat) did, of course, make a bond between former opponents when once the war was over. Indeed, for me, one of the genuinely surprising legacies of the conflict has been the ease with which most of us have been able to reconcile previous difficulties and quash old enmities.

One, on the Luftwaffe side, who has a capacity for friendship is Wolfgang Falck, one of their Air Force's most successful and illustrious night fighter commanders. Even in war itself, Wolf, a cultured man, practised an unusual degree of chivalry. Perhaps he started with an advantage for he knew England well and had friends here from pre-war days. In the peace which followed, he

became the internationally regarded representative of the US McDonnell Douglas Aircraft Corporation in Germany.

One day in 1941 – it was Monday, 22 September – while he was commanding the night fighter group at Deelen, in Holland, he was told that a British Squadron Leader had force landed a photographic Spitfire near the base after a petrol-feed failure and was now at the HQ. 'Send him along to my office,' said Falck.

All the proper civilities were observed, with the Squadron Leader giving no more than the Geneva Convention's requirement of name, rank and number – and being pressed to divulge no more. He was then offered food in the Mess and given a supply of chocolate to take with him into captivity. (He said long afterwards that the German pilots were surprised that someone of twenty-five could have reached the rank of Squadron Leader. 'You'd have to be forty,' they said jokingly, 'to get to that rank in the Luftwaffe!')

Taking, let's face it, a considerable personal risk with higher authority, Wolf then instructed one of his staff pilots to fly the Squadron Leader with an armed guard over to Frankfurt in his own personal Messerschmitt 110 – G9 + GA. The prisoner would then be taken to Dulag Luft for eventual transfer to a POW camp.

Years later, Falck told me this story in minute detail, and enjoyed recounting it. He had unfortunately lost his wartime records and so couldn't recall the name of the British pilot or the relevant date. 'I hope,' he said, 'the Squadron Leader has survived. I'd so like to meet him again.'

I made up my mind that I wouldn't rest until I had tracked down the former POW.

After five years of it, I had to tell Wolf that we had drawn a blank and that, regrettably, there appeared to be no likely indication from the PRU records of the identity or whereabouts of the Squadron Leader. Then, out of the blue, a Dutch historian, Hendrik Cazemier, in the course of his researches, stumbled on details of a photographic Spitfire which had force landed near Deelen on 22 September 1941. The pilot's name was known to be Peter Tomlinson.

Cazemier inserted a 'contact wanted' advertisement in a British aviation journal with the relevant details. In a thousand to one shot, a friend of the Squadron Leader's saw the announcement in Johannesburg. He at once contacted Tomlinson, who, after returning from captivity, had emigrated to South Africa and settled in Cape Town. There, he had started what turned out to be a highly successful shipping company with (wait for it) Sir Arthur Harris,* the former C-in-C of Bomber Command. Tomlinson had been Harris's PA and personal pilot for two years while the Air Marshal had been commanding Bomber Command's 5 Group at Grantham.

There is a sequel to this strange saga.

When Peter Tomlinson was released from captivity in 1945, he was flown back to Wing, in Buckinghamshire, from Brussels in a Lancaster bomber. With him was his friend, Ian Bourne, another ex-POW. They took the train to London. Tomlinson noticed from a map in the compartment that the train

*Marshal of the Royal Air Force Sir Arthur Harris

would stop at High Wycombe, the HQ of Bomber Command. He resolved instantly that he and his friend would alight there on the off-chance that he might be able to re-establish contact with his old, but now elevated, AOC.

The platform was swarming with Service personnel, but the Squadron Leader was fortunate to find a Wing Commander who appeared to know the form. 'Go to a telephone,' he said, 'dial 0 and ask for Rosedale. They should put you through.'

A WAAF answered Tomlinson's call. To his astonishment there was a click and a voice the other end snapped, 'Harris.'

'Sir,' said the Squadron Leader, 'this is Tommy.'

'Who?' The voice sounded unfriendly.

Tomlinson tried again. 'Don't you remember, sir, this is Peter Tomlinson.'

There was an agonized silence. 'Good God, where are you now? I've had an aircraft standing by for you for three days.'

'I'm at High Wycombe railway station, sir.'

'Hang on, I'll be down right away.'

'Ian and I honestly couldn't believe it. I thought I would wake out of my dream any moment!

'In no time, an open Bentley, with the C-in-C at the wheel and an Air Chief Marshal's pennant flying, came screeching round the corner to the station entrance. Everyone froze to attention. My troubles were over!'

● ● ●

However, of all the bizarre events which emerged from the fighting in the Second World War, none is likely to surpass the coincidence which confronted Michael Robinson, the Royal Air Force's charismatic leader, in a Kentish hop field in the late summer of 1940. Its little-known detail has been secured and verified by reference to the Wing Commander's surviving family, and his papers.

Robinson was, by any test, an exceptional officer. Handsome, with a personality to match, he was a knock-out with the girls. He was, moreover, a greatly admired Service pilot. Joining the Air Force after school at Downside in the mid-1930s, he lived to fly aeroplanes. Command of a Flight in 601, the County of London's up-market Auxiliary Squadron, in the Battle of Britain, was quickly followed by leadership of 609, 601's West Riding counterpart. When, eventually, he was lost in the spring of 1942 leading the Biggin Hill

The personable and charismatic Michael Robinson (*right*), Biggin Hill Wing Leader after Sailor Malan, talking to Belgian pilots of 609 Squadron and...

Wing in an offensive mission to occupied territory, 19½ enemy aircraft had already fallen to his guns …

In February 1939, Michael was on leave, skiing with a mixed party at Garmisch, in the mountain snows of southern Germany. One evening, in company with two young and personable Army friends, Robin Montgomerie-Charrington of the Argylls and Anthony Leatham of the Welsh Guards, there was a chance meeting in a local hostelry with some officers of the Luftwaffe's celebrated Richthofen *Geschwader*, based then at Augsburg, 60 miles or so away to the north. After a 'rather long Kümmel session', an invitation was accepted to dine with the Germans, a few days later, at a Guest Night in their Mess.

It was an impressive, smartly-turned out occasion, full of well-disciplined protocol and heel clicking, with dinner served immaculately by candlelight in the panelled dining room, draped with squadron banners.

As the evening progressed, it became clear that the aim of the younger *staffel* pilots was to drink their British guests under the table. In this they failed. Rather was it a case of the shoe fitting the other foot. Argument flowed with the brandy and liqueurs.

A somewhat intoxicated *leutnant* faced up to Robinson in perfect English. ('I rather think he had been at Oxford!') 'You've got Hurricanes? Well, we've got Messerschmitt 109s and God help you if you ever

Robin Montgomerie-Charrington, 'the Argyll', actors in one of the most bizarre stories of World War Two

have to fight us in your old tubs … If war starts – and I hope it will soon – I will take on three Englishmen and their Hurricanes in my 109!'

The hour was late and the Royal Air Force clearly wasn't going to fall for that one. Soon the party broke up …

Eighteen months later, on 31 August 1940, 601 was heavily engaged high up over south-east England. After damaging a couple of 109s in the jousting, Robinson spotted another low down, limping home just above the tree-tops. Now out of ammunition, he dived down and took up station alongside the German, pointing downwards vigorously to make him land, but without effect.

Two dummy attacks, pressed right home, did the trick and the Messerschmitt force landed abruptly, wheels up, amid a cloud of dust in a hop field just south of Maidstone.

Against every rule in the book, and taking an absurd risk (but such was his way), Michael put his Hurricane down in a good, firm open field a short distance away. Walking across a couple of fields, he met his opponent sitting beside his pranged aircraft. A note, written later, recorded the meeting: '… I recognized him before he recognized me. After he had handed over his pistol

I said to him, "Your face is familiar. I think we've met before … Could it have been at Augsburg in February 1939 …? It was a good dinner!"

'Then the Home Guard arrived and took him away …'

More than a month later, after keeping very quiet about the incident, Robinson consulted Squadron Leader J.S. Ward, the 11 Group PRO. Between them, they prepared a script of the story for broadcast by the BBC. Michael would deliver it anonymously. The text was submitted to the Air Ministry for clearance. After a brief pause, 'for reference to higher authority', it was vetoed.

'Can't possibly have that. Looks like fraternizing with the enemy!'

War certainly bequeathed some strange legacies …

CHAPTER 21

AFTER THE SURRENDER: THE PERSONAL FUTURE

The ending of hostilities in Europe at midnight on 8 May 1945 – and the peace which followed – marked a watershed in the lives of most aircrew.

For those who now faced the blast of civilian life, the transition to peace administered an unexpectedly sharp shock to the human system. One moment there was the Service to lean on, with everything found, the next there was substituted a chilly dawn of reality when, suddenly, we found ourselves 'on our own.'

For the rest who were to remain in the Air Force, for varying periods of engagement, the transition from the intensity of operations to the relative quiet of peace was not without its surprises.

For Laddie Lucas, there was an unlikely last act before the final curtain fell.

VALEDICTION

A fortnight before the surrender on Luneburg Heath, a letter had arrived for me at Cambrai/Epinoy from John Gordon, the editor of the *Sunday Express*. I was still then commanding 613 Squadron and its Mosquitoes. Gordon had posed a question for which I had no immediate answer.

'A General Election,' he wrote, 'must soon follow the ending of the war in Europe. Lord Beaverbrook feels that a few of the younger people in the organization, with the experience of war behind them, should consider standing as candidates. Your name has been mentioned. How would you feel about it? And if you did stand, which Party would you support?

'Politics is a dirty business, but let me have your answer. If it appeals, we could start the ball rolling here.'

Three weeks had passed since I had received the letter, and now peace had come; but still I hadn't given Gordon a definitive answer. I had been wrestling with it daily, often walking miles by myself over the flat and barren fields which had seen so much of the terrible slaughter of the First World War. The idea of entering politics had never occurred to me and there was no one in the Squadron or the Wing with whom I could discuss my decision. One

needs a sympathetic ear at such moments, a human mirror to reflect independent views.

As I agonized over my response, a message came through from Group to our Adjutant. I was to report to 'Mary' Coningham,* the Air Marshal Commanding, 2nd Tactical Air Force, at his HQ in Brussels on the morrow. I had no idea what it might be about.

Coningham came quickly to the point: 'Lucas, I gather you worked as a journalist for Lord Beaverbrook and the *Express* before joining the Air Force. I want to have a record written of the work of the Tactical Air Forces from Alamein to Berlin. It's quite a story. You would have a base in the UK, a small research staff and your own aeroplane to get about in. I feel this could be an interesting job for you before you leave the Service ...'

(The Air Marshal had been told by my AOC, Basil Embry, that I had already rejected the offer of a permanent commission and that I wanted, as soon as my turn came round, to leave the Air Force and return to civilian life.)

A quick calculation suggested that this might well be an eighteen months' job, perhaps more. I was already irrevocably in love with a super girl, Jill Addison, Thelma Bader's sister, whom I wanted to marry as soon as I was demobilized and had got settled with a company.

I played for time. 'Would you, sir,' I asked, 'allow me to think it over? I've had no leave since coming out to France last autumn. Could I take a week in England and give you my answer at the end of it?' The Air Marshal at once concurred.

Back in London, I went first to see John Gordon at the *Express* and then Ralph Assehton,† the chairman of the Tory Party. The Election had just been called and campaigning would soon begin.

'You're very late,' said Assehton, 'all the good seats have gone now, but I could offer you Limehouse against Clement Attlee.‡ Put up a good show there and that would help you with a seat later on. But I must know today if I can send your name in to the local Party.'

The picture was clear. Three weeks fighting Attlee in Limehouse would clearly be preferable to eighteen months and more researching and describing the road from Alamein to Berlin.

I threw in my lot with the Conservative Party, but, as things turned out, not as the candidate for Limehouse but for West Fulham, another London division, where a vacancy had just occurred. I was up against Dr Edith Summerskill, the sitting member.

Being close to Westminster I was able to encourage an all-star cast of speakers to support me. Moreover, Bader, then stationed at Tangmere with the Central Fighter Establishment, came up to speak for me in a school in Fulham, bringing with him a strong escort from the Sussex coast. The place was packed, hundreds overflowed outside.

The chairman lost control quite early on when a vociferous opponent, in the body of the hall, kept up a barrage of points of order, brandishing a copy of King's Regulations as he did so, on the legality or otherwise of Bader, a

*Air Marshal Sir Arthur Coningham

†Later Lord Clitheroe

‡Later Earl Attlee

serving officer, speaking on a political platform. Some skirmishes broke out. We were lucky to finish the meeting.

Edith Summerskill beat me handily, but not before we had mounted a spirited campaign with boisterous capacity audiences each evening. 'The candidate,' commented the political columnist of the London *Evening Standard*, 'is still clearly more at home in the cockpit of a Spitfire than he is on a political platform; but he's made a hit with the women!'

I had temporarily to leave the Service to fight the campaign. But now, back in again, the Air Ministry, plainly caring little for a would-be politician, warned me to expect a posting to South-East Asia Command, there to play out time before demobilization. My heart sank through the boards. I told Bader.

'Bloody ridiculous, old boy! Get that stopped tomorrow!'

If there was one thing which I thought would ensure my posting to India, it would be Bader's intervention with the Air Ministry on my behalf. But there was no stopping him. Astonishingly, it worked. Within forty-eight hours I had a signal from Fighter Command posting me to Royal Air Force, Bentwaters, to command. Located close to Woodbridge near the Suffolk coast, I had never heard of the place ...

On arrival, I pressed the bell for the Adjutant. 'What sector of Fighter Command is this in?' I asked him.

'The North Weald sector of 11 Group, sir.'

'And who is the Sector Commander?'

'Group Captain Bader, sir. As a matter of fact, he's just been on asking whether you had arrived.'

Playing out time until demobilization: Laddie Lucas, CO of RAF Bentwaters, with Peruvian Air Force visitor, September 1945

• • •

Bentwaters provided an agreeable valediction to my time in the Royal Air Force. We had a couple of Meteor jet Squadrons on the Station and, round about, the landowners were a particularly hospitable lot, still with plenty of partridges as well as pheasants on their land.

On 15 September 1945 – a Saturday – five years to the day of the climax of the great battles over south-east England, the Service mounted its victory fly-past over London. The weather, sadly, was poor with a lot of quite low and heavy cloud about; but there was something intensely moving about being part of this vast armada of aircraft passing proudly from east to west across the capital – over Docklands, then the City and St Paul's and, finally, the Mall and Buckingham Palace with thousands thronging the route down below.

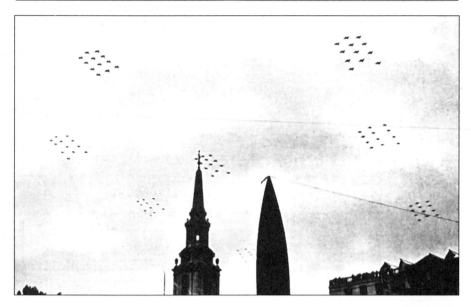

The first post-war fly-past over London, 15 September 1945. Aircraft approaching Trafalgar Square, with Douglas Bader leading. St Martins-in-the-Fields is in the background

On the ground, 'veterans' of the Battle of Britain lead the Royal Air Force procession to Westminster Abbey

Those of us who would soon be leaving the Air Force felt that it would have been fitting had we been able to take our bowlers and rolled umbrellas down from the shelf that evening and closed the door. It was an emotional moment and the nostalgia overwhelming.

There remained one important task to fulfil.

My future father-in-law, a tall and spare retired professional soldier of compelling dignity and charm, had suggested that, as I was soon to marry his daughter, and as my old Squadron was still in France, I might slip across the Channel and get a supply of good champagne for the wedding.

The Station Commander's aircraft at Bentwaters was a P-51D Mustang. When we measured the wing (and other) cavities we found that it would accommodate 188 bottles when the four .5 machine guns were removed.

The Messing Officer at Cambrai co-operated to the hilt and from his well-nurtured French sources saw to it that my aircraft was eventually loaded with 188 bottles of the 'finest stuff' – Krug '39 at, believe it or not, 12 shillings (60p) a bottle!

Back across the Estuary and southern North Sea to the Suffolk coast, the cloud base came down and down and the forward visibility less and less to the point where, low down just above the wave tops, the occasional ship whizzed past on either side. This, I thought, was no place for an old hand.

Up and up I went, through the overcast, 5000 feet, 8000, 10,000 ... and still I was in cloud. It wasn't until I had reached between 13,000 and 14,000 that I broke into the clear blue sunshine above. My God, I thought, with the change in the barometric pressure, all 188 corks will have blown. Whatever will the family say!

Once down at Bentwaters, I taxied to the apron in front of the hangar where my aircraft was always kept. Two armourers were standing by for the unloading. I told them the awful tale. They undid the studs, lifted the wing panels and peered inside as if to find a corpse.

World-beater and product of the great Anglo-US accord: the P-51D Mustang, powered by the two-stage, Rolls-Royce 60-series Merlin engine, built in the States under licence by Packard and Continental

After an unbearable pause, two pairs of thumbs went up. The wires had all held! Not a cork had blown!

STAYING IN: A SERVICE CAREER

It was an altogether different vista which confronted Johnnie Johnson, now a highly publicized star of the Royal Air Force. With his war record behind him and a permanent commission to sustain the forward march, a career in the Service was a natural. 'A long, green fairway' was to stretch ahead for the next two decades.

First, however, there was evidence to face of less agreeable changes overtaking the Royal Air Force as the reality of war made way for peace ...

After the war, I remained in Germany for about a year. Broadhurst, our AOC of great distinction, went home and the new incumbent was a non-operational type who, during the contest, had found some safe haven. We had not met when he telephoned to say he was coming to Fassberg for lunch and would like to meet the Squadron Commanders. When I asked him what time he would be landing, he replied that he would be arriving *by car* about noon and I was to meet him outside my HQ.

I was wearing battledress when the AOC, wearing his best blue, swept up in his big car complete with pennant stars, driver and ADC. I saluted smartly and thought he would shake hands, but instead he snarled something about getting into my office. Once there, the wretched man launched into a violent tirade against my tailor-made barathea battledress, which I infinitely preferred to the regulation garment made of some coarse material. Nor was he

mollified when I explained that Broadhurst wore the up-market variety, and shouted something about his being sent here to get some good order and discipline into his command. During lunch, which was not a success, I noticed that his few medal ribbons did not include that which called for only one operational sortie!

In the other two Services, admirals and generals led their men into shot and shell. Admirals had gone down with their ships and generals had fallen in battle. Air Marshals, however, were not so afflicted, and throughout the Second War no officer of air rank was killed flying on operations. Our views on this subject were aptly put by Basil Embry, also of great distinction, who remarked: 'Senior officers should fly high performance aircraft because it is good for promotion and the survivors are worth having!'

All of our tactical and operational knowledge was learned by junior officers and non-commissioned officers, and our leaders had to rely on second-hand information. This lack of operational experience by officers of air rank was a great weakness in our chain of command and explains why Squadron Leader Douglas Bader, in October 1940, was present at a high-level meeting at the Air Ministry to discuss fighter tactics. He was there because the Air Marshals did not know the form.

Pathfinder: Don Bennett, AOC 8 (PFF) Group, Bomber Command, (*left*) with their Majesties King George VI and Queen Elizabeth, talking to the 'target markers'

It would be argued that the general jumped with his paratroops because that was a function of his command and he had to be there with them to exercise command. One did not expect Leigh-Mallory, for example, to lead a wing of fighters; but one did expect him occasionally to fly a Spitfire on, say, a convoy patrol so that he knew – as every commander should – all about the tools at his disposal.

Later, outstanding pilots who had started the war as Squadron Commanders and continued to fly operationally found that their tactical knowledge led to rapid promotion to air rank. In the spring of 1942, our Station Commander at Wittering was the fearless Basil Embry, who already held the DSO and two Bars. He had been shot down in 1940 and captured by the Germans; after many adventures, including the killing of his guards, he escaped to Spain. The Germans put a price on his head, dead or alive; but the gallant Irishman flew on operations – some of them very hazardous – under a fictitious name until the end of the war. Basil was a leader of the highest calibre and, consequently, morale throughout his important command, 2 Group, was very high and men considered it a privilege to serve under him. He always carefully scanned the medal ribbons of the chairborne brigade and, noting the

absence of the one already mentioned would, irrespective of rank, tap the wretch on the chest and growl: 'I see you've been in the thick of it, old boy!'

At 37, Harry Broadhurst was the youngest Air Vice-Marshal in the Royal Air Force and continued to fly operationally throughout the fighting. We sang, as they say, from the same sheet of music. Likewise, Don Bennett, of the Pathfinders, also led from the sharp end.

These three illustrious Group Commanders, Bennett, Broadhurst and Embry, were exceptions to the sorry fact that the vast majority of Group Commanders would not face the shot and shell.

During the Battle of Britain, the Group Commanders – Brand of 10 Group, Park of 11 Group, Leigh-Mallory of 12 Group and Saul of 13 Group – never fired a shot, although Park flew a Hurricane when visiting his Squadrons. Morale comes from leadership by example, and the very high *esprit de corps* in Fighter Command, which few services have ever approached, came not from the Group and Station Commanders but from the brave and outstanding Flight and Squadron Commanders – Bob Tuck, Douglas Bader, Sailor Malan, Caesar Hull, Al Deere and Harry Broadhurst.

General of the Fighters, Adolf Galland, 'Dolfo' to the Royal Air Force and 'Mufti' to the Luftwaffe, legend of the air war

Although our Air Marshals were more at home at their desks than in the air, they were usually men of integrity whom we trusted. Galland's favourite after-dinner story reveals that it was not always so on his side. The Fighter General had received his Diamonds to the Knight's Cross from the Führer himself, and later, sitting in Göring's personal train, the Reichmarschall said: 'Tell me, are those the Diamonds the Führer gave you?'

Galland said they were, and Göring asked the General to take them off so that he could have a closer look.

'The Führer knows a lot about tanks and guns, General Galland. But he doesn't know about diamonds. Why, these are just chips.'

Göring said he would have a copy of the decoration made by his personal jeweller, and some weeks later sent for Galland. Holding the two decorations to the light he said: 'You see the difference, Galland? You see it?'

The Fighter General admitted that Göring's diamonds were bigger and better than those he had received from the Führer, and was pleased to have a spare decoration.

Soon after, Galland, wearing the Göring decoration, was summoned to Hitler's HQ when the Führer said: 'I can give you proper Diamonds to your Knight's Cross now, General Galland. The decoration you have was just a temporary copy. Would you take off your decoration, please?'

Taking the Göring Diamonds in one hand the Führer held the new Diamonds in the other and held them up to the light side by side and said: 'You see the difference, General Galland? You see it? You see that the diamonds in your temporary decoration are just chips!'

• • •

Of the 537 aircrew killed in the Battle of Britain 197 were senior non-commissioned officers, and I found it very odd to see an experienced sergeant pilot leading a section of three Spitfires into battle, two flown by pilot officers, two or three times a day. Then, when dusk fell, we would go our separate ways – he to the Sergeants' Mess and we to the Officers' Mess. Thus, we rarely met socially because the Royal Air Force held that, although a sergeant pilot could lead a Spitfire section or captain a bomber, this did not automatically bestow on him the necessary officer qualities, including 'the capacity to lead and set a worthy example!' I found this very strange and infinitely preferred the Canadian policy whereby a man was not judged by any of our standards of race, religion, birth, schooling or wealth, but simply by the test that if he had earned his brevet he was commissioned on graduation.

I suspected that our commissioning policy had a lot to do with our rigid British caste system of 'officers and their ladies, sergeants and their wives, and men and their women', and this was brought home to me when the AOC 11 Group, Air Vice-Marshal 'Dingbat' Saunders, a splendid man, asked me to prepare a list for him of well-decorated fighter pilots who were to be invited to have tea with the King and Queen and the two Princesses at Windsor. I included my friend, Wing Commander Don Kingaby, who had greatly distinguished himself in the Battle of Britain and held the DSO and the DFM with two Bars.

Somehow the SASO (Hawkeye's friend), who only flew as a passenger, heard about the invitation and told me that, in accordance with staff procedure, I must submit the list through him. Having done so, he summoned me to his office.

'I see you've included Don Kingaby in your list.'

'Yes, sir,' I replied.

'But he's got the DFM.'

'As a matter of fact he has three,' I parried and could feel my anger mounting.

'That's not the point. He has been in the ranks and we cannot possibly send a ranker to Windsor.'

My appointment gave me direct access to the AOC. I tapped on his door and entered. 'Dingbat', who had won a Military Medal as a dispatch rider in the First War, studied my list whilst I told him the sordid story. He said that I could leave the matter with him.

Don Kingaby went to Windsor Castle with his peers and, after tea, they had a dram with their King.

● ● ●

I joined the Air Force because I wanted to fly and I enjoyed flying, and I resolved that, come what may, I would keep flying – unlike so many deadbeats I had come across. It was not always easy to keep in good flying practice, and when I was sent to the RCAF's Staff College in Toronto, I thought it

would be a sabbatical year without flying, but I soon discovered that the College had a few Twin Beechcraft on its establishment at nearby Trenton, where I was always welcome.

After Canada, I went to the HQ of the Tactical Air Command at Langley Field, Virginia, where there were plenty of aeroplanes, and where everyone, including the Commanding General, 'Pete' Quesada, flew. On my arrival, Quesada sent for me and said I was to get 'checked out' on a twin-engined B-26, after which he did not wish to see me again until I had visited most of his combat units based in California, Texas, North Carolina and Florida.

Langley Field was also the home of the famed Fourth Fighter Group and I was able to 'check out' on their F-80 Lockheed Shooting Star and F-86 Sabre. Thus, when I was sent to Korea, in the autumn of 1950, I was in good flying practice and flew a B-26 over the combat zone and the Yalu River on the same day that I arrived at Taegu airfield. This so impressed my hosts that, soon after, I was summoned to the Commanding General's HQ at Seoul and awarded their Air Medal.

Towards the end of my stint at the Air Ministry, Harry Broadhurst, now C-in-C Bomber Command, phoned to say that, if I wanted to become a bomber boy, I could have the recently refurbished station at Cottesmore where 10 Squadron and 15 Squadron would soon re-equip with Victors. Cottesmore, in Rutland, was, and is, in the midst of some fine hunting country, and, soon after my arrival, Sir Harry Tate, a stalwart of the Cottesmore Hunt, asked me to his home for a drink. Other hunting men were present including 'Mickey' Gossage, the Honorary Secretary, Bill Rollo, of Lincoln's Inn, and others I knew from my Yeomanry days. The champagne was good and after the usual exchanges Tate said: 'I expect your new bombers will be arriving any day now. I suppose they will be noisy.'

'Yes,' I replied, 'they make a lot of noise, but we usually take off from the east and will be quite high when we cross your kennels.'

'I was not thinking of the kennels,' said Tate. 'You see, Cottesmore is in our Thursday country and hounds won't work in that noise.'

I had done my homework. 'Just let me know when you are coming and I'll make sure all the aeroplanes are off before you arrive and there will be no flying while you are on the airfield. And I hope you will meet at our Officers' Mess so that we can give you a stirrup cup.'

Thus began a happy relationship between the Cottesmore Hunt and Royal Air Force, Cottesmore. They held their Hunt Balls in our Officers' Mess and my successor, Denis Mitchell, did better than me when he had many a bye day with them.

• • •

We had learned our lesson in Bomber Command and all aircrew, from the C-in-C down, flew the bombers. All Station Commanders were qualified Captains whilst the C-in-C and his AOCs flew as co-pilots. It was a far cry from the bad old days, but, as Broadhurst discovered, it had its risks.

Returning from a world trip in his Vulcan, Broadhurst received a signal saying he was to land at Heathrow where the Chief of Air Staff and the press would be waiting. At Heathrow, the weather was bad and Broadhurst left the decision about landing there or diverting to Scampton, in Lincolnshire, where the weather was good, to the Captain, Squadron Leader Howard. The Captain elected to land at Heathrow and made a radar-controlled approach, but something went wrong and the Vulcan struck the ground short of the runway. It bounced back some thirty feet into the air giving the two pilots just time to eject and live. The three aircrew behind were killed because the Treasury would only fund ejector seats for the two pilots. Recovering in hospital, Broadhurst received a letter from the Treasury solicitor telling him what to say at the inquest!

● ● ●

I have always been fascinated by leadership and learned something of the qualities required by knowing and following natural leaders like Bader, Broadhurst, Dundas, Embry, Malan and Tuck. Nine-tenths of the qualities of leadership – character, integrity, common sense, professional knowledge and moral courage – can be learned, but I believe T.E. Lawrence's comments on tactics can be applied to leadership when he wrote 'Nine-tenths of tactics are certain and taught in the books; but the irrational tenth is like the kingfisher flashing across the pool, and that is the test of generals.'*

Douglas Bader had the 'irrational tenth' quality of leadership which won our hearts and minds. He had led us, all blessed with solid legs, not as a handicapped man but as an inspiring leader. Many people, including me, had drawn fortitude and encouragement from him. He had taught us, including those who sometimes wavered, how to conduct ourselves in battle. He was made of the right stuff.

> *Always a little further; it may be*
> *Beyond that last blue mountain barred with snow,*
> *Across that angry or that glimmering sea†*

'Small is beautiful,' wrote Schumacher, and our fighting unit, the Squadron, was in my day, just the right size with its 20 pilots and 70 or 80 airmen. The fighter Squadron was small enough to let us know each other, trust each other and to have responsibility for each other. My life depended on my rigger, Arthur Radcliffe, and my fitter, Fred Burton. They strapped me into the cockpit, waved me off and welcomed me back. And whenever I had any success in the air they were as pleased as me. We are friends to this day.

It was at Kingscliffe that Burton and Radcliffe were apprehended by a Service policeman when returning from the local pub. Burton was pedalling and Radcliffe was on the cross-bar of a bicycle made for one. The next day, wearing their best blues, they were marched in front of me and charged with the dastardly crime of riding two on a bicycle. In accordance with Service

*The Science of Guerrilla Warfare (Guerrilla, *Encyclopaedia Britannica*, 1929)

† James Elroy Flecker, 'The Pilgrim'.

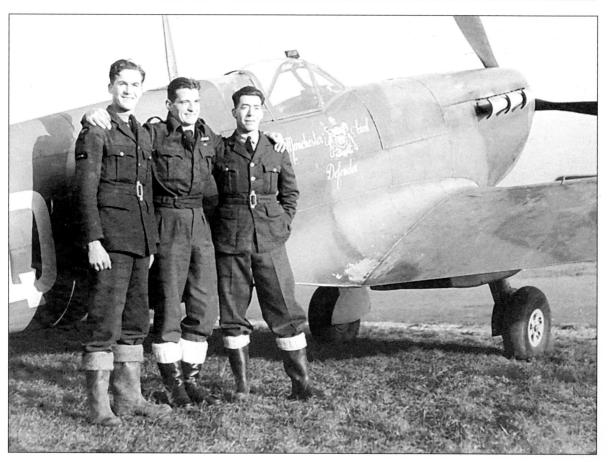

'For me, those men were closer than any friends had been or ever would be...' Johnnie Johnson on his groundcrew – Arthur Radcliffe (*left*), rigger, and Fred Burton (*right*), fitter, each of the Auxiliary Air Force

procedure I had to say: 'Are you 123456 Leading Aircraftman Burton F., and are you 567890 Leading Aircraftman Radcliffe A.?'

I, of course, had to look hard at my desk when I asked this ridiculous question of those two loyal and skilful boys who day in, day out, had cared for my Spitfire for nearly two years. Eventually I had to look into their faces and both boys – they were 19 or 20 – were looking at me as if I had gone mad, as well they might. I broke into a fit of uncontrollable laughter over such a bloody stupid question. Rigger and fitter soon joined in the laughter, and when some sort of order was restored they both pleaded guilty to the charge and were admonished (the minimum penalty) by me.

The Squadron was our family, our home and the powerful force that, once we were taken off operations, drew us back. For me, those men in the line were closer than any friends had been or ever would be. I had to be with them ...

He that outlives this day and comes safe home,
*Will stand a tip-toe when this day is nam'd**

*William Shakespeare, *King Henry V*, Act IV, Scene II

Was it the same in Bomber Command? What made the bomber boys return to their own holocaust at a cost of more than 47,000 young lives? Why

did they return for second and third tours, each of thirty operations, to face the new inventions of death in the darkened skies, where a man stood one chance in three of surviving one tour? At Cottesmore, I had the opportunity to find out.

My Squadron Commanders, Charles Owen, of 10 Squadron, and David Green, of 15 Squadron, were experienced bomber captains, both having won the DSO and the DFC. The New Zealander, Len Trent, VC, was next door at Wittering and I often saw Hughie Edwards, VC, before he returned home to Australia. I asked these brave men what made them return to the fire? Was it their leader, 'Bomber' Harris, remote at High Wycombe and rarely seen on his airfields? Or was it their Group Commanders, who, except for Don Bennett, were anchored to their desks? Did the Squadron call them back, as in Fighter Command? Or was it the comradeship and affinity of the closely-knit crews which I found at Cottesmore?

At the end of his first tour, Leonard Cheshire wrote: 'From now on, I'm just another has-been; from now on, I've got to sit in the background and live on memories, because never again will I be able to capture the companionship and confidence of men like these …'*

Hughie Edwards, VC (*right*), after leading the Mosquito attack on the Philips factory at Eindhoven, 6 December 1942. Wallace 'Digger' Kyle, CO of RAF Marham, has his back to the camera. Each would later become Governor General of Western Australia

'Of arms, and the man I sing,' wrote Virgil in his great epic about love and war – the very core of human experience; and it was love of their crews that drew back Leonard Cheshire, Guy Gibson, Micky Martin, Gus Walker and their gallant company to fly their 100 plus missions. The bomber Squadron was, indeed, their family and their home and their crews were very close. The Squadron and the crews called them back, and when these brave, resolute Wing Commanders and Squadron Leaders returned to the fray and led by example, others followed, and it was at this level that the real leadership in Bomber Command was to be found.

• • •

My last appointment was Air Officer Commanding, Middle East Air Forces – the best Air Vice-Marshal's job in the Royal Air Force. I had a big parish, ranging from Bahrain to Kenya, together with some internal security responsibilities for the Protectorates of Bechuanaland, Swaziland and Bustutoland. I had a variety of aeroplanes, including fighter-bomber Hunters, single and twin-engine Pioneers for the rough up-country strips, Beverley and Argosy trans-

*Leonard Cheshire, *Bomber Pilot* (Hutchinson, London, 1943)

ports, reconnaissance Canberras, Belvedere and Whirlwind helicopters and an ancient, yet reliable, VIP Dakota. The job would, happily, entail much flying to visit the widely dispersed units and Squadrons, and I managed to get my old friend, Mike LeBas, as my SASO. Mike, who had served with me twice before, had a first-class brain and could more than cope with most of the administrative chores at Aden, leaving me free to keep an eye on the sharp end.

Africa was rapidly changing and the pattern of progress seemed to be independence, total Africanization of the Army and sometimes revolution. In 1964, thanks to good intelligence, we were able to move our troops to quell mutinies in Kenya, Uganda and Tanzania, and, nearer to home, we had to deal with some dissident tribesmen in the Radfan. But the writing was clearly on the wall and the days of the colonial overlord were numbered.

We had excellent relations with the Royal Rhodesian Air Force, and during one visit to their HQ at Eastleigh, near Salisbury, I lunched with Prime Minister Ian Smith, who had joined 130 Squadron just before we crossed the Rhine in 1945. It was unusual that we had no papers about his posting, but he explained that he had been shot down in Italy, evaded and made his way to England. The authorities in London wanted to send him back to Rhodesia, but the young fighter pilot boarded an aeroplane at Tangmere, flew to Eindhoven and reported to my 125 Wing. We both had a good laugh when I told him that we never did get his papers.

One of my officers at Eastleigh, Nairobi, was Squadron Leader Andrew de' Nahlik, from a good Polish family, who had written a 'bible' about deer and was an Honorary Game Warden. He had arranged a short safari with Game Warden Denis Zaphiro, born in Greece and a most interesting and charming man.

The other occupant of our camp was Colonel Charles Lindbergh, who achieved great acclaim when, in 1927, he was the first man to fly the Atlantic in 'The Spirit of St Louis'. Lindbergh had a chequered life and suffered personal tragedy when his child was kidnapped. A huge ransom was demanded by the kidnappers, and when Lindbergh had paid up he found the mutilated body of his son within the grounds of his home. He incurred the displeasure of Theodore Roosevelt when, shortly before the Second War, he said Britain was finished and America should align herself with Germany.

I found 'Slim', as he preferred to be known, to be an honest and thoughtful man. At sixty-three he was very fit, did not smoke or drink and ate very sparingly. He talked learnedly about flying, engineering, archaeology and astronomy. He never came shooting with us but told me that he was looking for a Masai with a spear who could speak English. When he found his Masai he wanted to talk with him about his life, his ambitions and 'what made him tick'. I wondered what made Slim tick.

At Steamer Point, Aden, we had some excellent air-sea rescue launches, and from time to time I would accompany the crews to check their efficiency, and especially their navigation skills, since they could be called out at any

time to help a ship or aeroplane in distress in the Indian Ocean or the Red Sea. Thus, on one occasion we made the voyage from Perim Island, once a flourishing coaling station but then derelict and abandoned, to a group of rocks near the African coast known as the Seven Brothers.

Apart from the crew, we had on board Doctor Colin McCance, son of the renowned Professor R.A. McCance, who was advising on survival at sea and in the desert, two Royal Air Force doctors, and Val Hinds, a civil servant and a very knowledgeable fisherman, who was trying to establish a Government-sponsored fishing industry in Aden.

When we saw the Brothers we reduced our speed to about five knots, set up a couple of outriggers and trailed four fishing lines behind the launch. We soon had enough barracuda for our supper, and the remainder were cut up for bait on a 24-hook-long shark line which we laid between two buoys at last light.

Early the next morning we made for the shark line and began to haul it aboard. The first few hooks were empty. Then we got just a big head – the rest had been devoured by its mates. Then another head, but cruising round it an enormous tiger shark which Val estimated at about between 700 and 800 lbs and which was dispatched with my FN rifle. The line held one more dead shark with its tail sheared off as if by a circular saw.

We all took turns at trolling for the rest of the day, packed the barracuda (the biggest was 37 lbs), horse mackerel, garfish and sharks into ice, and, as the light faded, made for home accompanied by a dozen dolphins and a few frigate birds.

The following day, my ADC said the Financial Controller – a senior civil servant who was there to uphold the principles of public accountability – would like a few minutes, and I had an uneasy feeling we would not see eye to eye on the recent trip to the Brothers. However, it was about something else but as he turned to go he said: 'My staff tell me, Air Marshal, that the airmen at Steamer Point really enjoyed the fresh fish you brought them yesterday!'

● ● ●

In mid-December 1965 I said goodbye to Mike LeBas and other senior officers who were at Khormaksar to see me off. I inspected the guard of honour, saluted the Hunters of 8 Squadron flying overhead in the form of a J and walked across the hot tarmac with mixed emotions, for, at my own request, I was leaving the Royal Air Force and this would be the last time I would sit in the Captain's seat of a Service aeroplane.

However, the Flag Officer Middle East, a man of some perception, got things in the right perspective when he spotted my flag on the Argosy: 'Only thing wrong about Johnnie's flag,' he growled to the General Officer Commanding, Middle East, 'is that it should have the bloody skull and crossbones on it!'

Pilot Officer Ware.
NEW ZEALAND.

Pilot Officer Bowen.
CANADA.

Flight Lieutenant Johnson·D·F·C.
ENGLAND.

Sgt.Smithson.
AUSTRALIA

Sgt.Winter
RHODESIA

The Empire Strikes Back! This, in the final reckoning, was where Winged Victory lay...

INDEX